Videocracy

VIDEOCRACY

HOW YOUTUBE IS CHANGING THE WORLD . . . WITH DOUBLE RAINBOWS, SINGING FOXES, AND OTHER TRENDS WE CAN'T STOP WATCHING

Kevin Allocca

B L O O M S B U R Y
LONDON · OXFORD · NEW YORK · NEW DELHI · SYDNEY

Bloomsbury Publishing

An imprint of Bloomsbury Publishing Plc

50 Bedford Square
London
WC1B 3DP
UK

1385 Broadway
New York
NY 10018
USA

www.bloomsbury.com

First published in Great Britain 2018

British Library Cataloguing-in-Publication Data
A catalogue record for this book is available from the British Library.

ISBN: TPB: 978-1-4088-8027-2
ePub: 978-1-4088-8029-6

2 4 6 8 10 9 7 5 3 1

Typeset by Westchester Publishing Services
Printed and bound in Great Britain by CPI Group (UK) Ltd, Croydon CR0 4YY

To find out more about our authors and books visit www.bloomsbury.com. Here you will find
extracts, author interviews, details of forthcoming events and the option to sign up for our
newsletters.

For JoeA48

Contents

Pre-Roll

BEAMS OF SUNLIGHT streaming into his California home on the edge of Yosemite National Park prompted Paul "Bear" Vasquez, then forty-seven, to grab the camera that was almost always by his side and step outdoors, where two spectacular rainbows extended across the giant canyon in front of him. He'd uploaded hundreds of videos to his YouTube channel at that point, but as he recorded the scene in front of him, he knew he was capturing something special. It was his off-camera reaction, though, rather than the rainbows, that made his video a cultural phenomenon. Over its three minutes and thirty seconds, we hear Bear dramatically unraveling in the presence of the majestic rainbows. Here's a partial transcript:

> Whoa, that's a full rainbow all the way. Double rainbow, oh my God. It's a double rainbow, all the way. Whoa, that's so intense . . . It's so bright, oh my God . . . It's so bright and vivid! OH! AHH! AHHH! It's so beautiful! [*Sobbing in happiness*] . . . Oh my God. Oh my God, what does it mean? Tell me. [*More crying*] Too much. Tell me what it means. Oh my God, it's so intense. Oh. Oh. Oh my God.

The first time I stumbled across the "Double Rainbow" video (officially titled "Yosemitebear Mountain Double Rainbow 1-8-10"), I'd yet to start a career in YouTube video watching. I was taking some vacation

time from my job as a news-industry reporter to teach at a high school summer acting camp. While Bear had posted the video in January 2010, it hadn't taken off until six months later, when Jimmy Kimmel famously shared it on Twitter: "my friend Todd has declared this 'funniest video in the world'—he might very well be right."

I, like Jimmy Kimmel's friend Todd, couldn't get enough of Bear's hysterical reaction to the double rainbow. Over the course of that week, I must have watched it twenty times. The staff showed it on a big screen for the students before a lecture. They loved it too, and "It's so intense!" became the campers' new favorite catchphrase. The video is a document of one man's exuberant reaction, a suspended moment of pure joy. It embodies an emotion we love to share.

Since then, I've hung out with Bear a few times—including at an internet-meme symposium at MIT*—and "Double Rainbow" *is* Bear. It is a complete encapsulation of who he is. The video is silly and raw and overflowing with an almost unnatural intensity of feeling, and Bear is all of those things too. "You don't see me in it, you're seeing it *through* me," he liked to say. "You experienced what I experienced." People have asked me if he understands why people find it funny—the subtext being that we are laughing *at* him, not with him—and he does. But even laughing at him, you're sharing the moment with him. He told me that it is his mission to spread a message of happiness, spirituality, and positivity throughout the world and he believes the video helps him achieve that. It's what he calls his "gift to humanity." Every time we watch it, share it, parody it, or sing it, we join Bear's personal mission.

Years later, "Double Rainbow" remains my pick for the single best video on YouTube. Somewhere in between Bear's joyous exclamations and incoherent sobbing—and our laughter—lie some important truths. We are part of an entirely new era of creativity, one driven by people like Bear who have something they want to share with us and

* Yes, that is a real thing. I also met the Tron Guy there. #NerdGoals

people like the kids at that camp who want to join in those experiences and create new ones of their own. It's a culture shaped by all of us.

I WAS PRETTY much a '90s kid. I got up for *Ninja Turtles* on Saturday mornings. Tuned in to *TRL* to figure out which bands I was supposed to hate. Rented movies from Blockbuster Video. Watched the sensationalized South Florida local news with my family during dinner until my mother complained and we turned it off. I had way more entertainment options than my parents did growing up.

In the 1950s, when my parents were kids, the media biz had become more influential than ever thanks to the growing reach of radio and television, but participating in it required a lot of money. Broadcast antennas, film stock, and presses that could generate physical media, such as newspapers or records, didn't come cheap. A single RCA TK-41 television camera, one of the first to broadcast in color, cost approximately $50,000 in 1959 ($417,485 in today's dollars). Given the massive expense of productions, and the necessity of advertising dollars or box-office sales to offset those costs, pretty much every piece of mass-consumed entertainment originated from a handful of broadcast networks, movie studios, and record companies. To maintain economic viability, most of what they created sought to appeal to as many of us as possible.

This model was not necessarily a bad thing. It brought us many of the most important cultural touchstones of the twentieth century: the Nixon-Kennedy debates, the Beatles on *The Ed Sullivan Show*, *The Godfather*, and *Gone with the Wind*. It ensured that what was created was properly categorized (into audience-identifiable genres) and contextualized (through standardized marketing and branding), and that all of it was of generally high quality. But sometimes the result was a product that was bland and homogenized. "Popular culture . . ." wrote the sociologist Ernest van den Haag back in 1957, "is manufactured by one group—in Hollywood or New York—for sale to an anonymous

mass market. The product must meet an average of taste and it loses in spontaneity and individuality what it gains in accessibility and cheapness." Youch.

The emerging media of today is, in some ways, more akin to the culture that existed before any of us were born—prior to the Industrial Revolution and the advent of mass media—when creativity was expressed through folk art that reflected the distinct realities, passions, and fears of the common people, not a small elite group. Today's technology once again allows individuals to shape our popular art and entertainment, and this time, they—we—can do it on a massive scale.

WHEN I STARTED my job tracking trends at YouTube in 2010, the first thing I noticed was that nothing seemed to make sense: The most popular channel starred a sixteen-year-old boy with a sped-up, high-pitched voice; the biggest popstar in the world (Justin Bieber) had gotten his start because of some videos he recorded in his bedroom; and somehow at the same time, Barack Obama had been dubbed "the YouTube President." Something big was happening. But it was chaos. My job as the platform's first "trends manager" was to figure out what it all meant.

This book explains how the random, unpredictable mess I first encountered in 2010 is actually the totally logical product of our new creative freedom in this era of self-expression. Sure, along the way we'll dig into how videos go viral, why some creators find such large audiences, and what made the "Harlem Shake" meme a thing. But this book is really about what these phenomena say about us and the new influence we wield.

My experiences at YouTube have given me a unique window into how our evolving relationship with video has come to affect daily life in ways we don't always realize. I've seen how YouTube's underlying technology amplifies the impact we can have on our culture as individuals by measuring and responding to how we use the technology

and how it renders obsolete so many of the factors that have historically limited how our ideas spread, like geographic location or economic status. I've observed how innovative, creative tactics develop in response to our hunger for true authenticity in our entertainment and emerging, informal kinds of artistic expression, like remixing, bring our own perspectives and meanings to the media we encounter, altering the role audio and video can play in our lives. Thanks to a media environment where relevance comes from interactivity, entertainment has evolved to generate richer experiences for us, and businesses of all sizes have had to adapt how they communicate with us too.

But the ways we interact with video affect society on a more fundamental level as well. The manner in which we obtain and spread knowledge—and share our immediate experiences—has become more personal and direct, influencing the way we see the world and one another. When niche passions and interests drive programming, seemingly small communities can come to have huge influence in our lives, and the entertainment we consume can begin to reflect deeper, less conscious needs that often go unacknowledged in our media.

The result? A new type of pop culture is forming, one driven by individuals. The voices of the next generation are not movie stars or TV personalities, they're people who make things on the internet. The new celebrities we gather around earn our attention with transparency and authenticity, and their popularity comes as a result of our engagement; the people and videos that succeed are often the ones that facilitate connections.

Our culture is changing and there is no better place to find out how than YouTube. Here's why:

YouTube was designed to be democratic, to allow people to "Broadcast Themselves" and to connect viewers to whatever videos or channels they would be most likely to watch. The site quickly became the web's #2 search engine, and by 2015 more than four hundred hours of video were being uploaded every single minute from all over the world. Of course, each of us is exposed to only a tiny, tiny sliver of it

when we scroll through the homepage or search for cringeworthy covers of Smash Mouth songs.° You have to take a big step back to be able to see that all the small actions we take online each day—in choosing what to watch, what to share, and what to upload—are shaping YouTube itself and the unprecedented trove of knowledge it represents.

By 2013, the site had one billion users. And that number will likely have climbed significantly by the time you're reading this.† That's one third of Earth's internet-using population, which is a pretty significant data set. And given that its usage generally mirrors the demographics of all internet users, YouTube's data paints a fairly representative portrait of human behavior. YouTube is, though few realize it, really the largest database of culture in the history of humanity. As a whole, it reflects who we are in all our glory and ignominy. To put it another way: If aliens wanted to understand our planet, I would give them Google. If they wanted to understand *us*, I'd give them YouTube. Analyzing YouTube gives us a better understanding of who we are and what we're becoming.

This book is a peek under the hood. My hope is to show you how the "Oh my God" of Bear Vasquez, the "Aww" of your favorite cat video, and the "WTF" of some of our viewing habits point to something much larger about our newfound ability to influence modern society. The pages that follow contain data most people have never seen, interviews with people we rarely hear from, and lots of my own research into some very unorthodox topics. As we watch, listen, discuss, upload, follow, subscribe, share, and all the other things we do in this new environment, we connect more deeply to the things we're passionate about—and our actions ultimately transform those things. We do not merely observe, we *participate*, intimately and individually, but also with the crazy scale and reach of modern technology. Our activity has

° Maybe that's just me?

† Unless we've all since become subjects of an autocratic robot army during a nuclear winter, in which case you can stop reading now and feel free to use this for kindling.

huge implications for the future of how businesses are run, how important events are shaped and understood, and how we live our lives.

If we take culture to be the sum of our knowledge, our expression, our habits, and our art (both high and low), then our digital activity has undoubtedly become one of the most transformative forces within it. The unique ways we use YouTube every day reflect and influence these aspects of life and others. And as we change, YouTube changes. Just like us, it's a constant work in progress. More than a place to watch stuff, we've turned YouTube into a giant culture engine whose parts are consistently being broken, improved, and replaced by every person who uses it.

And so we immerse ourselves in this chaos to see what it can show us. Bear makes me laugh, but frankly, my personal experience exploring the trends, communities, and talents on YouTube has often been like my own version of the double rainbow. And, oh my God . . . It's so intense . . .

At the Zoo

E ARLY IN THE spring of 2005, Jawed Karim visited some friends in San Diego and met up with a high school pal at the city's famed zoo. While standing outside the elephant exhibit, Karim pulled out his point-and-shoot digital camera. "I had made up a list of random videos I wanted to do," Karim told me. "One was doing a silly introduction at a zoo." Karim switched on the camera's video mode and handed it to his friend Yakov Lapitsky, asking Lapitsky to film him. "All right, so here we are in front of the elephants," he says at the outset of the eighteen-second clip. "The cool thing about these guys is that they have really, really, really long, um . . . trunks. And that's cool. And that's pretty much all there is to say." Yakov returned the camera to Karim and the old friends parted ways, neither realizing the puerile joke they had just recorded was destined to become internet history.

Five years prior, in 2000, Karim, the son of a researcher from Bangladesh and a German biochemistry professor, left college early to join PayPal as one of the online payment platform's first developers. (He completed his computer science degree by correspondence a few years later.) It was there that he made two friends, Chad Hurley and Steve Chen, a friendship that would change the course of his life, my life, and maybe yours too.

By late 2004, Karim, Hurley, and Chen had all left PayPal° and were meeting up regularly to discuss startup ideas. One opportunity that seemed enticing was creating a better video experience. In those days, you may recall, uploading and watching video online was kind of

° Other early colleagues of theirs at PayPal went on to found Yelp and LinkedIn.

awful. For example, you generally had to host it on a website, if you had one, and provide people with a link they could use to download the file, praying they had the proper kind of video player installed to watch it.*

Despite all the headaches people faced, a network of online clip sharing emerged, demonstrating consumer desire for a portable, discoverable, always accessible video solution. The reaction to the Janet Jackson "wardrobe malfunction" at the 2004 Super Bowl made this clear, as did the digital dissemination of an eviscerating exchange *The Daily Show*'s Jon Stewart had with hosts of the cable news show *Crossfire*, a clip that, through BitTorrent and file sharing, had been watched millions more times online than when originally broadcast on CNN. Meanwhile, the tragic tsunami in the Indian Ocean in December 2004 proved that video-capturing devices like camera phones and digital cameras had become so ubiquitous that they could be used to document events all over the world with unprecedented scale and diversity of perspectives.

The pieces were there. Broadband access enabled higher-bandwidth streaming and Macromedia's Flash began supporting video, which allowed the YouTube team to ensure seamless integration into web pages. In the preceding years, sites like LiveJournal, Flickr, Wikipedia, and, oddly, Hot or Not had refined the basic elements of community-based online-content experiences. None were super complex in implementation. Karim, Hurley, and Chen would need to come up with an easy-to-use design and then scale the infrastructure to support lots of people. Fortunately, Hurley had been PayPal's original designer and user-interface expert, and Chen and Karim had worked together on PayPal's architecture team, scaling the payment platform to millions of users. They weren't the only tech team with this idea, though; sites like Vimeo and Google Video had just launched. So, on Valentine's Day

* I can already envision proudly recounting this, often, to my future grandchildren as they roll their eyes dramatically.

2005, they quickly got to work, not even sure an infrastructure for such a site would be possible; hosting costs, the transcoding of hundreds of file types, and more presented legitimate challenges. Hurley later joked that had they known how complicated it would be, they never would have attempted it.

They weren't certain how people would use it either. They expected people might like to create video profiles about themselves and, famously, set it up as a dating site at first.* In the initial design, you couldn't choose which videos you would watch; YouTube would pick for you randomly after you selected your gender and the gender/age window you were "seeking."

When deploying YouTube's first test server, Karim uploaded the video he recorded that day in San Diego. He titled it "Me at the zoo," because, well, leave it to an engineer to label something as efficiently and straightforwardly as possible. On April 23, the "Me at the zoo" test video became YouTube's first official clip. Two days later, Karim sent the following email to his friends:

From: Jawed
Date: Mon 25 Apr 2005 05:34:07 -0400 (EDT)
Well guys, we just launched this site:
http://www.youtube.com
Can you help us spread the word? Since we just launched, there are no girls on it . . . YET.
Can you guys upload your own videos? Let me know what you think!
Jawed

But things got off to a slow start. There weren't many videos, and a number of them were merely clips of airplanes Karim had recorded. In an effort to increase uploads, they took out ads on Craigslist and

* "Tune In, Hook Up" was the tagline. :-/

put up flyers on Stanford's campus. They soon bailed on the whole dating thing because people weren't using it for that. They were using it to share videos of their friends and pets, funny sketches, unusual internet ephemera, and more. In June, the crew did some retooling, adding a "related videos" feature to help boost views, easier sharing tools, and critically, the ability to embed the YouTube player onto your own website.

The new features worked, and as the site began to grow they studied the metrics and discovered something interesting. "Every two weeks there would be one video clip, which would be a totally random clip, that just went through the roof and it would be so popular that it would just dwarf all the other video clips," Karim recounted in 2006.[*] As the rate of uploads increased, so did the probability of hits like these, until the gaps between them started to shrink, and YouTube became, arguably, the fastest-growing website ever at the time.

"Me at the zoo" was never one of these hits, of course. The vast majority of the video's tens of millions of views occurred after Karim's bad joke became a legendary artifact in the museum of internet history. "Me at the zoo" doesn't represent the razzle-dazzle of what would come later, but the simple, unassuming video is a perfect example of the kind of personal experiences the platform would come to facilitate over the years.

I've often wondered if, in the gaze of history, Karim wished he had said something different in that first video. Surely, with more than a decade's worth of hindsight and the knowledge of the impact of the thing he helped create, Karim would have wanted to express something more profound than a pretty stupid double entendre about elephant anatomy, right? When I finally got the chance to ask him about it, he simply said, "I don't mind it being the first video. It does get the point across that on YouTube anyone can broadcast what they want and the community decides what its value is." That it does.

[*] Karim never ended up joining the startup YouTube as an employee and instead served only as an adviser while pursuing graduate studies at Stanford.

◄◄

What if there was a place where anyone could upload videos and anyone could watch them? This was the almost shockingly simple question upon which the YouTube we know today was built. And, at least initially, no one knew the true implications of the answer. But if nothing else, it proved to be popular. YouTube went from zero to thirty million users per month in just over a year, and by late 2006, one hundred million videos were being watched per day and 58 percent of internet-video viewing was happening on YouTube. A decade later, people are watching videos billions of times each day, and YouTube is consistently ranked as one of the most-visited sites and most-used apps in the world.

As I'll explain, the platform's systems use our own activity and input to shape the experience we have on the site, quietly giving us more influence over how everything works than we might realize. Through our everyday use of this technology, we are capable of introducing big changes. Let's talk about how that happens.

SERIOUSLY, WHERE ARE THE VIDEOS, AND WHAT'S A VIEW?

YouTube has more than a billion users, but very few of them actually understand how it works. Almost all of today's major online platforms are intuitively useful; the people who use them don't need to know much about how they actually function. British science fiction writer Arthur C. Clarke famously declared, "Any sufficiently advanced technology is indistinguishable from magic." If we are going to talk about the impact we have on culture through YouTube, you should know a few basics about what makes the magic possible, and it all comes down to the infrastructure that supports it and the measurements that make sense of it.

A group of middle school students once asked me a simple question: "Where are all the videos?" Turns out, the answer is rather complicated.

To sort it out, I went to Billy Biggs—one of YouTube's longest-serving and most respected software engineers, whose duties include overseeing YouTube's technical architecture—and asked him to explain. "An easy way to say it is, well, they get stored on hard drives," Biggs said. "But my god, that's a lot of hard drives!" When you upload a video file, YouTube's servers process the video by breaking it up into pieces and transcoding it into an array of different formats optimized for different screen sizes and connection speeds. Watching a video on a 4K television, a laptop with a high-speed connection, or a phone in a rural area could all require different types of video files. These files then get replicated and stored on servers all over the world so that someone watching "Double Rainbow" in Johannesburg does not need to access the same video file as the person watching "Double Rainbow" in Los Angeles. The more popular the video is, the more times it gets copied to all these different locations, meaning that for any popular video there might be a thousand instances of it out there in the world. So in that sense, YouTube videos are, quite literally, all around us.

BIGGS HAS BEEN at YouTube since 2006, when the company was growing rapidly. It was a thrilling time, and he was excited to see things thrive but was also aware of the possibility back then that there might not be enough servers configured to handle the traffic, especially on the weekends, when people have more messing-around-on-the-internet time. "When you have a system that's growing so much, it's going to reach some new peak every weekend," Biggs said. He kept a laptop and a 3G Wi-Fi card with him at all times in case something broke and once had to fix YouTube from the backseat of a car while on the way to the beach with his friends.

Today, things are far less tenuous than they were in those days, but YouTube is still constantly growing, expanding, and pushing limits. That constant evolution tests technological, legal, economic, and creative standards in ways that one can be only *so* prepared for. This all stems

from the reality that we, YouTube's users, are changing all the time too, with our desires and interests ever hard to pin down or predict. In order to adapt to us and what we want from it as effectively as possible, the platform must be able to measure the actions of people who use it.

The basic building block of measuring videos on YouTube is, of course, a view. The number of views indicates how many times something has been watched.° But what is an actual view? This is another thing I'm often asked, so I went to the source. "It's a playback of a video where the viewer actually intended to watch that video," said Ted Hamilton, rather unsatisfyingly. Hamilton, or "Hammy" as he is known to my colleagues, was the product manager for YouTube's analytics department in Zurich, Switzerland, for more than six years,† making him an expert on how we organize the data we publish about videos, channels, and more. Measuring a view, it turns out, is far trickier than you might think.

It's not so much the technical challenge of counting the billions of playbacks that occur each day and processing them; YouTube's systems have gotten very good at that. Determining whether or not those playbacks were intentional is more difficult. If someone misleads you with a title or thumbnail, did you intend to watch that video? What if you visit a web page and they have an embedded video autoplaying? Would you describe someone who replays a video five times in a row over a few minutes as five different views? What if videos are autoplaying while you're in another room making dinner? Certainly we would agree that the playbacks generated by automated systems shouldn't count, right?

Some of these scenarios are sneaky attempts to make videos look more popular than they are and some are totally aboveboard, but all of

° Note that this is not the "number of people" who have watched something, which is a common mistake I hear a lot, even in the news. Measuring the number of actual human beings who do something on the internet is a lot more challenging than you would expect.

† We actually started the same week, but despite "knowing" each other for years, we have never actually met in person.

them require the application of statistical analysis to help prevent questionable activity from corrupting the data. "Through the billions of views that we have every day, patterns emerge," Hamilton explained.°

The view count remains the metric most people use when discussing how popular something is on the internet, but I found out early at YouTube that trying to understand video popularity based on views alone can be very deceiving. First of all, *how* something gets viewed is often much more telling than *whether* it was viewed. The proactive interest displayed through a search-driven view suggests something different from the reactive interest of a subscription-driven one. *When* something is watched can give us a sense of velocity, which helps us understand the dynamics of a video's popularity. For example, in 2015, the video for rapper Fetty Wap's "Trap Queen" took months to pick up steam while Adele's "Hello" immediately drew a huge audience. Both were among the year's biggest singles but were embraced differently within popular culture. Perhaps most important is *how long* someone watched, which indicates not how enticing something seemed to be before you started watching but how engaging the video was once you did. The sum of the amount of time people spend watching something is called "watch time," and it's become a metric even more important than view counts.

Available to anyone who posts a video, the video analytics tool— for which Hamilton was, in part, responsible—displays all of this information and lots of other important statistics too. All day every day, YouTube counts the views, likes, shares, comments, etc., amassed by each video, and then the platform's servers summarize all the data for videos and channels in ways that allow people to slice and dice the important bits, like where their audiences lie and even basic age and

° Savvy YouTube users noticed that for years, the view counter on popular videos would briefly get "stuck" at 301 views. The reason: The view counter doesn't update in real time. It would freeze periodically so that YouTube's systems could detect suspicious behavior. The first time that would happen was at 300 views, which was very noticeable, especially if the same video had thousands of likes. The work to ensure credible view counts has become less and less perceptible over the years, but it's always happening in the background.

gender information.* Hamilton's job is to bring all the pieces together to make sure this activity is accurately captured. The data is important to viewers, to creators who use it to adjust their strategies, and to YouTube's own systems too.

You might also say that Hamilton's responsible for a headier task: registering and validating the reality of our existence in the digital world. For video creators, rich analytics data helps turn anonymous bits and bytes into a real audience made up of real people. "In the internet age, we're very detached," Hamilton said. "And there are people out there, but you can't see them. We provide the feedback that the people *are* out there and they're watching what you put out there and liking what you do."

All this information also helps me interpret trends on YouTube. Many YouTube employees and the systems they've engineered analyze this data every day to find ways to make the platform better and more useful, which means that it's our behavior—yours and mine: our tastes, our voices, and our passions—that actually shapes the YouTube we use today and the one we'll use tomorrow.

HOW YOUTUBE IS FOR *YOU*

When you visit YouTube's site or use the app, the first things you see are likely video recommendations, one of YouTube's most important features. These recommendations, while not always perfect, can be pretty damn effective.† Even the classic entertainment world has had

* This is primarily based on the information people use when they set up their accounts, which, while not flawless, is close enough, even if not everyone tells the truth. You might not be surprised to hear that a disproportionately large number of YouTube users claim to have been born on January 1, for example.

† Ironically, people who work at YouTube have some of the worst automated recommendations because the system has no idea what to make of employees whose personal interests and taste rarely drive what they watch. I may be researching the history of cat videos, a controversial trend in India, or the viewership patterns of various ads, and the clips I watch all get factored into my recommendations. Don't even get me started on music. After seven

to acknowledge that. In 2013, the National Academy of Television Arts & Sciences in the United States presented YouTube with a technical Emmy Award for its video recommendations.

One of the guys who accepted that prize was Vice President of Engineering Cristos Goodrow. A mathematician by training, Goodrow began as a business and manufacturing optimization consultant before moving into the world of search engines, managing search for Amazon and then Google's product search. He now oversees YouTube's search and discovery teams, an army of engineers—including many of the ones I work with on a daily basis—who are responsible for building and maintaining the systems through which YouTube recommends videos or channels to you.

"The fundamental thing that few people seem to understand about YouTube is that the whole thing is a giant crowdsourcing exercise," said Goodrow. "People often ask me about 'the algorithms.' The best we could hope for in the algorithms is that they quickly and faithfully reflect back the tastes and interests of the crowd and apply that information to your individual situation." As of 2017, YouTube's discovery algorithms were being automatically updated with over eighty billion new signals— views, likes, clicks, and more—from the audience every day. This helps make YouTube different from any other entertainment medium we've ever had, an extension of our individual tastes and collective psyche.

YouTube is a kind of experiment in human expression, and none of it was by design, really. YouTube's founders, and the many employees who've since followed in their footsteps, did not adhere to a carefully plotted plan, but rather worked to magnify the behaviors and interests of those who used the service. In other words, the experience you have on YouTube has been shaped directly by our individual and collective activity.

✿ ✿ ✿

years of tracking the most popular music videos, YouTube's systems must assume I have the aggregate taste of a tenth grade homeroom.

THERE ARE A lot of ways that YouTube leverages your tastes and interests, but let's start with the feed of videos that appear alongside the video you're watching, which have been the source of an astronomical amount of viewership over the years—and a leading cause of logging in to view one video about a giraffe and finding yourself watching a woman attempting to eat corn off a power drill three hours later. Initially, the "related videos" system was very straightforward. Jawed Karim explained, "The algorithm worked like this: Take the tags on the video you are currently looking at and find other videos with the same tags. Rank the videos that have the highest number of similar tags at the top. It was a very simple algorithm that worked surprisingly well for a while."

The algorithms evolved over time, and YouTube started to incorporate viewing habits, leveraging the behavior of the crowd to improve our individual viewing sessions. Goodrow and his team recognized that immediately after people watched a certain video, they tended to watch specific videos next. They posited that a new viewer of the original video would likely behave in a similar fashion. YouTube's discovery systems now note additional videos that were watched by other people who watched the same videos as you. The systems look for patterns that can improve suggestions, drawing on connections based on subject matter (e.g., people who like videos about the U.S. Open might often be interested in French Open videos) or shared taste (e.g., people who like to watch the video for Taylor Swift's "Blank Space" also like to watch Meghan Trainor's "All About That Bass," while people who still like Sisqo's "Thong Song" also enjoy Ginuwine's "Pony"*).

How do these suggestions get refined and improved? Through "machine learning," which, very simply, allows computers to draw conclusions based on historical patterns and statistics without needing to be explicitly programmed. Machine learning allows Google to take large, complex sets of data and make predictions or decisions that improve our experience, from the relevance of search results to the automatic organization of our photos. At YouTube, machine learning works to serve

* I didn't make this up. These are the facts. I'm sorry.

Goodrow's core philosophy: Give people what they want. "We've seen tremendous growth mostly based on the premise that if we don't think too much about what people *should* want, and instead just try to figure out somehow what they *do* want, and give them that, then they'll be happy. It turns out that works pretty well." Goodrow has four children, and all of them have completely different interests on YouTube, from video games to vloggers (video bloggers) like Hank and John Green. YouTube's search, browsing, and recommendation features each have to work equally well for all of them. "We believe that for every human being there's probably a hundred hours of YouTube that they would love. If they're not watching it, it's because they don't know about it or they can't find it. And so our job is to try to help you know that it's there and find it easily."

This is important as the number of different kinds of videos we watch has grown over time. Traditional media conditioned us to believe that the majority of people would be perfectly happy watching exactly the same things as one another, but YouTube has largely taught us otherwise. "You can't even begin to fathom the diversity of what people want to watch on YouTube," Goodrow said. "You can't."

WHEN I FIRST joined YouTube, its homepage included some personalized videos based on your viewing history but was mostly composed of popular videos organized into different categories. Over the years, YouTube's search and discovery teams launched change after change, until everyone's homepage was almost completely different. In fact, as of March 2017, the YouTube homepage showed over two hundred million *different* videos to people every single day. TWO HUNDRED MILLION. As Billy Biggs put it to me, "YouTube is for you, and just for you." In this way, our own decisions and interests literally reshape the appearance of the homepage. Today, every time you watch something on YouTube, you're changing the platform a little bit and, as you can see, you're changing everyone else's experience a little bit too (hopefully for the better).

You've also probably helped contribute to most of the different features built into YouTube, even the ones that have nothing to do with recommendations, like the placement of buttons or the technology used to process the videos you upload.

"We try to run an experiment to measure the impact of almost everything we do," Goodrow explained. "This measurement is built into all of the surfaces on which you experience YouTube." These experiments are basically tiny updates where a small percentage of YouTube's visitors see a change on the site. Over the course of the experiment, the automatically selected visitors' aggregate behavior is compared with that of people who didn't see the change. If the metrics are good, we launch it for everyone. Sometimes these experiments are exceedingly simple, like the time someone realized that if you just remove the little border from around the related videos, people will be more likely to watch them. (The marginal gain can be quite small, but, at the scale of YouTube, surprisingly meaningful.) Sometimes they can be complicated. Goodrow's team ran one where they trained an algorithm to suggest fewer trashy, clickbait-y, sensationalized videos to people who don't have a lot of viewing history. While the viewership went down at first, the group that saw almost none of that type of video eventually started watching more videos overall than the group that did. Score one for human decency!

That people will come back more often if you show them less garbage might seem obvious, but predicting how people will use YouTube can be really hard, particularly when many of our assumptions are informed by older media like television or radio. YouTube's user-experience researchers run interviews and studies—sometimes bringing people into a testing lab—to investigate hypotheses about how people use new or existing features. You might be shocked at how often these hypotheses are way wrong. That's because YouTube is defined not by traditional assumptions, but by the ways people actually use it, which can be surprising in practice but very logical in retrospect.

As a sixth grader in South Florida, I won the middle school science fair in the "botany" category with an experiment about the effects of different fertilizers on marigolds. My reward was a trip to the county science fair, which took place in the Coral Springs shopping mall. My competitors and I arrived early, before the stores opened, to set up our materials. We preadolescent science students were not alone, however. I was dumbfounded to see dozens of elderly people power-walking laps around the mall in sweats and orthopedic shoes. I doubt the mall's developers had foreseen that it would be used as a personal gymnasium by senior citizens, but in hindsight it made perfect sense. The mall was a safe place to walk, and it provided amenities like air-conditioning, bathrooms, and water fountains.*

The point is, when you give people something capable of suiting a multitude of unique purposes, it can be hard to predict how they'll use it. From the start, YouTube's founders decided to let the people who used the platform define it. YouTube has been designed to adapt to how we use it in the moment, rather than how we have used it in the past or how we might be expected to use it. An infrastructure that lets anyone anywhere post and watch videos capitalizes on an unparalleled diversity of interests and perspectives, upending our traditional assumptions of how media works.

THE UNEXPECTED K-POP STAR
AND THE FUTURE OF POP CULTURE

It was the end of the summer of 2012 and all day I had seen this one video creeping up the ranks of all the tools I use to track trending videos. It had been a busy day and, given that the video's cartoon thumbnail made it look like something related to a foreign video game, I had put off watching it. Late that evening, I spotted it again and

* I also dramatically underestimated the interest the Florida mall-going community would have in getting gardening advice from a sixth grader.

decided to succumb and see what it was about. It was a music video. It started with a man sitting on a beach chair, and then . . .

My jaw hit the ground. It was maybe the most absurd music video I'd ever seen. I laughed so hard my eyes teared up. I had no idea what the song was even about—it was in Korean—but it really didn't matter at all. Nothing in the video made sense, and it included a lot of people dancing as though they were riding horses. I immediately wanted every person I had ever met to see it and confirm my reaction, so I shared it on my social media feeds. It remains my most reshared post.

The video was called "강남스타일" or, as it is more widely known, "Gangnam Style," and, as I told everyone in the office the next day, I had a feeling it was going to be pretty big. (Nerds like us love this stuff.) But I was *way* off.

That this strange and outrageous video was in Korean held much of the appeal for me; I had come to love the access the internet provided to all kinds of unique entertainment from all over the world. I am one of those dorks who loves peculiar international things— Japanese game shows, Polish music videos, and so on—even if they never have mainstream appeal.

I had been tracking the rise of Korea's special brand of pop music (K-pop) on YouTube since the start of 2011 when I caught a music video from GD&TOP, a duo act spun from über-popular boy group Big Bang, drawing millions of views. Similar K-pop groups like Super Junior and SHINee were churning out a slick, colorful, plasticky version of R & B dance pop with some of the most visually arresting videos, which featured intricate choreography performed by young singer-dancers with spiky dyed hair and shiny pants. These videos were heavily viewed in Asia and within global Korean diaspora communities, as well as, increasingly, a small but loyal Western fanbase. In many ways, "Gangnam Style" was completely different. Its star was not a pretty nineteen-year-old boy. PSY—Park Jae-Sang, whose nickname is short for "Psycho"—did not have a pristine public image, a svelte figure, severe bangs, or a crooning voice that could melt all your worries away. He was thirty-four, pudgy (he once described his favorite hobby as

drinking), and had been arrested for smoking pot. Typical Korean pop idol he was not.

Given PSY's preexisting fanbase, the video had some reasonable success out of the gate, but word spread and daily viewership grew almost exponentially until "Gangnam Style" was garnering more than 10 million views per day. "Words cannot even describe how amazing this video is," tweeted T-Pain, who was one of the first to expose the song to a large U.S. audience. "Help, I'm in a gangnam style k hole," tweeted Katy Perry. Three weeks after I came across the video, PSY attended a Dodgers game in Los Angeles. In what must have been a surreal moment for all involved, the song played, and a Dance Cam panned around the stadium as fans imitated his moves from the video.

Typically, viral fads see a steep decline as audiences get tired of the joke or whatever qualities made each craze successful. But with "Gangnam Style," the views continued to climb. In just over four months, it became the most-viewed video ever on YouTube and a few weeks after that, in December 2012, the video became the first to cross one billion views. When we looked at the top videos for 2014, we discovered it remained the twenty-fifth most-watched video on the site . . . two *years* after it came out.

I can't imagine a major U.S. label agreeing to sign and promote "Gangnam Style" for Western audiences. The expected market would

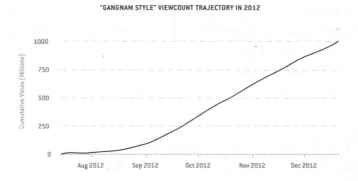

"GANGNAM STYLE" VIEWCOUNT TRAJECTORY IN 2012

have seemed quite small, rendering it a very poor business investment. Historically, the U.S. market has not been kind to foreign-language hits; the last #1 song was Los Lobos' 1987 rendition of "La Bamba." A tiny fraction of the world's population are Korean speakers, and a bunch of them are in North Korea, where, I gather, there is not a ton of hip-hop. PSY has admitted that he did not make the video for international audiences; he made it for the local Korean market, where he'd released five albums prior and had multiple hit singles. Many have pointed out that the central commentary of the video requires some understanding of Korean culture. "He parodies the wealthiest, most powerful neighborhood in South Korea [Gangnam]," writer Sukjong Hong explained in *Open City Magazine*. "All of his mannerisms, from the curled upper lip to a sinister neck-stretching move, come from the repertoire of a rich playboy, and in his hands, they become a little laughable. But ultimately, by declaring 'Oppa [big bro] is Gangnam Style,' he turns the lens on Gangnam, getting specific about power and privilege in a country where a single district has long dominated in almost every arena." PSY himself shakes off a bit of the scrutiny of the song's metaphors. "As the song has become popular, I am often asked if there is a hidden message," he told the *Wall Street Journal*. "Since the weather is so hot and the economy is in bad shape, I simply wanted to write a fun and exciting song with a good hook in it."

But "Gangnam Style" was much more than a song. Despite the cultural barriers, it didn't alienate people because the visual translation was discernable to nearly everyone. The video's type of physical comedy resonates almost universally. Parodies and fan videos rolled in from every corner of the earth with an internet connection.° The dance, which PSY and his team spent a month choreographing, infiltrated everything from the world cricket championships to *Saturday Night*

° A performance of the song by the Ohio University marching band became PSY's favorite fan video. You haven't heard "Gangnam Style" unless you've heard it performed by a marching band.

Live. In Paris, PSY joined fans for a flash mob of the dance across the Seine from the Eiffel Tower. Twenty thousand people turned up.

The craze proved decisively what we had seen glimpses of for years: that simple, open distribution of video could be a cultural force. "Gangnam Style" showed us that it is possible to have truly global pop culture moments outside of a handful of events like the Olympics or the World Cup. Even Wall Street did not escape PSY's reach. "Sorry, what is the recent video with the horse dancing? Gangnam Style?" asked Google CEO Larry Page at the company's quarterly conference call with investors that fall. "That kind of thing, to just really flip a switch, turn it on, and get a worldwide distribution . . . If you're a provider of this content, it's an amazing thing. And I think that's how we see the future."

I find it fitting that it's this particular video that broke so many records. Nothing against Justin Bieber (or his video "Baby," which was the previous record holder) but an American pop-music video is so . . . expected. "Gangnam Style," meanwhile, represented in a nutshell what was possible in this new environment and also what made it so delightfully unpredictable. PSY helped expose the world to Korean pop music, leading to the genre's massive growth outside the borders of South Korea. Global viewership of Korean artists tripled in the year following the release of "Gangnam Style" with 91 percent of the views coming from outside Korea. In 2013, at the first YouTube Music Awards, One Direction, Miley Cyrus, Lady Gaga, and others were up for "Video of the Year" in a fan-voting contest. Much to the shock of the American music press, the winner—in a landslide—was a video from K-pop group Girls' Generation.

PSY never expected his video to be a worldwide smash, but then again, how could he have? Up until recently, nothing like that had been remotely possible. We had no road map for it.°

° We were not just culturally unprepared for "Gangnam Style," we were technically unprepared for it too. After Psy's video crossed the two-billion threshold, the view counter on it became stuck because it was not designed to ever surpass 2,147,483,647 views. Engineers scrambled to update the view count system from a 32-bit to 64-bit integer, permanently resolving the

❖ ❖ ❖

IN THE MID-TWENTIETH century, where you lived mattered a lot in terms of what entertainment you could access, thanks to the limits of technology and the expense of disseminating media across international borders. The internet changed all that, but it took platforms like YouTube to show us the true power of unfettered distribution.

By 2016, the largest market for YouTube was still the United States, but it contributed less than 20 percent of the viewing activity. Countries like Brazil, Japan, Germany, and France made up sizable audiences too. And on average, about two thirds of a channel's views came from outside its home country. YouTube helped introduce the first moment in human history that such a broad, international audience could be reached simultaneously by any single artistic work. If I had wanted to watch a K-pop music video when I was a kid . . . well, I'm not even sure what I would have done. It would have taken a hell of a lot of votes to get Carson Daly to feature PSY on *Total Request Live*. Suddenly, almost anything people produced could reach an incredibly broad audience all over the world, which meant that YouTube and its creators could analyze the taste of an incredibly broad audience too.

At a macro level, we could, for example, see which trends spread between different countries and cultures. I remember raised eyebrows when the video for the Sertanejo (Brazilian country music) song "Ai Se Eu Te Pego" by Michel Teló suddenly became YouTube's most-watched clip in the first half of 2012. For several months after it was posted, the song was popular pretty much only in Brazil. But then there was a big spike in interest in Spain after Real Madrid stars Cristiano Ronaldo and Marcelo broke into the dance from the video after scoring a goal. As it became a popular victory dance throughout Europe, the song that inspired it, naturally, became a hit too. YouTube's analytics mapped the video's rise in Turkey, Poland, Mexico, and Thailand, and it unexpectedly

issue. Unless, of course, "Gangnam Style" ever crosses the 9,223,372,036,854,775,808 view mark, which, based on current viewing, is still forty billion years away.

became the most-viewed video ever in France. What united "Ai Se Eu Te Pego" fans wasn't a language or a location, but a love of soccer.

While I sometimes wondered if this meant that our entertainment was becoming globalized, I discovered—via a cool "Trends Map" we built depicting the popular videos in various cities around the United States—that some videos were popular exclusively in the areas from which they emerged. For example, "I'm Gonna Put You In The Auburn Store!"—a video in which the University of Alabama–obsessed parents of a screaming-and-crying little boy threatened to put him in the mall's Auburn University gift shop—became the most-viewed clip in Birmingham, Huntsville, and Mobile, Alabama, cities where the intense sports rivalry between the two schools is a way of life. The basic accessibility of a free-to-use global video platform means that our physical locations do not limit the spread of our ideas and experiences. Rather, they are limited only by the ability of the audience to access them culturally. What is popular highlights what viewers have in common, regardless of where they are located.

"Gangnam Style" found its way to us because of technology that allows a video posted in one place to be immediately accessible everywhere else—a system designed to give us what we want, even if what we want isn't all that predictable. And it became a massive phenomenon via a popular culture that is increasingly molded by shared interests and passions, rather than things like location, economic status, and distribution partnerships. There's no company or business deal to credit for making "Gangnam Style" into what it became. Its popularity was due solely to our own actions: our shares, our views, and our private horse-dances around our kitchens when no one was looking.

►►

One of the many unusual experiences you have as a YouTube employee is the day you realize that you and your colleagues do not actually

control the thing you are building together. Instead, it's almost like you've all been entrusted to act as a facilitator of some giant, complicated experiment in human communication that is much bigger than the small collection of people you work with. As much as any of us might want to assert that YouTube should be this or evolve into that, we are along for the ride; our role is to enable what the internet users of the world have made. Given enough time, everyone who works at YouTube seems to come to this realization. "You tend to think, 'Well, I'm making this great app and I made it better and that's why people love it,'" Cristos Goodrow told me. "But, really, the app is just a mechanism to connect them with the things they really love, which are those videos, those people, those creators, that stuff."

Chad Hurley, Steve Chen, and Jawed Karim all recognized it quite early. "One thing we couldn't really predict that really surprised us was the way the community drove the site," Jawed said in 2006. That still felt true ten years later (though we stopped calling it "the site" sometime after we realized the number of people using the YouTube app on their mobile devices would surpass those visiting the site on their desktop or laptop browsers.)

YouTube is ever evolving, diversifying based on what we watch, what we share, and, of course, what we post. It is one of the few brands in the world that is defined more by the people who engage with it than by the product it offers. This is, ultimately, what makes YouTube the comprehensive reflection of the human experience that it is and why it tells us so much about ourselves—it reveals back to us who we are and who we're becoming. YouTube is much more than the servers and code Chen, Hurley, and Karim initially set up back in 2005 or the elaborate technology that enables it today.

That any and every one of us can create a video that any and every one of us can watch changes the rules for what's possible. Democratizing the power of distribution is, perhaps, YouTube's most important innovation because it means that the art and ideas we encounter on the site will not necessarily be defined by the few with the economic

means to distribute them or by the international borders that restricted the spread of creativity in the past.

YouTube is ultimately what it is because of how all of us choose to use it. And as the culture of web video merged with general entertainment culture, as internet culture became pop culture, the way we use web video began to have more influence on the world than anyone could have imagined.

Creating Entertainment
in the Auto-Tune Era

W HEN I SAT down for lunch with Evan, Michael, and Andrew Gregory a few blocks from their Brooklyn office/studio to discuss the unique creative journey they'd been on for the past ten years, the first thing I asked, naturally, was how they had gotten their start.

"We started as brothers," Andrew explained. "And, really, the rest is history."

"Yeah, it was really involuntary," added Michael. "We were really forced to be brothers, actually, and we remain brothers by force."

This is what it's like to have a conversation with three people who don't take very much of anything seriously. Their atypical approach to answering interview questions mirrors the unconventional methods they use to produce their unique blend of music and comedy, making them a stand-out success in a world where the rules of creativity have been undergoing major changes. Their entire goal as performers may be to take an unserious approach to serious things. The Gregory Brothers, a quartet that includes Evan's wife, Sarah, combines musical talent with video production skills and an upbeat, subversive sense of humor.

The guys grew up in Radford, Virginia, but only really started performing as a group once Michael and Evan moved to New York as adults. In 2007, Andrew released an album under his own name and asked Sarah, Evan's then-girlfriend, to head out on a joint tour. Evan took leave from his job at a Big 5 consulting firm to join them and help flesh out their arrangements. To round things out, they asked Michael, who was a senior at Appalachian State, if he'd accompany them on drums. They traveled in a packed Dodge Caravan Evan had purchased for $600. "We did about fifty dates, and by the end of the tour we had basically merged into one band," Evan explained. At that point, they

mostly used YouTube to host snippets of their shows in order to prove to booking agents that they were, you know, a real band.

Michael had created his own channel in college. Technically his first success was a song mocking a comically tiny park in North Carolina, though its audience was pretty much limited to his small university town. By 2008, Michael had graduated and was sharing an apartment with Andrew in New York City while working in a recording studio. The 2008 U.S. presidential election was the country's first of the social media era, and suddenly, we all could participate in real time, reacting to events as they unfolded. The news shifted from daily story lines to hourly ones, and it seemed that the appetite for political commentary—as well as parodies, remixes, and other creative responses—was endless. Michael had the idea to make a comedic song about the presidential election, green screening himself into footage from the first debate between Barack Obama and John McCain. It became a modest hit and Andrew, Evan, and Sarah decided to join him for the next debate, except this time they thought it would be much more entertaining if the candidates were singing too. That, obviously, wasn't going to happen at the debate, but they could make it happen in a video. The vocal Auto-Tune had become the hottest trend in music, and Michael used it so frequently at the studio that he felt he could employ it on basically any voice or vocal pattern. The crew got lucky, because the vice presidential debate starred two bombastic speakers: Joe Biden and Sarah Palin. "Biden is the Beyoncé of our channel," Michael said. "He's the greatest male accidental singer."

To keep the momentum going after the election, the brothers invented *Auto-Tune the News*, applying their new signature style to all kinds of current-event clips. In 2010, a local news report from WAFF in Huntsville, Alabama, dominated YouTube's charts. Kelly Dodson, a resident of the Lincoln Park housing project, had fought off a potential rapist who'd come through her second-story window. Her furious twenty-four-year-old brother, Antoine, gave a flamboyant and sensational interview to the TV crew in an attempt to drum up attention for the unsolved crime. Here is the transcript:

Well, obviously, we have a rapist in Lincoln Park. He's climbing in your windows, he's snatching your people up, trying to rape 'em. So y'all need to hide your kids, hide your wife, and hide your husband, cause they rapin' everybody out here . . .

You don't have to come and confess that you did it, we're looking for you! We gonna find you! I'm letting you know, now! So you can run and tell THAT, homeboy.

You are probably aware of what happened next. The Gregory Brothers' fans immediately began requesting an Auto-Tune. Within two days, they posted one to YouTube and it was soon on every pop culture site. Say what you will about the tastefulness of the subject matter, but there was little denying that "Bed Intruder Song" was immensely catchy. "Our video, which we saw as sort of like a fan reaction/art piece based on this footage, started to be the biggest thing about this story," Michael recalled. "It just came out of nowhere to both amplify the original thing and become a primary part of the viral phenomenon." It took a few days for them to get ahold of Antoine Dodson, but when they did, they worked together to get an official song-length version up on YouTube and the iTunes store.*

While many questioned the exploitation of a somber incident, Dodson later said that he and his sister found happiness and comfort in hearing themselves on the track during a tough time. The video's popularity snowballed. I remember being at a party in the Lower East Side when someone put the song on. Surreally, people began singing along like it was just an ordinary pop hit. "We gonna *fiiiiiiind* you! We gonna *find* you!"

BY THE END of the year, YouTube had an unexpected conundrum. We were releasing our first "Rewind," a list of the top videos of the

* Dodson eventually used his cut of the proceeds from "Bed Intruder Song" (and related merch) to move his family into a safer home.

year, and the two videos tracking to take the #1 slot were a parody of Ke$ha's "Tik Tok" called "Glitter Puke" and this remix of the interview with Kelly and Antoine Dodson. At the time, my colleagues in PR and marketing were spending an incredible amount of effort trying to convince people of YouTube's legitimacy as a platform of elevated creative expression, and the popularity of these two videos did not seem to help the cause. The Gregory Brothers won out, and "Bed Intruder Song" was the most-watched video that year outside of official music-label videos. But that result turned out not to have much effect on public opinion of YouTube's legitimacy. People, especially young people, had begun to understand the web as a place for irreverence, for new ways to react to popular culture, for odd forms of creativity. A Gregory Brothers remix was all those things.

There were many imitators, and at some point, Auto-Tuned remixes or "Songify" versions of videos, as The Gregory Brothers dubbed them, became the *sound* of going viral. You could even judge the magnitude of a phenomenon based on how many Auto-Tune versions of it there were. Mainstream entertainment plotlines came to rely on the Gregorys' Songify sound as a narrative shorthand for when one of its characters became fictionally popular on the web. In 2015, composer Jeff Richmond enlisted the brothers to help him create the seriously catchy theme song for the Netflix series *Unbreakable Kimmy Schmidt*.

"Bed Intruder Song" changed things for the brothers. "That is when we bought our jet," said Andrew. "Yeah, we bought a private jet," added Michael.° The success of the clip was a tipping point for the quartet and The Gregory Brothers became everyone's full-time gig. The success of "Auto-Tune the News" had opened some doors for them; they were in talks for a pilot at Comedy Central and were asked to write jingles and perform at events.

Each mix is different, but Michael told me he usually starts with melodies, bringing in the band members' voices or those of anyone

° Note: The Gregory Brothers do not have a jet.

who joins them (actors Darren Criss and Joseph Gordon-Levitt have appeared in *Songify the News* and Weird Al Yankovic joined them for their 2016 presidential debate clip "Bad Hombres, Nasty Women"). It's a creative endeavor that can accentuate the natural absurdist qualities of something, rather than entirely reframe it. "For us, the best version is always the shortest journey from whatever the original voice is," Evan said. The Gregory Brothers feel that they collaborate with their subjects as opposed to appropriating them but admit that the collaboration is one-sided. Just as teams of producers and songwriters partner with pop stars to craft the hits, the Gregory Brothers compose arrangements and manipulate the vocals of their unwitting subjects. "Our process is really similar to that of Taylor Swift's or Beyoncé's songwriters," Michael added, only half-joking.

More than a passing fad, *Songify* felt just as appropriate in the 2016 election as it did in 2008. *Songify* is a very modern format, and while some of the novelty might wear off, the appreciation we have for these unique types of entertainment created in response to the zeitgeist seems to be as strong as ever. The Gregorys say they are often asked if they'd prefer to just "do their own music." But that's missing the point. "This *is* our music," Michael responds. The creativity of The Gregory Brothers is hard to classify. Much of it doesn't quite fit any long-standing category of entertainment. That's true of many of the shows and formats YouTube's creative community has developed.

The web offers a near limitless opportunity for artistic experimentation, and musicians, comedians, filmmakers, and all sorts of creative talents explore new formats and aesthetics to find out what might work. What emerges is not always what we expect. The things that we come to love don't always have traditional scripts or follow the rules of the media we grew up with. It's faster and irreverent and built for interaction, and it often muddies genres and the job descriptions of the people doing the creating.

"When someone asks me what I do, I often give them five different answers and all of them are honest," Andrew said. "Depending on

my mood, I've said, 'I'm a musician. I'm a director. I'm a video editor. I'm a comedian.' All those are true. We do all those things on our channel. And that's just a lot easier than saying, 'Uh, I make serial video remixes . . .'"

<div align="center">◄◄</div>

When we define books, we don't think of them as bound collections of paper with printed text; instead it's novels, memoirs, and anthologies that come to mind. When we define TV, we don't describe moving images transmitted over radio waves, cable lines, and satellites; we talk about the sitcoms, dramas, game shows, and live sporting events we watch. Various types of media gain their identity through the content they deliver to us. And with each new medium, creative professionals face new challenges in how to innovate production techniques and adapt to the new ways people experience their work.

When the online-video era began, people characterized most of what surfaced as either derivative of existing media formats or chaotic amateurism. In column A, you could find comedy sketches, music videos, and the twenty-first-century equivalent of public-access talk shows. Column B covered quite the spectrum; you had things like photographer Noah Kalina's video project for which he'd taken a photo of himself every day for six years, or the work of Fritz Grobe and Stephen Voltz, a professional juggler and an attorney, respectively, who founded EepyBird and discovered that combining Diet Coke and Mentos mints could be performance art.* A logical conclusion was that the kinds of creativity that were native to the web were mostly gimmicky, with some inspiring exceptions. But it turned out that we were looking at the products of a creative community trying to adapt to

* Column C was porn. Lots and lots of porn. But we will skip discussion of that here, as my mom is reading this book.

the ways we were engaging with a new medium. These were not just random amateurs messing around, but ambitious talents trying to *figure it out.*

The things that captured our attention on YouTube looked different and felt creatively distinct from past media. From the raw and disorganized slew of things people created, patterns and formats began to take shape. And platforms like YouTube allowed viewers to actually communicate what we liked, what we didn't like, and what we loved. The creators could see it in the comments, in the shares, and in the view counts, and the analytics and the techniques and aesthetic choices they employed evolved to tempt the tastes of the audience.

AESTHETICS OF CONNECTION
(AND A SIXTEEN-YEAR-OLD'S BEDROOM)

In the summer of 2006, a sixteen-year-old girl named Bree began a vlog. Every few days she'd post a new, direct-to-camera video about her life and interests, slowly becoming every teenage geek's dream girl. Her vlogs began hitting YouTube's most-viewed list and her channel soon became the most popular on the site. But things started getting strange. Fans noticed a photo of Aleister Crowley on the wall in her bedroom, and her parents, who homeschooled her, seemed to belong to a strange religion. Debate ensued and people became obsessed with unpacking the mystery of sixteen-year-old Bree's life.

Except Bree was not actually named Bree nor was she sixteen. Her real name was Jessica Lee Rose. She was a nineteen-year-old actress from New Zealand who had been cast for a scripted web series called *lonelygirl15* by a screenwriter, Ramesh Flinders, and a doctor, Miles Beckett. At first, Rose thought the project was a scam. (An unknown series on the internet?! Shot with a webcam?! She had been warned about this kind of stuff.) She'd been on only two auditions in her life before being hired for this gig, which required an initial

six-month commitment, but she took the leap. Everyone involved had to sign a nondisclosure agreement. Rose and her costar, bartender/waiter Yousef Abu-Taleb, hid their digital presences. Of course, they all knew the mystery could last only so long. It was all laid bare in an investigative news exposé four months after it began. Rose said she cried the night word broke, scared of the backlash she expected would be targeted at her from viewers. Something unexpected happened, though. While some fans expressed outrage, many stuck around to see where the story would go.

Contrived? Exploitative? Maybe. But it was clear to everyone that a new kind of storytelling had emerged, and it wasn't about deception either. The series cost almost nothing to produce—a $130 webcam was the most expensive piece of equipment in those early episodes—and the bedroom set, which was Flinders's actual bedroom, had been decorated with items from thrift stores and Target. The idea for the series stemmed from a conclusion the creators had drawn about the early world of web video: Audiences were so drawn to people sharing themselves honestly in front of a camera, they'd rarely even question the authenticity of the motives behind it. When the hoax was busted, the creators admitted they'd actually had no idea where it was going. Originally, they'd planned for these videos to be a prelude to a feature-length DVD release. But a mere few weeks in, they knew they were onto something even better when lonelygirl15's vlogs began scoring viewership comparable to some cable TV shows.

While to some the fake vlog encapsulated the sensational hucksterism of early web video, to others it demonstrated that this space could become a home for serialized storytelling. A video didn't have to just be a video, it could be part of a "show" too. Some of today's popular creators started vlogging in the first place after watching early *lonelygirl15* episodes, including Trinidadian YouTube star Adande Thorne (aka "Swoozie"), who said seeing Bree reveal herself that way inspired him to try it himself. For many younger YouTube viewers, *lonelygirl15* became an urban legend. It's kind of hard to go back now and watch

any of the more than five hundred episodes out of context and truly appreciate the furor. It was the internet equivalent of a "you had to be there" moment.

The *lonelygirl15* mystery exploited all the things that defined the new web video creativity. By re-creating and faking the unique aesthetics of the web, the *lonelygirl15* team actually, in a way, distilled them down to their essence. They never explicitly said the vlog was staged, they just let the audience believe what it wanted to believe. "We never lied," Rose later said. "We just put it out there."

We'd all developed an appreciation for web video as something created by real people to be consumed by real people. That directness drove the stylistic choices many popular video makers employed. *Lonelygirl15* became part of a larger trend of productions built around transparency and reality (even when fabricated) ruling the day.

OUR APPETITE FOR web video entertainment with authentic settings and interactions only grew with time. New formats, like lonelygirl15's vlogs, were born, and some familiar concepts were reimagined by the masses in ways that allowed them to reach new levels of popularity.

Take the longstanding infatuation with prank videos. Shows like *Candid Camera* have existed for years, but the internet ushered in a whole new prank-entertainment movement. Prank videos and channels rack up a surprisingly high number of views every day. Putting aside the sometimes-unethical tactics used by pranksters, the fact that these videos have maintained such an appeal after all this time says a lot about the new aesthetic principles at play here; their success epitomizes the value we place on entertainment built on reality.

The prank channel Improv Everywhere transcends the traditional definition of a prank. The tagline is "We cause scenes," and as founder Charlie Todd puts it, "One of the points of Improv Everywhere is to cause a scene in a public place that is a positive experience for other

people. It's a prank, but it's a prank that gives somebody a great story to tell." Todd formed the comedy collective after moving to NYC in 2001. I first heard about them a few years later through a stunt called "Best Gig Ever," when IE's agents attended a small-time band's gigs acting as superfans. (In 2008, they did the same thing at a Little League baseball game and set up an NBC Sports jumbotron with play-by-play commentary from sportscaster Jim Gray.) In these videos the performers share as much screen time as the passersby. What's being created is not just a "gotcha" gag, but a larger piece of impromptu theater in which the pranksters and the unsuspecting subjects play off one another to create something that is both staged and spontaneous. Their first big hit (and one of the first big viral pranks) was "Frozen Grand Central," where more than two hundred people froze simultaneously in NYC's Grand Central Terminal. Part of the fun is in watching the reactions of the befuddled tourists and commuters and the funny ways the agents froze themselves, but it's also in the very concept of the scene itself. Improv Everywhere's inspired comedy elevated the classic prank and ignited demand for more novel prank videos on YouTube.

These types of pranks, where the prank is really part of a larger set piece, had been attempted with varying degrees of success in TV, film, and recorded audio (e.g., *Trigger Happy TV*, *Borat*, *The Jerky Boys*), but they became prominent fixtures in the YouTube comedy scene.* It's a comedic format that's easier and cheaper to produce successfully than scripted sketches and animations, yes, but these prank channels draw big audiences because what they shoot and post resonates with viewers seeking comedy derived from authentic on-screen reactions.

In many cases, the perpetrators of these pranks are the figures with whom viewers connect. Roman Atwood is perhaps the most successful of the YouTube pranksters: In 2016, he averaged more than

* Nearly one in five of the top fifty most-subscribed comedy channels on YouTube at the start of 2017 were prank-based.

thirty million views per week. Many of his pranks involve elaborate setups, like the time he filled his home with colored plastic balls. In a video that would prove to be his most popular, Atwood set up a hidden camera in his hotel room in Aruba where he was celebrating his five-year anniversary with his girlfriend, Brittney Smith, with whom he has a son. "I'm gonna tell you something, and it's going to be the worst thing you've ever heard in your life," he says to her, voice quivering with regret and sadness. "Three weeks ago when I was in L.A., I met this stupid girl. It was one night . . . I swear to God I'll never do it again." Smith begins to sob, face in her hands. He tries to console her as she gets progressively more upset until, after a pause, she says, "I cheated on you . . ."

"What?"

"I cheated on you too."

"What did you just say? You did not cheat on me. Did you cheat on me? Brittney, yo?"

"Yeah, I did. I'm sorry!" she says through tears.

Atwood begins to flip out. He curses. He punches a lamp. His prank has backfired in a disastrous way, and we're watching this raw moment unfold. He demands to know who the other man is. He's gone from snide to torn apart in less than two minutes.

Smith stands up on the bed and shouts, "I SAW YOU SET UP YOUR CAMERA, YOU IDIOT!" Atwood, who looks like he might just pass out, tries to comprehend what's happening as Smith cackles with laughter. He deserves it. He knows it. The audience knows it. Despite debating whether to post the video, he knew he had to. For something so dumb, it's a complex document of the human experience. But that kind of makes it a metaphor for prank videos in general. For many of us who watched the video—including those among the channel's more than ten million subscribers—Atwood and Smith are not random individuals on the street, they're real people with whom we have an existing relationship. His videos succeed because they combine imagination with true human experiences we can connect with. Their popularity

speaks to an escalating desire for entertainment in the form of extraordinary moments within everyday experiences.

JOE PENNA, AKA "MysteryGuitarMan," gained an early reputation by creating videos notable for their special effects. Penna, who moved to the United States from São Paulo, Brazil, as a child and abandoned plans to attend medical school to get into video production, often uses clever editing and musical skills to create animated shorts and songs. Penna's videos aren't trying to convince you of the impossible, like the special effects in a Hollywood blockbuster, but they're not lo-fi either. The settings—Penna's office, the street outside, etc.—are decidedly normal, but the post-production is basically flawless. Can Penna's special effects compete with Weta Digital (*Lord of the Rings, Avatar*) or Industrial Light & Magic (*Star Wars, The Avengers*)? No. But that's not the point. I would argue that there is more magic in what Penna does because, unlike the unknown throngs of digital animators working on *Jurassic World*, we know exactly who made "MysteryGuitarMan Flip Book Flip Out." We can imagine the hours he spent creating it. With some videos, like 2012's "Stop-Motion Excel (Spreadsheet Animation)," the tools he uses to create them are available to pretty much anyone. One of his videos took ten months to shoot: a cute stop-motion time lapse of his wife's pregnancy. ("MysteryGuitarWife" and "MysteryGuitarBaby" proved excellent costars.) His productions have a tangibility in their real-life settings and themes, and because Penna so frequently addresses the audience directly, they acknowledge our presence. You wouldn't necessarily find a special-effects editor also starring in a TV show or movie they helped create, but it works wonderfully on YouTube, where video and creator are so closely linked for us.

Numerous channels like Penna's have sprouted up where *everyone* is part of the experience and the creators' stylistic choices reflect an awareness of the audience. These videos are not made in a vacuum. They're not made by an unseen, faceless production team. They're made by a real person who directly acknowledges that viewers exist and that

they might comment on or react to the work in different ways. Connection and relatability took precedence in a unique way, even from YouTube's earliest days. As some creators have commented to me: It's not like the director and cast of a movie appear on-screen after the credits and ask us to comment if we liked what we saw.

For a long time, the aesthetic of the web was thought to be intrinsically amateur. The traditional entertainment and advertising industries even began to embrace that look; expensive production shops tried to re-create the vérité feel that many viewers now associated with popular YouTube content. But the "realness" YouTube creators achieve has less to do with the cameras they use or their editing techniques and more to do with their general creative philosophy. Production value remains important to audiences, but authenticity is king.

Many YouTube personalities cast themselves and their friends in their sketches or shorts, and I won't name names, but some of them are pretty awful actors. This was jarring to me at first and contributed to the whole idea that internet video was for entertainment industry also-rans, but I later realized that the craft was not necessarily why people tuned in online. Sometimes the imperfect performances even added to the feeling that you were watching something honest, not contrived.

When we were developing *YouTube Nation*, a daily show YouTube coproduced with DreamWorks Animation, we had access to all the production equipment you could want in the studio we set up on the top floor of a strange-looking office building in Marina Del Ray.* I had long debates with our brilliant executive producers Steve Woolf and Zadi Diaz about how to give the show a look that was both "premium" and "YouTube-y." (*YouTube Nation* held the distinction of being the first daily show to launch in 4K resolution, for example.) Our designers fabricated an amazing workshop-esque set for our hosts, but every time we shot there, it just didn't look right. So Woolf and Diaz made the call to film in the office itself, at the desks where people actually

* Seriously, we used to call this building the "Hall of Justice" because it looked like it came straight out of a sci-fi movie.

worked. Despite the lack of a fancy set, the lighting and cinematography were impeccable on that show. The point wasn't to make it look amateurish; the point was just to make it feel, well, real.

The aesthetic of YouTube is about stripping away the artifice that prevents us from connecting with the things people make, the people who make them, and the other people who watch them. This is what we as viewers want most now. The most successful creators have found novel ways to achieve that aesthetic and have devised reliable and easily reproducible formats that achieve it consistently.

WE SHOULD ALL BE GETTING COPRODUCER CREDITS

The first time I arranged to chat with Benny and Rafi Fine, in 2011, it took about a day to schedule a meeting with them. Five years later, their time was so in demand that it took three months. In the years between, they'd built a flourishing web video company, thanks to the array of formats they'd perfected.

The Fine Brothers* started trying to make their videos go viral before internet video was even a thing. The pair have been making videos together since they were kids in Brooklyn, when Benny roped his younger brother, Rafi, into making shorts with him. As they grew older, they held screenings for friends. The goal was to get everybody talking about the shorts at school the next day so the kids who hadn't shown up wouldn't want to miss the next screening. "In everything we've done, we've always had an innate sense of what's going to make people want to talk about it," Benny told me. "You can see that now on steroids, how large we've ended up becoming with these formats. All the formats were built for conversation, interactivity, and the ability to participate."

* I know, more brothers. There's clearly something with siblings and YouTube. Maybe it's because our siblings can be our earliest and most willing (or, at least, available) creative collaborators.

When the brothers began posting videos on their personal website in 2004, they offered fans the opportunity to vote on the stories they made. "We used to say a long time ago that this is 'new media' and we love it so much, because it's not a passive viewing experience," Benny said. "It was so interactive and that was part of the experience." When YouTube came along, they began producing sketch comedy and parody video series. Not satisfied to make videos just to be watched, they were always pushing the limits of interactivity and experimenting with YouTube's features in ways they weren't intended to be used, like using the annotations feature to create elaborate games that were part web video, part choose your own adventure. While the Fines had become recognizable to fans as on-camera personalities, the duo always saw themselves as producers more than anything else. In 2009, they joined Maker Studios (now owned by Disney), and quickly became the heads of production and creative, producing series for many of the burgeoning YouTube talents on the network's slate. When they began focusing on their own channel again, they put those skills to work, exploring a variety of different novel formats. Some succeeded; some did not. Their channel began to take off in 2011 when one of these formats really caught on, a series called *Kids React* for which the duo interviewed a cast of children about viral videos.

This was the first hit of many formats that the Fines would explore on YouTube. I've known the Fines for years—primarily because they are two of only a handful of other people I've met who are just as obsessed with random viral videos as I am—and the thing that's always struck me is how insanely prolific they can be. The brothers used to say that they wouldn't go through with an idea if they couldn't shoot five episodes in a single day. And they knew how to milk a hit when they had one. *Kids React* begat *Teens React* begat *Elders React* begat *You-Tubers React*, which begat the series they were working on when we spoke: *Celebs React*. The React videos became so popular they had to spin them off to another channel. It's always a risk trying to start a new channel from scratch, but React picked up one million subscribers in a

single week. The hit series became a springboard for the Fines to launch other formats and shows, like the 2012 "transmedia mockumentary" series *MyMusic*.

Over time, the Fine Bros became Fine Brothers Entertainment, employing more than fifty people, churning out twelve videos per week across a number of different shows shot in three studios in their office, and producing everything from animated shorts to a fully scripted sitcom of twenty-four-minute episodes, *Sing It*, which launched as one of the early YouTube Originals series. This type of programming diversity within a single channel is rare, and most times ill-fated. "Everybody else told us that it was a problem, us doing so many different types of things," Rafi said. "But if you look back at our career now, you see that if we had stayed within the boxes of Hollywood and the entertainment industry that we thought we were supposed to, we would never have gotten to where we are." The common thread between all their hits? The audience is treated like a part of the show.

Their React series has always taken this pretty far. The Fines source ideas for each new episode from the messages they receive from fans and display these suggestions and their sources prominently at the start of the video. This style of audience engagement can be found in many of their shows. "Generally, I think that's part of what creates that great relationship with the audience: that they know that they do have impact, we do pay attention to what they are saying," Benny told me. Fittingly, the show that brought them the most success was the one that most directly placed the experience of reacting and interacting with entertainment front and center.

WHAT DOES IT say about web video that the most popular series from two prolific producers like the Fines stars mostly regular people often doing the same thing we're doing at the same time we're doing it? (Seriously, watching people watch videos? How meta can things get?!) The React series videos have accumulated more than four billion

views, so there must be something about the format that resonates with our digital-video tastes. Why *do* so many people enjoy watching these things?

Rafi told me to think about it like a focus group: a bunch of regular people with no agenda discussing the things that matter culturally. It could be a group of your peers or another demographic with some significance to you (your parents, your grandparents, your children, your grandchildren). I've always found it mind-warping to hear kids talking about technology, and I'm fascinated by what it must be like to grow up in a post-internet, post-smartphone world. But sometimes it's also just amusing to hear children discuss the original iPod and its baffling lack of a touchscreen. For some audiences, a panel like the one on *YouTubers React* represents a group of people whom they personally find influential or interesting. As Rafi put it, "Do they react the same way you do? Who can you identify with? Who can you not identify with?" The format gives you as a viewer an opportunity to validate or challenge your personal point of view in a noncombative way. The show becomes interactive the moment you start watching it and continues to be so when you like it, share it, or comment on it. It's a format that pairs well with the environment it exists within, both by taking advantage of all of YouTube's sharing and commenting features and, perhaps, by addressing a larger need in modern life. The Fines say that in a world where effortless and incessant communication has become so easy, we rarely truly listen to one another, and to them, the premise of React speaks to that. "I think people are very drawn to it because we actually don't communicate this way in society as much as we used to," Benny told me.

The Fine Brothers were neither the first nor the only creators to explore reaction-based formats. (In 2016, they experienced a brutal backlash from the YouTube community when they registered trademarks for the "React" format.) Many of the popular formats on YouTube feature regular people reacting to things. One of YouTube's most successful formats, "Let's Play," in which someone plays a video game

and provides amusing commentary, is a reaction-based type of entertain-
ment. (In 2014, eleven of the top twenty independent YouTube creators
utilized the Let's Play format.) One of the earliest big YouTube stars,
comedian Ray William Johnson, first achieved fame with his series *Equals
Three* by providing commentary on popular viral videos of the day.

"A lot of it comes down to humanity," Benny said. "You don't want
to be alone. When you watch someone play a video game or watch a
video . . . you feel connected to someone that you relate to and it feels
like you're with them." In a time when it's easier than ever to feel alone,
we've developed a taste for using video to connect, and the formats
that are built around interaction with viewers meet our needs.

Producing video in this way—creating things that consistently
deliver connectivity in a manner that doesn't feel artificial or forced—
requires a rethinking of the creative process. For some, it required
literally throwing out everything they thought they knew about enter-
tainment and media and starting from scratch.

TRYING TO CUT THE BULLSHIT

Ze Frank has been scheming up multimedia experiments for years.
Way back in 2001, before everyone sent Evites and Facebook event
invitations, the performance artist/humorist/digital artist created an
online party invitation for his twenty-sixth birthday featuring animated
images of himself performing a series of dance moves. He sent it to
only seventeen people, but a week later, more than a million were
viewing it on his site. Frank, who studied neuroscience at Brown Univer-
sity, then built a variety of Flash-based games and visual experiments
exploring the new world of digital entertainment. Eventually, he found
his way into video, launching *the show with zefrank* in 2006, a pioneering
video series that included numerous interactive experiments with his
audience. Many say it shaped the vlogging format that came to domi-
nate YouTube's creative community a few years later. In 2012, Frank

launched a fund-raising effort for a follow-up series, *a show with zefrank*, and fans donated almost $150,000. His video art was unpredictable and engaging and driven by a desire to generate connection. "We can build all sorts of environments to make it a little bit easier [to feel and be felt], but ultimately, what we're trying to do is really connect with one other person," Ze said in his 2010 TED Talk (his second). "And that's not always going to happen in physical spaces. It's also going to now happen in virtual spaces, and we have to get better at figuring that out."

When he joined BuzzFeed in 2012 to run its burgeoning video unit, BuzzFeed Motion Pictures, he treated it too like an experiment, but on a bigger scale. He sought to build a studio where he could challenge all the assumptions people had about creating video and explore radically different approaches to the medium. Frank had a staff of young, creative talent that didn't fit the traditional production roles. These "multihyphenates" weren't producers, videographers, or editors; they were producer-videographer-editors. Many of them became on-camera talent too. One of Frank's first rules: "We all make stuff." So even Frank, the group's senior leader, produced videos alongside everyone else.

Frank made another very unusual choice that surprises most seasoned creatives. He told his team that he wouldn't give them feedback until after they posted whatever they were working on. "If you can get your production cycle fast enough and you can get the volume high enough, having after-the-fact feedback is totally viable," he said. As someone who's been working in and around video production for most of my adult life and has sat through round after round of edits and feedback on projects, I can't tell you how bizarre this sounded to me at first. But it made perfect sense to Frank. Why debate whether something is good or bad when you can have proof—via the audience's views, shares, likes, and dislikes—that it succeeded or failed?

A lot of creative people struggle to resist the impulse to obsess over the details and treat every new endeavor as a precious work, but

Frank and many other web video creators buck that trend. The web, it turns out, can be a forgiving place for earnest experimenters; successes are maximized and failures often drift to the ocean floor of the internet, never to be heard from again. *"Of course* there's a lot of mediocre stuff, but I just so firmly believe that in spaces that have as much wide openness to them as video creation in the digital world, you have a way better shot at finding something interesting through this kind of a process than *thinking* about it," he explained. Thinking too much gets you stuck where you already are. To Frank your mettle gets proven through serious productivity. And he knows exactly how hard it is. "I've been through it, man," he said. "I did a show every single day where I didn't script anything. I woke up in the morning. I was fucking petrified. By the sixth month, I was a little less petrified." Frank's the-more-you-make-the-more-you-learn mandate seemed to work. "Within four or five months [at BuzzFeed Motion Pictures], we had gotten to a place where a new hire would get their first million-view video in about three or four weeks," he said. "It was pretty awesome." BuzzFeed's channels saw exponential growth over the subsequent years. By 2015, their primary channel was one of the top ten most-viewed on YouTube, and that year people spent more than a quarter of a billion hours watching BuzzFeed's four main channels on the platform. That's an increase of twenty times from two years prior.

THE WEB PROVIDES all sorts of real-time data to media publishers, and BuzzFeed is one of just a few large editorial organizations that rely on that data so heavily when shaping their content, and even their methods. The size of BuzzFeed's operation allowed them to try a variety of things at once to see what improved their stats. And the most important stat of all? Sharing. As you might expect, finding a statistical metric that captures the intangible qualities that make great art great, interesting perspectives interesting, or funny jokes funny is not really possible. But sharing data seemed to get closest to measuring whether a video had created an emotional experience that made viewers feel

connected to other people. "You look for nearest neighbor signals that show you that efficacy," Frank said. "Sharing was something that we felt pretty strongly about early on, because it's at the nexus of distribution and value. Unlike the view, it's hard to get people to share." The team evaluated each new aesthetic choice based on how it impacted that sharing rate, as well as other metrics. "It was just classic experimentalism, but that requires a lot of data, and it requires moving fast so . . . we tried to cut the bullshit as much as we could," he said.

Frank says one of the first unnecessary elements of video creativity is, surprisingly, story. Narrative arcs form the backbone of most every piece of entertainment, but Frank felt that trying to nail a "story" could be paralyzing. Instead of stories, they created a series of what Frank calls "moments." Think of the pieces required for a video like "13 Struggles All Left-Handed People Know To Be True." "If we did a story, we would have one shot at hitting that line that gets [a viewer] to be like, 'Oh my god. That's totally me,' but if we did it in just a series of moments, we had all those shots and maybe three of them wouldn't connect but then that fourth one would be the zinger." In the explicit abandonment of traditional storytelling, BuzzFeed was codifying what was being demonstrated in less methodical ways all over the web: that nonstory content could bring us many of the same values we used to derive almost exclusively from narrative productions. Reality TV had demonstrated that unscripted depictions of ordinary people could create a meaningful entertainment experience, but the web proved that there were many different types of nonnarrative formats that could provide us with the emotional rewards we craved.

"When you're reading a book, and there's that one line which you thought only you had thought of before, it was just in your head—there's that moment where there's almost a cathartic release. The universe has become a little more open and you feel a little more part of it. That's the biggest gift of this particular age we're going through," Frank said. "All of the manifestations of traditional media left part of ourselves out. I don't care who you are. Part of you—the way you felt, the way you looked, where you came from—was never represented in

media. But now we're going through this process where we're getting to have those cathartic moments over and over again."

At the laboratory that is BuzzFeed Motion Pictures, the team experimented with video length, sequencing, the use of large on-screen text, and more, discovering along the way that many of their preconceived notions were wrong. Their highly successful endeavors with Facebook's nascent video platform even taught them audio plays a less critical role than they had expected. (A 2016 report found that up to 85 percent of video views on Facebook occurred without the sound turned on.)

Much of the BuzzFeed team's experimentation is guided by their focus on driving connection. Most twenty-first-century creators focus on building connections between the on-camera talent and the audience, but Frank sees more opportunity in facilitating a connection between you and someone you already care about, rather than someone you've never met. "This constant conflating of the system as the artist connecting with the audience was silly," he explained. "You could build a system which was about people connecting to other people and just try to create media that facilitated those connections." The audience *does* end up connecting with a number of BuzzFeed's talent, as one might expect, but the true stars of a video are its concepts and moments.

BuzzFeed's model differs dramatically from the highly calculated types of production we see in traditional TV, film, or print. It's fast, it's unspecialized, it's very measurable, it's inexpensive, it's prolific, and the whole process can feel like a *mess*. But media creation, in Frank's mind, is "a very messy expression." It's hard to tell whether BuzzFeed Motion Pictures represents an outlier or the new standard for entertainment production on the web. But operations like theirs, as well as the one built by the Fine Bros—which create content that enhances the new ways we connect online—are becoming less of an anomaly. Driven by new technology, the basic approach to creating shows is transforming, even within the most traditional corners of the entertainment industry.

TWO JIMMYS AND A JAMES

When Jimmy Fallon debuted as the host of *The Tonight Show* in 2014, he had a major task ahead of him. He had to honor Johnny Carson's legacy, move the show past the whole Leno-Conan debacle, and face stiff competition from programming on other networks, cable channels, and the web, particularly for younger viewers. After an earnest personal monologue and a desk segment featuring a parade of celebs, what the team chose to do next in his premiere episode surprised me. The very first sketch was a parody . . . of a YouTube video.

Fallon was joined by Will Smith for "Evolution of Hip-Hop Dancing," a re-creation of YouTube's first huge viral hit, "Evolution of Dance," that legendary clip of Judson Laipply in his orange shirt performing a string of twentieth-century dance moves. This was how far the creative culture of the web had come: The first sketch on the relaunched version of the longest-running talk show in the world required a basic literacy in a twenty-first-century entertainment medium for the audience to fully get the joke. And it *was* indicative of the generational shift the show set out to achieve.°

What I didn't fully appreciate at the time was how much tighter the relationship between the web and late-night TV had become.

The late-night-talk-show format, with its delineated segments and charismatic hosts, lent itself well to the sharing economy of online video, and another Jimmy had been finding ways to blend what worked on the web and what worked on TV for a few years.

IN 2013, A young woman named Caitlin Heller posted a video in which she was twerking upside down against a door in her home when a friend opened the door, causing Heller to crash into a coffee table and set her yoga pants on fire. It was the perfect "someone being dumb

° Fallon's premiere week drew the show's biggest audience since Carson's final week in '92, and the median age of the show's viewers immediately dropped by almost six years.

on the internet" fail video, and it made the viral rounds accordingly, even getting picked up and aired on newscasts from CNN to many local stations. Amid the uproar, *Jimmy Kimmel Live!* announced they'd booked the woman for an exclusive interview (viral stars were appearing on talk shows regularly at that point). During the segment, Heller said that she'd share a few more seconds at the end of the video that hadn't been included when it was posted online. After her pants caught on fire, someone ran into the room with a fire extinguisher: Jimmy Kimmel. Caitlin was actually Daphne Avalon, a professional stuntwoman, and the show's staff had been behind the whole thing.

Kimmel and his team had been exploring the crossover potential of late-night TV with the internet since back in 2008 when comedian (and Kimmel's former girlfriend) Sarah Silverman debuted a musical number on the show titled "I'm F°@#ing Matt Damon" that became an instant hit on the web. Kimmel described its online popularity at the time as "bigger than that fat kid with the lightsaber." Kimmel had a few other online hits—at one point, the show enlisted the Gregory Brothers to create an Auto-Tune segment with T-Pain—but he really hit his stride when he broke the wall between the show and the audience. In 2011, Kimmel told his viewers to prank their children into believing that they'd eaten their Halloween candy. The highlight reels of that prank—and the numerous additional "YouTube Challenges" he's devised in subsequent years—have been watched more than three hundred million times.

In a trend that would spread across late-night TV, *Jimmy Kimmel Live!* occasionally resembled a supersized version of a YouTube show. While competitors like Jay Leno and David Letterman had ongoing segments that played off traditional media constructs (e.g., Leno's "Headlines" and "Jaywalking"), many of Kimmel's popular segments echoed the formats that had been gaining popularity in the digital environment. "Jimmy Talks to Kids" brought to mind *Kids React* and featured him chatting with a group of children about current events. For the 2014 Oscars, he even got a bunch of celebrities together for

big-budget Hollywood re-creations of famous YouTube videos.* His most successful series (to the tune of more than 750 million views), "Mean Tweets," had a very similar vibe to the kinds of collaborative vlogs in which YouTube creators reference fan comments.† And, of course, the pranks. Sometimes Kimmel himself was pranked, as in the times that Rihanna and Britney Spears showed up in his bedroom in the middle of the night with a team of dancers. Often he was pranking other people (most commonly Matt Damon). The *Kimmel* team's increasingly masterful understanding of the how the web worked is best illustrated, though, by the "Worst Twerk Fail EVER" video.

"We didn't send it to any TV stations, I didn't tweet it, we didn't put on any news websites," Kimmel said. "We put it on YouTube and just let the magic happen." This time Kimmel had pranked *everyone*. His "let the magic happen" strategy worked because a new type of creative cycle had emerged, one in which traditional media, in its effort to maintain relevance, had begun looking to the web for cues on what appealed to audiences.

Kimmel and his team were basically taking advantage of the new popular-entertainment culture where jokes could be made not just *for* an audience, but *with* the audience too.

WHEN JAMES CORDEN joined the late-night TV ranks, he faced an uphill climb. He wasn't well known in America and had a very late timeslot. To ensure the program's relevance and build buzz around Corden, his team went all-in to optimize the show for the YouTube era. "When I get in in the morning, I will check our YouTube hits before I check our overnight ratings," Ben Winston, the executive producer of

* My favorite part about this was that when Joseph Gordon-Levitt showed up to do his segment as "David After Dentist," he had, despite having received no direction to do so, already fully memorized the entire video with near perfect timing with the original.
† For example, Jack Douglass, of the popular jacksfilms channel, has a long-running series called *Your Grammar Sucks*, in which he reads aloud comments submitted by his fans.

The Late Late Show, told the crowd at the Edinburgh International Television Festival in 2016. "Because the overnights just tell us who managed to stay awake. They don't tell us anything about the quality of what we're making whereas the YouTube hits will tell us which bits flew." *The Late Late Show* took seriously the idea that entertainment is increasingly a collaborative process between those who create it and those who react to it and interact with it.

Data from YouTube's analytics tools and comments and likes on *The Late Late Show*'s video pages became, much like it does for many YouTube-native video makers, a part of the show's creative decision-making process. In the quest for hit segments that resonated online, the *Late Late Show* team stumbled upon a massive one relatively early. It didn't have the production value of an elaborate musical number or even the lights, cameras, and live audience of their studio set. This one was shot in the same way many YouTube creators shoot their own videos: with small, inexpensive cameras and raw, everyday fun that anyone could relate to. "Carpool Karaoke" started as a pitch that no pop star would agree to. "Imagine a recording artist. They said no," Corden once said. But a chance meeting with Mariah Carey helped launch the recurring segment that fans watched one billion times in less than two years. It became, online at least, the most popular segment of any comedy show, ever.

"It creates intimacy in such a lovely way," Winston said. "There's no managers, there's no publicists, there's no makeup artists. It's just James, who's this great character, alone with these people, singing wonderful music." It also looks just like a YouTube video.

In my early years at YouTube, I had a hard time figuring out what was a fad and what was the new normal. Every day, it felt like one thing was dying out and two new things were popping up. The idea of YouTube

as an entertainment platform felt, for a time, like it might be a fad itself. But at some point—exactly when is dependent on whom you ask—the creative works it spawned came to represent a much larger shift in how people now connect with entertainment. Industry observers, struggling for a way to describe what set this content apart, used the word "authenticity," which quickly became one of the cliché terms of the decade in the world of video production. Everyone wanted to know: How do I make authentic entertainment? As many creators will tell you, it's not about the production quality. And by that, I do not mean that good production design is not important. (Audiences definitely respond better to videos with decent lighting, camera work, sound, etc.) The authenticity that attracted us to early YouTube videos and channels came not from their amateurism, but from the aesthetic honesty that naturally accompanies amateurism.

Sometime around the start of the new millennium, we began to value the genuine and transparent at a level we didn't before, and as many of our entertainment and personal experiences have come to exist in the same places online, the things people created became inseparable from the conversations we have about them and the role that they can play in connecting us with other people. The formats and styles that have become most relevant enable and feed off our immediate presence. We want to see Adele singing in the car the same way we all sing. We'd perhaps rather share BuzzFeed's staff explaining the "5 Ways Girls Flirt That Confuse Guys" than a scripted short about gender norms. We want to see the Gregory Brothers sing *with* the actual presidential candidates rather than pretend to be them. That's not to say that scripted narratives can't work or that high production and special effects don't have a place here. They certainly do. It's just that when we can call out "FAKE" in the comments within minutes of something being posted, producers can't pretend the audience isn't there or that we're unaware of the illusions being employed. Those of us watching have more input and influence than ever, and this dynamic has actually changed the way entertainment is made.

We don't passively consume content anymore. We *use* it for our own purposes. The ways that we react and interact with our entertainment help us to connect to one another and to the things we love. And if content doesn't yet exist that serves our needs—that helps us perceive, interpret, and respond to the world around us as directly as we'd like—we'll use what's available to create it ourselves.

CHAPTER 3

The Language of Remixing and the Pure Joy of a Cat Flying Through Space

I N 2011, TWENTY-FIVE-YEAR-OLD Chris Torres spent his days as an administrative assistant at an insurance company in Dallas and his nights exploring the web, producing unconventional digital art, and hanging out with his cats, particularly a beautiful Russian Blue named Marty. Torres, who moved to Texas from Puerto Rico as a child, had no formal art training and taught himself visual design, even creating his own comics, which he shared on his blog. Marty the cat, whom Torres named after Marty McFly (because Torres is the particular kind of fellow dork who names his cat after Marty McFly), starred in many of them.

That February, Torres participated in a donation drive for the Red Cross, livestreaming as he created drawings based on suggestions from an online audience. In a moment of unassuming inspiration, the online crowd suggested that he draw Marty . . . as a Pop-Tart. "It was honestly just a split-second decision to combine the two, much to the delight of everybody in the chat room," Torres would later explain. Thus sprang up a rudimentary illustration of a sprinkled breakfast pastry with the head and feet of his Russian Blue and rainbow lines emanating in all directions.

When Torres later began teaching himself pixel art—a form of digital illustration that renders images in large square blocks of color much like the style of early video games—he came back to the drawing, and on April 3, 2011, he posted a re-created version as an 8-bit-style animated image on his website. A fan of his passed it along to *The Daily What*, one of the most influential web-culture blogs at the time, which reshared Torres's image and spread it through Tumblr to other internet nerds across the country.

The pixelated image of Marty as a Pop-Tart eventually found its way to a student named Sara Reihani. She and Torres had never met. Her friend PJ, one of those Tumblr internet nerds, showed it to her. PJ loved weird internet stuff and had also recently told her about a style of (mostly) Japanese music inspired by the use of a technology called Vocaloid. (Imagine Euro-pop on helium put through an overcomplicated synthesizer. That's what most Vocaloid tunes sound like.) PJ's favorite Japanese Vocaloid song—called "Nyanyanyanyanyanya!"—was originally composed by a Japanese producer named daniwellP, and the version PJ liked was sung by Hatsune Miku, a sixteen-year-old with turquoise pigtails.* Anyway, on April 5, 2011, a mere two days after Torres had posted his 8-bit, animated Pop-Tart likeness of Marty, Reihani took that repetitive Vocaloid song that PJ liked and laid it under Torres's looped image. Then she posted the whole thing to YouTube, as she once told me, "so PJ could watch them together without needing two tabs."

Somehow—Reihani herself is not even sure how—the "Nyan Cat" video on her YouTube channel and PJ's personal Tumblr page was rapidly passed around on forums and websites. What started as a joke between two college friends became a full-blown meme as the three minutes and thirty-seven seconds of bizarre, looped digital "art"—which Torres once described to me as "pure joy . . . and a cat flying through space"—turned into a viral hit. Suddenly, Nyan Cat videos were popping up everywhere. People made their own variations on it, performed it, and even dressed up as it. They made alternate versions featuring flags and Vocaloid-esque renditions of national anthems to represent almost every other country in the world. The video was watched more than eighty million times that year and was 2011's #5

* Also, Hatsune Miku is not an actual human. She is a fictional persona associated with a vocal synthesizer application created by Crypton Future Media, a software company in Sapporo, Japan. Any producer with the right software can have "her" "sing" on their tracks. I couldn't figure out exactly how many songs Hatsune Miku has appeared on, but it appears to be over 100,000. Crypton says her name means "the first sound from the future."

most-viewed video. The thousands of other versions were also popular. By 2017, there were more than 100,000 Nyan Cat–related videos on YouTube, and together they'd been watched over 1.2 billion times. (Among the highlights: a ten-hour looped version with over 50 million views.)

Over time, the Nyan Cat became a symbol of the internet itself, an icon that has appeared on everything from desktop wallpapers to posters at Occupy Wall Street rallies. (YouTube even named one of the larger second-floor conference rooms in our office after it.°) It symbolized the raw, democratic culture of forums and social platforms, where any voice or idea could become internationally known, no matter how ridiculous, on its own merits and at the will of the many.

After the spread of Nyan Cat, Torres received a deluge of inquiries from people looking to broker business arrangements. He copyrighted the image and quit his job at the insurance company to become . . . the Nyan Cat guy, licensing toys, shirts, a video game, and more. daniwellP, interestingly, did not want his song used for commercial purposes at the time. Reihani told me that people assumed she was cashing in big on the success of the video she had created, but it wasn't true. Despite being the essential hypotenuse of this bizarre creative triangle, Reihani had no claim to anything because the primary intellectual property, the source material for her video, didn't belong to her.† Torres owns the image, but he says he's not responsible for the phenomena. Who is? The creator of the image? The musician? The remixers? The blogs and sites that posted it? The people who made it their own?

I reflected on all this one day while sitting on the tarmac at JFK airport, preparing to depart for YouTube headquarters in San Francisco. Remix art like Nyan Cat challenged the assumption I'd grown up with: that art and entertainment were thoughtfully considered collaborations from teams of professionals. This was instead pop culture created

° It's just down the hall from More Cowbell and across the way from Honey Badger.

† She did work out a deal with Torres, though, and was able to buy a camera to produce videos and pay the fee to adopt a cat of her own.

by a group of disparate individuals working independently yet, somehow, together. The Nyan Cat was a symbol that gained meaning through the diverse ways people used it to express themselves. No one person created what became the emblem for the internet. Thousands of different people played an active role in making that happen.

It was a strange new world, I thought, as I watched an officially licensed animated Nyan Cat dance across the screen in the latest iteration of Delta's inflight safety video.

◄◄

Because it shifts the balance of power away from the original producers of works, remixes can cause confusion, strife, and business conundrums within the professional creative community. In the past, many people looking to express themselves stayed away from remixing in order to avoid that drama. In his book *Remix*, legal professor Lawrence Lessig wrote, "Though this remix is not new, for most of our history it was silenced. Not by censor, or by evil capitalists, or even by good capitalists. It was silenced because the economics of speaking this different way made this speaking impossible, at least for most."

Naturally, because the internet loves a good mess, remixing was among the first forms of creative expression to proliferate in the world of web video. As Matt Mason wrote in *The Pirate's Dilemma*, "The remix started as a happy accident in music, evolved into a controversial idea, and became a mass movement." This century, remixing went from a stylistic endeavor to a distinct and impactful mode of communication, one that thrived thanks to modern technology.

One of the first video remixes I remember was a mock movie trailer called "Shining," which reimagined Stanley Kubrick's horror masterpiece *The Shining* as a comedy set to the tune of Peter Gabriel's "Solsbury Hill." Created by a young editor named Robert Ryang for a contest called Trailer Park, run by the Association of Independent

Creative Editors, "Shining" won the New York chapter's competition in 2005 and jump-started the editing career of the then-assistant. But it achieved more than that. When Ryang discreetly posted his winning entry on his company's website to share it with a few friends, the volume of traffic to his "secret" link nearly crashed the site. That day he got a call from the VP of Warner Bros. "I thought it would be a cease and desist," he said. But the studio executive was just as curious about the hilarious clip as everyone else. Ryang received hundreds of emails each day from fans who adored the clip. It was the kind of funny, simple thing that people loved to share. But I also admired it because it was so fresh and deviant to take such a timeless film and make it your own like he had.

"Shining" went on to inspire hundreds if not thousands of similar creations from amateurs and pros alike. (*2001: A Space Odyssey* as a summer blockbuster. *The Ten Commandments* as a teen comedy. Willy Wonka as a delusional psychopath and Mary Poppins as a witch with supernatural powers.) A new world of creativity was opening up that played by a different set of rules.

"Remixing"—defined here in the broadest context possible: the selecting, manipulating, recombining, and restructuring of existing media to express oneself—became one of the most beloved and important new forms of communication on the web. It allowed us to interact with the people, ideas, and symbols that had influenced our culture in ways that, in turn, had their own influence and value. The things that made web video cool—the irreverence, the use of new production technologies, the novelty that comes from single-minded, obsessive creative pursuits—were exactly what made remixes so cool. Remixing was the first way of reacting, of *speaking*, that was distinctly of the internet.

And here's how we spoke.

THE INTERNET'S NATIVE TONGUE

Ophir Kutiel (stage name Kutiman), a jazz/funk/rock musician and producer, struggled to find work in his late twenties. He'd released a critically praised full-length album and had collaborated with other artists in Israel, where he lived. But the gigs dried up. That's when things took a turn. "I found out about YouTube, and my mind exploded," he said. "It was mostly cats and people falling on their head and it wasn't so creative. But there were a lot of [musical instrument] tutorials." Kutiel came across an instructional clip from legendary funk drummer Bernard Purdie and decided to play guitar along with it. He was fascinated by the idea of collaborating with someone without them even knowing. Then he had the even bolder idea to take two different clips of musicians and combine them. "From the moment I started, I didn't get up from the chair for two months," he told me. "This is all I did, searching YouTube and cutting and pasting. The first day I took this bass player and this drum player and cut them and they played together . . . I'm not sure I'm ever going to experience this excitement again." His layering became more complex, and his new obsession resulted in a series of tracks and videos he collectively called *ThruYOU*. The first video, "Mother of All Funk Chords," began with Purdie and blended twenty-two different musicians.

Some friends helped Kutiel design a site for the project and he uploaded the videos to YouTube. "I sent the website to ten friends of mine and asked them specifically NOT to share it because we were still checking the site. One of them didn't listen to me and it just exploded." The day after he sent that note, Kutiel checked his MySpace account (hey, it was 2009) and saw over one hundred messages. He thought something was broken. Soon his site crashed, and he was spending hours reading incoming email. When he finished with the email, he'd turn to the messages in his YouTube account. When he finished with that, he'd return to his email, which would be full again.

ThruYOU wasn't just a viral hit, it was a hit in the creative community too, leading to many professional opportunities and collaborations.

"I live in a small city in a small neighborhood in a small house in a small country," Kutiman told *Wired* at the time. "I didn't expect it to get this big this fast. It sometimes feels impossible to reach out to the world's music scene from Tel Aviv, but now it's all good." Many of the messages he received came from other musicians, including some really big names, though Kutiel wasn't very on top of the international pop music scene at the time. "I asked [my manager] Boaz, 'Do you know a band called Maroon 5?'"

Kutiel doesn't describe what he does as "remixing." "I just say I put a few YouTube videos together and create music," he explained. It was, to him, the natural and obvious thing to do. Kutiel never intended to make remixes, but saw meaningful connections between the videos people uploaded where others didn't. His work felt native to the medium of the web, but remained appreciable to broad audiences. He released a sequel, *Thru You Too*, five years later and produced many other commissioned or original works in between, including a mix composed of rehearsal footage from Maroon 5 that they asked him to make (once he figured out who they were).

"People cut-and-pasted way before I was born," Kutiel admits, but his work felt very of-the-moment in 2009. Video editing tools had become simple and affordable and the internet had a seemingly endless cache of photos, sounds, and videos. All of it could be source material that even the least savvy hands could use to express their points of view and reactions.

On the web, remixing became a form of communicating, a language that allowed us to express ourselves in ways that more traditional video creation doesn't make possible. A Kutiman YouTube remix says more about the interconnectedness of the things we post online, and even the universal passion we share for the craft of performing music, than any original recording might.

Remixing can take endless forms when so many different types of media are made accessible, navigable, and easily manipulated. The most interesting remixes are the ones in which the collected parts used to create them gain new meaning through the specific, personal ways

we fit them together. The sum of those parts reflects the perspective of the remixer, rather than the perspectives of the original creators. In fact, Kutiel told me that part of what fascinates him about this work is that his subjects don't even know they're collaborating.

I IMAGINE IT would be strange to discover a collaboration of which you were the unwitting original creator. Finding that someone had remixed your words and likeness would be even stranger. One of the more interesting case studies in unexpected remixes originated in the source of so many of the stupefying things on the internet: Russia.

Well, actually, whether it was technically Russia at the time is a matter of geopolitical debate in which I am not qualified to engage. In either case, in March 2014, Natalia Poklonskaya was named prosecutor general of the Autonomous Republic of Crimea, a Ukrainian territory on the verge of Russian annexation at the time. The day of her appointment, Poklonskaya voiced her highly controversial pro-Russian separatist opinion at a serious press conference. (Later that year, she would be the only woman on a list of twenty-four Ukrainian and Russian-backed separatists designated by the U.S. Treasury Department to be "responsible for, or complicit in, actions or policies that threaten the peace, security, stability, sovereignty, or territorial integrity of Ukraine.")

Video of the press conference, which was in Russian, drew international exposure and, rather unpredictably, struck a nerve in Japan, where thirty-three-year-old Poklonskaya's high-pitched voice and attractive features reminded many viewers of the popular *kawaii* (or "cute") Japanese anime aesthetic. Anime-inspired illustrated fan art of Poklonskaya poured onto the web from all over the place, "remixing" her into an anime heroine and building a fan community around her, unbeknownst to her. In mid-April, a music-video tribute to her became the most-viewed video in Russia and Ukraine for the period of a few weeks.

This type of celebrity wasn't something Poklonskaya had sought or desired, and the Russian prosecutor general's office had to put out a statement in response to repeated requests for comment explaining that "Natalia Poklonskaya doesn't write either on Twitter or blogs and isn't registered on social networking sites." It didn't matter, though; the creative responses she had inspired turned her into one of the most identifiable officials in the country. (She appeared seventh on Google's list of top-searched people of the year in Russia, just behind 2014 Olympic figure-skating champion Adelina Sotnikova.) The appropriation of Poklonskaya as a character by this excitable—generally male—audience was off-putting for many (myself included) but demonstrated just how far our capacity to remix could extend.

The original context was foreign and irrelevant to many of the people doing the remixing, but Natalia Poklonskaya the person became "Natalia Poklonskaya" the concept, a vehicle for people to express themselves in their own ways.

Many popular remix compositions do not convey some specific message or argument, but simply exist to amuse us. An actual question I asked aloud a few years ago:

"President Obama sang 'Call Me Maybe'? Publicly?"*

It turned out that yes, he had. Sort of. He'd also sung "Uptown Funk," "Get Lucky," and "U Can't Touch This," not to mention "Party in the U.S.A." as a duet with Mitt Romney. Fadi Saleh, then a nineteen-year-old biochemistry student at the University of Tennessee, had meticulously combed through a great many of the president's televised remarks, picking out the words that make up these songs' lyrics and even more meticulously timing them to the music. Better known as "Baracksdubs" on YouTube, Saleh "mashes together people's words to the tune of popular music, based on fan requests." When I first saw "Barack Obama Singing Call Me Maybe by Carly Rae Jepsen," Saleh's most

* Because Barack Obama is a human being, I assumed he too had, at one point or another, sung "Call Me Maybe" privately.

popular video, I was stunned by the bizarre juxtaposition and incred-
ibly impressed by the grueling effort obviously required to produce it.
And I'm not the only one. Justin Bieber and LMFAO excitedly tweeted
about the Baracksdubs versions of their songs. Given that Saleh's videos
have been watched more than two hundred million times, you might
have had this experience as well. It can take Saleh up to three weeks to
assemble a Baracksdub video, which rarely exceeds a minute and half.
While the videos no doubt require strong editing chops to make every-
thing fit together, Saleh's dedication and painstaking work are more
impressive than any technical or creative mastery.

The web is littered with fun examples like this. You may have seen
work by Benjamin Roberts, aka "AnimalRobot," who was once inspired
by the DJ Girl Talk to carefully sync family TV shows with hip-hop
songs. Imagine Big Bird lip-syncing Big Pun ("I'm not a player I just
crush a lot") or, in a Webby Award–winning stroke of genius, Earl
Sinclair from the sitcom *Dinosaurs* mouthing Notorious B.I.G.'s "Hypno-
tize." Roberts once said his edits took him between ten and one
hundred hours.

There is certainly a novelty to Baracksdubs and AnimalRobot and
perhaps their specific style of videos will not stand the test of time. But
making someone else say (or sing) something they didn't solely for the
purposes of amusement speaks to a larger trend. We've become used
to taking things from one context and moving them to another in an
effort to shift their meanings for our own purposes, often in collabora-
tion with one another.

SETTING ASIDE THE seeming trivialities of singing presidents and
Big Birds, remixing has become an important part of how we express
ourselves in the twenty-first century. It allows us to weave together our
own ideas and perspectives with those of others, and it is through this
creative interaction that we are able to give videos new meaning and
purpose.

In fact, there are many examples on YouTube where a piece of media derives its value from its plasticity. The answer to why this video or that meme is popular might have much less to do with any artistic quality and more to do with how flexible it can be as a vehicle for our participation. These are the clips and images that gain popularity not because they necessarily resonate with the audience artistically but because they turn the audience into artists too. It's actually not until the crowd becomes involved and participates that the work gains any real value at all.

In advance of their 2015 graduate show, a group of 150 students at Central Saint Martins art school in London were given the following instructions: "Submit a piece of text lasting up to 30 seconds or no more than 100 words. This can be as poetic, abstract or literal as you like—with the emphasis on expressing the feeling and tone of the work being introduced." The assignment was part of a collaboration with British artist Luke Turner and Finnish artist Nastja Säde Rönkkö, and an L.A.-based actor the pair had been working with. For the Central Saint Martins graduate show, the actor would film brief introductions to the students' work in front of a green screen in California so the students could manipulate the footage. As a collective, the trio explained to the *Guardian*: "Right from the beginning, our collaboration has been about . . . the fact that in this connected world . . . we are all seeking the sense of humanity in the shared experience and a way of expressing and articulating ourselves sincerely." Thirty-six videos were recorded in one day, ranging from breathing quietly to reading from a book to reciting poetry and advertising copy. The project was called *#INTRO-DUCTIONS*. The actor was Shia LaBeouf.

At the eight-minute fifty-eight-second mark in the half-hour compilation was a one-minute monologue written by a student named Joshua Parker who was exploring how public health becomes corporatized. "DO IT! JUST DO IT!" LaBeouf shouted, using gestures that were somehow both robotic and wild. "Don't let your dreams be dreams! Yesterday, you said tomorrow. So JUST DO IT!" In an interview, Parker

explained that he had been inspired by our increasing reliance on technology to support the active lifestyle that our use of other technology had weakened. As the clip spread, many people thought LaBeouf had gone insane. "Make your dreams come true! Just do it!" LaBeouf ranted. "You should get to the point where anyone else would quit, and you're not gonna stop there! No! What are you waiting for!? DO IT!"

The full thirty-one-minute compilation video was offered up on Vimeo, and while other segments drew chatter, it was Parker's that caught most people's attention, given LaBeouf's animated delivery. "The reaction has been overwhelming," Parker said. Because the green screen–backed footage was designed to be easily manipulable, professional remixers around the world sprung to action. Within days, hundreds of fan versions had popped up, many highly inventive and entertaining. A video titled "I'm sorry Shia, I'm afraid I can't do that" had him screaming at HAL in *2001: A Space Odyssey* to open the pod-bay doors. "Apple Watch Shia LaBeouf Edition" envisioned him as a miniature motivational hologram you could summon on your wrist during a workout. "Shiawalker Inspirational" (perhaps my favorite) has him shouting encouragement to Luke Skywalker as Luke attempts to lift his X-wing starfighter plane from the Dagobah swamp.° Ranting "Shia LaBeouf" gave a TED Talk, appeared in a "deleted" cameo in *The Avengers*, and got Auto-Tuned by the Gregory Brothers in a remix that was watched over ten million times. (Parker said this was one of his favorites.) When we were working on the YouTube Rewind end-of-year video for 2015, my only real demand was that we try to get Shia LaBeouf. It didn't work out, sadly, but we got forty-five YouTube celebrities quoting the speech instead, as well as model Karlie Kloss, singer T-Pain, and TV host John Oliver. Shia's rant was everywhere.

Superficially, people might have seemed to be mocking LaBeouf—a celebrity who, to outsiders, had appeared to go completely off the

° I think there's a scientific law that all internet phenomena must at some point intersect with the Star Wars universe.

rails in the preceding year or two—but LaBeouf, Turner, and Rönkkö, as well as the students at Central Saint Martins, viewed the piece as a vehicle for remix creation from the start. Parker called it "a sort of long-distance collaboration" and the trio of artists said in an interview, "The audience for our projects and experiences are as much part of the work as we are—they complete the work. It comes from this idea that we are all artists really." The original introductions weren't intended to be humorous, but the funny remixes were how the masses chose to "complete the work."

While a video of Shia LaBeouf ranting would have been moderately popular on its own, the true value of the clip was that it was so easily modifiable. The "Shia LaBeouf" meme is unique in that it was constructed in a context that was artistic and cognizant of the highly interactive popular culture it existed within, but memes are really just another form of remixing, and they exemplify this new opportunity to collectively participate in creating epic works of art that make more sense in the aggregate than individually. Coming across one LaBeouf video would have been pretty confusing, but watching six in a row is a rather wonderful experience, in part because they're funny, but also because they underscore an inspiring larger point about what technology makes possible now. If "we are all artists really," the web has begun to help us fully realize that potential.

MORE THAN CUTTING AND PASTING THINGS

"This video was created in a spontaneous randomly perfect collaboration with my ex flatmate and secret lover Eleonora while we were wasting too much time on the internet, in our living room in Shoreditch, London," writes Alessandro Grespan in the description of "Youtube duet: Miles Davis improvising on LCD Soundsystem," a mashup he uploaded in 2011. "No editing or other tricks, just 2 youtube videos played at the same time." (A music mashup is a remix where recognizable pieces of

songs are combined to play off one another.) With an absurdly simple premise—a recording of "New York, I Love You But You're Bringing Me Down" simultaneously accompanied by footage of Miles Davis freestyling—the video, by its creator's own admission, took almost none of the skills or labor we normally associate with creativity, yet was subsequently described as "The Pinnacle of Musical Mashups" by *Uproxx*. It was basically just a good idea that, with some simple musical intuition and elementary technical know-how, somehow brought new life to LCD Soundsystem's emotive ode to the Big Apple. A *Gawker* headline drolly proclaimed that "The Whole Internet Has Been a Prelude to This Mashup of LCD Soundsystem and Miles Davis."

Remixes challenge how we think about and understand the act of creativity in so many ways. Historically, we'd judge the quality of video on its production, lighting, editing, acting, writing, etc. But in the context of web video, we value the idea and point of view more than the production aesthetics. While, yes, some of these works originate from "spontaneous randomly perfect collaborations" that require little work or technical skills, many of the most popular remix styles on the web are quite the opposite. Remixing opened the door to a different type of creative talent using a different set of skills, artists who were not just screwing around with their "secret lovers" late at night.[*]

FOR YEARS, WHEN people would ask me to tell them about something really cool happening on YouTube, I would say one word: "Pogo."

South African–born Nick Bertke remembers being hypnotized by the classic family films his mother played for him when he was growing up. By the time he graduated high school his family had relocated to Australia, and he began training as a graphic designer and video editor. At seventeen, Bertke came across the work of Canadian electronic music

[*] I still have no idea what that "secret lovers" comment means, but I suspect, in that one sentence, Mr. Grespan neatly summarized why his life is probably disproportionately more exciting than mine.

artist Akufen, best known for 2002's *My Way*, a minimalist house-music album containing over two thousand samples of radio feeds. "I couldn't believe what I was hearing," Bertke said. "I thought, what if I did something like that, but with a single film or a single game or something like that."

The basic ideas of sound collage date back to 1949 and Pierre Schaeffer, who, along with composer Pierre Henry, developed an experimental style of music called *musique concrète*, generating compositions out of trains, piano sounds, saucepans, and more. "Instead of notating musical ideas on paper with the symbols of solfège and entrusting their realization to well-known instruments," Schaeffer said, "the question was to collect concrete sounds, wherever they came from, and to abstract the musical values they were potentially containing." He pioneered the use of magnetic tape to manipulate and create music. Since then—and particularly in the past fifteen years—the tools to do such work have gotten increasingly advanced *and* accessible, allowing us to wield audio and visual material at a speed and level of sophistication that would have been unthinkable to Schaeffer. "Computers and sequencers now, you can have so many samples going on . . . you can create patchworks that are so intricate they deviate entirely from the original content," said Bertke. "If we were back in the early '90s, I don't know if I'd be able to achieve [these remixes]."

Using the software at his fingertips, Bertke dismantled and reassembled sounds and melodies from Disney's 1951 *Alice in Wonderland* adaptation. The resulting mix, a sound collage, "was rocking," he said, and he listened to it on the commute to work almost every morning. Finally, after a few days stringing together animated image files over the mix, he uploaded a video version to YouTube under the name Pogo.

Before he even noticed, "Alice" by Pogo was pulling millions of views. "I had absolutely no idea what was going on," he said. "I couldn't comprehend the fact that I made that connection with so many people at once." Despite starting a new job, he continued making more mashups, using films like *The King and I* and *Willy Wonka & the Chocolate*

Factory. His process became more sophisticated as he refined his sound, which focused on syllables and the notes in the voices of the characters rather than words or sentences. Eventually, someone at Disney reached out to him directly. "I thought this was some bigwig just having a laugh," he said. Three weeks later, Bertke, who had studied 3D animation and screenwriting with the original goal of becoming a filmmaker, was flown to California to meet with Pixar's executives, including Chief Creative Officer John Lasseter himself. "It was blowing my mind how I could make some music in my bedroom, and the next thing you know I'm shaking hands with all these amazing people." These meetings spawned his first commissioned work, a remix to promote the Blu-ray release of the film *Up*. Bertke's work became so well known among the creative industry that he didn't need to actively sell himself; businesses came to him with opportunities. He put other career aspirations behind him to focus on commissions and original music he sells through a variety of platforms.

"With *Alice in Wonderland*, that was a film I grew up on, a film that mesmerized me before I could even speak English," Bertke said. "I didn't know what the film was about, but it had me in a trance because of the music and the atmosphere the film created." These child-hood films and his experience with them served as the creative inspiration for the unique "Pogo style" he developed, which he describes as "a euphoric, dreamy, ethereal" sound.

"I can't think of a faster or more effective way to express myself than through music," he said. "It's kind of like putting a piece of my soul out on the internet." Even though Bertke is manipulating someone else's original work, and none of the sounds in his most famous pieces were created by him, he still has a distinct and recognizable style of his own. "I'll take single notes out of a voice and use them as a kind of piano, and I'll actually compose an original melody with that," he explained to me. "I'll take notes out of the soundtrack and I'll layer them to create chords and chord structures. And then I'll take little percussive sounds out of the film and create percussion sequences and

drum sequences. So, in a sense, it's more difficult than making a track using synthesizers or instruments, because I have to build those instruments and synthesizers using very unconventional material. A lot of people look at it like, 'Oh, you're just cutting and pasting things together from the film. How much of that is actually your work?' Well I'd say all of it. It's kind of like saying to someone who's composed a score, 'Oh, those are just sounds of violins. That's just the sound of a cymbal or a timpani. Isn't that the work of the people who designed those instruments?'"

Despite relying on the original works of others, the pieces by Pogo, Kutiman, and others like them are unmistakably theirs. No matter where the material originates, their art contains their points of view and, generally, captures the affection they often have for their sources.

MANY REMIXES ON YouTube are just as much about the relationship between the creator and the material being remixed as they are about their creator's point of view. Some of the best and most impressive works of remix bring us closer to the art and creativity that inspires us. I love these kinds of videos because they embody how web video allows people to explore their passions with incredible fervor and to connect in a deeper way with other people who share that appreciation. YouTube is filled with endeavors that build connections within fan communities, including one that was forged a long time ago in a galaxy far, far away . . .

Actually, the time was 2008 and the place was Brooklyn. Casey Pugh *was* a huge Star Wars fan, though. A developer at Vimeo, Pugh was brainstorming ways for filmmakers to collaborate virtually. The year prior, Evan Roth and Ben Engebreth had launched an open-source artistic initiative called the White Glove Tracking project, enlisting the help of strangers across the web to pinpoint the exact pixel outline of Michael Jackson's white glove across 10,060 frames of his famous televised performance of "Billie Jean," so the data could be creatively

repurposed. The project, as well as other crowdsourcing efforts at the time, inspired Pugh to explore a similar concept, splitting a movie into pieces and asking people to remake it. What movie? "Obviously, Star Wars," Pugh said. "It's the most famous movie. Also, I love it." After six months of brainstorming, he broke *Episode IV: A New Hope* into fifteen-second chunks—the equivalent of 473 scenes—and spent two weeks building a site "completely without the permission of LucasFilm" that allowed fans to claim, produce, and upload their scene of choice.

Over the following months, nearly one thousand people collaborated to re-create their favorite movie through a mix of computer animation, live action, stop-motion, and more. Pugh couldn't believe the efforts people had made. "People spent *weeks* filming and shooting and editing this single fifteen-second scene," he said. "They would make these elaborate Darth Vader costumes from scratch that only appear on the screen for half a second." The effort oscillated between unabashed tribute and open parody, and it gave fans the opportunity to be a part of a cultural touchstone they knew and loved.

Pugh's project won a 2010 Emmy Award for Outstanding Creative Achievement in Interactive Media—Fiction, a category that had debuted just two years prior. I consider "Star Wars Uncut"—and its follow up, "Empire Uncut," which Pugh organized *at the request of* LucasFilm— one of the first great examples of organized, crowdsourced remixing. It can be choppy to watch, sure, but there's no way to separate the experience of watching it from the passion of the people who created it.

Most of the remixes we create are really about our relationship to the material being remixed. One of the most prolific subgenres of video remixes is the "supercut," and they tend to sit somewhere on a spectrum between fan-art tribute and pointed critique. In 2008, blogger/technologist Andy Baio coined the term in a brainstorm with web designer Ryan Gantz after Baio "noticed a trend of obsessively edited videos isolating a particular word or characteristic from film/TV." He wrote a blog post describing a phenomenon wherein an "obsessive-compulsive superfan collects every phrase/action/cliche from an episode

(or entire series) of their favorite show/film/game into a single massive video montage." Sometimes they lampoon tropes: reality show stars declaring they're "not here to make friends," TV detectives enhancing surveillance images, or horror movie protagonists startled by mirror scares. Sometimes they lampoon stars: a collection of clips of Arnold Schwarzenegger screaming or David Caruso putting on and taking off his sunglasses on *CSI: Miami*. Even the highbrow artistic community has embraced the supercut. Christian Marclay's *The Clock* may be the most impressive supercut ever created, sequencing ten thousand movie clips. Leveraging both famous and obscure scenes featuring time-pieces of various sorts in films, Marclay documented the passage of time, editing the clips in real time in a work spanning twenty-four hours. This one's not on YouTube; I experienced it as an installation at New York's Museum of Modern Art.

Some of the best remixes come about when a point of view or even criticism combines with dogged effort. One of my favorite super-cuts is called "Sorkinisms," in which Kevin T. Porter, a fan of screen-writer Aaron Sorkin, montaged phrasings and plot lines reused throughout the award-winner's various works. The original video took Porter two years to compile, and while he writes that "this is not intended as a critique but rather a playful excursion through Sorkin's wonderful world of words," it's hard not to watch it and see at least a glimpse of sausage making, or at most, quite a stinging criticism of Sorkin's writing. I love it not just because I love me some Sorkin walking-and-talking or because I think it's amazing someone spent two years making one YouTube video. Really good supercuts transcend the sideshow of their creation—the "wow" factor at the amount of effort that clearly goes into them—and lead us to think even just a little bit differently about how a part of our culture works. They cause us to question the conventions of our media, the motives behind the messages we take in, the meanings and values of the entertainment we watch.

The most resonant remixes are, of course, the ones that don't just amuse but also make an argument.

HITLER IS INFORMED OF A CHAPTER ABOUT REMIXES

It's no coincidence that the modern pop culture remix movement has its roots in hip-hop and Jamaican dub, two movements born from disempowered communities. "Early dub is a liminal space in which colonial ideology becomes appropriated by those on whom it was initially imposed," writes Eduardo Navas in *Remix Theory: The Aesthetics of Sampling.* "This is crucial to understand because Remix carries this critical trace of colonial resistance." A remix serves as an ideal vehicle for reacting to the world we find ourselves in, providing not just entertainment, but also a healthy dose of pop culture subversion.

Perhaps one of the most far-reaching and well-known examples of "remix as commentary" came from a very unlikely source: a 2004 film about Adolf Hitler's last ten days leading Nazi Germany. Critics said *Downfall (Der Untergang* in German) "may be the definitive account of Hitler's final days and the collapse of the Third Reich," but the Academy Award–nominated film might be best known solely for a three-minute-and-fifty-second segment. In it, Hitler angrily berates his officers for perceived traitorous actions against him as he realizes the war is coming to an end— but I suspect most people are not aware of that context. I myself have seen this scene play out hundreds of times, yet until researching this book, I'd never actually seen a version with the original subtitles.

A *Downfall* parody is simple to create. All you have to do is swap in your own subtitles over Hitler's furious tirade, which it turns out is a surprisingly flexible device.

Hitler has ranted about getting banned from XBOX Live, about President Obama's reelection, about his friends backing out of Burning Man at the last minute, and about the tyranny of the grammar police ("My Fuhrer, you, uh, you just ended a sentence with a preposition"). There are at least a few hundred thousand estimated *Downfall* parodies on YouTube, and they still draw more than one hundred million views annually, years after the trend first surfaced. "I think I've seen about 145 of them!" *Downfall*'s director admitted in a 2010 interview.

"Of course, I have to put the sound down when I watch. Many times the lines are so funny, I laugh out loud, and I'm laughing about the scene that I staged myself! You couldn't get a better compliment as a director."

The most biting of the *Downfall* parodies are the ones in which Hitler reacts to some absurd or unjust cultural development, and we find we may (gulp) agree with . . . Hitler. These might range from the trivial "Hitler Is Informed His Pizza Will Arrive Late" or "Hitler finds out no camera in iPod touch" to more serious problems such as "Hitler reacts to SOPA" or "Real Estate Downfall" regarding the collapse of the housing market. These simple memes can wryly express our indignation and undermine the sanctity of some of our cultural constructs while using one of history's worst villains to do so. I rewatched many of the *Downfall* videos as I researched this book, and I can tell you, it's an odd experience to spend an afternoon laughing at Hitler, something you certainly don't want to mention while meeting someone for drinks after work. (Laura did not respond to my texts for a second date.) But the *Downfall* parody meme has stood the test of time in part because of this extreme and surreal quality, not in spite of it.

It's remixing at its best/worst. I came across this user comment from a BBC story covering the *Downfall* phenomenon that seemed to sum it up: "The popularity of this clip is a clear indication of how access to technology has led to the democratization of the dissemination of information, and our ability to now make OUR voices heard in a way that frightens politicians, big business, teachers, institutions, and the established media industry."* It's true. A remix can subvert and even diminish the power of some of our most revered or formidable symbols.

THE INTERNET, WITH its myriad forums for enabling immediate, semi-anonymous responses, has no doubt been an unprecedented boon for cynics, and few styles of communication so aptly capture a cynic's

* Apparently, the BBC gets a much higher grade of commenter than most of the places I hang out online.

point of view than remixing. In the right hands, it can dramatically undermine serious ideas and figures that populate our culture. The capacity for subversion is heightened when our criticism or humor comes craftily represented through direct footage of the actual people and symbols we intend to take down, making remixes far more effective than impersonations and other forms of parody.

My fondness for the art of the remix began with my first job in New York, at a politics and news satire project called 23/6, run out of the Huffington Post. ("23/6: Some of the News, Most of the Time." Get it?) In the run-up to the 2008 presidential election, we crafted all kinds of satire and parody, picking apart American politicians and the news media that covered them. I did a fair bit of writing but also a lot of silly Photoshopping and video editing, perfecting what we called the "In a Minute" format, supercuts and mashups of news clips highlighting the absurdity of the rhetoric at that time. My favorite was CNN's "Situation Room in a Minute" for which I would mock—via edit—Wolf Blitzer's relentlessly dour tone and John King's increasingly disturbing obsession with his "magic wall" touchscreen of election data.° My most popular was a mashup of all three presidential debates, highlighting how many times then-senator Obama and Senator McCain repeated themselves.

While I made these, my colleagues were producing brilliant original shorts with then-up-and-coming comedians like Eugene Mirman, H. John Benjamin, and more. Yet, somehow, my stupid "In a Minute" montages were outdrawing their more cleverly crafted satire, which I found very confusing. It took me years to understand why that had happened. It's one thing to hear a joke about the news but another to see the news transformed into a biting caricature of itself before your eyes. What in 2007 seemed like a novelty had, a decade later, become one of the de facto ways we react to current events.

° Much to my disbelief, Keith Olbermann and Rick Sanchez both aired my mocking mashups of their shows directly on MSNBC and CNN. Olbermann remarked, "You, sir or madam, have too much time on your hands," a quote that will undoubtedly be etched on my tombstone.

By the time the 2016 election cycle rolled around, remixing had become a commonplace means to critique and parody the candidates. Donald Trump, in particular, became a popular target of mashup mockery. Creating, watching, and sharing remixes of Trump joined the list of modern activities that allowed us to vent our feelings about the highly charged race made possible by the internet. There were mashups of contradicting statements he'd made and montages of words or phrases he seemed to reuse—like the supercut of his odd pronunciation of "China" that people watched more than ten million times. Music producer Andrew Huang even composed a hip-hop beat out of Trump's nasal sniffs from the second debate.

It's one thing to criticize or deride a public figure, but another entirely to deliver that scorn using their very words and image. This type of manipulation can be a devastating tool for voicing dissent and irreverence, particularly in the face of sanctimony. There are few better ways of exposing hypocrisy or delivering a searing hit of blasphemy than with a mocking remix.

ON FEBRUARY 22, 2011, North Africa was really beginning to feel the effects of what would later be known as the Arab Spring. Libya's Colonel Muammar el-Qaddafi, dressed in his characteristically absurd attire, gave an impassioned televised address vowing to chase down dissenters "inch by inch, house by house, home by home, alleyway by alleyway."

Noy Alooshe, a producer, DJ, and music journalist in Israel, got a call from a friend telling him to turn on his TV. Alooshe had made a name for himself in the preceding years with the hit techno song "Rotze Banot," which he enjoys describing as "the first 'Gangnam Style' before 'Gangnam Style'" (though that's a bit of a stretch). He and a friend had recorded the song in thirty minutes and it turned them into modest popstars for a year. "After that I started to understand the power of the internet," he said. A few years later, inspired by the

popular American viral meme "Obama Girl," he created "Livni Boy," a song with a similar premise about Israeli foreign minister Tzipi Livni, which is regarded as the country's first hit online parody. Later in his twenties, Alooshe wanted to do something more serious, but as he followed events in Egypt and Tunisia (where his family originated) and the Arab Spring became the region's biggest story, he couldn't find the right entry point. That is, until he got that phone call imploring him to turn on the news.

As Alooshe watched Qaddafi gesturing with his hands in the air and shouting repetitively, it reminded him of a techno concert. "I heard it and I said, 'Okay, I just need to put a beat under it and it's going to be great,'" he recalled. Alooshe grabbed the beat from a recent Pitbull and T-Pain collab (is there any better sort of collab?) and focused on slicing and Auto-Tuning the speech. In public appearances, Qaddafi was often flanked by his all-female guard unit, the "Revolutionary Nuns." To increase the humor, Alooshe added semitransparent imagery of a gyrating, scantily clad woman on either side of Qaddafi, which, he admits, he thought would help boost his views. The result: Colonel Qaddafi ranting musically over "Hey Baby (Drop It to the Floor)" complete with backup dancers.

Alooshe named it "Zenga Zenga"—*zenga* being an approximation of the Libyan term for "alleyway"—and shared it online, particularly with the social media accounts of young revolutionaries in the Arab world. The song took off, and the video quickly racked up millions of views as fans wrote to Alooshe declaring him a hero.* Alooshe received videos of people dancing to the song in nightclubs. He remembers a journalist calling him to say, "I'm in the market now in Syria, and someone put the song on the speakers and everybody is dancing to the song." Two Egyptian rappers recorded a live version of it. DJs were

* Upon learning he was Israeli, some initially accused him of being a Mossad operative. But the backlash quickly subsided. "After two days, nobody cared," he said. "A lot wrote me, 'I hate you. I hate your country. I hate Jews. But this is really funny and I need to share it.'"

playing the remix in Tel Aviv, and Alooshe was featured prominently in the newspaper as "the Israeli guy that made the song of the revolution." He had to persuade his friends to skip work just to help him field all the media requests. "It was like an episode of *Entourage*," he said. He eventually created an alternate version with his own original beat and made it available as a ringtone on iTunes. He says he sold sixty thousand in the first week in Israel alone.

The most notable reaction was in Qadaffi's home country, Libya. Activists informed Alooshe that it had become a hit song there despite the country's widespread internet blackouts and blocking of YouTube. In some cases, the video file itself was passed around or, more commonly, just the audio file. A BBC journalist on the ground in Libya told Alooshe that he'd stopped a man who was blasting "Zenga Zenga" from his car stereo to ask him where he'd gotten it. Someone had burned him a CD with it. "It became viral not just in the virtual world. It became viral in the physical world," Alooshe joked. Because of this hard-to-trace sharing, the official YouTube view count really reflects only a fraction of the activity around the remix.

The subversive nature of "Zenga Zenga" was immediately apparent to the younger generation,* but not everyone understood it. Libyan state TV reportedly aired the clip for a few weeks before realizing it was mocking their leader.

"It changed the way people think about Qaddafi," Alooshe said. Qaddafi had been well known for his eccentricities, which Alooshe believes had made him seem relatable. "After the remix, after the 'Zenga Zenga,' it became the opposite . . . he became like a cartoon, you know?" This type of open mocking was very, very rare at the time. "Until this year, few had openly criticised either him or his four-decade rule," wrote the *National*, an Abu Dhabi–based English-language newspaper, in 2011. "February's 'Zenga Zenga' speech, however, may have

* At the request of young people who wanted to share it with their parents, Alooshe made an alternate video without the dancing girls.

marked a turning point. As Libya erupted in revolt, the song became an anti-regime anthem of sorts." In the era of Auto-Tune, the hastily done mix did not exactly forge new musical territory. But its subject matter did. And that's where its power lay. Here was the self-described "king of kings of Africa" reduced to a cheesy dance-hall dictator. It was mockery-by-Pitbull for the whole country to see.

After Qaddafi's death, Alooshe saw news reports of people triumphantly holding up photos of the deceased ruler while shouting "Zenga! Zenga!" Journalists began referring to him as "the guy who killed Qaddafi." But the video's repercussions in the Arab world extended beyond Libya into other countries where Alooshe's remix had shown how the sanctity of such leaders could be spoiled. Bashar al-Assad became a target in Syria as a reworked version of "Zenga Zenga" floated around.

Alooshe went on to produce locally popular videos targeting Israeli politicians or current events. Like his brethren in other parts of the world, he began accepting jobs from brands and media companies. "Everything you can bring me, I can mix," he told me with the chuckle of a car salesman. (He and fellow Israeli Kutiman often get approached about the same opportunities.) During the next election cycle, he said, every political party tried to hire him to make (positive) remixes of their candidates. In Israel, remixes became a part of the language of activism.

But not everyone wanted to use his powers for good. Alooshe told me he declined the one request he got from a minister's office to make a remix that would have trashed a rival. His experiences over the previous few years had taught him that beyond its entertainment value, a remix could have a real impact on the world around him, changing the way that people view world events and political leaders, and it was something he is now wary of trifling with.

►►

Remixes aren't just one random subgenre of videos on the web. They are a whole mode of communicating that we, the general population, didn't have full access to, as creators or viewers, until this century.

Our actions online give each of us the ability to shape culture through our own perspectives, and creating a remix is one of the most effective and most modern languages we can use to do it. Noy Alooshe's "Zenga Zenga," Robert Ryang's "Shining," and Pogo's "Alice" all spring from and inform a popular culture that has become more interactive than ever before. All three of these creators, like me, grew up in a time when creating and distributing entertainment was so expensive that their irreverent use of the original source material would have had no chance of dissemination. Technology brought a major change. "Digital technologies have now removed that economic censor," Lessig wrote in *Remix*. "More people can use a wider set of tools to express ideas and emotions differently. More can, and so more will, at least until the law effectively blocks it."

Remix art is not just a fad but an effective widely adopted format of expression. Remixing as a form of reacting has become second nature to many of us, and that makes it challenging—if not irrespon sible and unrealistic—to block it, even in the name of protecting intellectual property rights. "Just a few months ago, I did this thing for kids in third grade," Ophir Kutiel told me. "I showed them what I do, one second of a clip. I asked them, 'Do you understand what's going on?'" They understood immediately. "They just *know it*, you know? They know the language."

The rapid rise of remixes is a function of the increasing desire to more actively and communally engage in a pop culture that is saturated with media of all types. It's a creative tool that can change our relationship with television, movies, music, people, and images and what they represent. It allows us all to share our unique perspectives on the symbols and concepts we're exposed to every day. It lets us take

media we're familiar with—photos, songs, people—and assert our points of view. It both speaks to and subverts the power of audio and visual media in our lives by allowing us to engage directly with it. Sometimes it's simplistically idiotic. Sometimes it's devastatingly critical. Sometimes it involves Hitler complaining about his pizza being late. But it's never not personal.

Remixes force us to consider how limited our view of entertainment and production for a mass audience had become. Nyan Cat's very existence is completely illogical based on every rule and principle of the past. But our behavior online has introduced a new logic on which it has thrived. The next Nyan Cat cannot be stopped; it's a furry toaster pastry of inevitability.

CHAPTER 4

Some Music That I Used to Know

I N GIANNI "LUMINATI" NICASSIO'S quest for inspiration and new material for his band, he regularly researched music charts in other countries looking for songs that might eventually break in North America. His latest discovery hadn't taken off in the United States or Canada yet, but it was gaining some traction in Belgium and Australia. He loved it immediately. "Gianni came into the room and said, 'You've got to hear this song. It's really different from everything that's being played on the radio right now. It's really cool,'" his bandmate Sarah Blackwood recounted. "'It's going to be a smasher, we've got to cover it.'"

Luminati and fellow musician Ryan Marshall started Walk off the Earth in 2006, cherry-picking the best talent in Burlington, Ontario. "We were just kind of like your average local party band," Luminati told me. They were seasoned performers, but all of them still had day jobs. Marshall worked for a company that sold bathroom fixtures and toilets.

Luminati had met a singer whose heavy metal cover of a Lady Gaga song was drawing a huge audience on YouTube, despite not being very inventive. Walk off the Earth had posted performances to YouTube too, but they weren't getting anywhere near that much attention. The singer told him that fans liked to check out different versions of the tunes they loved to connect more deeply with the music. "A light bulb just blew up in my head," said Luminati. The band began uploading unconventional takes on pop hits and he realized that to cover a song in a way that made people take notice, you really needed to find an original angle. For example, he'd had the idea for a while that they should record a song where they all played a single guitar simultaneously.

When he came to Blackwood and the band in early 2012 about
that "smasher" he'd heard called "Somebody That I Used to Know"
from Australia-based Gotye, Luminati finally had the right tune to
bring that idea to life. The band spent a week or so composing the
arrangement and a day learning their parts and creating the video.
Luminati belted out the chorus as he sat squished between Blackwood
and Marshall, who handled the verses and other guitar parts. On the
outside, Joel Cassady handled the percussion by knocking or tapping on
the guitar's body and Mike Taylor, who later became a bit of a meme
as "Beard Guy," flicked the strings on the guitar's headstock with a
deadpan expression. It was challenging for five adults to play a single
acoustic guitar, and the video took more than thirty takes. The recording
went until two or three in the morning. "It was very frustrating," Lumi-
nati recalled. "Like most videos, it gets heated and stuff. Especially
when you're pressed up against each other like that."

By Luminati's standards, the sound recording was "kind of half-
assed" and Blackwood said if you listen closely you can even hear
typing in the background of the final track, but they posted it to YouTube
and less than six hours later, the band woke up to find the cover airing
on morning radio. People watched the video almost a million times
that day. The band put it up so fast they hadn't even finished the paper-
work to have a licensed audio track up for sale. Luminati frantically
called the company that handled distribution for them and thousands
of other small acts. "I'm the guy from that video you probably just
watched," Luminati told the man who answered the phone. He had. It
was up for sale on iTunes shortly after and hit #1 in Canada a week
later. The number of views multiplied by fifty over the first month, and
it became the biggest cover and the #2 trending video on YouTube for
the year.

Five or six days after it went up, the band received an email from
Gotye himself congratulating them on their cool video and suggesting
they write a song together sometime. The Belgian-born Australian
musician was about to go on a ride of his own. In the coming weeks,

"Somebody That I Used to Know" hit the top of the charts in more than twenty countries on its way to becoming one of the bestselling songs of 2012. A hit viral trend certainly helped.

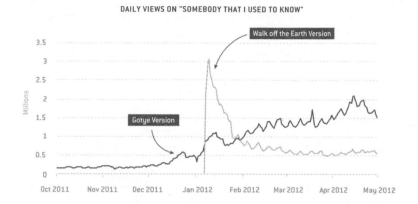

DAILY VIEWS ON "SOMEBODY THAT I USED TO KNOW"

The Walk off the Earth cover of "Somebody That I Used to Know" was among the first of many versions that flooded YouTube, and the creativity of fans—both pros like Luminati and many amateur musicians—became a part of the song's legacy. That year, Gotye even published a video he'd made mashing up all the popular covers of his song, calling it "Somebodies: A YouTube Orchestra."

Walk off the Earth drew millions of viewers with many more covers and original videos featuring unusual instrumentations and whimsical concepts. Unlike groups Luminati describes as "record label bands," who rely solely on labels for distribution and promotion, the Walk off the Earth crew personally connects with their huge fanbase online. "We can tour in any country in the entire world and get two thousand people in a room, which is great for not ever having had any radio play in many of those countries," he said. When we spoke over the phone, Luminati and Blackwood were in a limo heading to the airport for a gig in Quebec. They had recently gotten back from a tour

that took them through Denmark, Belgium, France, and England.
Everyone had long since quit their day jobs. Ryan Marshall, notably,
got to stop selling toilets.

The environment of the web pushed them to become a totally
different kind of act. Walk off the Earth is now anything but "your
average local party band." Though they aren't your average mainstream
rock band either. They've become something else, something harder to
describe yet a natural fit for a new world of music where the creativity
of the fans and artists blur together.

<div align="center">◄◄</div>

Before Thomas Edison's phonograph, the idea that you could repro-
duce the musical experience outside of a live concert seemed prepos-
terous. Edison even assumed that we would use his invention for the
purposes of dictation, improving our ability to produce written text.
Before then, music was produced live at the symphony, the opera, the
local hoedown, and church on Sunday. One *attended* and *partici-
pated in* music. One rarely heard Stephen Foster's music professionally
performed, but "Camptown Races" and "My Old Kentucky Home"
were widely known in households around the United States as some-
thing *you* were required to help re-create via a piano or a guitar or your
voice.° Parlor songs were distributed via sheet music and written specif-
ically so they'd sound decent when sung and played by amateurs. The
live performance of music was inseparable from music itself.

The advent of recorded music changed all that. With the phono-
graph, the best performers and songwriters could be enjoyed by anyone,
though not everyone was happy about it. In 1908, John Philip Sousa
published "The Menace of Mechanical Music," a rather amazing essay

° How we went from Foster's "Oh! Susanna" to Spears's "Work Bitch" in fewer than two
hundred years remains a mystery to all.

declaring the death of the experience of music thanks to our diminished participation. It was music without *us*. "Music teaches all that is beautiful in this world," he wrote. "Let us not hamper it with a machine that tells the story day by day, without variation, without soul, barren of the joy, the passion, the ardor that is the inheritance of man alone."

But there was quickly a market for recorded music on physical media, despite Sousa's concerns, and with it came some other limitations. Seventy-eight rpm gramophone records (and the famous forty-fives that replaced them) could hold only around three minutes of music per side, so most popular songs of the early twentieth century had to be less than three minutes long to ensure distribution across radio and jukeboxes.

The way we define "music" is based on the available technology of the time and economies that allowed it to be distributed and funded. Is a song, if defined as a three-minute auditory experience with the ability to be reproduced repeatedly, the ideal means for experiencing music now, or just the culmination of a hundred years of music technology? We're in the process of finding out. Today's audio/video platforms dispense with the restrictions of the past, and technology is once again changing the experience of music before our eyes, but this time on YouTube. Web video takes what MTV started in the 1980s toward its natural conclusion, an unbreakable union between the visual and the aural. But reducing music in the digital era simply to the evolution of the music video vastly underestimates the impact of what's happening. The new ways we create and distribute video have brought *us* back into music where our role as participants is what truly defines it.

RADICAL REFUSAL TO SUSPEND YOUR DISBELIEF

In 2002, OK Go toured, had a hit single, "Get Over It," and were poised to star in their own video with famed music video director (and future *Hunger Games* director) Francis Lawrence. "We were squeezed

in between Will Smith and, I think, Britney Spears or Pink, or some-thing like that," Damian Kulash, OK Go's lead singer, told me. "It was big. It was a kind of a coup to get him. Giant budget and a two-day shoot. The camera itself had won a technical Academy Award of some kind. It was a big deal." This was to be their first MTV hit, but the videos they're best known for don't look anything like a Francis Lawrence production.

Kulash had technically made a lot of music videos by the time they shot "Get Over It." Growing up in Washington, D.C., he and his sister, Trish Sie, used their parents' camcorder to create their own home-made music videos to their favorite songs. "I remember doing one to something off of the Chili Peppers' *Blood Sugar Sex Magik* record," Kulash said. "We would just run around town with a camera and be like, 'Go stand on that mailbox and pretend you're humping it!' It was just goofing around." They would record all their dramatic action in sequence on a tape, and then Kulash would place a boom box next to the camera as they overdubbed the audio track.* Kulash also enjoyed making these videos with his best friend, Tim Nordwind. The pair had met at summer camp as eleven-year-olds, and during school breaks, Nordwind would travel from his home in Kalamazoo, Michigan, to hang out with Kulash in Washington, D.C., where the two would produce all kinds of silly videos together, including some music videos.

Years later, Kulash and Nordwind formed OK Go with Dan Konopka and Andy Ross in Chicago. (Nordwind is the band's bearded, bespectacled bass player.) In an early break for the band in 1999, the Chicago public television program *Chic-a-GoGo* invited them to perform their only song at that point, a bouncy number called "C-C-C-Cinnamon Lips." The only problem was *Chic-a-GoGo* didn't have the capability to actually broadcast a live musical performance, and the band would have to lip-sync. "We decided, if we had to lip-sync,

* As a middle schooler, I did the exact same thing with my sister, Kristine, using Stone Temple Pilots songs. God bless enthusiastic and cooperative siblings.

we would swing for the fences," Kulash said. They gathered at his apartment and, with the aid of some NSYNC videotapes they'd rented, choreographed the most ridiculous boy band dance they could muster.° As the band toured to support their self-titled first album, they routinely ended their shows with the number as a means to break the self-serious indie-rock mold that had taken hold of the scene at that point.

When it came time to go on tour for their second album, *Oh No*, in 2005, everyone was eager to keep the signature bit, but they didn't want to end the show with a song from the previous album. So Kulash asked his sister, Trish, by then a professional ballroom dancer, to come to L.A. to help them create "a much more ridiculous dance" for the single "A Million Ways." It took a week to choreograph. They intended to use it solely for their live shows, but around the same time, they'd heard through a connection that famed French director Michel Gondry was in town working on a new video. "He'd come up with this amazing, giant dance-routine video for some rapper called Kanye, who we'd never heard of," Kulash recalled. "And we're like, 'The fuck? We're the dance band!' What became the 'A Million Ways' video, and this is no exaggeration, was literally made just for Michel Gondry." Determined to get Gondry to make *their* video instead of one for that Kanye dude, Kulash, Nordwind, and the band set up a camera in Kulash's backyard and performed the dance Trish had choreographed with them. It took four attempts. "We never got it quite right, but on the fourth one, it was pretty decent, and we said, 'Well, that's enough for him to see that clearly he should be working with us,'" Kulash told me. They gave the video to their friend to pass along. No one's sure if Gondry ever saw it.

The one-take, low-res dance video was not so very unlike the shorts Kulash, his sister, and his best friend had made as kids. And the size of the intended audience was pretty similar. "We didn't think of it as a music video," he said. "We thought it was another in a long line of

° Since the band would be dancing, they enlisted some friends to play pretend instruments behind them. Ira Glass, host of the radio show *This American Life*, played the drums.

ridiculous crap that we liked to make for fun." The band circulated it
to friends as an email attachment until someone uploaded it to an early
video hosting site called iFilm.com. It was a huge hit on the site. The
band had an epiphany: "Oh my god, it's a music video!" Except no one
knew what to do next. When they excitedly took it to their label, they
got turned down because it wasn't broadcast ready. "It didn't meet TV
specs for all sorts of reasons, not the least of which was the content
was so fucking weird," Kulash said. Meanwhile people were eating it
up online.°

Soon enough, fans were making their own versions of the "A
Million Ways" video, filming their attempts at the OK Go guys' dance
in their own backyards, driveways, and school gymnasiums. This kind
of thing is relatively common now, but was unheard of in those days.
"Our management company received hundreds of videotapes of people
being like, 'I live in Brazil; this is me at my wedding,' or 'This is our
school talent competition in Wyoming.' They were from all over the
place," Kulash said. "The hours that *we* put in making this up and
learning this, *they* put in learning it themselves. It just felt like this
shared thing." Many of these videos made it online and OK Go eventu-
ally ran a contest through YouTube to find the best one. (A group of four
teenage girls in San Diego were the victors.) Of course, the big ques-
tion on the band's mind was this: If they could create a hit online video
by accident, could they do it on purpose?

In an attempt to up the ante on the ridiculousness, the band
locked themselves away for ten days at Trish's house in Florida with
eight treadmills and the goal of creating a rogue music video for the
song "Here It Goes Again" with basically no budget. It took seventeen
attempts and probably a few injuries to complete the elaborate dance.
When it hit the web several months later, it was one of the most popular
viral videos the young world of web video had seen. No one could

° One day Kulash got an email from a guy named Chad asking him to upload the band's video
to a new website he'd launched: YouTube. "I don't think we even took it seriously," Kulash
said. "It was another dude with a stupid video startup, you know what I mean?"

believe the numbers. "After we made the treadmill video, it was a few weeks before we were like, 'Oh, shit. My gravestone is gonna say: Those treadmill guys.' Like, we're never gonna outlive this thing," Kulash said with a laugh. Their label, which had caught on to how to handle the viral success, pushed their radio play and, in a surreal moment, MTV invited the band to perform the choreography live (with treadmills) at the Video Music Awards. "I remember sitting in the rehearsal, and Justin Timberlake was onstage doing his number, and we're just in the empty auditorium waiting for our chance," Kulash recalled. "There's a guy who must have been from Timberlake's label sitting behind me, and he leaned forward and said, 'I don't know whether to thank you or to slap you, man. You guys just fuckin' changed the whole industry.' It was that ridiculous moment. Suddenly, *that's* how you make a music video."

The smashing success of their inexpensive, self-shot videos was a game-changer. But the reaction to "A Million Ways" and "Here It Goes Again" also suggested a major new opportunity for artists to express themselves in ways that allowed fans to more meaningfully connect with their work. Maybe music videos were not just promotional collateral meant to market a song. Maybe they were the main event.

In the years following "Here It Goes Again," OK Go has made videos incorporating optical illusions, robotics, a giant Rube Goldberg machine that required sixty takes to film successfully, and in the case of "I Won't Let You Down," more than twenty-three hundred extras in Japan for an epic aerial-drone shot. These clips started to feel more like performance art than music videos. And each drew huge audiences who loved to watch and discuss the productions' intricacies. When we spoke, OK Go had just released a video filmed in a reduced-gravity aircraft in parabolic flight for "Upside Down & Inside Out." "For ten years, every time I had the opportunity to pitch a video idea, I'd go through three other ideas and say, 'Or, if you want the best motherfucking video in the world, zero gravity,'" Kulash said. The video was,

naturally, once again directed by Kulash and his sister, Trish.° But they'd come a long way from humping mailboxes.

THE LOOK AND feel of OK Go's videos underscore how the music video has evolved too. Starting with the accidental success of "A Million Ways," the band's prevailing aesthetic comes from the sense that, no matter how outlandish or visually complex their videos get, you're still firmly grounded in the reality that Kulash and Nordwind and Konopka and Ross are real people doing real things. "I realized that part of what we really needed was radical refusal to suspend your disbelief," Kulash told me. "It's increasingly hard to do this because digital technology gets better and better, and the line between reality and computer graphics is so hazy now. We have to try really hard to leave in indicators that this is real, this is real, this is real, just so that people can have a sense of wonder." To the frustration of his perfectionist camera crews, Kulash gives instructions to allow things like lights and camera dolly tracks to fall into the frame. In the twenty-first century, effects and computer-generated wizardry can make any imaginative suggestion into visual reality. "If there are no rules, then nothing is really that impressive," he said. "So if we can establish really clearly, 'This fucking happened,' then people have the framework where *wonder* is a possibility."

Even a simple video like the one shot by Francis Lawrence in 2002, three years prior to the start of their web video adventure, feels big and impersonal compared to the massively up-leveled DIY videos the band made a decade later. Suddenly, shiny production for shiny production's sake seemed pretty . . . uncool.

° In addition to being an accomplished ballroom dancer, Kulash's collaborator-sister, Trish Sie, also became a choreographer and movie director, directing one of the installments in the Step Up film series. My collaborator-sister, Kristine, did not go on to direct any of the Step Up movies, but she is a very accomplished elementary school teacher.

OK Go is any of us. I mean, yeah, they're a rock band and all that too. But the digital environment where OK Go's fans connect with their videos is the same one where those fans make videos of their own. The rules had changed. OK Go (accidentally) proved to the music world that the "music video" could be more than promotional material, that it could be an organic part of how fans connect with and experience music. Kulash's work acknowledged that in a world where everyone can make a music video, the gulf between a band making a music video for their own song and a fan making a music video for their favorite song wasn't all that large. OK Go made videos anybody could make, or at least imagine themselves making, but with a level of creativity and complexity that only the band could bring. "It's hard to amass eight treadmills anywhere, but the point was not: We can get eight treadmills. The point was: If you happen to have eight treadmills, you also could do this," said Kulash. "It's still like: If you could get access to a Russian cosmonaut training plane, you could do this."

Once a typical rock band, OK Go became a team of multimedia creators that represent a new direction for our experience with music. They construct experiences for their fans that go beyond three minutes and thirty seconds of recorded stereo audio. They're still a rock band, sure. But, by design, they have none of the distance we associate with rock 'n' roll stardom.

Our use of new technology has compelled artists to innovate their strategies to remain relevant. It has also refocused on the essential qualities of what made music special in our lives in the first place: being a part of it.

VREI SA PLECI DAR NU MA, NU MA IEI

In December 2004, almost six months before YouTube launched, Gary Brolsma, a nineteen-year-old kid in Saddle Brook, New Jersey, recorded a video of himself dancing and singing along to an odd song he'd

uncovered in a web forum. The song had originated in Romania in 2003 and spread through Europe the following year. Though the title of the song was actually "Dragostea Din Tei," everyone on the web who didn't speak Romanian called it "Numa Numa."

Many of us remember Brolsma's "Numa Numa" as one of the first viral videos. More than a decade later it still pops up from time to time, either when some advertising director is too lazy to find a more modern, less obvious meme or when you need a good shorthand nod to the early internet. (E.g., on the crime procedural *NCIS*, the younger members of the team enthusiastically show "Numa Numa" to their grizzled boss, Special Agent Gibbs, to explain how web video works. Agent Gibbs is not amused.) But at the time, it felt like a revelation, a window into something new. Wrote Douglas Wolk in the *Believer* in 2006, "Everyone laughed at the Star Wars Kid; everyone wanted to *be* the Numa Numa Guy—to feel that un-self-consciously self-conscious joy he felt in his body, flailing around in his chair and lip-synching [*sic*] a stupid pop song in a language he didn't understand."

O-Zone's "Dragostea Din Tei" never became a chart topper in the United States, but for young adults of a certain age, it's instantly recognizable, thanks in large part to Brolsma. The Moldovan Eurodance tune even found its way into a T.I. song featuring Rihanna. The first time I heard Rihanna's chorus on "Live Your Life," which heavily samples "Dragostea Din Tei," I almost fell over. Was the primary influence of a song by two of 2008's top artists a nineteen-year-old lip-syncing in his bedroom? At the time, that felt absurd, but today it seems very plausible.

What Brolsma did in the video was nothing groundbreaking, but the fact that everyone else could watch it and share it was, because it meant that a common experience of music fans—enthusiastically singing along to a song in your bedroom—could reach such renown as to be forever wedded to a piece of music in our minds. The culture of popular music could now be defined by creativity that existed beyond that of professionals. YouTube took the small ways we love to individually

celebrate and enjoy our favorite songs and made them part of the universal experience of that music.

YOU COULD SENSE very early on that platforms like YouTube had a keen ability to turn common fan behavior into reproducible art forms, like when lip dubs became, for a number of years, the king of home-made music videos. Technically, a "lip dub" is like a lip sync but with the audio overdubbed later. But when most people think of them, they think of those elaborately choreographed, one-take setups in which a number of different people jump in to sing different portions of a song. This type of lip dub originated in 2007, when the staff of Connected Ventures, which included CollegeHumor and Vimeo, created the first one as a fun way for the team to goof off in the office after work. Their lip dub to Harvey Danger's "Flagpole Sitta" inspired thousands of others in offices, high schools, and universities. In 2011, the city of Grand Rapids, Michigan, in reaction to a *Newsweek* article declaring it one of America's "Dying Cities," closed off its downtown so that five thousand people could perform a record-setting lip dub to Don McLean's "American Pie." The video, which included police officers, firefighters, gymnasts, a wedding party, an ice sculptor, football players, cheerleaders, and a marching band, encapsulates so much about life in that city and other towns like it. Roger Ebert declared it "the greatest music video ever made."

People have been mouthing the words of songs to amuse one another for, I imagine, a few thousand years. It's such a popular international pastime that, in an effort to reduce foreign influence, the former president of Turkmenistan—and hall-of-fame crazy person—Saparmurat Niyazov actually banned lip-syncing in public, on TV, and at weddings. I've been lip-syncing since at least age nine when I learned all the lyrics of Tag Team's "Whoomp! (There It Is)" to impress my fourth grade class. I'm not sure if I won over any of my elementary school crushes, but the schtick allowed me to express

myself *through* the music I loved,[*] even though I had few musical skills of my own.

Video platforms allowed all of us to take this concept to another level.

Fifteen-year-old Chicagoan Keenan Cahill's lip sync of Katy Perry's "Teenage Dream" became one of the first big hits I had the responsibility of tracking at YouTube. Cahill, who made videos to songs he liked on a laptop webcam in his home, was born with the rare Maroteaux-Lamy syndrome, and his exaggerated features and transfixing bespectacled eyes made his passionate rendition of the pop hit irresistible. "I heart you @KeenanCahill," tweeted Perry herself. Soon, artists and their representatives started messaging Cahill directly, leading to collaborations like the one of rapper 50 Cent joining Cahill in lip-syncing his verse on Jeremih's "Down On Me." Over the following months, Cahill created videos in various bedrooms, hotel rooms, and living rooms with Justin Bieber, LMFAO, Jason Derulo, Lil Jon, David Guetta, the San Francisco Giants, Sean Kingston, and, in a clip that perhaps dates Cahill's phenomena to the specific pop culture time-frame in which it took place, DJ Pauly D of *Jersey Shore*.

Lip-syncing, and the fan music video in general, became a strange point of intersection between the lo-fi music experience of the web and the world of mainstream music entertainment, which were increasingly merging.

ALMOST EXACTLY FIVE years after Cahill first began his lip-sync adventure, the cable channel Spike debuted *Lip Sync Battle*, a series based on the very popular segment on Jimmy Fallon's *Tonight Show* of celebrities lip-syncing pop songs onstage. Spike's *Lip Sync Battle* was the highest-rated unscripted debut in the network's history, and more than ten international adaptations were rolled out.

[*] Gotta appreciate the lyrical taste of fourth graders.

The idea for *Lip Sync Battle* originated from a car ride actor John Krasinski, his wife, actress Emily Blunt, and comedian Stephen Merchant once took as they were trying to come up with an idea for something fun for Krasinski's upcoming appearance on Fallon's show. "What if we did this thing like *8 Mile* but we lip-synced?" Krasinski asked Merchant, who suggested they try it in the car. A few renditions of Lionel Ritchie's "All Night Long (All Night)," Will Smith's "Boom! Shake the Room," and Blackstreet's "No Diggity" later, the bit was born. "As cliché as it sounds, something magical happened," Krasinski told the *New York Times* of his first *Tonight Show* performance. "Jimmy turned to me and said: 'Oh my gosh. This is going to be huge.'"

Krasinski hadn't invented something new; rather, he found a way to bring the online popularity of lip-syncing to broadcast TV. "The huge culture of lip-syncing online has nothing to do with *The Tonight Show*," the show's executive producer Casey Patterson told *Entertainment Weekly*. "Taylor Swift will post herself lip-syncing to someone else's song in the car. Everyone is into it. It's just a thing that's happening in pop culture anyway."

Brolsma. Cahill. Krasinski. The art that they shared (and it *is* art) at first might sound derivative and unoriginal, but in practice it is expressive and individualistic. It allows the personal connection we have with music to become nearly as memorable as the music itself. Because lip syncs are not about us *or* the music, they encapsulate our experience *with* music. They provide a mechanism for us to bring the music we love into our lives in a deeper way. Considering the amount of listening and singing along it takes to truly nail a good sync or dub, such videos truly embody the elevated relationship we can have with their source material.

The popularity of lip-syncing on YouTube is a metaphor for the larger shift in the ways we use the web to express ourselves through the music we love. YouTube moved these expressions from our bedrooms and classrooms and neighborhood dance halls to the center stage of pop culture. Our response to music had become as important as music

itself. And it wasn't long before the success of the latter became dependent on the former.

THE VERY DEFINITION OF A HIT

As choreographer Tianne King taught her dance class, her students' eyes often wandered from her to her two-year-old daughter, Heaven, who appeared to have learned all the moves herself in the corner of the studio. Tianne began posting videos of her and Heaven dancing together on her YouTube channel, and much like her students, other people loved watching Heaven too. The clips drew huge audiences, leading to a performance on Ellen DeGeneres's show, which itself has been watched almost one hundred million times. But Heaven and Tianne's biggest pop culture contribution came a few years later in collaboration with a seventeen-year-old rapper in Atlanta named Ricky Hawk.

Still in high school at the time, Hawk had a reputation for his singing and dancing. In January 2015, he and his producer, Bolo Da Producer, released a single online that referenced a few popular dance moves. Hawk, using the stage name Silentó, titled it "Watch Me (Whip/ Nae Nae)." Counter to what had become common practice, Hawk didn't release an actual music video for six months. That's because he didn't have to; lots of other people made videos for him.

The indie distributor Hawk used to get his song out had collaborated with DanceOn—a network of around twelve hundred YouTube dancers founded in 2010—which incentivized "influencer" dancers to produce videos featuring the song in the "#WatchMeDanceOn" campaign. The song picked up steam as the professional and amateur dancers who made videos set to it drew hundreds of millions of views. When the official Silentó music video finally dropped in June, Hawk and his team incorporated all the videos these dancers had made, including the version choreographed by Tianne starring then-five-year-old

Heaven. Hawk even invited Heaven to appear alongside him for his segments. Little Heaven King's "Watch Me (Whip/Nae Nae)" became YouTube's top trending video in 2015, and a year later, Silentó's official rendition became only the twenty-ninth video to cross the one-billion-views mark. Hawk credits the DanceOn campaign as one of the driving factors of his song's success. All those dance covers turned the song into something much bigger than an underground hip-hop track.

While dance-based entertainment has certainly had its shining moments in mainstream media history, the competitive atmosphere of web video one-upmanship—where everyone's moves can be shown off, shared, imitated, and bested—pushed the art form to the forefront, created new stars, and, most notably, provided a new way for us to shape and be a part of popular music in a much more active way. "Watch Me" was one in a long line of such hits.* Today, a good dance trend doesn't just help fans connect with a new song by giving them a way to participate, it can literally drive it up the charts.

WHILE *BILLBOARD*'S RELATIONSHIP with YouTube data began with a YouTube-specific chart launched in 2011, streaming data wasn't introduced into the famed Hot 100 chart until February 2013, which turned out to be an interesting moment to release a new music-ranking methodology that incorporated web video activity.

A few weeks earlier, a nineteen-year-old college student/YouTube personality who goes by "Filthy Frank" was hanging out with some friends when one of them started playing a bass-y dance track from a somewhat unknown Brooklyn DJ. When the beat dropped, they all started dancing like crazy. Naturally, he and his friends all put on stretchy colorful bodysuits and re-created that moment within one of his videos. Shortly after seeing Filthy Frank's video, a crew of young

* Others include "Crank That (Soulja Boy)" by Soulja Boy and "Passinho Volante (Ah Lelek Lek Lek)" by MC Federado & Os Leleks, a song that became popular in Brazil outside the mainstream via videos often posted by residents of the country's impoverished favelas.

skateboarders in Australia made their own. One stood in the middle of the room with a motorcycle helmet, thrusting his hips, while the others sat around quietly. Suddenly the beat dropped and the camera jump-cut to a roomful of insanity. One guy is flailing about wearing only his underwear while another stands on a chair shaking his butt. And thus, the world was introduced to the "Harlem Shake." Other people began to replicate it, including Rawn Erickson II, the cofounder of Maker Studios, who roped his colleagues into making one of these videos in their cavernous L.A. office. Within a week, basically every company in Silicon Valley had posted one with increasing levels of cringeworthy-ness.*

I watched as a huge influx of "Harlem Shake" videos hit YouTube. (It is worth noting that very few featured people doing the *actual* Harlem Shake dance, to the chagrin of many of my fellow New Yorkers.) By mid-February, some ten thousand of them were uploaded per day. There were university swim teams and service-academy cadets and wedding parties. Musicians Matt and Kim produced one with all of their fans at a concert. A bunch of soldiers from the Norwegian army filmed the most popular one, which has been watched more than one hundred million times. Even LeBron James, Dwayne Wade, and the entire Miami Heat team made one in their locker room. I've seen people "Harlem Shake" on every continent. (Well, *almost*, if we include the one filmed in the Southern Ocean off the coast of Antarctica.) A number of people got fired for making them, including a bunch of miners who were accused of breaching safety protocols. Today, there are more than two million videos of or about the "Harlem Shake" meme on YouTube, and they've been watched more than three billion times.

The person perhaps most stunned by all of this? The Brooklyn DJ who created the song, a twenty-three-year-old trap music producer named Baauer (real name Harry Rodrigues). Baauer composed the

* One was filmed at YouTube's own HQ in San Bruno, California, but it came out so poorly and took so long that I lobbied against posting it for the sake of everyone involved.

track as a "happy accident" in his Williamsburg apartment one day and put it out online. It got scooped up by an imprint of Diplo's Mad Decent label and made a fair amount of noise in certain communities. But Baauer had no idea the command to "Do the Harlem Shake," sampled from a decade-old song by the rap group Plastic Little, would be followed by millions of people. He didn't so much make the "Harlem Shake" happen as the "Harlem Shake" happened to *him*. No, he did not want to be viral famous. No, he didn't want to be on *Good Morning America*. "I got a little taste of what it's like to have a song in that stratosphere and I can truthfully tell you that I'm happy with that being the only time it happens," he told *Pitchfork*. "I don't want that shit."

Whether Baauer wanted to be a meme or not, on the very first day of the new YouTube-ified Hot 100, his single went straight to #1, making him the first unknown artist to debut in the chart's top slot. It stayed on the chart for thirty-six weeks. "The very definition of what it means to have a hit is ever-changing these days," *Billboard*'s editorial director Bill Werde said in the company's announcement. While the change in *Billboard*'s methodology was designed to better capture the new way people were finding popular music, it ended up, in its first week, capturing something else: the way our participation in music had begun to redefine the qualities of a pop hit.

In a weird way, the audio tracks for "Watch Me (Whip/Nae Nae)" and the "Harlem Shake" by themselves hold lesser significance; their relevance lies in the bigger phenomena they inspired fans to create. More than songs, they were platforms that allowed fans to participate creatively in a larger movement.[*]

These kinds of trends show us just how potent the little ways we use video to participate in music today can be. We are generating new music experiences (or perhaps returning to old ones) in which something as small as singing or dancing along with music is not merely

[*] These were not isolated incidents. In 2016 alone, at least three separate tracks were propelled into *Billboard*'s Top 40 thanks to the memes for which they provided the soundtrack.

supplementary and reactive but is central to the experience of that music itself. Today's biggest stars are tapping into the videos, images, and conversations we freely share with one another online to create, with us, the defining music iconography of this century.

ALL THE SINGLE LADIES

Five female superstars (not all of them necessarily single) have used the relationship between artists, fans, music, and art in the digital era to yield some of the most quintessential music experiences of their time. Each can teach us something different about how fan creativity and interaction has reinvented the pop music experience.

LADY GAGA

Given that 2004's #1 song mostly featured Usher repeatedly singing the word "Yeah!" while his primary collaborator shouted "WHAT!" and "OKAY!" in the background,* the idea that you could be both a pop megastar AND an avant-garde artist seemed pretty far-fetched in the mid-00s. But a few years later, Lady Gaga figured out how to leverage new social media tools and her army of fans, her Little Monsters, to do just that.

In 2008, the year her first single and album dropped, Gaga gathered a group together for a brainstorm. "I called all my coolest art friends and we sat in a room," she later recalled. "I said that I wanted to make my face light up. Or that I wanted to make my cane light up. Or that I wanted to make a pair of dope sunglasses." This group evolved into the Haus of Gaga, a team of designers, stylists, and artists who created everything from the incredible sets for her world tour to that insane dress made of raw flank steak that she wore onstage at the VMAs in 2010.

* God, how I miss Lil Jon appearing on every hip-hop single.

The alien couture costuming and design in the 2009 music video for "Bad Romance" was Haus of Gaga's first real masterpiece, and the video became the most-viewed video on the web the month it was released. It epitomized Gaga's ability to combine the visual elements of her craft with the actual music. "Summer of 2008: I had just finished my freshman year of high school and was at a house party when 'Just Dance' came on," one longtime self-identified Little Monster told *Nylon* in a 2016 interview. "I knew I enjoyed the song, but it wasn't until I watched the music video on YouTube that I became obsessed." But this was more than MTV 2.0. In the age of social media, everything produced by the Haus became fodder for her legions of digital followers and their feverish, 24/7 network. The videos in particular were shared, dissected, and rewatched over and over. Gaga's fans became collaborators, flooding their social media feeds with her latest creations or—particularly given that many were predisposed to creative arts—bringing her aesthetics and music into their own videos, artwork, or designs, injecting Gaga art into the popular consciousness with speed and frequency. "I see my work in a series of images, like a fashion editorial, like a movie but there's no story," Gaga said in a 2011 interview about the Haus. "The story doesn't matter; the story is you and the fans are the story of the show."

The fans responded to Gaga's approach and turned into one of the most powerful fan communities on the web. It was different from the boy-band fanaticism I remember in middle school; her Little Monsters didn't simply idolize her, they built a community around her, her art, and the perspectives that drove it. Gaga's Haus and fans combined music, visual art, and the power of social media to create an experience that challenged societal norms, embraced outsider identity, and made her music feel like the centerpiece of a larger movement. While re-creating the Gaga phenomenon would be nearly impossible, the way fans connect with artists and one another online through video and media years later shows that what might have seemed like a fad has become a permanent fixture of pop music. As if to further make that point, Gaga had the words "Little Monsters" tattooed on her arm.

KATY PERRY

When it comes to creating music videos people love, it's hard to compete with Katy Perry, whose official videos have racked up more than ten billion views since 2008. Perry was one of the first major stars to truly understand how to use video and social media to build the connection between her music and her fans. She took to her accounts to share behind-the-scenes moments, respond directly to fans (and haters), stand up for causes, celebrate music and videos she loved, and crack jokes. There's a reason she became the most-followed person on Twitter.

Perry also popularized one of the most prominent ways fans connected with music in the 2010s: the professional lyric video. Lyric videos—in which a song plays while lyrics appear on the screen—were first posted by music fans as a means to share in the music they loved with others when, say, an official video wasn't available, or as a form of personalized tribute. While the earliest artists that embraced the phenomena were often religious bands and singers, Perry was the first major music star to release official lyric videos of her own, starting in early 2010 with her hit singles "Teenage Dream" and "California Gurls."* With videos like the one for "Wide Awake," which featured a parody Facebook feed and "Last Friday Night," which caricatured the emoji-ridden messaging habits of her fanbase, Perry and her team's creations were inventive stand-alone entertainment and, most important, a tool for fans to more deeply engage with her tunes.

Official lyric videos are an innovation that totally aligns with our behavior online, and they now play an important role in the cycle of the modern pop single. Artists and their labels offer them as official content when a song first gains traction before committing to the production of a full-fledged music video. They're useful for sustaining buzz, allowing fans to easily pass around and discuss tracks, and by

* Okay, so you could make the case that technically Bob Dylan introduced the first widely known lyric video forty-five years prior with the iconic short film he created for "Subterranean Homesick Blues"—you know, the black-and-white one with him holding the cue cards for the lyrics? The promotional clip originated as the opening of D. A. Pennebaker's film *Dont Look Back* and is considered to be the forerunner of the traditional music video.

2015, it wasn't uncommon for artists to release teaser videos *for* their lyric videos. Between teasers, lyric videos, and official videos, Justin Bieber released *five separate clips* for the song "What Do You Mean?"

Lyric videos also serve another obvious purpose: They help fans learn the lyrics. (Those lip dubs ain't gonna learn themselves, people.) As Perry articulated herself in a message to fans about one of her lyric vids, "YO! Impress all ur homies & stay straight stuntin by learning deez lyrics to keep ur party trill." *Indeed.*

The lyric video is designed to facilitate our participation in the songs we love, both literally and digitally. Once just a fan activity, lyric videos have become integral to modern music, thanks to someone who, from the start, seemed to understand what we wanted out of the pop experience.

BEYONCÉ

We could expound for ages on Beyoncé Knowles's music videos and their influence—from epic visual albums like *Lemonade* to the iconic "Single Ladies," which even I know the dance to. (Like, I could accurately describe it, not, you know, perform it.)* But I'd like to focus on how Queen Bey represents the ways our access to creative expression from people all over the globe can shape the highest reaches of pop culture, influencing even the most mainstream of performers.

While many artists now scour YouTube to find inspiration for their own work, Knowles is a master of that craft. For example, she and her choreographer, Frank Gatson Jr., spent more than two months in 2011 tracking down Tofo Tofo, a Mozambican dance troupe she'd discovered on YouTube. She flew in two dancers, Kwela and Xavitto, to teach her and to perform in her video for "Run the World (Girls)" where their Pantsula-style moves became the centerpiece. "We say, 'Share the light, you sparkle brighter,' and we share our light with a lot of new, creative people," Gatson told MTV at the time. "I feel like we

* Please do not imagine me doing the "Single Ladies" dance please thank you.

really nailed it and, again, my hats off to the Tofo Tofo guys, 'cause none of us could imitate that."

But Bey's masterpiece, in my eyes at least, was 2014's "7/11." Unlike Francis Lawrence's epic desert set piece in "Run the World (Girls)" or the production staff of forty required to create and capture "Single Ladies," "7/11" was recorded on a smartphone (a Galaxy Alpha to be specific). The video, which primarily stars Knowles and her gorgeous, talented crew of backup dancers screwing around in a Los Angeles penthouse, is also, at its heart, an homage to YouTube.

Earlier that year, Knowles, much like myself, became enthralled by the video exploits of Gabriel Valenciano, a professional dancer/ performer from the Philippines and the son of musician Gary Valenciano. While looking for a new idea for super-short videos to share, Valenciano created a series of silly, hyper-edited montages in his home that perfectly showcased his personality and dance style. These "Super Selfies," as he called them, took off on YouTube and Instagram. Knowles's team reached out to him, saying she'd seen the videos and wanted to do the same thing herself, so they brought him on as a consultant to help create what many music writers would come to regard as one of the best music videos of that year.

While "7/11" drew its inspiration from an approach someone else had invented, it ultimately became the perfect embodiment of Knowles's own style and personality. The product of a rather unlikely collaboration, it was derivative in a way that still felt completely individual and new. It transcended the simplistic production style, resulting in something that anyone could produce themselves but no one else could ever actually replicate. It might stand out within Knowles's high-production catalog, but "7/11," like the rest of her work, still feels totally and completely 100 percent Bey.

MILEY CYRUS

Miley Cyrus knew how to play the game as a cross-platform celebrity from the start, probably because she's the first major pop star *of* the

YouTube generation. Back in 2008, before she became the bleached-blonde lunatic, Cyrus, who was transitioning from Disney-fied Hannah Montana to a performer in her own right, and her friend Mandy Jiroux started a series called "The Miley and Mandy Show" on YouTube. The videos—which they often filmed in their bedrooms, just like pretty much every other teen vlogger at the time—included them telling jokes, answering questions, and just dancing around. That year, they were challenged to a dance-off by director Jon Chu and actor/dancer Adam Sevani of *Step Up 2*, which spawned a multipart, back-and-forth video sensation. As huge teen audiences followed online, their choreographed routines became more elaborate, and the battle became an arms race of celebrity talent featuring a diverse assemblage of the era's biggest stars, including Channing Tatum, Adam Sandler, and Lindsay Lohan.

The natural ease with which Cyrus pulled this off (it *was* essentially a promotion for a movie at the end of the day) signaled a new type of mainstream talent, one that didn't have to figure out how to use a new medium, but instinctively adapted to it. You might say that the dance battle foreshadowed the absurd digital influence Cyrus would exert in subsequent years. Among the many creative innovations with which she has blessed us, even the internet's obsession with twerking can be traced back to Ms. Cyrus. On March 20, 2013, Cyrus posted a black-and-white video of herself dancing around to the song "WOP" by rapper Flo Rida and J. Dash and shaking her rear end while wearing a unicorn pajama onesie.

YouTube global search interest in "twerking"

Cyrus most convincingly (and disturbingly?) demonstrated her skill at breaking the internet later that year, when she, as you may recall, appeared completely naked astride construction machinery in the video for "Wrecking Ball," which was watched more than twenty million times in the first twenty-four hours of its release—one of the biggest video debuts ever at the time. I remember a lot of my colleagues remarking that it seemed like everything Cyrus did felt ready-made to maximize the attention the web can bring, and they were right. For better or worse, Cyrus exemplifies the power of digitally native mainstream celebs. (And of unicorn onesies.)

CARLY RAE JEPSEN

In February 2012, Carlos Pena Jr., of the band and Nickelodeon show both named *Big Time Rush*, posted to his YouTube channel a low-resolution lip dub recorded mostly in a kitchen on what seemed to be a laptop camera. It was not a music video. It was just a bunch of friends goofing around. The friends? Justin Bieber, Selena Gomez, and Ashley Tisdale. Justin Bieber had come across the song "Call Me Maybe," a new single from twenty-six-year-old Canadian singer Carly Rae Jepsen on Canadian radio. It hadn't yet gained traction in the United States. He declared it "the most catchiest song" he'd ever heard and brought it to the attention of his manager, Scooter Braun, who later became Jepsen's manager too.

"Call Me Maybe" seemed to explode out of nowhere, but the song's popularity originated with that video. While a conventional music video was eventually released, that homemade video made by young and influential stars signaled to their fans that this was a song to be sung with your friends. It was a goofing-around-with-your-friends song. And, thanks to web video, goofing around and singing with your friends can be a socially engaging act of creativity. Pena and his friends had basically made a how-to manual for every teenager (as if they really even needed it): Get your friends, grab a camera, and lip-sync Jepsen's song. Over the ensuing weeks, it felt like pretty much everyone had made a lip dub to "Call Me Maybe." A version posted by the Harvard

University baseball team, who recorded it in the van on the way to a game over spring break, spread like crazy. The Miami Dolphins Cheerleaders, the U.S. Olympic swim team, a group of soldiers in Afghanistan, the cast of *The Big Bang Theory*, and literally thousands of other people made them too. Even Katy Perry made one with her friends.

The song shot to #1 on the charts and *Billboard* eventually declared "Call Me Maybe" the #2 song of 2012 (behind only Gotye's "Somebody That I Used to Know"). Jepsen had created the perfect earworm to be paired with such an unironic meme. It *was* "the most catchiest song," and she became one of the first major artists to break out at that scale, thanks, in large part, to this unique form of fan interactivity. Prior to "Call Me Maybe," few songs had so rapidly rocketed to the top of the charts as a result of the enthusiastic participation of music fans. Now it happens all the time. It proved that something as simple as goofing around with friends could now be an unstoppable force in music culture, given the right circumstance.

As a fitting follow-up, Jepsen wanted to have a male actor do a lip dub as the official video for her next album's lead single, "I Really Like You." Her manager told a friend about it over dinner. "Why didn't you ask me?" said the friend. "I would do it." The friend was Tom Hanks. And he did.

▶▶

After a five-month stint aboard the International Space Station, Commander Chris Hadfield prepared to return home. As his last act from space, he posted a music video that he had recorded in the ISS°: a cover of David Bowie's "Space Oddity." The first music video from space featured the Canadian astronaut floating through various areas of the space station as he sang, occasionally strummed along on an

° His son Evan edited it on Earth.

acoustic guitar, and stared out at the planet floating below him. It almost felt like Bowie had recorded the song in 1969 in anticipation of this exact moment. "It's possibly the most poignant version of the song ever created," Bowie shared on Facebook. The video garnered a lot of attention upon its release in May 2013, but was watched more than one million times on January 11, 2016, the day news of Bowie's passing reached the world. "His art defined an image of outer space, inner self, and a rapidly changing world for a generation finding themselves at the confluence," Hadfield wrote at the time. "Being able to record [Space] Oddity on the International Space Station was an attempt to bring that art full circle. It was meant as a way to allow people to experience, without it being stated, that our culture had reached beyond the planet."

Hadfield's fan video gave Bowie's song new significance, and while that's a rather extreme example, the same thing happens every day on smaller scales with lesser songs. While I doubt John Philip Sousa would have been a huge fan of lip dubs or the "Harlem Shake," none of these collaborative creations are, as he described the sounds emanating from the phonograph, "barren of joy, passion, and ardor." The ability for anyone anywhere (and, as you can see, I mean *anywhere*) to share their own personal experiences with music—their lip dubs and dance memes and Lady Gaga makeup tutorials—instills new meaning in it. And artists who lean into this, who combine the audio with the visual in ways that anticipate how we'll share, re-create, and interact through them, have begun to make these new experiences with music inseparable from music itself.

I'm not suggesting that the purely auditory experience of music has died. In fact, it's thriving; Nielsen announced that music consumption hit an all-time high in the United States in 2016, driven largely by increases in on-demand audio streams. (More than 90 percent of Americans—so pretty much all of us—listen to music, spending over twenty-five hours each week listening, and most of that is the very traditional form of audio-only songs and albums.) But video has shifted from

mere promotional collateral to a vital part of modern music, one to which fans can contribute, expanding the definition of music once again to include our participation in it.

And the music industry isn't the only media biz taking their cues from our activity on YouTube.

The Ad Your Ad Could Smell Like

A S A YOUNG copywriting duo, Craig Allen and Eric Kallman had a knack for oddball comedy. (Among other famous commercials, Allen wrote a darkly hilarious spot about a man whose touch turns everything into Skittles candy.*) It eventually landed them gigs at Wieden+Kennedy in Portland, Oregon, where they were assigned to one of the big Procter & Gamble accounts and, in 2009, were tasked with writing a television commercial for men's body wash. According to P&G's research at the time, women mostly bought body products, not men, so P&G instructed them to come back with something that appealed directly to women but wouldn't alienate the dudes.

They had only two days to draft a commercial that P&G could air during the 2010 Super Bowl. At the time, they felt all advertising focused on one-way conversation. Perhaps they could create a TV ad that felt more interactive by speaking directly to the viewer in a clever way? They knocked around ideas until Allen turned to Kallman with a line he was trying out: "Hello, ladies. Look at your man. Now back to me. Now back at your man. Now back to me." Kallman thought it was funny, so they wrote it down and riffed a bit more. The next day they took the script to their creative directors.

The Old Spice "Man Your Man Could Smell Like" ad that many of us now know and love began filming that winter with unknown

* They even compiled material to pitch to *Saturday Night Live* and spoke to one of Kallman's improv classmates, Will Forte, then the new guy on the show, about their showbiz aspirations. He thought they were crazy. A good advertising gig paid better than comedy, and while late-night TV needed sharp comedic minds, the advertising world was perhaps in even more desperate need of clever humor.

actor and former football player Isaiah Mustafa. According to Allen, Mustafa was a total pro on the shoot, despite numerous snafus, including a moment when the bathroom set fell down and nearly killed him. They filmed more than sixty uninterrupted takes of the elaborate thirty-second setup over two days. There were so many technical issues— from mistimed props to misbehaving horses—that only about three ended up being usable.

For many of us, "The Man Your Man Could Smell Like" became the most memorable ad of Super Bowl XLIV (despite the fact that P&G elected to air it during a commercial break before the game even started). Allen told me, "We always put things online, but we didn't think it would be as viral as it was. Not because we didn't like it. But because, you know, it's an ad. People don't go out of their way to see advertising." In this case, though, they did. People loved the ad, and over the first few weeks, millions of people sought it out and shared it. The clip ended up becoming one of 2010's most-watched videos on YouTube.

People began doing something else that they don't normally do with ads. They started making their own versions of "The Man Your Man Could Smell Like." Hundreds, if not thousands, of parodies popped up. Everybody from college kids to pro athletes to Grover on *Sesame Street* appeared in one. "It was so new to us, to advertising, and to our clients that no one quite knew what to do with it," Allen said. These parodies could be seen as contorting the brand's intellectual property or drawing attention away from the core messaging, but Allen and team convinced everyone to encourage it, not fight it. "We had a saying on Old Spice, the internet always wins," Allen told me. "No matter what we did, the internet would beat us at it."

Over the ensuing months, Old Spice sold a LOT of body wash, seeing high single- and double-digit growth in their sales of body wash and deodorant after the ad debuted. Things were going so well that when the W+K team pitched P&G on a social video campaign in which The Man Your Man Could Smell Like himself would respond to

comments and messages, they got the thumbs-up, despite the fact that it would have to be done in real time, meaning that no one from the main office would get to approve anything in advance. It helped that the stunt wouldn't cost much and, should it fail, would probably go mostly unnoticed on YouTube. "We didn't even know how many people would care," Allen said. "We thought, 'Man, if we talk to fifteen people, that'd be cool.'" Creating these types of videos, which were in direct response to comments and social media posts, required a totally different approach. "We worked on that original Isaiah spot for a month, and then here we were making 183 videos in two days," Allen said laughing. He, Kallman, and the other writers came up with a process where they would pass laptops around in a circle, and as long as one other person saw the proposed response and thought it was funny, it would get dispatched to a teleprompter for Mustafa to perform. They got it down to a five- to seven-minute turnaround time in some cases. While the first day started slow, by day two they'd created a social media phenomenon. Celebrities, bloggers, and lots of fans were posting questions and the Old Spice Guy was responding. When Digg founder Kevin Rose tweeted about being sick, Old Spice Guy posted a video saying, "Hello, Kevin, how are you? Feeling better, I hope. I personally have never had a fever because my body is ninety-eight percent muscle and muscles can't get sick. The one percent of my body that isn't muscle is my ears. They are made of cartilage."* While the original Super Bowl spot got a lot of attention, it was this interactive stunt that really made people sit up and take notice. In the years since, these kinds of real-time sketches and takeovers have become more commonplace, but at the time, it felt a bit like magic.

Allen noted that afterward, clients who previously wouldn't have taken such risks began to acknowledge the necessity of fresh approaches if you wanted to break through to people on the internet, where they

* Yes, I also noticed this does not add up to 100 percent, but then I remembered that obviously the Old Spice Guy transcends any laws of science and mathematics.

were spending more and more time. Old Spice subsequently tried out all kinds of unorthodox ads, the weirdest of which was another project Allen worked on: *Dikembe Mutombo's 4 1/2 Weeks to Save the World,* a 16-bit-style video game challenging you to navigate a series of bizarre internet-joke-laden levels as the former NBA all-star.*

The popularity of "The Man Your Man Could Smell Like" led to more than just ridiculous video games; it helped change the mindset of the entire industry, which began to see the web as a forum for distinct types of creativity in advertising. "That was the first time we saw the benefit of entertainment over just straight selling of products," Allen told me. "Basically, it changed everything for us."

The campaign epitomized a change in the relationship between consumers and the businesses trying to communicate with them. On YouTube and social media platforms, many brands struggled to figure out how to connect with us in ways that were honest and meaningful. "I think that a lot of people, brands especially, don't respect the internet," Allen said. "There are a hundred thousand examples all over the internet of when a brand tries to look at the internet and then respond to it, and it feels just like a forty-year-old dad at a middle school dance." Respecting the internet, for Allen, meant treating it like a channel for collaboration instead of distribution, a place to use creativity for mutual benefit. "The reason a writers' room works is because you all respect each other, and you're able to work together and make something better. I think that's kind of how we view the internet, as opposed to a new outlet that we can exploit."

* Actual email from the game's developer, Adam Saltsman, to his staff: *Hey guys, I just got the brief. We're going to be doing a Battletoads-style level where you're descending down the throat of America through the use of a jetpack throwing election ballots to people dancing "Gangnam Style" on little ledges in the throat while avoiding disco balls before having a boss fight with the state of Ohio. Any questions?*

◀◀

According to a 2014 study, Americans are exposed to about 360 advertisements per day, and we register some 150 of those. That's a lot of ads, and companies are desperate to get us to notice theirs. Companies have put so much strategy and research into reaching us with their marketing that you can tell a lot about a given time period through the ads of that era. Ads might even say more about our collective psyche and societal norms than traditional art and entertainment. (Seriously, go watch some Folgers commercials from the 1950s. *Shudder.*) But how these ads originate, how they reach us, and how we interact with them once they do is just as telling.

Until fairly recently, most online ads were interruptions and distractions, obstacles to the entertainment we were seeking out in the form of forced pre-roll ads or web page overlays. These days we have increased expectations for advertisements. Allen pointed out that now we expect advertisers to add to culture, not put up speed bumps within it. And that's something a lot of businesses and creative professionals have had to try to reconcile.

Companies of all sizes and the advertising agencies they employ have had to think differently about how to capture our attention or risk irrelevance. They've had to assess our roles as individuals who watch, react to, and even help spread their messages. To reach us is one thing, but to meaningfully interact with us in this space is something else.

THOU SHALT NOT SKIP

The first video to cross one million views on YouTube was not a cat video, a prank, or a fail. It was an ad. In late summer 2005, Nike launched a digital campaign promoting their Tiempo cleats and shot a video with soccer star Ronaldinho—one of the most recognizable athletes in the world at the time—in which he took a break from training to put on

special-edition "Touch of Gold" kicks. The Brazilian midfielder juggles a soccer ball and launches it repeatedly at the goal's crossbar from about twenty yards out, catching it with his feet as it bounces back, never allowing the ball to hit the ground. It's a jaw-dropping feat of athleticism. Or of visual-effects work, depending on your predisposed skepticism. In the internet forums, people wrote:

"I've shown it to a few friends and it's a split 50/50 fake/real."

"Of course it's staged. What else could it be?"

"Yeah, it could be faked, but I'm betting it's real."

"What is stopping Ronaldinho, one of the best ball handlers the world has ever seen, from doing a good 10-15 takes and finally getting one right?"

"Everyone with a brain knows it's fake. What he does in the video is impossible."

Of course, Nike was aware that bullshit detecting is a kind of sport on the web, and the ad capitalized on that. Message boards (as well as pubs, offices, and schoolyards) were flooded by comments like these. The video in its very concept came prepackaged with a debate that helped further proliferate it. The fact that the video did not look or feel like an ad—it felt like it was shot on a camcorder; it had a longer runtime than most advertisements; it never aired on television—made its veracity seem much more plausible. It felt like someone from Nike just happened to catch something special rather than a coordinated production shoot, even though it was clearly a cleverly conceived piece of marketing.* It was the first successful ad that had been designed to work in the setting of YouTube, where our reactions can help drive exposure. It was a stunt, sure, but many of the popular videos of that moment gained an audience through surprise and shock value. Unlike other video marketing at the time, "Touch of Gold" existed naturally within the context of everything else we watched and shared.

* I reached out to Nike to see if they would finally be willing to discuss their bit of internet history, but they politely declined, preferring to keep that mystery alive more than a decade later.

The success of the "Touch of Gold" spot, and many other "Real or fake?" ads that followed, exemplified a change in our relationship with advertisements: Getting us to pay attention was best achieved not by interrupting us, but by becoming a part of what we were already doing.

WITH THE RISE of content platforms like YouTube, businesses no longer completely controlled the immediate context of the messages they put out. If a marketing department broadcast an advertisement on television or printed it in a magazine, they were confident in who it would reach, when, and what other types of content would surround it. Today, digital platforms offer targeted advertising placements with unprecedented granularity, but ads can also exist outside of those placements. Thanks to personalization systems and sharing tools, messages from advertisers become a part of innumerable situations and conversations. The opportunities (and challenges) presented by this movement from controlled spaces into our personal spaces has forced many companies to rethink many long-held strategies.

For years, the biggest advertisers kept their Super Bowl spots under lock and key until game day, which acted as a debut for their best and most attention-grabbing work. After all, 20 percent of people watch the Super Bowl just for the ads. It made sense: Maximize your chance that your message will be one that people talk about by taking advantage of the moment when the most people would simultaneously see it. The web doesn't work that way though.

In 2011, Volkswagen prepared to run its first Super Bowl ads in ten years. They had purchased two thirty-second spots, one for the Passat and one for the Jetta, and ad agency Deustch had produced both. The problem: the sixty-second version of their Passat commercial was really *really* good, but it was too long. Super Bowl spots are not cheap (thirty-second spots averaged $3 million a pop that year) and, you know, they're kinda strict about the time limit. So Volkswagen took a major gamble and posted the ad online early. You'll likely remember it: "The Force" featured a child dressed as Darth Vader running around

his home trying to telepathically manipulate objects until he finally succeeds, thanks to his father's secret use of the Passat's remote ignition starter. People watched it tens of millions of times that week. Despite the bigger ad buys of other automakers, "The Force" became the most memorable and talked-about spot that year. Five years later, it remained the most-shared Super Bowl ad ever.

In 2010, Old Spice had proved that a Super Bowl ad could be used as a launching point for a much larger moment, and the following year, Volkswagen demonstrated that the Super Bowl could be a key element of a campaign rather than an end-all-be-all distribution strategy. "I don't look at Super Bowl ads as TV commercials," Mike Sheldon, CEO of Deutsch North America, told *Time* magazine in an interview about the ad years later. "The Super Bowl is a social media and PR phenomenon that has a number of integrated components in which one is a TV commercial." The Super Bowl shifted from a single broadcast opportunity to one spread out across multiple platforms and composed of many smaller and more personal interactions. Companies had the opportunity to not just expose their message to a lot of people all tuned in at once, but to be a part of the conversations playing out for days before and after the game. More and more ads started appearing online in January, well before the game, and we saw search queries for these ads start to rise in January too. An industry study found that the full ads that went up earlier tended to average 2.5 times the number of views of those that went up on game day and averaged significantly more sharing too. Some smaller companies that didn't have the millions to buy a slot during the game created Super Bowl ads that aired only in small markets or didn't even air at all, just so they could take advantage of the buzz of the moment.

Our YouTube habits forced advertisers to rethink their distribution strategies. The Super Bowl was the most prominent example, but it was happening every day. And as the conventions of distributing videos changed, so did those of designing them.

❊ ❊ ❊

AS ADVERTISERS RELINQUISHED control of context, they inherited new rules from us. Ads needed to fit naturally within how we were already using the web to connect with one another and the things we loved. We expected the same authenticity from giant companies that we did from friends and entertainers. When we spoke, we expected them to speak back, but we demanded that interaction to be honest, not phony.

In June 2012, I noticed a video from McDonald's Canada trending. This was unusual. It was titled "Behind the scenes at a McDonald's photo shoot" and when I clicked it, I was very sure I was about to be treated to some Grade A–quality advertising bullshit. The video had been created in response to a question many of us have probably had, which was posed by a woman in Toronto named Isabel: "Why does your food look different in the advertising than what is in the store?" But the video wasn't what I expected. We're greeted by Hope Bagozzi, the director of marketing for McDonald's Canada, who takes us to a McDonald's to purchase a hamburger. This takes about a minute to prepare, and then we're brought to the company's creative agency where we meet Noah, the food stylist, and Neil, the photographer, who spend a few hours crafting a burger of their own using the same ingredients but optimized to be photographed, complete with perfectly sliced and manicured pickles and onions. Like a surgeon, Noah melts down the cheese with a hot palette knife and administers perfect dollops of ketchup with a syringe. We even see a photo editor, Stuart, retouch it.

Obviously, McDonald's was operating in a controlled environment: They picked the question, and they chose what facts to include or not include. But the ad *felt* authentically honest in a way that can seem foreign in corporate communications. It acknowledged our existence in a way that hadn't been necessary before.

In 2015, Geico launched a series of video ads that, while very simple in concept, went on to win numerous awards, including *Ad Age*'s Campaign of the Year. The videos ran as skippable pre-rolls on YouTube and all the action happened in the five seconds before viewers

could opt to skip the ad. In one of the four ads they released, a stock-video mom character says, "Don't thank me. Thank the savings," as she serves spaghetti dinner to her classic American nuclear family sitting around a dining room table. Then comes the voiceover: "You can't skip this Geico ad because it's already over. Geico. Fifteen minutes could save you fifteen percent or more on car insurance." The Skip Ad button pops up, but the video doesn't stop. The family remains there, holding as still as possible, even as their huge Saint Bernard leaps up onto the table to eat the food right off their plates. "'Unskippable' injected inno-vation into the otherwise creatively barren world of pre-roll ads with its series of boring, everyday scenes made utterly watchable—and hilar-ious," wrote *Ad Age*. Besides the humor, these ads stood out because they implicitly acknowledged our behavior. They were self-aware. It was as if the ad was saying to us, "Hey, we know this is an ad, and you know this is an ad, and we both know you usually skip these things, so joke's on you!"

By reflecting and embracing the settings where we experience ads and acknowledging the contrived experience we are thrust into, adver-tisements start to feel like more human forms of communication. In their quest to more effectively reach us and to differentiate from the formulaic and expected, marketing pros are not just having to get more human. They're often having to get *weird*, too.

IN 2012, THE Metro Trains public transit system in Melbourne, Australia, set out to reduce the number of accidents caused by foolish behavior. They wanted to reach a younger generation, but PSAs don't effectively penetrate that demographic. So they challenged ad agency McCann Erikson to come up with something different. The result was a brilliant piece of dark comedy that combined an upbeat tune with bright, pastel animated characters who, in succession, meet their demise in ridiculous and grisly fashions. "Dumb Ways to Die" became an overnight sensation. The humorous incongruity of a super-morbid topic

with cute animation and catchy lyrics made it unlike any kind of traditional safety message. ("Eat medicine that's out of date. Use your private parts as piranha bait. Dumb ways to die! So many dumb ways to die!") In the ensuing years, people watched the video and its follow-ups more than a quarter of a billion times. The campaign even spawned a children's book and video game.

"Dumb Ways to Die" was weird, and that's what also made it so successful. It felt like the kind of unfiltered, irreverent communications we have with one another. "Technology's greatest gift is that it makes us more human if we use it correctly because it allows us to share things that make us feel more human," John Mescall, the global executive creative director at McCann who created the ad and wrote the lyrics, said in a 2013 interview. "Creating work for platforms to show off the platforms' capabilities, who gives a shit about that? I think your thinking needs to be humanistic and it needs to operate at a basic human level. And that's lo-fi, that's lo-tech. Don't think technology when you create the idea. Think person to person. It's one human being to another."

In other words, ads began to feel a bit more like content created by real people, not companies. They began to look the same structurally too. In 2014 and 2015, all the spots that appeared on YouTube's Ads Leaderboard at the years' end were longer than a minute (in 2014 the average length was three minutes). In fact, it can be hard to separate ads from non-ads these days by just looking at things like a video's title, description, tags, or length. And it's not just the underlying principles of creating ads that are evolving. The way they're made is evolving too.

STICKING YOUR ADS IN A BLENDER

It was a very cold winter—that one with the polar vortex, remember? A film crew went around Manhattan—Harlem, the Lower East Side,

the Meatpacking District, and Midtown—positioning an "abandoned" stroller and hoping for the best. "It was actually a miserable shoot, like one of the worst," producer Sam Pezzullo told me. "We were outside all day in the freezing cold, rain, sleet, snow. It was awful, but the reactions were tremendous." Inside the remote-controlled stroller was a horrifyingly detailed animatronic prop that would spring out at unsuspecting pedestrians curious enough to get close. When it worked—the cold kept causing the puppet to malfunction, requiring extra shooting days—the reactions were indeed perfect, and the two-minute compilation became a hit online, one of 2014's top ten trending videos. "I couldn't go anywhere without meeting someone who had seen it," Pezzullo said. Sounds like your standard prank video filmed by a crew of enterprising YouTube creators, but "Devil Baby Attack" was actually an ad produced by Thinkmodo for the movie *Devil's Due*.

Sam calls Thinkmodo a creative agency—they mostly produce ads for companies who hire them, after all—but Mashable called them "madcap hacker/video-makers/marketers" and some have labeled what Thinkmodo does as "prankvertising," a portmanteau that made my eyes roll so hard that I just fell backward out of my chair. "Our approach is always to focus on one specific element of the film or the brand and somehow amplify that," Pezzullo said. "And the way we do that is we take it and put it into a real-world environment." While it's rare that I know which agency has produced an ad on television, I can usually tell when I'm seeing a Thinkmodo production. The agency was founded by writer-filmmakers James Percelay and Michael Krivicka in 2011 and is known for fabricating elaborate props and physical set pieces in real-world locations. Many of their videos feel more like demos of crazy inventions than advertisements. The most complex prop built by Thinkmodo was a tricked-out selfie stick, complete with lights, fans, and a motorized extender. It's seeing objects like these in the practical realm—a combination of movie-magic effects and real life—that makes the best Thinkmodo videos so attention grabbing. Creating something physical that people interact with in the real world helps differentiate

these types of videos from the artificiality of traditional advertising creative.

What Thinkmodo does is a highly effective variant of good ol' content marketing. While the term had existed for a number of years, "content marketing" really became the buzzword du jour around 2011, when basically every business conference began hosting panels on the topic in various identical, drab Marriott conference rooms. The approach, as defined by Forrester Research, includes "producing, curating and sharing content that is based upon customers' needs and delivers visible value." On YouTube, this led to an explosion of specially crafted pieces of advertising that doubled as entertainment in an effort to connect with us.

Unlike TV ads that are mostly designed to directly drive brand awareness, Thinkmodo videos are primarily built for driving buzz. "It doesn't look like marketing," Pezzullo said. "It doesn't look like it's consistent with another project or brand. It just looks like something fresh and organic that the news media can then discover themselves. We're sort of tricking the media into advertising." The use of shock tactics and lack of overt branding meant bloggers and TV news could highlight Thinkmodo's creations as they would any other unique viral gem.

Thinkmodo's clients are among the many companies whose marketing strategies attempt to capture the resonance of the best photos and videos posted by people like us. It's a communications approach that allows companies to take advantage of our social media behaviors and build buzz by drawing us into an authentic content experience. And some have been quite successful. But is it possible to build an entire business on this new way of communicating?

TOM DICKSON FOUNDED Blendtec in 1975, but when the company's new marketing hire, George Wright, came across Dickson messing around trying to break his own blenders in 2006, the most modern of ideas came to him. Wright used a fifty-dollar budget to purchase

marbles, a rake, a six-pack of soda, a rotisserie chicken, and a lab coat with Dickson's name on it. They created "Will It Blend?," a game-show-esque series in which Dickson's Total Blender destroys just about anything you can think of. Sales skyrocketed, and suddenly a company that'd never spent a dime on marketing had one of the first marketing-campaign success stories in web video history. By 2016, there were one hundred episodes, and they had an audience of nearly one million subscribers tuning in to see iPhones, markers, and golf balls blended to dust.

"Will It Blend?" succeeded not just because it was entertaining, but because it felt honest. Dickson was an unlikely star for a wacky web series, but that's what made it work. No actors or elaborate production techniques are required in a world that places such high value on authentic communication, and the unvarnished silliness of the whole thing was made more engaging by the fact that Dickson was a real person enjoying himself as much as we were.

Companies like Blendtec as well as Thinkmodo's clients deliver videos that can be both entertainment and advertisements. The internet rewards businesses that are less conventional and directly engaging; these unconventional pseudo-ads they put out build buzz and even build brands by existing more naturally in the contexts we find ourselves in online than traditional advertising.

Some companies went much, much farther down this path, however, and pushed the melding of entertainment and advertise-ment even further, causing one to wonder how to define an ad at all these days.

I THOUGHT I KNEW WHAT AN AD WAS . . .

"Uh, eight million people are watching this right now."

On the morning of Sunday, October 14, 2012, a bunch of engi-neers from YouTube's infrastructure and livestream teams gathered in

a group video chat from their homes. (I also dialed in from my apart-ment in Queens.) We had, at that point, never had a livestream with that many concurrent viewers and, frankly, no one knew what would happen. I was managing the "Ticker," the promo link that ran across every page of YouTube that alerted people when a major event was happening. I would need to pull it down immediately if the stream crashed or, in a scenario that somehow seemed to be of less immediate concern in that moment, if the man who was about to leap from the edge of space died catastrophically on the way down.

We watched in amazement with millions of other people as Felix Baumgartner became the first man to break the speed of sound in a freefall as he descended from 128,100 feet at more than 800 mph. (Thankfully he survived and the stream worked perfectly.) Red Bull's Stratos jump, which took five years and a team of scientists to prepare for, was the world's first daredevil stunt/science project/ . . . advertisement?

Red Bull, both an energy drink company and an action-sports media property, represents how far things have come in the advertising world. They sell terrible-tasting, oh-so-popular caffeinated drinks while developing, producing, and distributing engaging entertainment content. They didn't have to find their target audience; it came to them. They built a digital entertainment presence that includes one of the most-subscribed sports channels on YouTube, which has racked up billions of views. Their "ads" were so popular that they made money from other people's ads running on them. WTF? They achieved the thing career-obsessed marketing managers drool over: The brand transcended the product. "Everything we do pretty much pays back and powers the brand," Red Bull Media House's Managing Director Werner Brell said in a 2012 *Forbes* interview. "The brand is why we do the things we do. We put life into the brand with all of the activities." #Brand.

In an effort to communicate with us in a meaningful, valuable way, Red Bull took the ads-as-entertainment model to its natural next step and became a hybrid brand: Red Bull Media House is a legitimate

production house within a company whose primary objective is to move units of an energy drink. The Stratos jump was maybe their finest work. That Sunday morning, when a bunch of YouTube employees and millions of other people around the world sat on the edge of our seats, the last thing on everyone's mind was whether they were watching an ad or not. And no one seemed to care.

WHEN COMPANIES CREATE real entertainment that functions as advertising, there's a more equal exchange of value. We get something deserving of our interest, and they get, in theory, our potential business. As our demand for greater immediate value from every communication put in front of us increases, we've started to become less discriminating in regard to the source of the content we encounter.

Clearly we're comfortable with businesses providing us with entertainment like extreme sports competitions, but what about health and wellness tips or financial advice? How about when they engage with us around social causes or political issues?

Most companies are not in a position to invest so heavily in producing their own original entertainment and must connect with us in other ways. In the quest to capture our attention on a more personal level, some began to use their advertisements to attempt substantive conversations with us about issues that matter. You probably recall those Dove "Real Beauty Sketches" ads in which Dove hired a sketch artist to do blind portraits of women based on their descriptions of themselves and the descriptions provided by women who'd just met them. (The self-described portraits were much less attractive than the ones based on the third-party descriptions.) It was a campaign about body image and self-identity. There was no mention of soap. The brand Always took a similar tack with their award-winning "Like a Girl" ads, one of the most-discussed advertising campaigns of 2015. Both were part of the "meaningful marketing" (aka "sadvertising") trend that sprang up in reaction to the increasing challenge of trying to build

relationships with customers whose patience for brute-force tactics—
like using lots of obtrusive ads we're forced to sit through—has begun
to dwindle.

And so the question arises: Do we really need, say, a company
selling feminine-hygiene products to open a conversation with us about
gender equality? Or a battery company to engage our empathy toward
those with hearing loss? Shouldn't they just stick to explaining the
benefits of their products?

The truth is that we might not *need* it but we sort of require it. As
the entertainment we seek becomes more direct, personal, and closely
tied to the ways that we communicate every day, companies have to
adapt their messages in order to reach us. Ads have always reflected,
to some extent, the culture of the moment they exist within. These are
no different.

▶▶

Real, honest communication is hard. Communication that offers benefit
in two directions, not one, is even harder. But now it's essential: We've
come to expect more value in exchange for our attention.

In the past, companies primarily communicated with us through
advertising placements. Now they also use the same forums, platforms,
and channels that we use to communicate with one another. When a
business can, for example, have a YouTube account or social media
profile that looks and operates just like our own or the ones managed
by the entertainers or personalities we enjoy, we expect the same level
of meaning and honesty in those messages as the videos and posts they
intermingle with.

This doesn't mean companies have to talk like us in the literal
sense. Lord knows the internet graveyard is filled with examples of
official Twitter accounts trying to use the word "fleek" and other
desperate shortcuts to authenticity. In fact, our social media feeds and

trending-topic tags have been so overrun with flat, me-too posts from well-funded social media marketing firms, younger internet users are gaining an appetite for brand-free communication zones. In 2016, dark, off-color memes based on topics like the deceased Cincinnati Zoo gorilla Harambe and 9/11 trutherism rose, in part, precisely because no brands would dare to touch them. *New York* magazine noted that, for many young adults and teens, "It's hard to come across cultural products online untainted by corporate advertisers or sponsors."

Those growing up in the internet era do not necessarily desire that companies use their slang, jump into every discussion they have, or reappropriate the things they care about. Instead they've simply come to expect that businesses communicate with self-awareness, forthright intentions, and some relevance to the setting in which we interact with them, whether they're using paid advertisements or accounts like ours to reach us.

We may have always desired, at some level, that ads contribute something to our lives or to our culture, not subtract from it. But for ads to have an impact in the future, that might now be an imperative.

CHAPTER 6

The World Is Watching

SENATOR GEORGE ALLEN seemed to be entering the peak of his political career with the Republican Party in the summer of 2006. The former governor of Virginia and folksy southern conservative had served as senator since 2001 and reelection appeared likely.

On August 11, Allen spoke to a crowd at Breaks Interstate Park on a pleasant day (for August in Virginia) in a small town near the Kentucky border. Partway through his remarks, Allen, in a blue oxford shirt with the sleeves rolled up, told the crowd, "My friends, we're going to run this campaign on positive, constructive ideas and it's important that we motivate and inspire people for something." In the crowd stood S. R. Sidarth, a twenty-year-old University of Virginia student and volunteer for the Jim Webb campaign. Webb, the Democratic challenger, had a savvy campaign team that had assigned the young Indian American the unenviable duty of following Allen's "Listening Tour" and recording everything Allen said on a camcorder (this position is known as a "tracker" in political circles). Sidarth had spent five days following the campaign.

At this point in the speech, Allen gestures at Sidarth, straight to the camera, and says, "This fella here, over here with the yellow shirt, Macaca or whatever his name is, he's with my opponent. He's following us around everywhere and it's just great. We're going to places all over Virginia. And he's having it on film—and it's great to have you here— and you show it to [my] opponent because he's never been there and probably will never come." The crowd starts to cheer and Allen's next few words are inaudible. After taking another swipe at Webb as an outsider candidate, Allen adds, "So welcome. Let's give a welcome to

Macaca here." The crowd applauds. "Welcome to America, and the real world of Virginia."

"I had an idea of what he was getting at—that he was injecting some sort of derogatory comment toward me that had a racial bent to it," Sidarth would later recall. "I knew that it meant 'monkey'* and it was used toward immigrants." Sidarth's parents had emigrated from India twenty-five years prior, and he had been born and raised in Virginia. A few hours later on that Friday evening, he called Webb's campaign HQ to let them know what had happened, but the team, unsure what to do with the video, went out for drinks and decided to deal with it on Monday. The campaign only put the video up on YouTube a few days later after a *Washington Post* reporter bit on the story. Allen claimed that he'd made up the nickname not knowing what it meant, insisting in a statement that it "was in no way intended to be racially derogatory" and "any insinuations to the contrary are completely false." It was suggested that the nickname the campaign had given Sidarth, "Mohawk" after his hair style, had morphed into "Macaca." Allen eventually apologized. And Sidarth, who felt he'd been singled out as the nonwhite face in the crowd, made national headlines.

The incident changed the tide of Allen's Senate seat defense. In the preceding months, some polls had Allen ahead of Webb by as much as ten to twenty points. In the first poll following the incident, Webb had overtaken him for the first time. The election itself was incredibly close; Allen lost by a margin of a mere 9,329 votes, less than 0.4 percent of the vote. His loss had far-reaching implications too. The election swung the entire U.S. Senate's balance of power to 51–49 in favor of the Democrats, costing the Republican Party its control of the lawmaking body. Just nine months prior to the run-in with Sidarth, the

* Depending who you ask, "macaca" is a) the name of the genus to which over twenty different species of monkey belong (including the rhesus macaque that many of us know), b) the Portuguese word for a female monkey, or c) a derivative of the demeaning term colonialists used to refer to Africans in the Belgian Congo that became a slur for individuals of darker skin tones in several cultures. In the context of Allen's remarks, none of them are good.

National Journal asked Republican "insiders" to rank the top contenders for the party's 2008 presidential nomination. Allen was #1, placing just ahead of Senator John McCain and Governor Mitt Romney. The loss took Allen out of contention for a presidential run and left him with an uncertain political future.[*]

Allen's gaffe was far from the first or the last political caught-on-camera incident, but it was the first demonstration of the weaponization of web video for political gain. In fact, when Republican congressional leaders reportedly met in 2009 to review a comeback strategy in the wake of President Obama's election, it was said to include guerrilla tactics like surprising opponents on video with a barrage of questions. In 2010, Representative Bob Etheridge (D-NC) fell victim when two "students" equipped with a camera asked him, "Do you fully support the Obama agenda?" Etheridge, in an awkward and aggressive tone, glared at them repeatedly asking, "Who are you?" and grabbed one cameraman forcefully. Etheridge, whose actions were described in sensational headlines as bullying and even assault, later apologized in a news conference, but lost his reelection bid by a mere 1,400 votes. Both Mitt Romney and John McCain were also the subjects of "gotcha" videos circulated widely online: McCain jokingly referencing "that old Beach Boys song, 'Bomb Iran'" and singing a few notes to the tune of "Barbara Ann" at a 2008 appearance in South Carolina, and Romney telling a wealthy group of donors at a private 2012 fund-raiser that 47 percent of Americans would vote for his opponent because they feel entitled to government support. "I'll never convince them they should take personal responsibility and care for their lives," he said. Both clips were played and replayed on news networks and embedded within blogs and news stories for months.

The "Macaca" incident also served as an early indicator that a balance of power had shifted. Salon named Sidarth Person of the Year

[*] In 2011, Allen launched a failed bid to reclaim his seat in a race against future vice presidential candidate Tim Kaine. Surprisingly, given everything that had happened, Allen announced his candidacy via . . . a YouTube video.

in 2006 and in a *New York Times* opinion piece titled "2006: The Year of the 'Macaca,'" columnist Frank Rich wrote, "The moment became a signature cultural event of the political year because the Webb campaign posted the video clip on YouTube.com, the wildly popular site that most politicians, to their peril, had not yet heard about from their children."

The "Macaca" video showed how any of us could document and share our own experiences in ways that had wide-reaching implications for established institutions in the world. One twenty-year-old guy holding a camera had helped change political history by allowing us to react as though, for one minute, we were in his shoes, witnessing the same thing he was.

◄◄

While it seems as though every event today is documented in some form, most major moments in history have no visual record at all. Occasionally, well-written historical texts effectively capture the small details of great wars or the reigns of tyrannical royalty, but we generally go without the nuance that allows us to connect to the emotional weight of a moment we did not experience personally. The best historical paintings may help us visualize civilization's great turning points, but even those can have considerable flaws. One of my favorite pieces at the Metropolitan Museum of Art in New York is the famous *Washington Crossing the Delaware* by Emanuel Gottlieb Leutze. To many, it's a document of the clever military leadership of one of our most revered Founding Fathers. But Leutze was born forty years after that event took place, and critics widely agree that the scene as depicted would have been impossible, based on both the record of history and the laws of physics. I mean, I love George Washington and everything, but have you ever tried to stand up in a small rowboat? If attempted in real life, he and those other eleven dudes would actually be flailing

around in the icy waters of the Delaware, cursing at one another in whatever passed for profanity during the Revolutionary War. The vast majority of paintings of important events in human history were captured by artists who were not present (nor generally even alive) when they occurred.

It wasn't until the 1900s that accurate visual representations of major moments became commonplace. But for most of the century, the cumbersome nature and expense of videography and even photography equipment meant that only a limited number of camera lenses were available to capture impromptu events of significance. We primarily relied on photojournalists, whose business it was to be present at the right moments, to provide us with the visual documentation of the important happenings in our world. Relying solely on journalists and news media to document and distribute that visual information is of course limiting in its own way; photojournalists can't be absolutely everywhere at all times. Additionally, between photographers, reporters, producers, and editors there were numerous intermediaries between us and the events themselves. We were detached observers at home.

Abraham Zapruder hadn't remembered to bring his Bell & Howell camera to his office at a dress manufacturing company in Dallas on the morning of November 22, 1963, but he returned home to get it upon his secretary's urging. Via his telephoto lens, Zapruder captured what may be the most notorious home movie of the twentieth century: the assassination of President John F. Kennedy. The following morning, Zapruder screened the 8mm film for two Secret Service agents and *Life* magazine's Richard Stolley. Eventually they got to the most graphic moment in the footage, frame 313. "When that happened," Stolley would later recount, "the three of us, two grizzled agents and this not-so-grizzled reporter, all reacted with 'UGGHHHH.' It was as if we had been simultaneously gut punched. I've seen that film now perhaps a hundred times in my life. The impact, remarkably, has never diminished."

During his testimony to the Warren commission, Zapruder broke down. "It was an awful thing and I loved the president, and to see that

happen before my eyes . . . it leaves a very, very deep sentimental impression with you; it's terrible." The footage inspired that kind of reaction in nearly everyone who saw it, both when *Life* initially printed the stills and over the subsequent decades. It haunted Zapruder, and it haunts us. "His silent, 26.6-second home movie has become the focal point of America's collective memory on that weird day," wrote *Motherboard*'s Alex Pasternack fifty years later. "For many of us, especially those who weren't alive when it happened, we're all watching that event through Zapruder's lens."

By the early 2000s, we'd reached critical mass of lenses, thanks to the smartphone. For the first time, everyday people were documenting events of consequence, and we will now remember entire societal movements through their footage. This was a development that would have a major impact on how these events were reported within the news industry but, more important, would also dramatically change our relationship to them. We went from detached observers to virtual bystanders. We were not simply spectators of our most unthinkable experiences; we made one another *witnesses* to them.

MAKE THEM DO IT IN THE GLARING LIGHT

Steve Grove was finishing his graduate studies at Harvard's Kennedy School when George Allen's "Macaca" incident made national headlines. "It was that moment that put YouTube on the national political radar, and certainly put it on my own radar as something that wasn't just a site for, you know, fun stuff, but had some political implications," he said. Grove joined YouTube in February 2007, just a few months after the young video site had been acquired by Google. He served as the news-and-politics content editor, helping identify important videos and up-and-coming voices in the burgeoning web video community for the site to feature.

Six months into his job, protests erupted in Myanmar, leading to a somewhat violent crackdown from the country's military junta. Thousands of Buddhist monks joined the Saffron Revolution and video of their demonstrations streamed out across the web, despite the notorious media censorship exerted by the country's ruling factions, which had made the work of foreign journalists difficult if not impossible. Regular citizens could document events that journalists couldn't reach, and Grove was tracking it all. "Videos [from those in Myanmar] were the only window into what was taking place there," he said.

In 2008, Grove brought on Olivia Ma to help spearhead YouTube's young news initiatives.[*] She and Grove worked directly with major news organizations around the world espousing the possibilities of YouTube and attempting to gain exposure for the regular people who wanted to share their perspectives on major world events through the videos they created.

Then, in 2010, Grove made the most pivotal decision of his young career at Google: He hired me! Steve was my manager for the first year and a half of my career at the company, and together he, Ma, and I were YouTube's front lines for breaking news during that period, which included the Arab Spring, the tsunami in Japan, and a presidential election.

By that time, cellular phones with cameras had proliferated globally, and when people witnessed incredible events, YouTube became the go-to place to share what they had captured. For Grove and Ma, the event that truly put the spotlight on the impact this could have for news was the '09 Iranian election. "It was a story the whole world was watching, and they were really watching through YouTube," Grove said. They'd understood that citizen reporting and bearing witness via video was significant, "but Iran was the tipping point," Ma told me.

[*] After college, Ma probably would have gone to work in the news business for a big publication like *Newsweek*, but one of her classmates had built a website that made the idea of media technology an appealing prospect to her. (Mark Zuckerberg launched Thefacebook .com in her dorm at Harvard. She was account fifty-one.)

In the summer of 2009, Iranian president Mahmoud Ahmadinejad won reelection in a highly contentious race. Ahmadinejad's opponents, including Mir-Hossein Mousavi, the reformist candidate, cried foul. "I personally strongly protest the many obvious violations, and I'm warning I will not surrender to this dangerous charade," Mousavi had announced. His supporters took to the streets in what became known as the Green Movement, and peaceful protests turned to violence as demonstrators clashed with riot police. A disputed number of protesters were killed in the gunfire that occasionally broke out, and thousands were arrested. While social media was a nascent concept, many of these conflicts were captured on cell phone cameras and distributed online. A lot of the footage was tough to watch. "It's one thing if you catch a politician flubbing a line," Grove said. "It's another to see someone be killed by a policeman or shot by a sniper from the roof of a building, or beaten with a billy stick in a public arena." These videos painted an alarming portrait of events on the ground and showed us how even just a single moment, captured digitally, could have immense impact.

NEDA AGHA-SOLTAN, TWENTY-SIX, had not been known as very political, but like many young people in Iran that year, she had been swept up in the emotion of the protests and what they stood for. In the early evening of June 20, despite warnings from her parents, she and her friend and music teacher, Hamid Panahi, headed to one of the demonstrations. "If I don't go and others like me don't go, then who's going to go?" she'd told her mother. The air-conditioning didn't work in her old Peugeot 206, so once they were close enough to Tehran's Azadi Square, she and Panahi decided to walk in the fresh air. Antiriot police approached on motorcycles and tear gas was fired. A loud crack rang out and Soltan collapsed to the ground. A number of people rushed toward her, including someone with a camera. "I'm burning. I'm burning," Panahi heard her say. Blood poured from her chest and out of her mouth and nose. Her eyes rolled back. As a group formed

around her, Panahi frantically reassured her, "Don't be afraid! Oh my God, stay with us! Stay!" Screams, both male and female, can be heard, the kind of anguished screams that pierce to your core. A doctor who happened to be in the vicinity ran to her aid and attempted to stop the bleeding, but Soltan died in less than a minute, with the camera still recording.

"My first reaction to the Neda video was just sorrow," Grove recalled. "I remember being really moved by it and feeling moral outrage at what was taking place. And I think that a lot of other people did as well, because her name and that video became synonymous with the entire revolution." I had a similar reaction when I saw the clip. Many years later I can still recall the video with considerable clarity, and I will likely never forget it. Ma first came across it while scouring for new uploads from the region and recognized almost immediately that it would be significant. The wrenching video spread rapidly and "I am Neda" immediately became a slogan that rallied the protest movement. Even for those who had never known her or her story, the video elicited deep empathy. "It's heartbreaking," President Obama told reporters after viewing it himself. "I think that anybody who sees it knows that there's something fundamentally unjust about that."

The "Neda" video has since become a touchstone of the power of bystander footage to inspire public outcry from the local and international community. The video, which reportedly made its way to the web after the man who filmed it sent it to a fellow Iranian seeking asylum in the Netherlands, seemed to be everywhere, and so many duplicates were uploaded from different accounts that few were certain which was the original. It didn't matter. The clip famously won a George Polk Award for videography in journalism, an honor unprecedentedly bestowed to an anonymous group of individuals.

The "Neda" video also alerted many at Google to the fact that people were using their technology in ways no one had anticipated and were having a serious impact in the world. Grove and Ma together started to reach out to some of the people recording and sharing this

material, sometimes even instructing them on best practices, like how to give videos the proper context and metadata so they could be useful to journalists. One of the most unusual figures in the spread of clips like these was a twenty-eight-year-old graphic designer from New Jersey named Mehdi Saharkhiz, whose YouTube channel onlymehdi became the go-to source for amateur videos of the events on the ground in Iran in 2009. Activists sent him clips to share with the public while they remained anonymous. "We were able to identify a police car [that ran] over a protester," he recounted in a 2010 interview. "And have proof of this. Not from one angle. Not from two angles. But three different angles. That makes even governments change the way they behave, because there is proof of every wrong move. We are going towards a new kind of a democracy. It's not one million or two million people watching. It's six billion people watching." Given the ubiquity of smartphones and social media accounts, our ability to access and view pivotal moments is unprecedented. And visual evidence can inspire real change.

ONE OF THE flash-point events of 2015 began with a nonfunctioning brake light. Walter Scott, a fifty-year-old black man and father of four, was pulled over by police in North Charleston, South Carolina, on April 4, as he entered the parking lot of an auto-parts store in his 1991 Mercedes. During the stop, Scott fled and a scuffle ensued that ended when a white police officer, Michael Slager, fired eight shots at Scott, ultimately killing him in a lot behind a nearby pawn shop. "Shots fired and the subject is down," Slager radioed to dispatch in the immediate aftermath. "He took my Taser," he said. The shooting occurred during a period of national tension following a number of disturbingly similar incidents. Now yet another unarmed black man had been shot by a white police officer. "A statement released by North Charleston police spokesman Spencer Pryor said a man ran on foot from the traffic stop and an officer deployed his department-issued Taser in an attempt to stop him," reported the *Post and Courier.* "That did not work, police

said, and an altercation ensued as the men struggled over the device. Police allege that during the struggle the man gained control of the Taser and attempted to use it against the officer. The officer then resorted to his service weapon and shot him, police alleged." Slager quickly retained the services of an attorney. "The driver tried to over-power Slager in an effort to take his Taser," the attorney explained. "Slager felt threatened and reached for his department-issued firearm and fired his weapon." News of Scott's death made national headlines, and that was the plausible explanation we demanded.

Except one man knew it wasn't true. Feidin Santana, twenty-three, had been walking to his job at a barbershop at that same moment and watched as Slager ordered Scott to "Stop!" as he chased him through the lot and eventually tackled him. As Santana looked on, Slager struck Scott and put a Taser into his side. "I remember police had control of the situation," Santana would later recount. "[Slager] had control of Scott and Scott was trying to get away from the Taser." Scott slipped away and continued to run. Slager drew his gun and fired the shots into Scott's back from about twenty feet away. "Shots fired," Slager said into his radio as he walked over to Scott, placed him in handcuffs, and dropped what appeared to be the Taser near his body. Santana continued to watch as more police and an EMS team arrived on the scene over the next few minutes. Officers asked Santana to stay where he was, but he ran, concerned for his safety. Because Santana had not just witnessed the incident. He'd captured it all with his phone's camera.

It was only later that Santana found out who the man was and that he'd not survived the shooting. Santana immediately understood the value of what he had on his Samsung phone. He was scared of the repercussions, but knew that if he'd been in Scott's place, he'd want his own family to know the truth. "I saw the police report, and I saw it was going the wrong way," he said. "I got mad." From what Santana saw, Scott never grabbed the Taser, as official statements had purported, and Scott, in his view, hadn't deserved to meet such a tragic end. So

Santana contacted Scott's family through some social media connections and quietly met up with Scott's brother to deliver the footage. The Scott family lawyer, in turn, provided it to the *New York Times*, who posted it on the web for all to see, shocking and incensing the country.

The revelations associated with the clip led to widespread criticism of everyone involved. "As a result of that video and bad decisions made by our officer, he will be charged with murder," North Charleston mayor Keith Summey eventually announced. Investigations were initiated by the FBI, the U.S. Attorney's Office in South Carolina, and the U.S. Justice Department. A South Carolina congressional bill funding two thousand body cameras for officers in the state was renamed for Scott the month following. In 2017, Slager plead guilty in federal court to violating Scott's civil rights.

The Scott killing wasn't an isolated one, and eyewitness videos of other incidents fueled an entire movement that put a spotlight on relations between the black community and law enforcement. Eight months prior, Ramsay Orta had filmed the arrest of Eric Garner in Staten Island after Garner had been accused of selling loose cigarettes. Garner was put in an illegal chokehold and declared "I can't breathe" eleven times, with no intercession by the responding officers. Garner died of a heart attack. At a subsequent memorial service, Orta received applause from the crowd. "He showed the whole world exactly what was going on," said Garner's daughter in an interview.

"We will no longer let them use their clubs on us in the dark corners," Martin Luther King Jr. declared in 1965. "We're going to make them do it in the glaring light of television." Fifty years later, what "television" represented to Dr. King has come to encompass a lot more than a box in the living room, and the power to shine that glaring light is in any of our hands. The most significant cultural movements of this century are influenced by the direct access we have to one another's immediate experiences in the form of the videos we can record, view, and share.

A BILLION WITNESSES

The cameras we carry will produce the visual record of our experiences in the twenty-first century. In fact, we're not even always carrying them. In Russia, for example, mounted vehicle dashboard cameras have become ubiquitous, providing cautious drivers recourse against corrupt police officers or insurance scammers and the rest of us with a steady stream of inadvertently captured craziness from the streets of Moscow and the backroads of Siberia.° At no time in our history have we had a remotely comparable volume of daily life committed to media. Dashboard cameras, phone cameras, personal security cameras, cameras built into our eyeglasses . . . While all this recording and sharing raises some major ethical questions we'll be grappling with for decades, there's no denying that the world's capacity for bearing witness has dramatically increased. Now we almost take for granted that important moments will be documented and disseminated for the world to see. But for videos and photos to have an impact, there must be more to it than simply posting them to a YouTube account. The ability for such videos to go from your camera to our social feeds to headline news to the center of the public consciousness is relatively new and relies on the mass adoption of tools to record them and processes to legitimize them.

For the scenes we capture and upload to pierce the collective consciousness, for them to reach us in ways that generate meaningful reactions, they also must have credibility. Expert newsgatherers play a critical role in increasing the impact of clips from average citizens by vetting their veracity and helping us understand the larger context. Without third-party screening and contextualizing, many of the important eyewitness clips from the past decade might have been far less powerful. Without confidence in a video's basic information, like where and when something was shot or what the motives of the person filming

° Most of us witnessed the February 2013 Chelyabinsk meteor, the largest known natural object to penetrate the earth's atmosphere in over one hundred years, via videos recorded on the dash cams of stunned Russian drivers.

might have been, it's hard to feel invested. "In some ways, the journalist's role in all this is the same as it ever was: to report," Ma told me. "This content is original raw reporting material that needs to be vetted, verified, fact-checked, and contextualized."

Irishman David Clinch spent more than twenty years at CNN and by 2010 had become a senior international editor at the network's headquarters in Atlanta. Clinch and others in the news media saw the potential of the web not just as a publishing platform, but as a news-gathering tool. He refers to it as the "social media insurgency," and it reached a breaking point in January 2010, when a 7.0-magnitude earthquake hit the impoverished nation of Haiti, eventually claiming the lives of more than 150,000 people. "All of the excitement about social media had reached a peak, and every news company was aware and looking on the web for content—YouTube, and other places—and none of the difficult questions had been answered about verification or usage rights," Clinch told me. "It was the best and the worst of the social web in real time." Reporters had access to unprecedented amounts of on-the-ground footage, but no one had any means to verify it. "The layers and layers between the actual person who took the video and how it ended up on the web, at the time, left absolutely no way of knowing whether it was real," Clinch recalled. "CNN and others got caught in situations where people who claimed to be witnesses weren't. People who claimed to have videos of events were lying." In other words, it was an amazing, transformative time. But it was also a total cluster.

For every video, Clinch had three questions to answer: 1) Is it real? 2) Who does it belong to? 3) Can news publishers use it? Protocols for answering such questions had not yet been formed by the start of 2010, and it created chaos as newsrooms scrambled to cover important stories. In those days, YouTube and traditional media often felt at odds. Many organizations feared that the financing of their whole industry was about to be upended, but global events forced a symbiotic relationship between the two. Unfortunately, the basic infrastructures of each could make things quite difficult for the other. For example,

YouTube was designed to receive and present, with minimal organiza-
tion, clips that often had little specific information or corroborating
detail, while newsrooms were designed to track down sources, docu-
ment events on their own, and perhaps follow their own unique approval
processes before we could see what they uncovered. The news reporting
industry was on the cusp of enormous change.

By the time I arrived at YouTube, the disharmony between news
media and the billion witnesses of the web had become even more
pronounced, and finding a solution was critical.

On December 17, 2010, corrupt local officials in Sidi Bouzid,
Tunisia, harassed a twenty-six-year-old fruit vendor named Mohamed
Bouazizi on his way to work. It was, sadly, not an uncommon scene in
his town and one Bouazizi would normally have to bribe his way out of.
Things turned physical as Bouazizi tried to protest the confiscation
of his scales and produce, the purchase of which had just forced him
into significant debt. Less than an hour later, Bouazizi, humiliated
and distressed, stood in the street outside the governor's office, doused
himself in paint thinner, and lit himself on fire. Protests broke out in
the city a few hours later, which Ali Bouazizi, Mohamed's cousin,
captured with his cell phone and posted online. Mohamed Bouazizi's self-
immolation became a symbol of Tunisian frustration with government
corruption and inspired a movement throughout the country. Subse-
quent demonstrations, which sometimes resulted in violent confronta-
tions with police, were documented via videos widely shared on social
media sites, incurring further outrage. Experts generally recognize these
as the inciting incidents of the Arab Spring.

A month later, on January 25, protesters were dramatically clashing
with police in Cairo. As video poured in, work began to try to identify
and collect legitimate footage of the events as they happened—a chal-
lenging task for English-speaking reporters given that all the contex-
tual information (titles, descriptions, keywords) was in Arabic. Video
files were sometimes uploaded to YouTube after being shared as email
attachments or cellular messages, making other embedded data, such

as geo-tagging, unreliable. The press needed some help parsing the videos, because just as often as they came across something of seemingly huge significance, they'd find something that was unintentionally or even intentionally deceptive.

Clinch and another journalist, Mark Little, had by this time launched a company called Storyful, designed to comb the social web and figure out what was real and what the original sources of such material were. We called Clinch at midnight and asked if he could help us make sense of the Arab Spring. Clinch asked what we meant. My then-boss Steve Grove replied, "I'm not really sure what I mean, but I need a yes or a no right now." They said yes. "Think about that," Clinch said when we spoke again in 2016. "That was just a few years ago. The Arab Spring was one of the most pivotal events that's happened in our lifetime, and the only way of covering it was YouTube."

As I worked with Clinch and his colleagues in 2011, it became clear that the Arab Spring, regardless of the murky geopolitical implications, would be turning point for the role of social media in documenting and, ultimately, shaping our perspectives on world events, particularly given that many of the countries affected by the Arab Spring had very tight media restrictions. "They either weren't allowing or were allowing very, very limited media access to outside journalists," Clinch said. Many journalists who had made it into the region resorted to filing stories from hotel balconies as drama played out across the city below, but video that captured the reality of the movement was flowing in from regular people in Cairo and all over Egypt. The scenario was replayed in Bahrain, Libya, Yemen, and Syria. "I don't think that those revolutions would have had as much impact if social media and YouTube videos, in particular, had not been a factor," Clinch said. "Because governments would have found ways to say, 'Things aren't happening,' or 'It's not as big as you think,' or 'Foreign press are misinterpreting it.' The only way that the world saw and ultimately even the local government officials themselves saw how big it was, was social media and YouTube video."

That these types of eyewitness videos are often all we have avail-able to interpret events of significance only further underscores the importance of context and verification. For them to matter, mecha-nisms must be in place to ensure their credibility. In a world of a billion witnesses, truth and authenticity have never been more important.

THE BIGGEST STEP FOR EMPATHY

Part of what gave the George Allen slipup more bite and made the Arab Spring footage more gripping was the fact that we witnessed these events through the relatable and immediate first-person perspec-tives of other people. The fact that these videos look like anyone could have shot them—and that they're posted and shared in a similar fashion to the videos and photos that we post and share—heightens their ability to provoke emotion and sway opinion.

The hours I spent in 2011 researching the most important videos from Egypt taught me how much more affecting nonprofessional eyewit-ness video could be. Some of the images from that time remain stuck in my brain. On the first day, I came across a video depicting a crowd on a side street in Cairo confronting an armored truck. Police were using water cannons to prevent protesters from navigating to Tahrir Square, the focal point of the growing demonstration. The pixelated clip seemed to be captured from a fourth-story apartment balcony whose tenants, as well as neighboring onlookers, could be heard shouting as the armored truck's water cannon blasted young men in the street below. One man walked in front of the truck and stood there, alone, with his hands at his sides, refusing to move even as he got blasted by the high-powered stream of water. (The anonymous man became known as Egypt's "Tank Man," acknowledging the clear parallel with the iconic image from Tiananmen Square in 1989.) Even though I didn't speak a word of Arabic, the alarm and tension in the voices of the bystanders and the defiant, symbolic stance of the man below left me speechless as

I replayed the clip over and over. The subsequent weeks brought many
similar scenes as protests intensified and spread. I regularly returned
home at night drained and emotionally exhausted. I vividly remember
sitting with tears in my eyes at my desk on the fifteenth floor of our NYC
office one morning after watching a particularly difficult clip of guards
firing live ammunition directly into a group of unarmed Bahraini
demonstrators.

These were, sadly, not the only atrocities that had been committed
by a government against its people in my lifetime, but something about
how I experienced these particular events made them exceptionally
moving. And I wasn't alone. Even as news correspondents descended
on Egypt and elsewhere in 2011, many of us watched the Arab Spring
unfold via YouTube clips. It is in the form of these charged YouTube
clips that the Arab Spring remains in our memories too.

Emotional connection is central to the power of these eyewitness
videos, and the intimacy of web video magnifies that experience. The
relationship video can engender between us and the experience of
the person who filmed something drives our reactions. I asked Steve
Grove what he felt made clips like the "Neda" video so galvanizing. "I
think it personalized a crisis in a way the news never could have," he
told me. In seeing events unfold through a bystander's point of view—
particularly the vantage of someone living that experience versus, say,
a professional photojournalist—a connection is formed with both the
event and the experiences of the people present for it. "You almost feel
you're a part of that moment," he added. "I think in some ways online
video was the biggest step for empathy in journalism that we'd seen in
a long time."

These clips get in our heads in an incredibly literal way, even
changing our neurochemistry in ways that can alter our future behavior.
Scientific evidence points to the power of short video clips to impact
our brain, increasing our empathy for others. In 2009, two researchers
at Claremont Graduate University, Jorge Barraza and Paul Zak,
published the results of a study where participants played a game

designed to assess generosity. Prior to the game, some subjects were shown a video intended to elicit empathy, a two-minute clip "in which a father explains his current experiences with his 2-year-old son who has terminal brain cancer." Those subjects who viewed the video experienced a 47 percent increase in oxytocin, a hormone best known for its role in facilitating social bonding among humans, and acted more generously when playing the game, illustrating a link between empathy, oxytocin, and increased generosity.

We are part of an era in which technology documents and archives so many of the consequential moments in life. These videos inspire societal change, in part, through this deep emotional connection. Heightened relationships can form for us as viewers with the people and experiences exposed to us through this footage. That potential is one of a number of complexities that has reminded me why we must navigate this new reality with great care.

IT'S A COMPLICATED THING, WITNESSING

"They are going to denounce what I am saying. They are going to put so many things on me after this," worried Dr. Arash Hejazi in a 2009 interview with the BBC. That year, Hejazi had accidentally become the most famous doctor in Iran when he inadvertently costarred in the "Neda" video while attending a postelection protest. He'd never met Neda Agha-Soltan, but when he heard a gunshot and turned to find a young woman gushing blood, he did his best to help save her, applying pressure as the blood drained from her. Less than two weeks later, he fled Tehran for the United Kingdom, fearing that his life was in danger.

I'd like to believe that using modern technology to share the act of witnessing through videos and social posts can engender human connection and spread truth, literally and metaphorically. That a person in the most dire and unjust of circumstances can document their experience and share it with us. That masses of people, so moved by that

person's act of bearing witness, can unite as a community of empathetic witnesses and improve that person's situation. That those actions can lead to negative consequences for any oppressive parties responsible. But, like most things, it's actually far more complicated than that. The gift of the web as a medium for free expression comes with complex ethical baggage.

"I deeply believe in the power of watching something and being moved to action," Sam Gregory told me. Gregory is the program director at Witness, an organization that trains and supports people using video in human rights initiatives. It was cofounded in 1992 by Peter Gabriel° in the wake of the beating of Rodney King, a moment that had a nationwide impact, thanks, in large part, to the fact that it was caught on camera by bystander George Holliday. While initially Witness focused on distributing cameras, mobile and internet technology pushed the organization in a different direction during the twenty-first century. "The dream is that we could have a world in which anyone who has anything bad happen to them of this sort has a chance of getting their story uploaded, being seen, being watched, that they really know that they can be heard," Gabriel explained in a 2006 TED Talk.

Today Witness focuses on identifying situations of human rights concern and training those affected to use video safely, ethically, and effectively to document their experiences and advocate for change. That includes teaching production basics, building tools and apps, lobbying technology companies to improve support for this activity, and helping draw attention to important footage produced within its network. They estimate that their videos have been seen in some capacity by more than a quarter of a billion people. But Gregory is quick to point out that trying to spread an eyewitness video to a large audience is not always the best strategy. In many cases, there are better routes to bringing these videos to relevant parties than the promise of millions of views. Sometimes getting a video to the right activist or human

° Yes, *the* Peter Gabriel.

rights lawyer or policy maker is what actually leads to change. The Witness team regularly preaches *against* the dream of viral success because it must be approached with more caution than most people realize.

When we capture something meaningful on video with the intention of sharing it, we consider the immediate community we intend to share it with, sympathetic people who will empathize with our experience. But, of course, the reality is that numerous other individuals with their own motives will see it too. Gregory explained that most people who post something assume they have control over the situation and believe they're doing something smart, but they neglect to consider the variety of ways their footage might be used once someone else sees it or consider the number of people it could affect. Even videos documenting clear-cut abuses of power can make a situation more complex by involving perpetrators, other victims that may be depicted in the footage, opposition groups, and even hostile government entities, sometimes resulting in further vulnerability rather than empowerment.

While George Holliday's Rodney King video led to police reform and a nationwide movement, the subsequent criminal proceedings infamously resulted in three acquittals and Holliday, the owner of a small plumbing business who'd merely dropped off the tape with KTLA the morning after he happened to capture the events on his camcorder, found himself grilled on CNN by house Republican Pat Buchanan. For twenty-five years, Holliday maintained a bitterness toward the news industry he'd felt had exploited him. Ramsay Orta, who filmed the Eric Garner video, later reported repeated harassment from police officers, one of whom he quoted as saying, "You filmed us, so now we're filming you." He told *Time*, "Sometimes I regret just not minding my business." He ended up in prison on unrelated charges.

Jordi Mir, an engineer in Paris, filmed what he thought was a bank robbery in January 2015. It turned out that his forty-two-second recording depicted the aftermath of the *Charlie Hebdo* office shootings and included, most notably, the shocking, callous murder of police officer Ahmed Merabet by two masked gunmen. In what he later

described as a "stupid reflex," Mir posted the video on his Facebook account. Fifteen minutes later, he took it down, but within the hour the clip was on television. Despite his pleas and refusal to give permission for people to use the unedited clip, it was duplicated, replayed, and screenshot over and over, becoming the most iconic image of the attack. While some say it played an important role in rallying the French people, others claim it did more harm. "How dare you take that video and broadcast it?" Merabet's brother told journalists. "I heard his voice. I recognized him. I saw him get slaughtered and I hear him get slaughtered every day." Mir felt terrible. He told the AP that if he could do it again, he never would have posted it.

Documents of oppression can also be exploited for nefarious purposes by our oppressors with disturbing ease and, sometimes, with an alarming scale of coordination. In 2009, it was reported that Iran had created a crowdsourced site for the purpose of identifying protesters from photos and videos so they could be arrested. This is why Gregory and his team have taken a cautious approach to the documentation of human rights violations. "It's a complicated thing, witnessing," Gregory said. "How can we help people be safe, ethical, and effective witnesses?" And that's a question not just for people who film something. It's a question for the people who watch it and share it too.

"I PUT IT on Facebook [to] go viral so that *the people could see*. So that *the people could see*," declared Diamond Lavish Reynolds to a group of reporters standing outside the Minnesota governor's mansion. "I wanted the people to determine who was right and who was wrong. I wanted the people to be the testimonies here. All of us saw with our eyes. The only thing you guys didn't see is when he [was] shot. And if I [had] moved while that gun was out, [the police officer] would have shot me too." Just two days prior, she had livestreamed the aftermath of the fatal shooting of her boyfriend, Philando Castile, by police officer Jeronimo Yanez, who opened fire as Castile reached for his wallet. The video, in which Reynolds narrates the events with surreal

composure as her boyfriend bleeds from his injuries in the seat next to her, incited nationwide outrage.

It was, without a doubt, one of the most important pieces of video in 2016 but also raised more questions about the ethics of broadcasting or sharing such a disturbing moment in someone's life. In a world of instantaneous and unmediated communication, what responsibilities do we have to one another?

While most of us wouldn't stop to consider the incidental repercussions of how we use web video in a moment of crisis, we're entering an era in which responsible use of media technology will be an essential lesson for younger generations. We might not think twice about resharing or commenting on a video of a seeming injustice, but those actions introduce new ethical conundrums. Gregory cited an incident in Russia in 2013 when a group of male neo-Nazis surrounded a teenage boy, subjecting him to a twenty-minute verbal assault of homophobic harassment. The perpetrators uploaded the video to a Russian social media platform and it spread on hateful websites. But it was also shared and reposted by LGBT activist groups and international media, who called attention to it as a way to inform people of a disturbing trend of LGBT bullying sweeping Russian society. "What do you do with that stuff?" Gregory asked me. "You kind of want people to see it, but by making people see it you're reinforcing the purpose of the people who created it; you're re-victimizing the individuals."

Many of us have experienced situations when well-intentioned intervention from ourselves or others served to make a problem worse rather than better. The unrestricted media environment of the web makes the same thing possible except on a much greater scale. The responsible use of media was once something debated in university classrooms and company boardrooms, but it's now a duty we all share.

EVERY DAY, SOMEONE somewhere will document and upload a moment of tragedy, pain, or despair, none any less worthy of our attention

and empathy than another. While organizations like Witness help educate people who capture those moments to do so responsibly, it is often how the rest of us choose to react to them that their positive or negative effects are amplified. Our reactions have that power. Getting this right might be one of our most important responsibilities of this new era of expression. The consequences are not small.

Governments are aware of the power of web video to dramatically influence the populations over which they exert control. Direct and specific actions taken by governments to cut access to YouTube during moments of civil unrest can be inferred directly through the platform's incoming traffic data:

*YouTube country traffic compared to worldwide traffic, normalized and averaged daily (Pacific Time).

Iran, 2009

*YouTube country traffic compared to worldwide traffic, normalized and averaged daily (Pacific Time).

Egypt, January–February 2011

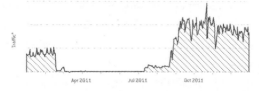

*YouTube country traffic compared to worldwide traffic, normalized and averaged daily (Pacific Time).

Libya, 2011

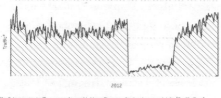

*YouTube country traffic compared to worldwide traffic, normalized and averaged daily (Pacific Time).

Tajikistan, 2012

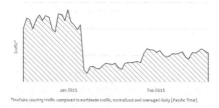

*YouTube country traffic compared to worldwide traffic, normalized and averaged daily (Pacific Time).

Democratic Republic of Congo, January–February 2015

Ultimately, your local dictator is not afraid of people seeing something. They're afraid of the reaction they'll have to it. Whether it's international pressure, unrest in the streets, or the undermining of their authority, they're afraid of what the "glaring light" might mean for them.

YouTube was not directly conceived to support eyewitness videos, to hold the powerful accountable, or to document abuses of power or the destructive force of Mother Nature. As the servers were set up, I expect no one really had Neda Agha-Soltan or Walter Scott or the Haitian earthquake in mind. This is how *we* chose to use YouTube. Within just a few years of the invention of this technology—amid all the comedy clips, beauty tutorials, and dance fads—web videos shot and uploaded by individuals helped upend political campaigns, connect us with disaster victims, and incite revolutions.

Bearing witness has always been a meaningful act, one with a great many possible consequences, both good and bad. It can be traumatic, awe-inspiring, dumbfounding, or enraging. "Home video" of significant events like JFK's assassination and the beating of Rodney King occasionally reached the mainstream, but it was the technology of this century that truly unlocked the empathy-stirring potential of eyewitness video, permitting us to draw a near limitless number of people into our direct vantage with immediacy and over great distances at little monetary cost. We will continue to see the effects for decades.

Cameras will get better. New visual mediums will magnify these moments that inspire anger, sorrow, and action. Virtual reality devices as well as 360-degree cameras and sound will perhaps escalate the emotional accuracy of the experiences we're drawn into, further increasing their potency. Mobile livestreaming—something that took many years to get right—further reduced the time between the documenting of an event and its dissemination to milliseconds. We've reached a point where we assume every important thing that happens will be documented by someone.

The power of this technology comes not from its ability to document, but from its ability to connect us. "I recorded the video so that maybe he can feel that someone is there," Feidin Santana told NBC about his decision to film Walter Scott's confrontation with Michael Slager. "I couldn't tell what was going to happen, so I just wanted him to know that he's not by himself." Making witnesses out of one another ultimately means empowering one another. Sam Gregory described it to me as a moral obligation, because seeing without acting, as he put it, is not witnessing.

I Learned It on YouTube

B EN BUIE, TWENTY-TWO, was in South Korea doing missionary work for the Church of Jesus Christ of Latter-day Saints (LDS) when he came across some inexpensive neckties. "They were selling ties for dirt cheap there, and we sell them for a lot here, so you know, my business mind starting clicking," he told me. Buie didn't know much about ties—other than that he had to wear them a lot in his work as a missionary—but he returned home to Utah with two thousand ties and began selling them door-to-door. And so, My Nice Tie was born. He transitioned to selling ties online, and in an effort to drum up business, he posted a video on YouTube at the start of 2008 demonstrating how to properly tie a double Windsor knot, a popular knot that works with lots of different ties. (It was also the only knot he knew.)

He'd recorded the video in his closet. If Buie knew little about ties, he knew even less about how to make videos. "It ended up taking probably a solid week to get that first video because I went from no knowledge of anything to my first edited video," Buie said. "I put the video up there and I was like, 'Wow . . . no one is watching this.'"

Buie had written off his video foray as a failure, but over time the view count picked up steam. Two years after he posted it, the video crept past 750,000 views and two years after that, 4.5 million. Today, "How to Tie a Tie: The BEST Video to Tie a Double Windsor Knot" has been watched more than 30 million times and counting. It occasionally hits 40,000 views per day, which is not bad for a years-old tie-tying tutorial.

It turns out that "how to tie a tie" is one of the most common "how to" searches on YouTube, and well over half of the views Buie's video garners come from people searching. Searches drive billions upon billions of views on YouTube each week and many handy videos like these get discovered that way. While there are many, *many* videos that answer this same query, Buie's stood the test of time. Buie credits this to the fact that he went slow enough that people would not have to skip back and forth and could easily find success on the first try. (He also makes faster videos for viewers who are coming back for a refresher.) He's since uploaded tutorials for a number of different knots he learned, including some less common ones like the trinity knot.

My Nice Ties donates 20 percent of its sales to fund microfinance projects on Kiva, something that Buie thought up while sitting in a business class at Brigham Young University. This philanthropy keeps the business from feeling hollow, he told me, and it's the element of his work of which he's most proud. When we spoke, he'd funded more than six hundred loans in countries all over the world. It's kind of wild to consider that somewhere a small business exists because so many of us are terrible at remembering how to dress ourselves.

Why do so many of us struggle with tying a tie? "It's kinda complicated and it's one of those things that you do so rarely that you pretty much have to have a refresher every time you go to tie a tie," Buie explained. Once an absolute business necessity, by 2007, less than 10 percent of men wore a tie to work every day or even most days. But ties are still worn on special occasions; "how to tie a tie" searches see an uptick each May in the United States (prom season), and Buie's videos generally see a spike in viewing on New Year's Eve.[*]

Whenever we need help, whenever we need someone to *show* us how something is done, Buie's videos—as well as the tens of millions of other "How To" videos that exist on YouTube—are available. In contrast

[*] I imagine there is a near perfect correlation between black-tie events and views of "how to tie a bow tie" videos as well.

to the entertaining diversions we often associate with online video, they represent a whole other side of the internet, one that's driven by our curiosity, our immediate needs, and even our hopes for the future.

◄◄

In 1961, Newton N. Minow, recently appointed by JFK as chair of the Federal Communications Commission, addressed the National Association of Broadcasters and delivered a verbal jab to the schnoz. "I invite each of you to sit down in front of your television set when your station goes on the air and stay there, for a day," he told leaders of America's TV industry. "Keep your eyes glued to that set until the station signs off. I can assure you that what you will observe is a vast wasteland." Minow took issue with what he perceived as their over-reliance on vacuous entertainment programming. (*Gunsmoke* and *Wagon Train* were the top two shows that season.) Wasn't there room on TV to teach us, to inform us, to expand our horizons? "I like westerns too, but a steady diet for the whole country is obviously not in the public interest," he said, marking the last time anyone used a declaration of love for cowboy TV shows to score points with a crowd of media professionals. "We all know that people would more often prefer to be entertained than stimulated or informed. But your obligations are not satisfied if you look only to popularity as a test of what to broadcast. You are not only in show business; you are free to communicate ideas as well as relaxation." Minow concluded by threatening that anyone who didn't do more to "serve the public interest" risked having their FCC license renewal denied. He vowed to do everything he could to help educational television, ratings be damned!

YouTube, another medium entirely, with an endless parade of channels operated by millions of people all over the world, has no such mandate; it's a veritable free market of entertainment. If useful,

informative programming was unpopular then there would likely be little of it here. Surely, anything of educational value would be dwarfed by all those cat videos everybody's watching.

Not exactly. Which is why I enjoy telling people that we collectively spend ten times the amount of time watching videos in the "Education" category than we do "Pet & Animal" videos.* *Ten times*. I love this fact. I used to bring it up in interviews and presentations all the time because it blew people's minds. It still does. That we spend quite so much time watching "useful" content is something that is rationally understood by most adults—I mean, we've all watched a video about how to operate a certain piece of software or cook a particular dish—but, at the same time, it's not overtly reconcilable with the notions we have of the kinds of crap people watch online.

So what are people watching? Those helpful videos that provide answers to our very basic and, occasionally, very odd searches, assisting us with everything from household repairs to our homework. Channels with addictive casual education content. And then there's all the stuff most of us might not think of as "educational" or even recognizably useful but that, in the right hands, becomes invaluable.

For many, "YouTube has become synonymous with learning new stuff," as Ben Buie put it. YouTube was never designed for this, but we are all passionate, curious people, and as I've said before, the platform continually adapts to how we use it. Our natural inquisitiveness turned YouTube, in just a few years, into an influential force in how we acquire knowledge.

For me it started with fruit.

* I admit that this is a bit of a simplification. On the one hand, the "Education" category over-weights kids and family videos like ABC sing–alongs that some parents might watch with their children over and over again. On the other hand, the "Education" category excludes what we might call "casual" education content (e.g., "How to fix a sink" or "Adobe Photoshop tutorial 37") since these videos are often attributed to different categories like "How To" or "Science & Technology." In either case, I can say with confidence that people spend way more time learning stuff from YouTube videos than they do laughing at stupid dog tricks.

SEARCHING FOR AN ANSWER

One of my earliest YouTube memories was of a tutorial: "How to slice a mango." As anyone who's tried to cut one up knows, its stupid shape makes it impossible to stand up properly, it has a huge pit, and its skin is somehow thin enough that you can easily pierce it but thick enough that you can't eat it. Seriously—what gives, mangoes? But then I saw a video of a father at a kitchen table expertly dissecting the ripe fruit. We treat this as rather ordinary in the twenty-first century, but it's kind of an incredible thing that a stranger single-handedly changed my life (albeit in a tiny, tropically delicious way).

Every day, literally millions of YouTube searches contain the phrase "how to" in the United States alone. Here is a list of the most popular ones globally:°

"how to draw"
"how to make"
"how to tie a tie"
"how to kiss"
"how to get a six pack in 3 minutes"
"how to make a cake"
"how to make slime"
"how to solve a rubik's cube"
"how to draw a rose"
"how to make ice cream"
"how to make a paper airplane"
"how to lose weight fast"
"how to draw cartoons"
"how to twerk"
"how to curl your hair with a straightener"

° Note: Based on aggregate global searches in 2015. I have removed some incomplete queries as well as those that were looking for a specific video or channel such as "how to love" (Lil Wayne song) and "how to basic" (the name of an amazing channel that seems like it would be full of informative content, but is mostly videos of a man smashing things and throwing eggs at them—highly recommended).

These searches represent perhaps the most tangible manifestation of human curiosity ever recorded and paint a collective portrait of us, a society that strives to fit norms, seeks outlets for self-expression, and totally wants some hot abs.

"How to" searches can occasionally adapt to fads, like Rainbow Looms, which were one of the top "how to" topics for a period. But our search interest in that, as you can see, came and went:

RELATIVE GLOBAL SEARCH INTEREST IN RAINBOW LOOM TOPIC ON YOUTUBE

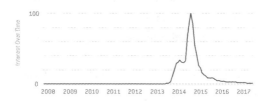

Some fads seem to have some lasting power, such as "how to twerk" (though perhaps not for much longer), while others are truly persistent (good to see the Rubik's Cube going strong all these decades later). The popular subgenres found within our "how to" search behavior can also tell us something. For example, we tend to break a lot of stuff. What are the most common things we are searching "how to fix" on YouTube? Scratched video game discs and cracked phone screens top the list by far, followed by headphones that work on only one side (seriously?), a zipper, a leaky faucet, a hole in the wall, a cracked windshield, and a broken nail.

The foods we most want to learn "how to cook" or "how to make"? Removing desserts from the list, the top dishes are pancakes, pizza, sushi, lasagna, and chicken. If the data tells us anything, it's that we have a sweet tooth. The "how to" videos with the most all-time views are primarily dessert related, such as "How to make Balloon Chocolate Bowls," in which a Japanese channel called Mosogourmet shows you how to prepare edible chocolate bowls by dipping balloons in melted

chocolate. It'd been watched 133 million times when I saw it. Shaved ice, Jell-O Popsicles, ice cream cupcakes . . . many of these videos are likely popular not just because they are fun do-it-yourself projects, but they also have very clickable images that appeal to children and parents as well as those of us who enjoy the indulgence of a good dessert without the calories that come from actually eating it.

The most common "tutorial" searches are for makeup and hair, followed by piano, Photoshop, guitar, and hijab. One might seek out these lessons in order to pick up a new hobby or . . . prepare to work as an international war reporter. In 2011, CBS News correspondent and noted badass Clarissa Ward wrote about how she used a YouTube hijab tutorial to figure out how to use one to properly conceal her blonde hair for the purposes of sneaking into Syria.

In 2015, we spent more than three million hours every day watching cooking videos and well over six million hours watching do-it-yourself or tutorial videos, by a conservative estimate. What we are looking for evolves over time, but it's clear from the volume that the practice of learning things via web video has begun to touch many aspects of our lives.

For many of us, these videos solve a very specific immediate motivation: There's something I want to learn how to do, I do a search, some person I will never see again shows me how to twerk properly, the end. Except, some clever people are building off of that same human curiosity in a totally different and creative way.

WE CAN'T LIVE NOT KNOWING

Remember that statistic I mentioned earlier? The one about how much more time is spent viewing "Education" videos than "Pet & Animal" ones? It wasn't always that way. Here is a graph comparing global daily viewing of the "Pets & Animals" category with the "Education," "Science & Tech," and "How To & Style" categories:

COMPARATIVE MONTHLY VIEWERSHIP

As you can see, viewership on these other categories starts to take off around 2011–2012. There are a number of reasons why, not least of which is that searching YouTube for this type of information has gone from helpful novelty to everyday habit. A 2016 study conducted by some of my colleagues with market research firm Ipsos found that 73 percent of Gen Xers who go online at least monthly watch YouTube videos to learn how to do something. Almost simultaneously, a whole slew of channels appeared that served these categories and were staffed by energetic, captivating . . . well, nerds.

Hank and John Green of Vlogbrothers fame launched Crash Course and SciShow, two channels focused on the engaging and educational. "Our goal is to make Crash Course the most fun you've had learning," announced John at the outset. After completing his Ph.D. in physics education at the University of Sydney, Derek Muller launched Veritasium, a channel composed of fascinating experiments, interviews with scientists, and other topics he found interesting. Preexisting channels like the one operated by Victoria Hart (aka Vi Hart), an entertaining combination of mathematical principles and captivating notepad doodling, saw their audiences grow.

And the success of these channels inspired more like them.

✿　✿　✿

GREGORY BROWN AND Mitchell Moffit met as biological science undergrads at the University of Guelph outside Toronto. They studied together, discovered a shared passion for science, and, inevitably, started dating. Despite their university majors, both had a creative bent as well. Brown studied art and Moffit was into video production. After graduation, Brown became a teacher and Moffit an editor.

No longer students themselves, they had little outlet for their scientific interests. If you hung out at night with Greg and Mitch, it was not uncommon to have them bust out some fascinating science knowledge for you. "I think we both loved our schooling, and we would always try and take that and just be like, 'This is why you feel hungover' or 'This is why you get drunk,'" Moffit told me. "Mm-hmm," Brown interjected, "*when* we were drunk." They were really good at this brand of bar-room education, and they basically became "the science guys" to their friends. At the same time, Brown had started to see the power of YouTube with his middle and high school students, many of whom were coming to class with clips from channels like Veritasium, while Moffit had met some YouTube creators in his work as a video editor. "We can do that," they thought.

In 2012, they decided to launch AsapSCIENCE, "Your weekly dose of fun and interesting science." Then just twenty-three, they committed to posting one video a week for a year to see what would happen. "Our whiteboard animated-video style took a topic that seemed intimidating to a lot of people and made it seem childish," Moffit explained. "Having cartoon stick figures or just cute little drawings strips away that fear for people." Neither had animation backgrounds, but Brown leaned on his art school training to create the whiteboard drawings and Moffit provided the voiceovers, music, and editing. In the beginning they concentrated on the topics they'd already explained to their friends. A video called "How to SEE or HEAR the Big Bang" was quickly followed by "Why do coffee and alcohol make you PEE more?" Then they asked friends and viewers to share questions they were interested in and sifted through the suggestions to find the best ones. Brown's mom was particularly effective at providing potential topics.

They found quick success with "The Scientific Hangover Cure," which drew hundreds of thousands of views after being featured on some popular sites. "Our first really shared one was 'The Scientific Power of Naps,'" Greg laughed. "And I think that was the first one that was a perfect blend of everything we'd been trying to do. It was four weeks in." Within a year, twenty-eight of their videos had achieved one million views. Brown continued to teach, but Moffit implored him to commit to this as a full-time job instead. By the time we spoke in 2016, they'd built an entire enterprise, working full time on the channel and amassing half a billion views and more than five million subscribers. Their goal is always to intersect science with everyday life. It's not like jumping into a textbook. "We're talking about something they already experience in their life," Moffit told me. "Sleep, coffee, alcohol. Psychology, money . . . Things that people think about on a daily basis, that they don't think are science." Some of Brown and Moffit's most popular videos include "What if You Stop Sleeping?," "Does Being Cold Make You Sick?," and "Could We Stop An Asteroid?," which features Bill Nye, the original science guy himself.[*]

Sometimes these videos took off straightaway while others accumulated more views over a longer period of time. When we spoke—in a hotel meeting room in which a woman was rather aggressively vacuuming literally directly underneath our feet for no apparent reason—their most popular video was "What Colour[†] is this Dress?," which explained the science of the famous "Black/Blue vs. White/Gold" debate that swept the internet for a few weeks in 2015. It had been watched more than twenty million times, mostly in the first week or so. Meanwhile, their second-most-popular video—and by the time you're reading this it must have surpassed the dress video—was "Which Came First— The Chicken or the Egg?" That video was still being watched twenty-five thousand times per week three years after it was posted. Brown and Moffit got really good at predicting how their videos would perform

[*] Interestingly, it was during this period that science educators like Bill Nye and Neil deGrasse Tyson saw a huge resurgence in popularity, elevating them to the status of social media icons.
[†] Canadians . . .

based on the topic, even if they had the occasional miss. Their video "Could You Outrun a Fart?," in particular, failed to meet expectations. "That video was a *really* tough challenge to figure out," Brown said. "Yeah, it was," agreed Moffit. "Because smell dynamics are *very* hard and interesting."

In many ways, being "the science guys" at the bar might have been the best training for their future roles as science communicators. "We were lucky in the sense that our friends were not into science," Brown explained. "And it forced us to start thinking, 'Okay, wait. How do we explain this to people who have zero background?'" Some of the popular topics they choose might be taboo in a classroom—everyday realities like masturbation and pubic hair—but would not be out of place after a pint or two when our curiosity gets the best of us. And the style they've honed is fine-tuned for an environment of easy distractibility too. All their videos are just a few minutes long, quick paced, and visually stimulating.

AsapSCIENCE came to prominence just as the "Explainer" format was taking off. These are videos that "explain" a single topic or question, usually in a brief period of time, using animation or other visual aids. The most popular ones may debunk common misconceptions or answer those everyday questions that rattle around in your brain. Creator CGP Grey became one of the masters of this with videos like "The Difference between the United Kingdom, Great Britain and England Explained" and "Daylight Saving Time Explained," which were both early hits. When TED launched its TED-Ed channel dedicated to "creating lessons worth sharing" in 2012, they combined educators and animators to achieve similar effects.

The most-subscribed education and science channels on YouTube, which include AsapSCIENCE, can draw a million hours of viewing in a month. So why are channels like AsapSCIENCE so successful in this environment? Why has the "Explainer" found such a natural home on the platform?

The AsapSCIENCE guys realized early on that nailing the titles was critical. For example, videos with titles that asked a question rather

than made a statement were more popular. "It was about piquing people's curiosity," Brown said. Moffit recounted one of their early debates: "We wanted to make an episode about Vitamin D, because it's like the coolest vitamin, and it affects your body in so many amazing ways. Obviously, the sun plays a big part in that, but for so long, we just thought, 'No one's going to want to watch an episode that's called "The Science of Vitamin D" or "The Sunshine Vitamin."' We were trying to come up with names like that. Eventually we landed on 'What If You Stopped Going Outside?'" That video has been watched over six million times. The insight underlying this discovery wasn't that question marks are more clickable, but rather that we are more interested in videos about us. Brown and Moffit needed to reframe their videos to make them more about the people watching than the concept itself. "Everyone experiences science," they said. "We need to let people know that this is about them."

THE "EXPLAINER" IS successful because it is programming driven by our curiosity. A video titled with a question triggers a near Pavlovian response within us. As Moffit explained, in the age of the internet, "you can't live *not knowing* once you've been brought into an environment with a question." In other words, we're so used to getting immediate answers to our questions that when one is posed to us, we *need* to know the answer immediately. But the AsapSCIENCE guys discovered that their most successful videos were ones that created an active experience for us. They found we loved illusions or vision/hearing tests, but also videos covering topics that we could discuss with others like pop culture events (e.g., "the dress") or surprising facts we could share with friends.

We don't just watch; these videos are also heavily shared. Unlike "how to dry out a water-logged iPhone that fell in the pool" instructional clips that we search for once (hopefully), these are channels we subscribe to and post on our social feeds. They have a natural place in our daily behavior, which begs the question, are these the new

educators of our time? "We are not a replacement for teachers," Moffit stressed to me. "We have three-minute videos that talk about loosely interesting things. When you have to actually learn something, you have to spend dedicated time to really learn and understand it."

At the same time, Brown and Moffit achieve the same thing as every good teacher I ever had: They make learning about foundational abstract concepts engaging and fun. Our experience of their videos is interactive—our commenting and sharing means that, whether we realize it or not, we're having the kinds of active discussions that have always helped us interpret and retain information. Much of what Brown and Moffit do taps into the same ways we've been processing knowledge for years.

What's changed is how we discover and interact with the things we learn from. Our views, our shares, our searches, and our comments all inform and increase the distribution of these videos and educators. "I don't know if the internet has magically made people learn in a different way," Moffit told me. "I think that the revolution of education through the internet is almost fully because of access."

A LITTLE ACCESS TO KNOWLEDGE . . .

One thousand eight hundred. That's the number of times people search YouTube for "javelin" each day. It's not a lot in the scheme of the platform's overall search volume, but it doesn't take a lot of views to have a big impact. Sometimes the potential of a web video to impact the world is not illustrated by the way *everyone* is using it but rather how an individual makes that video work for him or her.

Julius Yego grew up in central-west Kenya. He dreamed of athletic glory, but he wasn't a great runner, and, well, in Kenya that puts you at a disadvantage. Of the country's nearly one hundred track and field Olympic medalists, none were from the field events. But Yego had a strong, flexible, elastic hand, and as he got older, he became obsessed

with the javelin, practicing alone, despite his father's insistence that he give it up.

He didn't even have a coach. Instead, Yego would walk to the local internet cafe, where he'd watch videos of famous athletes like Jan Železný, a three-time Olympic gold medalist and holder of the top five javelin throws of all time. He studied their throwing motions and training methods. "I could see that training like these people could improve me," he later told CNN. "I started now using a different mode of training. Gym exercises. Flexibility exercises. Everything changed. I was always increasing my distance. My coach is me, and my YouTube videos." Yego won the gold medal at the 2015 World Championships and landed the eighth-longest throw in the history of the javelin. Back home, he became famous as "Mr. YouTube Man." At the 2016 Olympic Games in Rio, Yego became the first Kenyan ever to win a field event medal.

As you're probably figuring out by now, YouTube represents a vast collection of exceptionally uncommon and specific uses that are just as impactful as the universal ones. Much like an obscure research text waiting for the right grad student to come along, the value of the internet's obscurities is unlocked only when they are available to everyone.

For most of us, most of the time, educational videos on YouTube are simply a helpful modern convenience, but the availability of the right knowledge to the right person at the right moment can be a game changer.

LAUREN LARAY COLLINS, eight years old, of North Las Vegas, was sad when she heard her best friend's sister was undergoing cancer treatment. "And then I learned there are all these other little girls with cancer who've lost their hair," she told the local newspaper. "I want to help them feel a little more girlie." She told her father she was going to start making them wigs. He wasn't sure she was serious. She had never even made one before. But Collins watched tutorials on YouTube and got to work. "The first wig—she did it with ease," her mother said. Before

long, the Collinses found their table covered in Lauren's professional-looking wigs, and she was able to start delivering them to patients. The mayor of North Las Vegas named May 14, 2016, as Lauren LaRay Collins Day.

South Africa–born CJ Stander admitted to using a YouTube video to learn the Gaelic words to Ireland's national anthem after being drafted onto their national rugby team. I can't blame him. *"Le gunna scréach faoi lámhach na bpiléar, Seo libh canaídh amhrán na bhfiann"* doesn't exactly roll off the tongue on the first go.

The uses for the random bits of knowledge we absorb as we follow our temporary obsessions down their digital rabbit holes might not even be immediately apparent. Local authorities in Ko Lanta, Thailand, were trying to figure out what to do about a nearly seventy-pound cobra that had found its way under a bench outside a woman's home. Worawut Longasan, fifty-six, took charge, grabbing a stick and piece of rope and confidently captured the enormous snake using a technique he said he'd learned from a video online. Perhaps snake-catching techniques pass for standard viewing in some parts of the world, but I imagine that when Longasan lounged around watching "Must see new cobra capturing trick," he didn't know how handy it would become.

An incredible and ever-growing volume of instructional, educational content sits at our fingertips. Easy access for everyone opens up educational opportunities at the individual level that makes for inspirational unpredictability. The possibilities are endless and the future implications of such an enormous, organized collection of knowledge might go well beyond what we can imagine.

THE POTENTIAL VALUE of this curiosity engine goes even beyond humanity. In 2015, a research team of computer scientists at Stanford and Cornell universities recognized that the tutorials humans produce tend to follow a basic pattern. They developed Robowatch, a computer algorithm that could take a large number of YouTube videos and analyze

the visual information as well as the subtitles. The researchers fed in instructional video clips that were the results of popular "how to" searches on YouTube and trained Robowatch to break down the individual steps it observed within them. How to make an omelet, how to bake a chicken breast, how to make a Jell-O shot. Not only could the machine figure out the individual steps of complex tasks, it was even able to describe those activities. Just so we're clear, once an algorithm can break down the steps in a task, you're not very far removed from creating a robot that can reproduce that task in real life.

Yep, the giant archive of instructional material that is YouTube not only plays a role in enhancing our lives, it could also play a role in enhancing the artificially intelligent machines I presume will soon be ubiquitous. Cool or terrifying? You decide. Let's just hope they keep training them to make Jell-O shots.

That people use YouTube videos to learn should not be a surprise. You could say that we've been preconditioned for it for centuries. Visual learning predates other forms of learning, and most of us can accurately interpret graphic imagery by the time we turn one year old. "The research outcomes on visual learning make complete sense when we consider that our brain is mainly an image processor (much of our sensory cortex is devoted to vision), not a word processor," noted educational psychology researcher Riad S. Aisami in a 2014 study. "In fact, the part of the brain used to process words is quite small in comparison to the part that processes visual images." Additionally, the ability to manipulate those visual images in the videos we watch (stop and restart and controlling speed) has been shown to enable students to engage more fully in informational material. In other words, a platform optimized for repeated viewing of cat videos is also, bizarrely, similarly optimized to help your brain obtain and process skills and information.

The availability of millions of videos covering millions of categories changes the daily lives of everyone from prom kings to Olympic medalists in both subtle and tremendous ways. Our culture is, at least in part, defined by how we acquire and share knowledge, and web video has equipped us with more equitable and personalized access to that knowledge.

Of course, the most important type of control we have on YouTube is in choosing what we watch in the first place. As more and more of us sought or provided information online, the platform evolved into a giant library and over time, our collective curiosity has shaped its contents, both in terms of subject matter and creative approaches to teaching it. So what do our choices say about us?

Aside from quantifying just how much we like dessert, they demonstrate the aggregate power of our individual inquisitiveness. The internet doesn't need its own Newton N. Minow to question whether there is room "to teach, to inform, to uplift, to stretch, to enlarge the capacities of our children," or the rest of us for that matter. We not only made room for this type of media, we flocked to it, shaped it, and proliferated it. The broadcasters Minow dealt with back then used the ratings to defend their programming choices, but Minow argued that those ratings never actually reflected the interest audiences may have had in informative content, and it would seem he was right. But to be fair, broadcast platforms like television, whose programming had to serve the interests and needs of the masses, never could have unlocked the full power of video as a tool for learning.

On YouTube, it's the audience's curiosities that drive the programming. It's the audience's needs that determine the most valuable moments. Javelin-training videos or wig tutorials might not be useful to most of us, but such clips don't need to be. They need to be available only for that moment when one of us needs them. This is where obscure knowledge achieves life-altering potential and where the value of YouTube's myriad of niche applications starts to reveal itself.

Niche: The New Mainstream

IF YOU MET Jordan Maron on the street in Los Angeles, you prob-
ably wouldn't peg the twenty-four-year-old as a Hollywood type.
You certainly wouldn't guess that you could walk into a Toys "R" Us
and pick up a plush toy or action figure version of him. But you can.*
And the way his incredibly popular animated music videos get made
sounds a lot like what happens in a Hollywood studio. He begins by
storyboarding out every shot, since every frame in an animation needs
to be determined in advance. Next the digital sets are generated and
these "worlds" are transferred to animation software. "Then we animate
it, add in the effects, render it all out, combine it with the music, and
that's that," he said. This is where any similarities to the traditional
entertainment industry end.

The "worlds" Maron and his small team assemble exist within the
blocky, three-dimensional environment of a video game: *Minecraft*.
(The songs are about *Minecraft* too.) While the music videos are his
most popular productions, much of what he posts on YouTube, where
Maron is better known by his nom-de-video "CaptainSparklez," resem-
bles the kind of gameplay commentary you'll find from other popular
gamers. The audience he's found for these seemingly niche videos took
him from chemical engineering student to twenty-first-century enter-
tainment mogul in just a few short years.

Maron started publishing YouTube videos of his gaming exploits
because, as he put it, he "wanted to be a showoff," but he grew into a
legit entertainer. Ten million people subscribe to his channel and for

* He comes in three sizes and has his own custom sword.

many gamers around the world, he's basically a household name. In addition to having his own action figure, he launched his own game studio, XREAL, in 2015 and was named one of *Forbes*'s "30 Under 30" the next year.

While he got his start narrating his gameplay on the first-person shooter game *Call of Duty* and can be found playing all kinds of games, Maron, like many others, has seen his greatest success with videos about *Minecraft*. For the unfamiliar, *Minecraft* describes itself as "a game about placing blocks and going on adventures" and contains multiple gameplay modes where players can explore environments, battle enemies, and/or craft landscapes with textured cubes. The indie game (which was later sold to Microsoft in 2014 for some $2.5 billion by its Swedish founder Markus "Notch" Persson) became popular almost entirely through digital word of mouth. Maron, for example, discovered it through a friend. "We were playing games one night and he's like, 'Oh my god, I found this game where you could like, punch blocks and punch chickens, and it's the greatest thing that's ever been created, ever,'" Maron recalled. "This is the weirdest pitch," he thought. "But sure, I'll try the thing out."

Some gamers argue that *Minecraft*'s not really even a video game. It's become the LEGO of the digital world.° One of the game's most common social activities is sharing the things people build within it. Videos showing off players' elaborate creations, like a one-to-one scale model of the starship *Enterprise*, started flooding YouTube in late 2010. Things got more and more impressive with time. Take the "Kingdom of Galekin," a giant fantasy world constructed over the course of more than four years. Its creator, "Linard," sometimes spent more than eight

° I once heard a LEGO executive explain why LEGO did not become the LEGO of the digital world, despite releasing a similar piece of open-build software in 2010. Given the company's commitment to protecting the brand, they were required to manually review every creation before it could be shared with the community. They were most worried about a proliferation of LEGO penises and even tried to create "dong detection" software. It did not work.

hours per day working on it. "I became hooked on the idea of finishing it," he told *PC Gamer* in 2016. "My goal is to create the biggest, most detailed map ever in Minecraft." Anyone can now download the expansive medieval environment he built, though perhaps its primary purpose is to be displayed via YouTube videos. I've never played *Minecraft*, but I can't help being floored by the incredible detail and passion that clearly went into Linard's masterpiece. Over time, *Minecraft* went from just a game to an entire YouTube entertainment genre with a community of fans and creators who upload, watch, and discuss videos about it. "I would say it's a community broken into many, many, many, many subcommunities," Maron told me. Subcommunities might form around certain creators, ways to play the game, or types of videos, which range from role-playing (scripted and unscripted) to animation to instructional tips to demos of in-game modifications to podcast-like videos discussing current events.

Barely on the radar in 2010, *Minecraft* became one of YouTube's highest-ranking topics less than a year later, and by 2013, the word "Minecraft" was the #2 search query on YouTube (behind only "Music"). In 2016, people were spending close to twenty-five million hours each day watching *Minecraft* videos. No other games reached even half of that number. It was an entertainment monster. While *Minecraft* clips draw viewers of all ages—the average player is twenty-eight to twenty-nine years old—for younger audiences, these videos had become the equivalent of Saturday-morning cartoons. Channels like TheDiamond-Minecart and SkyDoesMinecraft drew millions of views every single day. (Along with Maron, the likenesses of Dan Middleton and Adam Dahlberg, the young men who run these respective channels, are also available in action-figure form.) People spent more time in the first half of 2016 watching videos from *Minecraft*-related channels than videos from the NBA, NHL, NFL, and MLB combined.

Much of the viewership on these channels comes from videos of creators recording themselves as they play the game and narrate. Because of the minimal production requirements, many of these creators

are *prolific*. Maron puts out at least two videos each day, most of them *Minecraft* related, on his CaptainSparklez channel.°

But the individual videos that drive Maron's biggest numbers are those animated song parodies and original tunes, like "Dragonhearted," an upbeat electronic dance number about a team of heroes taking on an oppressive villain. Given the laborious production required, it takes months between releases. When we spoke, seven people had been involved with producing his latest video. The majority of the modeling and animating has been spearheaded by an animator known as "Bootstrap Buckaroo" and vocals are handled by "video game singer" Igor Gordienko (aka "TryHardNinja"). The videos are a team effort, though Maron said he's interested in taking on more of the music production himself these days. Over the past few years, Maron's music videos (parodies and originals) have been watched more than half a billion times, making him one of many new kinds of entertainers who are defined more by the genres and communities they explore than the specific kind of videos they make.

While the dude with the *Enterprise* model indicated to me that a unique community was forming, it was the production value behind Maron's work and the big audiences that turned out for it that convinced me *Minecraft* could stand alone as a distinct entertainment genre. Not that my opinion matters here; the beauty is that it doesn't matter what anyone outside the community thinks.

Unlike many of us, Maron didn't find *Minecraft*'s seemingly improbable YouTube success all that surprising. He pointed out that given how many people in the world play video games, it was simply a matter of time before they gravitated toward one another and the kinds of videos he watches and creates. In a world where entertainment

° Maron picked up the name CaptainSparklez, a somewhat unexpected moniker for a gamer in his early twenties, before any of this blew up. It had occurred to him that, in the bizarre instance his old channel ever became popular, his previous username, "ProsDontTalkShit," might not be appropriate. "What if, one day, my channel somehow through some weird crazy circumstances had to be like written down in an article or in an interview?" he said. "It's going to be a problem if I have 'shit' in my name." That turned out to be a pretty smart move.

responds entirely to our interests, the rise of *Minecraft* as a video genre was not so much an anomaly as it was an inevitability.

<div align="center">◄◄</div>

"Not very long ago, media futurists believed that the TV dial would become the video equivalent of the corner newsstand," wrote the *Los Angeles Times* in 1991. "Thanks to the myriad channels offered by cable, viewers were promised as many program choices as there are magazines to read." (As many program choices as there are magazines to read!?) Despite noting that "the number of cable networks soared to 69 last year from 27 in 1980"*—that's right, *"soared"*—the *Los Angeles Times* pointed out that TV channels had begun to merge to avoid fighting for space and advertisers. Sure, there seemed to be a lot of channels, but the market forces that controlled them still kept the offerings quite limited.

When Discovery Communications launched OWN with Oprah Winfrey in 2010, it initially committed $100 million to get it off the ground. That wasn't nearly enough. The true challenge, though, of launching a cable network is not even the production or the equipment, it's getting one of the cable providers to actually carry it. While it might seem nutty given the seemingly endless list of channels in your onscreen guide, getting a slot on Comcast's lineup is like getting tickets to the Green Bay Packers: either someone has to die or you better be ready to cough up some serious cash. This, among other reasons, is why many newly launched TV channels rise from the ashes of old ones.

The obvious truth is that books, magazines, records, movies, and TV channels emerge from numerous supply-and-demand discussions. Unfortunately, market research into the potential demand for formats and genres that do not yet exist remains expensive, inconsistent, and

* For comparison, the average American home received 189 TV channels in 2014. That's the *average*. (I don't have cable anymore, but I'm fairly certain 70 of those were just ESPN.)

relatively rare.* Creating something to serve a new and nonderivative audience need is not easy. And not cheap.

One imagines that a *Minecraft* TV channel or even show wouldn't have made it past an intern's desk in Manhattan or the Valley. For many years, part of our pitch to potential YouTube advertisers and media industry folk was that whereas a cable company could only offer a handful of possible channels that could, at best, approximate the interests of the audience, YouTube could deliver a giant long tail with hours of programming from an endless array of channels suited to the specific tastes of everyone, no matter how narrow. A lot of us at YouTube saw this loose cable TV allusion as a helpful way to clarify the value of niche programming, but I've found that it's a metaphor that misses the true value of the niche experience on YouTube.

* Which is why if you have ever looked at an actual magazine rack, half of them look pretty much the same. For example, as a teenager I could never discern the difference between *Redbook* and *Ladies' Home Journal* other than the former seemed to acknowledge that sex existed.

THE DAMN VEGAN COOKING CHANNEL

From about 2011 to 2012, YouTube executives were obsessed with vegan cooking. It felt like one could not go a single week without hearing someone reference "vegan cooking channels" in a team meeting or update email or press interview, and I would not-so-quietly groan each time. It was like the future of technology laid not in machine-learning algorithms, but in pan-fried seitan. I have absolutely nothing against veganism or cooking channels or any combination thereof, mind you. I guess I just have a low tolerance for business clichés. And this one got beaten to death.

Mentioning channels dedicated to vegetarian or vegan cuisine became shorthand for a larger philosophy: that YouTube could offer a kind of specificity in programming that would be unparalleled, the breadth of which would make it indispensable to viewers (and, of course, those advertisers trying to reach us). That line of thinking was not wrong. But I personally found that the niche-channel phenomenon was best

captured when the genre or format ran totally counter to what traditional broadcast audiences might find interesting.

I seemed to stumble across at least one example of this each week. Often they were amazing, like the time that we found a channel run by a boy named Robbie called The King of Claws and my whole team ended up engrossed in a land of shockingly popular channels operated by claw-machine aficionados. I think we all lost at least an hour that week to watching people win stuffed toy prizes in arcades around the world. (We later discovered that people spent about two hundred thousand hours per day viewing claw-machine videos in 2016 alone.)

One of my other colleagues became obsessed with something called "먹방," or "mukbang," a phenomenon that emerged in South Korea in 2013 through video site AfreecaTV before gaining international interest in 2015. A portmanteau of the Korean words for "eat" and "broadcast," mukbang videos star often-attractive young people eating absurd amounts of food. We're talking pounds and pounds of noodles, dumplings, and fried chicken noisily slurped and devoured over the course of hour-long broadcasts. During dinnertime hours in 2015, more than forty-five thousand Koreans watched these livestreams simultaneously. Top stars earned $10,000 per month on their streams alone. These "broadcast jockeys" (unfortunately abbreviated as BJs) have become quite popular on YouTube too. Yuka Kinoshita launched her YouTube channel in 2014 and within two years had amassed more than two million subscribers and more than half a billion views.* Some people believe mukbang acts as a vicarious culinary experience. "Viewers who watch my mukbang are on a diet," Rachel Ahn, who streams weeknights at 9 P.M., told NPR. "So you call this a sort of gratification through others." Others say watching helps combat loneliness by re-creating the communal/social eating tradition common in many cultures. Whatever the reason, people watched around five hundred thousand hours of the stuff each day on YouTube by the end of 2016.

* For those wondering, being a successful mukbang "broadcast jockey" and not killing yourself involves a lot of exercise. Five-foot-nine-inch BJ Banzz, who has more than one million subscribers on YouTube, says he works out six to ten hours per day.

Talking about strange types of channels like these in unfamiliar company is a great way to keep your existing pool of friends at a manageable size, but they're not specifically intended to be broadly palatable in the first place. Comparing them to genre-focused TV channels misses the point because these niche YouTube channels transcend genre altogether.

ONE OF THE first trending phenomena to unfold right after we launched YouTube Trends in 2010 started at a Macy's department store in Philadelphia. That October, the Knight Foundation kicked off an experimental project called "Random Acts of Culture" that attempted to introduce the arts into people's everyday lives. They plotted to pull off one thousand acts (and they did), but the most impactful one occurred in their very first month, when they sent the Opera Company of Philadelphia and 650 choristers to Macy's to perform the "Hallelujah Chorus" from Handel's *Messiah* at the strike of noon. Shoppers were stunned. Many took photos with their phones. Some people cried. Obviously, the video turned into a predictable hit. (2010 really felt like *the* year of the flash mob, didn't it?)

Two weeks later, a photography firm in Ontario, Canada, gathered a local community choir to stage a similar stunt at the Seaway Mall not far from Niagara Falls. The video they made turned out to be one of the most-watched clips that month and the most popular example of what became the prevailing video trend that holiday season. Suddenly, shopping-mall food courts across the continent became weekend targets for organized groups of singers performing the "Hallelujah Chorus" as unsuspecting onlookers wolfed down Panda Express Sweet and Sour Chicken. I haven't been able to prove it with data, but I'm fairly certain every mom in North America watched one of these videos at some point. Especially the churchgoing ones. "That's the beauty of the Web," Dennis Scholl, organizer of Random Acts of Culture, told the *New York Times*. "You can create a sense of community that isn't geographic." Many of the "Hallelujah flash mobs" that hit our most-shared feed each

day had been staged by church groups. Not-very-impromptu impromptu chorale became the hottest thing in community ministry. (Some preachers now even refer to Palm Sunday as "the first flash mob.")

The massive display of sincerity that comes with nonstop attempts to surprise people with Christmas carols at shopping malls—besides being the most Midwestern thing ever—underscored how community-driven entertainment could resonate deeply with the non-nerds among us. While us tech company heathens don't often admit it, religious groups have proved to be among the most skilled online communicators, which makes sense given their centuries of experience disseminating messages and stories.

We're not just talking about random viral videos either. While not widely publicized, a few times a year the top livestreams on YouTube are broadcasts from the Church of Jesus Christ of Latter-day Saints Conference Center in Salt Lake City. While that fact raised some eyebrows, it's completely logical. If you are one of the many Mormons who can't get to Utah to watch the semiannual general conference in person or on local TV, I suppose YouTube is the next best thing. Lots of creators have amassed large audiences with explicit or subtler religious themes. Jefferson Bethke—who now has more than six hundred thousand subscribers—first broke out with a spoken-word hit video titled "Why I Hate Religion, But Love Jesus," which turned into something of a trend itself when the devout of different faiths around the world began creating responses. Suddenly, Muslims, Christians, and atheists were watching, sharing, and discussing views on religion in the same way that others took on the latest dance trend. But religious videos and channels draw consistent audiences outside of these trends too. In 2016, the amount of time people spent watching videos related to religion on YouTube was more than three times that of videos related to basketball, baseball, and ice hockey combined.[*]

[*] Soccer comes closer, but even the world's most popular pastime can't beat out God, apparently. *[Looks quietly at Maradona]*

Religious themes don't often appear in pop entertainment (*The Exorcist* doesn't count), nor do many other areas of interest that might be deemed divisive or lacking in broad appeal. It's even hard to find traditional programming related to popular crafts, like knitting or woodworking. But when you look at the YouTube data, it's clear that we flock to videos and channels that represent something we care about. I mean, people spent more than three quarters of a billion hours watching knitting videos in 2016 alone.

Among YouTube's diverse offerings, content that speaks to aspects of our identity or our personal philosophies, be it faith, politics, or just hobbies we're passionate about, is just few clicks away. Within the context of mass media, which reaches a broad audience, this type of subject matter might be considered alienating or even off-putting. But on the web, where entertainment can be specific and targeted, they often flourish.

TO BE CLEAR, optimizing for specialized audiences can result in expression that advances negativity when the philosophies or goals of those audiences aim to antagonize or demean. I've seen too many things that come close to crossing the line of hate speech, and I think we'd all agree that even if you believe everyone should have a voice, there are some voices that don't deserve a megaphone.

We can't let such aspects the digital video environment go unacknowledged, but I do believe that the niche experiences that most often win out are the ones that help you and me and everyone else fight alienation, not create it. Exemplifying this are YouTube creators celebrating natural hair, who have inspired many young black women to feel a stronger sense of self-identity, and transgender creators who have helped change the dialogue about one of society's most misunderstood groups.

It is the passions and interests of everyday people, not business strategies, that leads to the growth and proliferation of these niche communities and genres. Our enthusiasm spawns the knitting channels

and the mukbang channels and, yes, the vegan cooking channels. And while many of those are destined to remain truly niche, some of them are poised to break through to the mainstream.

WHEN NICHE STOPS BEING NICHE

Thousands of fans erupt in cheers. One dude a few rows in front of me grips his hair in absolute disbelief at what has just unfolded. Madison Square Garden is sold out and the crowd is losing its mind. I, meanwhile, have no goddamn idea what's going on.

After deciding years ago that this was something we needed to see for ourselves, my colleague Jeff Rubin and I finally got hooked up with tickets to the annual *League of Legends* world tournament. *League of Legends*, or *LoL*, is a multiplayer online battle arena video game played on PCs around the globe, and in October 2016, New York City hosted two nights of the world semifinals. South Korean teams SK Telecom T1 and ROX Tigers faced off for a chance to compete for the Summoner's Cup at Los Angeles's Staples Center. I'm not sure what I was expecting,° but in the center of the arena sat ten computer stations (five facing five) below four enormous screens controlled by an unseen crew tracking the action as it played out across the expansive fantasy battlefield. The peculiarity of watching ten scrawny gamers compete in one of the most legendary American sporting venues—home of Ali vs. Frasier and so many other major moments in the history of athletics—was not lost on me.

Professional competitive video gaming, or eSports, were relatively easy to dismiss (and make fun of) during the late '90s and much of the 2000s. The occasional competition would be aired on television, like the short-lived World Series of Video Games, but it would be a stretch to

° This is a lie. I knew exactly what I was expecting, and it was basically that climactic scene with Fred Savage from 1989's *The Wizard* where they play *Super Mario Bros. 3* for $50,000. BTW the teams in the 2016 *LoL* Summoner's Cup competed for a $6.7 million pot.

say very many people took it seriously. By the 2010s, however, improved technology meant that live broadcasts of professional and amateur competitions could be streamed reliably by gamers around the globe. YouTube viewership of these events dramatically increased between 2012 and 2016 and Riot Games' *LoL* and Valve's similar *Dota 2* emerged as the top dogs.

In *LoL*, the goal of each team is to destroy the other team's base, though that is basically like describing the goal of American football to be to move a ball across a line. It's a game of both physical skill (you need sharp reflexes and timing for all that clicking) and mental acuity (to employ a great deal of statistical strategy). And, once you understand how it works, it's very fun to watch (so it seems). Determined to get into the spirit, I picked a team (SKT) and a player ("Faker," actual name: Lee Sang-hyeok) to root for. How could I not pick the guy ESPN has called the "undeniable greatest of all time" as well as—wait for it—the "Unkillable Demon King"? Even Ali didn't have a nickname that wonderful. Professional gaming has many of the same tropes we appreciate about professional athletics: underdog story lines, dramatic comebacks, running rivalries. The crowd's energy is fun to feed off. A gentleman behind me explained that the scene in MSG couldn't even compare to the scene he witnessed in Seoul at a previous final.

The bartender told me this is definitely one of the stranger events she's worked at the arena, but she's happy enough because people are buying more alcohol than she expected. While nongamers might expect to see tons of kids in the crowd at a video game tournament, I saw none. Ninety percent of the crowd seemed to be in their late twenties and, judging by the surprisingly orderly yet lengthy bathroom line, male.

LoL is arguably the most mainstream eSport game, despite being—to me, at least—stupidly complicated. While the rules for the most popular athletic sports can get obtuse, you can usually at least get a sense for what's going on pretty quickly without needing a manual.° But

° I say that, but I was once watching a college football game with a Swedish friend who'd never seen the game played and asked me to explain. At one point, the team kicked a field goal on 4th and 4, but the defense had jumped offside, so they accepted the penalty in favor

LoL is just soooo layered. Even Jeff, who is quite the gaming guru and estimates he's played *at least one hundred hours of the game*, often found himself puzzled at what exactly had transpired. When skirmishes break out between the competitors, there's so much happening that it can be hard to process even in slow motion. At any given moment, there are no fewer than seventy (seventy!) different numerical indicators displayed on the screen. "It's super competitive and uncompromising on that deep mastery curve," one of the game's cocreators, Brandon Beck, said in an interview about its origin. "It would take a real commitment to get any enjoyment or value out of it." I suppose that's part of the appeal, as there's never an end to the depths you can explore as a fan. At one point, the announcers claimed that one team had endeared the crowd with their relatable personalities, which made me laugh because, from my vantage, almost all ten of the players remained basically expressionless through each forty-five-minute match in the best-of-five series.

Five hours later, Faker and his SK Telecom comrades took the fifth and deciding game in dramatic fashion, completing an exciting series that would be dissected online by fans for days. I dramatically fist-pumped for a second when it became clear my team had victory in sight, but then I remembered that I was cheering on a team that I had chosen arbitrarily as they competed in a game I barely understood. (Whatever. SKTelecom4LIIIIIIFE.) When I checked YouTube's livestream, more than two hundred thousand people from all over the world were tuned in at that exact moment. One week later, SK Telecom defeated Samsung Galaxy to win the championship, their second in a row, before an estimated audience of more than forty-three million. These world championship matches were among the most-watched livestreams on YouTube for the year.

Gaming entertainment has exploded over the past decade. A Nielsen report found that almost two thirds of the U.S. population plays video games on some device. A quarter of YouTube's top one hundred

of the first down. To save us both from passing out as a result of the mental expenditure required to comprehend what had just occurred, I gave up and told her to basically ignore everything she'd just seen for both our sakes.

most-subscribed creators in 2016 were predominantly gamers. It's become a big business too. In 2014, Amazon acquired livestream gaming platform Twitch for nearly $1 billion. All told, gaming has become a huge mainstream entertainment genre, right under everyone's noses. And it's a genre with huge thematic diversity. In 2016, the number of individual games for which associated video drew more than a million hours of viewing topped thirteen hundred. It's been hard for traditional entertainment platforms to create the kind of content that can tap such varied audiences. It took a breadth of offerings only the web can support to make the gaming entertainment explosion possible. What was supposedly a subgenre with narrow appeal turned into a massive creative opportunity with major demand.

AFTER GAMING, BEAUTY and fashion creators rank among the next most popular atop YouTube's charts. In 2016, the most-subscribed woman on YouTube, behind only major popstars like Rihanna and Taylor Swift, was Mariand Castrejon Castañeda, a cheery twenty-three-year-old from Mexico better known as Yuya. Yuya's Spanish-language lifestyle videos, which range from nail polish tips to cooking to home décor, have made her famous across Latin America; more than fifteen million people follow her handiwork, and everything she posts achieves millions of views. You'd be hard-pressed to find many lifestyle hosts on any platform that command that size of audience. One of her English-language counterparts, Bethany Mota, who also helped popularize haul videos—the mall-shopping equivalent of an unboxing video—built such a sizable fanbase that it enabled her to develop a clothing and décor line, launch a singing career, appear on *Dancing with the Stars*, interview the president, and grace a whole bunch of YouTube-produced television ads and billboards all before she turned twenty.

The "Fashion & Beauty" creator community has birthed some of web video's biggest stars over the years. And its ranks are not entirely composed of women either. After years of watching beauty tutorials on

YouTube, New York teenager James Charles started posting photos on Instagram as a way to drum up business for his makeup services during prom season, but his following quickly grew, and he launched an attention-grabbing YouTube channel shortly thereafter to demonstrate how to re-create some of his more dramatic looks. In 2016, at the age of seventeen, Charles was officially named CoverGirl's first ever CoverBoy.

The web provides the opportunity for niche content creators to explore their interests and embrace experimentation. In some cases, as creators in the fashion and beauty community have found, those niches can stop feeling like niches pretty quickly as audiences flock to those creators whose seemingly narrow interests are actually widely shared. On YouTube, what starts out as niche can snowball into an entire content pillar of channels with its own stars, trends, and more, achieving mass media levels of exposure and changing mainstream perspectives in swift and meaningful ways.

IN 2010, COLUMNIST Dan Savage wrote emotionally about the suicide of a bullied fifteen-year-old boy in Indiana. One of his readers left a comment directed at the boy, saying, "My heart breaks for the pain and torment you went through . . . I wish I could have told you that things get better." The sentiment got Savage thinking: Despite all the torment he and his husband experienced as kids, things *had* gotten considerably better for them. But most of the young people experiencing that torment have little opportunity to hear about happy outcomes. While Savage regularly spoke about homophobia and intolerance at universities, he certainly never received invitations from high schools or middle schools. Such a thing likely would be impossible given pressure from parents and religious groups in most of the country. Talking to youth about life as a gay man, he felt, would be viciously labeled as some kind of lifestyle indoctrination. It was a topic that fell outside mainstream teen pop culture, and one that the institutions teenagers spend their days within seemed set up to ignore altogether.

"I was riding a train to JFK Airport when it occurred to me that I was waiting for permission that I no longer needed," Savage wrote. "In the era of social media—in a world with YouTube and Twitter and Facebook—I could speak directly to LGBT kids right now. I didn't need permission from parents or an invitation from a school. I could look into a camera, share my story, and let LGBT kids know that it got better for me and it would get better for them, too. I could give 'em hope." Savage launched the It Gets Better Project with the goal of getting one hundred people to post videos discussing how life, despite the experiences of their youth, got better. People uploaded more than fifty thousand. They spanned gender, race, and orientation. Countless celebrities made them. The staffs of many major tech companies, including Google, Facebook, and Apple, made them. One of the most famous ones came from President Obama.

The massive scale of the It Gets Better Project sent a positive message to LGBT kids, letting them know that more than fifty thousand people were rooting for them. The diversity of voices posting these videos played a role in the success of the project too. A teenager might respond to a video from a pop singer or a YouTube star while their parents connected with one from a politician. The breadth of different videos made it possible for every social group—from Orthodox Jews to tech nerds to soldiers and police officers—to connect with at least one of them.

It Gets Better was part of a larger movement in digital media in which the minority perspectives on social issues like marriage equality, racial justice, and gender identity could influence the mainstream without requiring access to mainstream mass media instruments. "The internet has caused the perception of LGBT+ people to change," YouTube star Tyler Oakley said in an interview with the *Telegraph* about his support of the Trevor Project, which fights LGBT youth suicide. "And now, when I talk to the younger generations, I know that the future will be just fine thanks to the openness and opportunities the internet promotes. These young people are so socially aware and

socially conscious, and just so passionate about what they do . . . To them, it's refreshingly a 'duhh' kind of thing, it's obvious now. Whereas, with past generations, there has been a lot of debate about rights and equality. But with all the role models and discussions they can freely join in with now, gay rights and being gay has become just second nature; a part of everyday life."

IT'S NOT ABOUT THE ELEVATORS

I have never been to San Antonio, but, rather strangely, I know what it's like to ride an elevator twenty-four floors at the Grand Hyatt San Antonio hotel. I've watched a first-person perspective video on a YouTube channel called DieselDucy in which an excited man intermittently narrates the ride as he films. "Guess what? It's an Otis!" he points out upon entering. "*This* is a high-speed elevator," he declares upon reaching the twenty-fourth floor. "Look at those LED lights," he says as he films the elevator's ceiling. "I like that button, look at that," he adds, pointing at what appears, to me at least, to be a run-of-the mill elevator button. "That is cool." When I watched the video, it had already been viewed 279,119 times. "DieselDucy"—aka Andrew Reams of Roanoke, Virginia—has many, *many* other videos of elevators, and the Hyatt in San Antonio is not even his most popular (that distinction belongs to a five-minute-and-thirty-four-second clip titled "Beautiful Otis Scenic Traction elevator @ 2 Eaton Harbour Centre Hampton VA"). In all, DieselDucy's videos have been watched more than *eighty million times*. You read that right.

"Ever since I was a little kid, I've loved elevators," Reams, a thirty-nine-year-old man with Asperger's syndrome, told me. He can still remember his first ride at a since-demolished Famous-Barr department store in Des Peres, Missouri, he visited with his mother at age two. "I was like, 'That's scary. I don't wanna go in there.' And she's like, 'It's magic. When the doors close and open, you're gonna be

somewhere else.' So I get in there. She lifts me up. I press the button. The doors close, and a minute later they open. I think, 'Wow, that was fun. I wanna do that again.' So ever since then, I've just been totally intrigued by them," he said. "Other people take pictures of flowers. Instead, I would go around taking pictures of elevators." Rather than heading to the park to play, Reams's father took him to office buildings so he could ride the elevators.

One day in the fifth grade, he spotted a VHS camera on the school's A/V cart. He'd just read a magazine article that, in a photo caption, identified the article's subject as standing in an elevator at a Marriott Marquis in Atlanta. "I've got to go down there and videotape those," he thought to himself. A few years later, in 1993, when Reams was fifteen, his father's secretary offered to lend him her sister's Handycam and take him for a visit to the Atlanta hotel and the elevator that had so captivated him. "I was in heaven," Reams said. "I wore out that VHS tape watching those elevators over and over again." Reams was able to buy his own camera eventually, but he found making home movies to be less than rewarding. "If I can't share them with anyone, what's the point in taking the video?" he thought. In 2006, a friend suggested he check out a new video site called YouTube. He created a channel and posted an odd assortment of very brief clips: a lock spinning, a plane taking off, a construction vehicle running a red light. When his job took him down to Atlanta for a training, there was one opportunity he couldn't pass up: recording a new video of that magical elevator in the Marriott Marquis. He uploaded the video of his ride along with a few others to his channel where he let them sit.

When he returned to check his channel's progress, "my eyes about popped out of my head," Reams said. His videos had hundreds of views and a growing number of comments. "Who's watching this crap?" he recalls thinking. Up until that moment, Reams believed himself to be the only human out there with an elevator obsession, but here were all these commenters requesting footage of more elevators. Reams soon filmed every elevator he could in his town, often sneaking into buildings to do it and drawing lots of strange, confused looks from the

people he met along the way. After a year or so, he noticed that more channels operated by other elevator enthusiasts were popping up. A whole elevator-video community gathered online to post, watch, and discuss amateur footage recorded inside something many of us use every day without thinking twice. Today, there are hundreds of channels dedicated to elevators from France, Italy, Sweden, Norway, Denmark, Poland, Indonesia, Israel, and the Netherlands, among others.

Reams was delighted to learn that there were other people out there who also enjoyed watching footage of a well-maintained Thyssen-Krupp Synergy elevator, and soon made another discovery. "I'd say a good seventy to eighty percent of my viewers have autism," Reams told me. While certainly not the rule, young people with autism make up the largest segment of elevator enthusiasts, both in terms of viewers and video creators. "It's the multisensory experience," Reams said of riding elevators. "It stimulates several of your senses—sight, sound, feeling—and you have some degree of control over it too." (Therapists advise that activities engaging multiple senses can calm and organize the minds of children with autism.) "A lot of these kids, they sound just like me on camera," he told me. "It's funny."

In the last decade, Reams, a freight-train conductor for Norfolk Southern Railway, has uploaded more than 2,750 videos on his channel. Many of these clips are unrelated to elevators, but it's the elevaTOURS, as Reams refers to them, that he's best known for. It's even made him something of a celebrity in what I imagine is the very small world of elevator manufacturing. A few times each year, his contacts in the elevator industry foot the bill for him to come and document their latest projects. Before the new One World Trade Center (and its famed high-speed elevators) opened to the public, Reams was invited for a sneak peek and tour of the machine rooms.

THE FIRST TIME I came across these elevator videos, I couldn't really believe that people were watching this stuff. I didn't know anything about the community that had formed around them nor the

autism connection. Subcommunities like these represent my absolute favorite thing about platforms like YouTube; they draw people together around the hobbies or topics that are not just of interest to them, but define a part of who they are, providing a sense of belonging.

You can find this type of passion in many of YouTube's ultra-niche enthusiast communities, like the channels dedicated to American Girl Stop Motion (#AGSM), intricate and often laborious short films made with the dolls, or LPS Tube, movies made with toys from the Littlest Pet Shop franchise. Many subcommunities are not quite so peculiar. Outdoor adventurers might belong to the BASE jumping community or voracious readers might be a part of the BookTube community. The latter started as a microcommunity and has grown into something larger in recent years with "BookTubers" pulling hundreds of thousands of subscribers and capturing the eyes of many publishing house publicity departments. Moms on YouTube even have an annual YouTube Mommy Meetup.

In 2013, Reams considered quitting YouTube. He was having fun, but it all started to feel a bit repetitive, a shocking revelation from someone whose favorite pastime is already, you know, riding up and down elevators. But he had an epiphany. "It's not about the elevators," he realized. "The elevators are simply a vehicle or form I'm using to connect with these people."

Initially, Reams and his new elevator friends communicated entirely through YouTube comments and messages, but eventually, they began to meet up and sometimes collaborate on filming elevators together. Jacob Bachta, who runs The Elevator Channel, and Reams really hit it off. Bachta lives in Saint Louis, so he and Reams are able to meet up only around twice a year, but they now talk every other day. "He's probably my best friend, and had I not gotten on YouTube, I would not know he existed," Reams said.

He also began speaking at autism conferences and seminars and talking to parents of children with autism about how to handle their sons' and daughters' fascinations. As often as ten times a year, fans even come to Roanoke to visit him. Reams told me that a mother of a

young fan once likened her child's experience to visiting their own version of Disney World with Andrew Reams as their Mickey Mouse. That a thirty-nine-year-old man with Asperger's has the same degree of cultural sway with certain children spread out across the country as the most identifiable cartoon character in media history is a bizarrely twenty-first-century occurrence. It would have been inconceivable in the days before YouTube.

In a world with so much divisive media and relentless self-expression, sometimes it seems just as easy as ever to feel alone. But the web's subcommunities drive us toward one another, rather than away from one another, altering our views of the world and ourselves. And that can be particularly powerful for those most likely to feel marginalized.

"When I was younger, I thought I was weird because I liked elevators," Reams recalled. "I hid it because there was nobody else. And now that there's a whole community, and it allows these kids to come out of their shells and not feel ashamed of themselves. They don't have to be scared to be who they are."

Traditional entertainment is designed for broad comprehensibility. Even when targeted to specific audience demographics, mainstream content uses devices that ensure basic levels of accessibility to the uninitiated. Plots are recapped, a standardized set of formats are employed, the same familiar genres of storytelling are reused over and over. But YouTube creators don't have to focus on content that known quantities of audience will flock to; specialized content in this environment finds its audience.

Niche content on YouTube is optimized for those niche audiences and their familiarity with the topics covered. The resulting programming can often be impenetrable and off-putting to those of us outside that community, but if you make <i>Minecraft</i> videos, you don't really

care whether non-*Minecraft* fans watch your stuff. In fact, fans are turned off by videos that pander to outsiders.

For people who wanted to think about web video channels as analogous to TV channels, YouTube became the test case for what would happen if your TV programming guide contained an *infinite* number of choices. When the costs of distribution are removed from the equation and the costs of production can be reduced to essentially nothing, there's no limit to the variety of things that can be explored. The value is clear: a long-tail of entertainment options that can appeal to any type of viewer.

TV channels, however, are designed for a prospective audience whose perceived tastes match the channel's programming. On YouTube, the audience defines programming as much as the creators. Our reactions as viewers shape what entertainment is now much more directly. Niche genres popped up that were indeed matched to our specific interests, but they evolved and grew to the point that some of these supposed "niches" began pulling huge viewership. The channels that supported what were previously obscure or unknown genres—like Jordan Maron's gaming videos or Yuya's lifestyle vlogs—could achieve a level of brand recognition and audience strength that rivaled the influential mainstream franchises I remember from my youth.

The staggering scale of *Minecraft*, eSports, and beauty content doesn't tell the whole story about what niche entertainment does for us, though. As it turns out, the narrower something becomes and the more tight-knit the community around it is, the more acutely these videos and channels serve our universal need to connect, to feel as though we belong to something that extends beyond ourselves. It's a need we've always had, but one that twenty-first-century entertainment technology—as opposed to all those magazines on the corner newsstand or mainstream TV shows—is uniquely positioned to satisfy. The entertainment that can truly change people's lives is often the entertainment that has the narrowest appeal.

Scratching the Itch

THE EFFECT OF the entertainment niche-ification that YouTube made possible went beyond opening opportunities for new communities to form and new content genres to succeed. Access to endless, distinct channels and video formats also opened the door for content that serviced a deeper and wider range of audience motivations. New types of content had begun to expand the definition of entertainment, capitalizing on cravings we already had but might not have been recognized—by the media industry or even ourselves.

"Good evening, this is Maria again with you," whispers a pleasant-looking woman with big hoop earrings and long blonde hair. "This video is going to be dedicated to your relaxation." In the video's description, she writes that she is "going to do a few different effects to hopefully give you tingles °fingers crossed° and to help you feel comforted and relaxed."

I have put on some good noise-canceling headphones so I can hear every word she says. It's not *what* she's saying so much as it's *how* she says it. She whispers in a voice so soft and quiet that you can hear the light smacking of her lips opening and closing, her tongue connecting with the roof of her mouth, her breath passing through her teeth. She picks up a hairbrush and rubs her fingers across it, then lightly taps it before running it through her blonde locks.

Ten minutes later, Maria is rubbing a feather across her face. (Yeah, this video is sixteen minutes long.) I can't place her accent; it sounds vaguely Eastern European? "Don't worry about anything," she whispers softly. "Everything is going to be all right." I listen intently, waiting for that effervescent sensation I've heard about to creep down my spine.

This is not the first time I have attempted to experience the effects of Autonomous Sensory Meridian Response, better known as ASMR, via a YouTube video. Considering the popularity of these videos, there's a good chance you've given it a go too.

What is ASMR? "Enthusiasts describe the feeling as a reliable low-grade euphoria in response to specific interpersonal triggers, accompanied by a distinct sensation of 'tingling' in the head and spine," wrote medical researcher Nitin K. Ahuja in the first piece of academic writing about the phenomenon (and one of the few that exist). A yet-to-be-defined percentage of the population experience some form of this, and I want to know if I'm one of them. Accounts of ASMR seem to vary, and there's little in the way of scientific inquiry. There's no doubt that ASMR fans are feeling *something*, though. One comment on Maria's video read, "I twitched so much while watching this . . . The combination of twitching and tingles made me feel like I was losing control of my own body. It was intense." How could you NOT want to try that out for yourself?

The term itself was coined in 2010 and began to enter the public consciousness in 2011, when it saw a dramatic rise in interest.

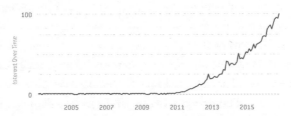

Note: Global Google search interest for "ASMR" queries 2004–2006

Maria is the star of the Gentle Whispering channel, which has more than eight hundred thousand subscribers. Her videos have been seen more than 250 million times, and the one I was watching—titled "°_° Oh such a good 3D-sound ASMR video °_°"—was her most

watched, with more than seventeen million views. She has over 250 videos, ranging from "~ Relaxing Fluffy Towels Folds ~" to "°Whisper° NY Times newspaper article reading." Gentle Whispering is the most popular channel on YouTube dedicated to ASMR, but it's far from the only one. There are many, many "ASMRtists" including Heather Feather ASMR, Massage ASMR, and Cosmic Tingles ASMR, each of which have more than one hundred thousand viewers subscribed.

"I just woke up. I'm sorry if my voice is not to your expectations," Maria said from her home in Baltimore when we first spoke over the phone. She had yet to perform her vocal preparations for the day, which include singing, drinking special tea, and eating apples and honey. Despite her concerns, her voice was *precisely* what I'd expected and I'd characterize our conversation as the most soothing interview ever.

Maria had her first experience with ASMR as a child in Lipetsk, Russia. She and a friend were playing "teacher and student"—Maria was the student—when something about the way that her friend spoke and flipped the pages of a book triggered a sensation within her. "At that moment it was just a rush of champagne bubbles traveling through me," she recounted. "I couldn't figure out exactly what it was, but it was such a pleasant feeling, yet overwhelming." The feeling would return occasionally as she was growing up. "Mostly it was from people with very soft voices, with slow and deliberate movements."

In 2009, Maria, who'd immigrated to the United States when she was nineteen, found herself dealing with the emotional toll of a divorce. She turned to meditation videos on YouTube to calm her anxiety and, one day, discovered something called a "whisper video" showing up in the related videos section. The video featured a woman named "whisperflower" who, not surprisingly, *whispers* in English and Russian. "As I heard her voice, it just hit me like a brick wall. That was it. It was such a strong sensation." This was also the moment Maria realized she wasn't alone. "I started looking through the comments and a lot of people were saying exactly the same thing that I was feeling." Over the

next year, Maria became a regular viewer of these videos, which she credits with enabling her to overcome her anxieties.

"After a while I noticed that a lot of people concentrated on whisper videos, but nobody did other things that I would want to see," she said. So in 2011, Maria launched her own channel, Gentle Whispering. At the time, Maria was working as a receptionist at a medical supply store. Her audience started quite small, but after about two years, she'd amassed more than one hundred thousand subscribers, and in 2015 she quit her receptionist gig and earned a living by focusing on her channel.

Nearly every person I chatted with in the course of researching ASMR who was not already familiar with it had pretty much the same reaction: *Damn, that's a weird sexual fetish.* I must confess that this was also my first impression, and despite the insistence in online forums from ASMR enthusiasts to the contrary, I remained skeptical that it was more than a new kink. Many of these channels star rather attractive young women; it's not hard to find explicitly erotic ASMR audio on the web; and "role-playing" scenes are quite common. It all suggests that ASMR is a sexual fetish. But maybe not.

Maria's audience data is almost perfectly divided between males and females. (In fact, it skews slightly female.) And there are a fair number of male ASMRtists. While this might confound your gender expectations, it's not proof that ASMR is a nonsexual phenomenon, of course. In fact, as one friend of mine—who would be very excited to know she was quoted in this book but displeased to discover it was in this context—put it, "Feathers and whispering might be exactly what a female audience *would* find arousing." The internet *has* predisposed all of us to assume that anything we do not understand on the web is just some fringe perv-ball thing. But in 2015, two researchers in the United Kingdom published results from a study that anonymously surveyed a sample of individuals who congregated in ASMR forums and groups. They found that only a "small number of individuals (5%) reported using ASMR media for sexual stimulation, with the vast

majority of participants (84%) disagreeing with this notion." The largest number of respondents used it to sleep or deal with stress.

One theory for the high percentage of female ASMR creators is that the softer tones of many women's voices might be better suited for it. Maria thinks there may be a deeper psychological advantage as well. "Women themselves are very nurturing creatures by nature, so we see them as a softer, more caring gender," she said.

At the time of our conversation, Maria's videos were being watched more than a quarter of a million times per day and climbing. The average view duration was nearly eleven minutes and for some of her longer ones it was closer to twenty, sizable metrics for web video. Those numbers are even higher among her dedicated subscribers who, she told me, often come from a diverse range of backgrounds and professions, particularly those with stressful jobs like emergency workers, firefighters, teachers, and lawyers. Many of her fans have reached out to her over the years. "I get hundreds of emails every day, comments and messages on all different platforms," she told me. She's heard from pilots who use them to fall asleep during their breaks in long-haul flights,° veterans with PTSD who watch the videos to help them avoid night terrors, and parents who watch the videos with their babies and small children. "It's amazing if you think about it, that I am participating in somebody's life in that way!" she exclaimed.

It *is* wild to think of how such unusual videos can play such a deep and meaningful role in our lives. The success of ASMR epitomizes what can happen when our entertainment works to serve our individual reactions and needs as a viewer. "We're not doctors, we don't have degrees," Maria said with a laugh. "But in all reality, it's just one human nurturing another human through the power of internet . . . I think that's beautiful."

° Henceforth, I am going to assume that every pilot I see wearing headphones when I get up to use the bathroom on an international flight is watching Maria's video titled "-ꓱ-ASMR Gentlemen's Suit Fitting Session-ꓱ-."

◄◄

In November 1966, Fred M. Thrower, then general manager of New
York City's WPIX (channel 11), sent a memo outlining an idea he had
for the independent television station's Christmas Eve broadcast. He
wanted to broadcast a fireplace log for three hours. The *New York
Times*: "In what must be the television industry's first experiment in
non programming . . . from 9:30 P.M. to 12:30 A.M., there will be nothing
on the screen but a crackling fire to dream or dress the tree by. And
thanks to the wonders of electronics, ashes and smoke have been
eliminated along with the commercials." Nostalgic and comforting, the
Yule Log fulfilled an unexpected desire for many New Yorkers that
Christmas Eve, a desire that no one had necessarily articulated. It was
such a hit that it became an annual tradition all over the country.

Almost five decades later, NRK (basically the BBC of Norway)
made a similarly peculiar decision. In the summer of 2011, the network
broadcast 134 continuous hours of a boat trip up the coast of Norway
from Bergen to Kirkenes. Though not the first, *Hurtigruten minutt for
minutt* was the boldest entry in the "Slow TV" genre that had emerged
in Scandinavia.° More than half of Norway's five million residents
tuned in at some point and almost seven hundred thousand people
simultaneously watched the boat enter Trollfjorden in Vesterålen.
Numerous other boat and train rides followed—as did eighteen hours
of salmon fishing and twelve hours of knitting. "Slow TV is very different
from the way everybody—including myself to be honest—has always
thought that TV should be made," NRK producer Rune Møklebust
told *Time*. "TV has mostly been produced the same way everywhere
with just changes in subjects and themes. This is a different way of
telling a story. It is more strange. The more wrong it gets, the more
right it is."

° *Bergensbanen*, a broadcast of the nine-hour train ride from Oslo to Bergen two years prior,
was NRK's first attempt at slow television.

Both the *Yule Log* and the Slow TV fad began as strange program-
ming experiments that went against popular convention but became
unexpectedly satisfying experiences that viewers really loved, even if
they too were initially baffled by them. Nathan Heller of the *New
Yorker* wrote of Slow TV, "As entertainment, it is backward: it appears
to do its job by casting viewers into their own minds." Experiments like
these seem absurd for two reasons. First, TV is a one-way-communica-
tion medium that relies on clearly established expectations of what it
will deliver in order to ensure we'll tune in again. You'd think that
beaming five days of a boat ride into millions of people's homes would
confound those expectations and create mass confusion. Second, they
come at a price. The original *Yule Log* reportedly resulted in a $4,000
loss in revenue for WPIX in 1966 (approximately $30,000 in 2016
money).

Web video has, in most cases, neither of these problems, so profes-
sional and amateur video makers are freer to carry out experiments in
programming (or, like the *Yule Log*, "experiments in non programming")
that seem to go directly against traditional conventions. These can
probe deeper and deeper into the various psychological needs that
media can satisfy for us, pushing the boundaries of what qualifies as
entertainment and introducing us to new genres that stimulate specific
reactions within our brains that we never think about but secretly
enjoy. Deceptively simplistic video and audio content can trigger
complex reactions inside of us, meeting a need that we might struggle
to articulate if pressed. And because these experiences are so personal
(or unusual), we very rarely talk about them. Their existence is, largely,
made known to us only through nontraditional means: a message forum,
an errant click, a vague search, or casual mention from a friend. They
are often designed to be discovered and understood solely by the people
who are looking for them.

Sometimes they're not meant to be understood at all. Their signif-
icance comes not from the itch we feel or the thing that scratches it
but from the sensation of the scratching itself. Enabled by technology

like YouTube, they represent an emerging side of our popular culture that is forming in response to our almost unconscious—or at least unspoken—selves.

AM I THE ONLY ONE WHO THINKS THE FEELING OF A DRY SPONGE BEING REHYDRATED IS THE BEST THING EVER?

By 2014, I considered myself pretty much an expert in all things popular on YouTube, so imagine my surprise when I realized one day that suddenly the platform's most-watched channel was one that I knew literally nothing about. An account by the name of Disney-CollectorBR seemed to defy the rules for popular channels. It did not contain music videos. There were no charismatic on-screen personalities. It had nothing to do with video games. DisneyCollectorBR (or as the channel has also been known, DC Toys Collector and Fun Toys Collector) featured a grown woman playing with children's toys. The woman never appeared on camera, with the exception of her hands, which would pry open packaging, manipulate Play-Doh, or, quite commonly, pop open plastic eggs containing small toys or candy in little bags. In a Latin American accent, she narrates the process. Her channel debuted in 2011 and within a few years became one of the top five most-watched channels on YouTube. By 2016, DisneyCollectorBR videos had been viewed over ten billion times, making the channel technically more popular than Justin Bieber's(!). The videos have very long titles such as "Play Doh Sparkle Princess Ariel Elsa Anna Disney Frozen MagiClip Glitter Glider Magic Clip Dolls," which is one of the channel's most popular videos and has been watched in the neighborhood of half a billion times.

DisneyCollectorBR° is far from the only channel specializing in this type of fare. Channels called SurpriseToys and DCTC Toy Channel have each accrued a few billion views.

° The individuals behind DisneyCollectorBR have opted to remain anonymous, despite numerous inquiries from press, some of whom have attempted to "out" the channel's star and

"I can think of few things more damaging to the self-esteem of the 40-something parent still trying to hang onto thin tendrils of cultural currency than to look at something your 2-year-old is watching and be utterly baffled," writer Mireille Silcoff shared in a funny and bewildering 2014 essay after she, like so many others, came across these videos via her daughter. "Her obsession with these videos suggested to me some kind of deep neurological massaging, as if my child's developing brain had a keyhole opening that lay in wait only for a faceless woman with a South American accent and brightly manicured nails removing letter-shaped Play-Doh molds from their packaging."

As this craze gathered steam, so did the number of panicky articles decrying its potential negative impact on young minds. Are we indoctrinating a new generation of consumer sheep by feeding them a constant stream of cheap merchandising propaganda to obsess over? "They're not a 30-second commercial that we might see on television that markets to children. These are 10- to 15-minute advertorials," said a psychologist quoted in one such panicky news story. But then again, half of the TV shows I remember as a kid were actually based entirely on toys, and I can still recite the lyrics of the theme song to the *Gummi Bears* cartoon on command. Those seem pretty bad in retrospect, though at least they contained actual stories, often with some kind of positive message. Certainly videos of people opening and playing with toys just serve to get children more excited about buying and playing with toys of their own, right? But the more time I spent examining this, the more convinced I became that something more complicated drives the popularity of a ten-minute examination of a "Dora the Explorer Talking Backpack Surprise" toy. Mireille Silcoff came to a similar conclusion: "It occurred to me that perhaps the appeal . . . has no practical relationship to consumerism, that its satisfactions are more mysteriously folded into our emotional response system."

the silent male star of the related channel called Blu Toys as a Brazilian couple living in the United States.

Many people point to the familiar experience of children opening gifts on Christmas or their birthday. "The thrill of getting something new is so exciting, and anyone who has ever watched little children at a birthday party knows that it's not all about receiving the toy themself—they really enjoy watching their friends opening their presents," Scott Steinberg, author of the Modern Parent's Guide series, told the *Telegraph*. "Children, as is the case with adults, enjoy mystery and suspense, especially when that is embedded in contexts which are likely to have safe, predictable outcomes," wrote Jackie Marsh, an academic at the University of Sheffield, in a 2015 paper examining the toy video phenomenon. "This of course is the case with a surprise egg, which is always likely to contain a toy, in children's experiences. These unboxing videos, therefore, contain structural elements common to popular media genres, such as mystery fiction."*

This craze reminded me of one of my favorite TED Talks, a 2007 presentation by director J. J. Abrams titled "The Mystery Box," in which he used an unopened box of magician's props he purchased many years ago as a metaphor for a storytelling device. To Abrams, the contents were not nearly as intriguing as the mystery and the enigma of the box that contained them. The talk was prior to his big-screen blockbuster forays, in the midst of the run of *Lost*, a popular television show he created that I had come to love and hate at the same time. Centering on a group of stranded plane crash victims on a mysterious island, *Lost* could be incredibly addicting (and infuriating) in its constant string of questions presented to the viewer. What is the island? What is the smoke monster? How is everyone so goddamn attractive all the time despite being in a sweaty showerless jungle? And as *Lost*

* While this sounds unique to children, perhaps parallels exist for us in adulthood. In fact, adult unboxing videos were among the first emergent YouTube fads to gain mainstream attention, and adults now spend millions of hours watching unboxing videos on YouTube each day, though perhaps more for the product reviews than the sensory experience. I recently tried to find some items in my apartment that *didn't* have an unboxing video available on YouTube. I failed. I even found an unboxing video for my specific brand of frying pan. WE'RE LIVING IN THE FUTURE!

answered various questions, it would present new ones. "I realized that mystery is the catalyst for imagination," Abrams said in his talk, reflecting on the concept of the "mystery box" throughout his work. "I started to think that maybe there are times when mystery is more important than knowledge." Perhaps what a child experiences when he or she puts on an Angry Birds Play-Doh video is similar to how I felt when I put on a new episode of *Lost*. Perhaps each new Peppa Pig Kinder Surprise egg serves as a literal mystery box.

But maybe that's just me trying to make sense of it through a media concept I understand. There's some thought that the pleasure young viewers derive from these videos comes from a less straightforward place. "Many of these videos also offer close-ups of hands and fingers prising things open, and it may be the case that the activities of hands could be of particular interest to a young viewer," Marsh wrote in her study. "In addition, the videos have accompanying sounds, which include the clicking open of the eggs and the crackle of plastic as the toy is unwrapped." She suggested that the aesthetic experience and the comforting emotional response the videos trigger could be the source of appeal.

YouTube is home to a wide array of channels like these that draw significant viewership, but have a precise appeal we struggle to recognize and to which we cannot draw clear parallels within existing media. People of all ages seek out a wide variety of eyebrow-raising material that offers multisensory satisfaction.

SITTING IN THE YouTube office café one day, I noticed, over my colleague's shoulder, a video of what appeared to be a cookie undergoing a medical procedure. With a scalpel, tweezers, and blue latex gloves, an unseen individual slowly extracted all the raisins from a Pepperidge Farm soft-baked oatmeal raisin cookie and then replaced them with Toll House chocolate chips. I could not look away; I found the meticulous process utterly captivating and, strangely, relaxing. The

video, titled "Cookie Reassignment Surgery," was produced by a man
known as "The Food Surgeon" who spends six to eight hours filming
each of his procedures. He told *Adweek* he prefers to remain anony-
mous: "The focus is on the food, the sounds and the sights. I want it to
remain that way."* His videos, such as "Reese's Peanut-Butter-Ectomy
with Oreo Cream Transplant" and "Butterfinger Fracture Repair
with Twix Splint," provide aesthetic experiences that trigger emotional
responses within us, responses that we love but that we might not always
entirely understand.

I've also seen this in action with videos people describe as "Oddly
Satisfying," a category that truly challenges our perception of what
video content passes as acceptable entertainment. A time-lapse video of
a dirty sidewalk being pressure washed. A grape perfectly, thinly sliced
with a sharp knife. A hockey puck sliding down a cardboard tube with a
nearly identical diameter. "I think in the times in which we live, we are
so inundated with so many things, that to be able to bring order to things
that don't necessarily go together, to make them fit, provides some sort
of comfort in a world where there's all sorts of different things coming
at you in all different ways," psychologist Gillian Roper told the
Atlantic. It seems we have an innate desire to put things in order.

This is why I was not surprised when I saw that a video titled
"Sponge being hydrated," depicting a dry sponge placed in a rectan-
gular dish of water, had been watched fifty-nine thousand times. The
post on Reddit directing other users to it read simply, "This is me
hydrating a compressed sponge" and had drawn eighty-eight comments,
which ranged from "Am I the only one who thinks the feeling of a dry
sponge being rehydrated is the best thing ever?" to "Part of me wished
it would exactly fit the container . . . it was so close."

* I don't know anything about this guy, but he seems pretty awesome based on another answer
he gave in this same Q&A: "To be considered for an operation, the food item must be dissectible
in some form or another. Though delicious, a square of fudge would make for a boring
operation for lack of internal variation. Though my most popular videos are candy related, I am
the food surgeon and not the candy surgeon, so diversity is important." Can we be friends?

Leaving aside for the moment that there are apparently at least eighty-eight distinct things to say about hydrating a compressed sponge, I must acknowledge there really is a calming pleasantness to "Oddly Satisfying" videos. Only in the environment of the web would something that appears to be so boring draw such an audience. But that's because the value comes from the experience we have ourselves, privately, not from the perceptions we need to live up to publicly. There are too many stakeholders, budgets, and egos involved for something so unprecedentedly uncool to ever have a place in mass distributed entertainment where the bandwidth is limited and return on investment closely managed. This is why, for most of my youth, the programming offered by the dominant mediums rarely veered too far off the beaten path, for better or worse. Neither "Sponge being hydrated" nor "The Food Surgeon" ever needed to justify their existence to anyone. We as viewers decide and extract the value. And when private, individual reactions are all that matter, you get some very strange results.

YOU MAY BE surprised to learn there are at least two different genres of ear-cleaning video on YouTube. I believe this merits repeating. There are at least two *different* genres of ear-cleaning video on YouTube. I am not referring to the cleaning of corn, as we will (inexplicably) cover this in another chapter; I am referring to the cleaning of human ears. The first are ASMR-style role-playing simulations in which you, the viewer, play the silent role of a person getting your ears cleaned by a pleasant, whispering lady, as in the case of "☆ ASMR Ear (Cleaning) Groomers & Spa Roleplay ☾ (unisex)," which had amassed more than eight hundred thousand views when I saw it. The other is something one would have trouble bringing up casually in polite conversation. (I know this because I did and accidentally ruined a colleague's lunch.) These are videos of actual earwax extraction. Yes, with a few keystrokes, you too can take in professional and amateur home earwax removal procedures. In "Hard Impacted Huge Ear Wax removal in one stroke," a doctor in India used an endoscopic camera and some knockoff Brian

Eno ambient music to document a metal instrument coaxing large glob out of a woman's ear. In "FUNNIEST EAR WAX EXTRACTION," a vlogger couple named Justin and Allison chronicle Justin's apprehensive experience having his ear canal washed and vacuumed at the doctor's office. (It was not particularly funny, but perhaps I'm a tough critic?)

The worst one I came across was unassumingly titled "Removing impacted ear wax" and involved a pair of tweezers and the removal of an impossibly large glob of human cerumen. By the time I'd seen it, I'd already seen enough such videos to have gotten over my queasiness (well, as much as one can), and I must say that I did actually enjoy watching it. The blog *Medical Daily*, where I found it, exclaimed, "Watching the tweezers pick at the sticky ball of wax until it's finally jostled out is slightly sickening, but fulfilling at the same time. Imagine how clear his ears must feel now!" *Cosmopolitan* had a similar reaction: "It's disgusting, but that just makes it all the more satisfying when the extraction is complete." In other words: One essentially internalizes the feeling of relief.

If you found the above difficult to read, you're going to love this: Perhaps more popular than ear cleaning on YouTube is pimple popping. "Strangely satisfying," commented someone named Mrs. Bangtan on "Biggest Zit Cyst Pop Ever," a video I confess I could not bring myself to actually watch despite its 12.7 million views at that time. Cumulatively, pimple/blackhead videos get more than five times the viewership earwax ones do. Dr. Sandra Lee—who goes by "Dr. Pimple Popper"— started on Instagram and opened shop on YouTube, where she gained more than two million subscribers with hit videos such as "A Goldmine of Blackhead & Whitehead Extractions" and "Dr Pimple Popper's Top 5 Most Amazing 'Pops' of 2015" all filmed at her dermatology practice in Upland, California. In the intro to her channel, she explains that her goal is to educate viewers about skin disease and care, but admits, "Along the way, you will still see your favorites, what has become my 'bread and butter' so to speak: pimples popped, blackheads extracted, cysts and lipomas excised."

Pimple-popping videos and their equally gross-though-somewhat-less-dramatic counterpart, blackhead-clearing videos, seem to induce

a common feeling of satisfaction among viewers. While such videos have been popular for a while, 2016 was the year that the community of people who enjoy watching and sharing such videos (known as "popaholics") began to achieve notice in the mainstream press and Lee became something of celebrity, with her own line of Dr. Pimple Popper merch.

Why do people like these things? Perhaps our natural curiosity leads us to seek danger and disgust from the safety of our YouTube player. Perhaps many of us are experiencing some form of the sensory condition called synesthesia, wherein some stimuli might involuntarily trigger other sensations, such as sounds we can see as colors, shapes we can taste, or music we can feel. (It's suggested that one in three hundred people might have some form of it.) By watching someone's ear get cleaned, do we experience the satisfaction of having our own cleared out? I still don't know.

Kinder eggs, oddly satisfying exploits, and ear-cleaning videos seem so unimpressive on the surface that the incredible viewership they can draw left me determined to uncover everything about exactly why they are so popular. But that we don't even fully understand why we enjoy these things is precisely the point. "Why" doesn't matter. On YouTube, where anyone can upload and watch nearly anything, entire genres of successful channels can exist without anyone needing to truly understand the mechanics of why they exist at all.

The most important thing is, literally, what's happening inside the recesses of our brains where we experience this mysterious psychological and neurological stimulation.

THE EVERYDAY UNKNOWN

"That is both more *and* less water than I would have expected," I thought after watching four minutes and thirty-five seconds of a video titled "GoPro - Full wash cycle in a dishwasher." Rarely can an individual video deliver on its title so effectively. "Always wanted to see

what happens in my dishwasher after I close the door," wrote "Bito," the video's creator. "Many of the other videos I saw had terrible lighting or bad angles," he added, dispelling the myth that capturing footage of the inside of your dishwasher requires no fundamental understanding of cinematography. I believe this video appealed to me for the same reason creating it appealed to Bito: It depicted something I had wondered about since childhood. Every infant (as well as puppy, kitten, and pet parakeet) has thought, however briefly, "What the hell is going on inside that thing?" Some people become adults and grow out of this. Others become adults who write books about YouTube and do not. I might not be alone, however; when I watched it, "GoPro—Full wash cycle in a dishwasher" had been seen some eight million times and a quick search turned up several hundred similar videos. In my tireless research, I even stumbled across one captured with a 360-degree camera. Inside-the-dishwasher videos had entered the space of virtual reality.

"GoPro—Full wash cycle in a dishwasher" has eight million views, in large part, because it squarely addresses a near universal curiosity, dull and unimaginative as such a premise may be. (Have you not, in reading the last paragraph, become increasingly intrigued as to what's going on inside your own dishwasher? Hmmm? HMMM?)

The power of simple curiosity to drive human behavior is a well-tread field of study, with some researchers going so far as to prove that humans will, even with the expectation of negative consequences, be compelled to resolve uncertainty when it crops up. This is what both drives our development as children and as well as our interest in *Law & Order* reruns as adults. But YouTube actually transformed the basic resolution of uncertainty into a distinct entertainment endeavor in the most rudimentary fashion. A new group of creators emerged, largely unintentionally, to become YouTube's masters of turning our curiosity in the everyday unknown into a compelling, if seemingly mundane, brand of amusement.

❖ ❖ ❖

"ALL MY LIFE I've been I guess what you'd call a 'tinkerer.'" Matt Neuland, twenty-seven, is the man behind a channel called carsandwater, and in many ways, he is the antithesis of what comes to mind when you think of a popular YouTube creator. "Probably you can tell over the phone, I'm not the best speaker," he told me. "So it's a little nerve-racking for me trying to make a story with my words." Neuland, who works in maintenance and security, essentially uses no social media to connect with fans outside the commenting system on YouTube. He rarely appears in his videos, and it's not even common to hear his voice. It doesn't really matter. Nearly one million people have subscribed to his channel and his videos have been watched upward of two hundred million times.

Neuland started making videos after he received a camcorder as a gift from his siblings when his first child was born. "The original purpose of starting on YouTube was putting up videos of my family, but after a while I just started doing do-it-yourself-type videos," he said. These DIY projects ranged from stained-glass windows to pool heaters. When people started watching, he began experimenting more. "And that's kind of how I stumbled into the 'Red Hot Nickel Ball' thing," he said. One day, Neuland heated up a palm-sized sphere of nickel using a homemade electrolysis torch that separates water molecules into oxygen and hydrogen gas, which can then be set on fire. Neuland described this to me as "just kind of fooling around," suggesting that we have very different levels of tolerance for potential injury in our recreational activities.

Using a wrench, he simply picked up the ball and dropped it in some water. "It did the Leidenfrost effect* thing, which I think got people asking me, 'Oh what would happen if you put a hot ball of metal in this or that,'" he said. "I just tried to satisfy people's curiosity." Until

* Wikipedia: "The Leidenfrost effect is a physical phenomenon in which a liquid, in near contact with a mass significantly hotter than the liquid's boiling point, produces an insulating vapor layer keeping that liquid from boiling rapidly." It looks more awesome than it sounds.

this video took off, Neuland hadn't really thought about the potential°
of a ball of nickel to command an audience, but it did. Neuland began
branding the videos "RHNB" (Red Hot Nickel Ball) and estimates he's
placed the RHNB on more than one hundred different materials. The
videos, which pretty much all take place in his garage workshop, have
provocative titles such as "RHNB-Dry Ice," "RHNB-Jello," and "RHNB-
Nokia 3310." "RHNB-Stack of CD's" was surprisingly cool. "RHNB-
Brick Of Velveeta" was surprisingly disturbing. Almost nothing happens
in "RHNB-Hockey Puck," but people have watched nothing happen
1.7 million times.

And as he said himself, Matt Neuland is not an incredibly talk-
ative person. For example, when I asked him to describe the format of
his videos to help you, the reader, get a sense of them and his process,
he told me, "It's pretty basic, you know: Intro. Um, what do you call the
middle of the video? That. And an outro. That's pretty much it." Thanks,
Matt.

I will admit, though, when it comes to the actual conceit of
Neuland's videos there is a rather refreshing lack of complexity. "What
it is is what it is," he said. "I've seen a lot of comments like, 'What is this
video?!' And people say, 'Read the title. It's *a red hot nickel ball versus
a block of ice*.' Which is what it is." His videos are all pretty short, but
the average viewing duration for many of the popular ones is over two
minutes.

Neuland invites his viewers to submit things for him to destroy
with his red hot nickel ball (or "be RHNB'd" as he puts it) and he's
received more objects than he can count. These submissions have
served as source material for some of the most watched videos. "RHNB-
Floral Foam," his most popular, depicts a colorful chain reaction of
decomposition in a rectangle of green foam and has been watched more
than fifteen million times (the average viewer watches over two thirds

° There's a really great/terrible "potential energy" joke to be made here, but I didn't pay close
enough attention in physics to do it justice. Apologies to Mr. Papanearchou for blowing this
moment.

of it). Neuland now has fans all over the world. Less than half of his viewers are in the United States, and in 2015, his videos were watched more than one million times in as diverse locales as Taiwan, Poland, Turkey, and Malaysia.

The Hydraulic Press Channel, operated by a jovial Finnish gentleman (and part-time powerlifter!) named Lauri Vuohensilta, is similar to Neuland's and features, as you might have already guessed, a variety of items placed under a hydraulic press. Vuohensilta, who creates the videos at a hydropower-plant-parts factory, drew inspiration from other channels featuring the destruction of household objects, including, of course, the RHNB. Vuohensilta's channel description leaves little in the way of nuance: "Wanna see stuff getting crushed by hydraulic press? This is the right channel for you." (You could say he fills a gap in the landscape of workshop object destroying; whereas the RHNB was no match for a hockey puck, the hydraulic press excitingly decimated it.) When I spoke to Neuland, the Hydraulic Press Channel had grown to nearly five hundred thousand subscribers in just a few weeks. Neuland already knew of it and had enjoyed it himself. "Why wouldn't you want to see just about anything you can think of put in there?" he asked me. Fair point.

While there isn't yet a name for this genre of simple, curiosity-triggering channels, I've come across many of them. In fact, as I wrote this chapter, one of the most popular videos on YouTube was "What's inside a Rattlesnake Rattle?" from the channel What's Inside?, a rather adorable father-and-son operation starring Daniel and Lincoln Markham of Kaysville, Utah. The channel began as Lincoln's second grade school project to find out what was inside some sports balls, and two years later more than two million people had subscribed to follow their adventures cutting things in half. "It all started with a little science project . . . and has turned into something much larger than we ever could have imagined," Daniel Markham told the local news.

At first, I had mostly decided that the appeal of these videos derived from their aesthetic qualities, particularly given the internet's

love for the oddly satisfying. Indeed, Neuland and I both found it supremely enjoyable to watch the RHNB bore through something. But it's not just about the satisfying destruction of an object. Neuland, Vuohensilta, and the Markhams are in the business of "What If" videos, entertainment adapted to one of the simplest ways our minds function. Much like AsapSCIENCE guys, they open a question that we must have answered, but rather than always exploring the intellectual, they explore the experiential. They draw on instinctual urges and deliver immediate audiovisual gratification.

Neuland's own curiosity, his amateur-scientist/tinkerer enthusiasm for exploring the unknown, serves as the foundation for his channel and its premise, even if you don't see or hear him on-screen. "I have to somehow keep it interesting and personal, the way I'd like to see it," he said, acknowledging that it's his own personal fascination that keeps the channel alive.

"*And* I've got a drawer full of stuff I gotta burn for people," he added.

OUR APPETITE FOR suspense in the small things we experience daily is evident in the popularity of channels from creators like Matt Neuland, but we viewers are just as prone to generate this drama for ourselves as well, even in places where none would otherwise exist. YouTube has been home to numerous mysteries propagated and intensified through discussion in the comments sections of various videos. They can result from overtheorizing in fan communities, calculated guerrilla marketing schemes, or, my favorite, merely an odd confluence of events, as was the case with the "Webdriver Torso" incident of 2014.

That summer, in the span of two or three weeks, approximately eighty thousand videos were uploaded by a channel called Webdriver Torso. (More than five hundred thousand would be uploaded in the ensuing years.) The videos made no sense and were composed mostly of weird geometric shapes and sounds. For example, a video titled

"tmpdKHvbS" consists of still images of one red and one blue rectangle of varying sizes—each displayed for one second at a time—accompanied by high-pitched tones. There are hundreds of thousands of videos exactly like this, the lone exception a six-second video of the Eiffel Tower titled only "00014." Most are eleven seconds long, though "tmp 1DXWQ" goes on for twenty-five minutes. In general, they have very few views, but some have been watched tens of thousands of times. The "tmpdKHvbS" video has more than half a million views, most of which were accrued when someone discovered the channel and began enlisting others to figure out what the hell it was.

The phenomena inspired many a headline. The *Daily Dot*: "Is this mysterious YouTube channel trying to contact aliens?" The *A.V. Club*: "'Webdriver Torso' is either something incredibly sinister or nothing at all." The *Daily Mail*: "Are French spies creating mysterious YouTube videos?" A number of people who might have seen *Independence Day* too many times seemed pretty certain Webdriver Torso was attempting to contact extraterrestrial life forms.[*] Unfortunately, as with so many things, the truth was far, far less interesting than the conspiracies invented by viewers.

What was Webdriver Torso? A test of video-compression technology run by one of our colleagues on the YouTube Uploads team who never expected anyone to stumble across the footage. In the end, Webdriver Torso was a Kinder egg for nerds, though instead of a plastic toy or a chocolaty treat, inside was a complicated infrastructure test being run by a Russian engineer named Ekaterina in our Zurich office.[†] It was a mystery box. It was a watermelon yet to be RHNB'd or Hydraulic Pressed. The channel combined a classic dramatic principle—that where you end up is far less interesting than the ride there—with our

[*] To be fair, if it turned out that aliens do watch YouTube, it would help explain the success of certain vloggers.

[†] How this would turn out became an exciting mystery for Ekaterina too. "It was fun to see what happens, but also pretty scary," she told me. "I didn't know what I should expect next. Maybe the press would meet me in the morning when I leave my house, or something else!"

collective desire to find the extraordinary. And the result was made possible only by the new ways technology allows us to explore, discuss, and analyze the things we see.

"What is going on inside of that thing?" "What would happen if that object was flattened, burned, or cut in half?" "What if this unexplained-but-not-overtly-suspicious thing was indeed something fishy?" We all ask questions like these, but in the past, we did so in isolation. YouTube turned that very personal experience into a communal activity. It turned our fascinations with the everyday unknowns into actual entertainment and allowed us to experience it together.

This all might sound a little silly. But content that adapts to and indulges the more basic impulses of our psychologies could have real consequences. The process that turned Webdriver Torso from an innocuous infrastructure test to a flash point of international intrigue is the same one that propagates and bolsters unfounded conspiracy theories. Platforms that reward the promise of quick satisfaction offered by RHNB risk devolving into a clickbait-ridden chamber of vacuity. The way such uncomplicated videos convert the ordinary into vehicles for suspense and fascination is innocuous enough in the context of dishwashers and flattened hockey pucks. But other types of videos provide similar releases and concentrated stimulation on a deeper and more emotionally complex level.

EVERYBODY WANTS A LITTLE REVENGE SOMETIMES

I used to cry a lot at work when I first started at YouTube. Not because I was perpetually embarrassed by my inability to remember the outlandish code names everyone at the company gave the projects they were working on. (I still contend that it was wholly unnecessary to make people describe a channel page redesign as "Cosmic Panda.") No, the tears came in response to something entirely different. I don't know that I—or any ex-girlfriend for that matter—would describe myself as a

very outwardly emotional person. Yet to the kind folks from the Google Maps team with whom I shared an office cube, I occasionally appeared to be a hysterical mess. Out of nowhere, I'd be fighting back the tears while watching some new clip. The worst kind of kryptonite to my stoic masculinity: "Soldiers Coming Home" videos.

A brother surprising his sister at her wedding. A mother surprising her son in science class. A husband surprising his wife at a baseball game. Or, absolutely the worst/best of all, a steely-faced marine surprising his hysterical dog in the front yard. I almost teared up just thinking of these examples and I WASN'T EVEN WATCHING THEM. That these videos moved me to tears may not surprise you, but what is interesting is that I found myself returning to them often.

And I'm not alone. "U.S. Marine Surprises His Sister During College Graduation Ceremony" draws twenty-five thousand views every week four years after it first appeared. Ultimately, these videos succeed because they offer us the satisfying pleasure of emotional release wherever and whenever we need it. It's catharsis on demand.

In 2011, hearing-impaired twenty-nine-year-old Sarah Churman had a hearing implant activated at a doctor's office in Texas. Her husband, Sloan, felt reluctant about filming the intimate experience, but did so at his mother's encouragement. Twenty-five seconds into the footage, Churman breaks into tears. It is at this point that every person who's seen this clip does the same. With thirty million views, it's the most watched of the "Hearing for the First Time" videos, and it has found its way into more than one YouTube marketing montage over the years. The clip's initial spike in interest propelled the Churmans to internet fame and a tour of the TV morning shows, and years later it still averaged over one hundred thousand views per month. These private, emotional moments depicted on video become private, emotional moments for us as well, extending their shelf life.

We know that videos can elicit a boost in oxytocin, and while researchers have not fully determined the extent to which the hormone plays a role in our bodies, some studies suggest that increased levels

can help calm us. In a 2007 presentation at the Society for Neuro-science, three researchers announced they'd demonstrated that when subjects experiencing stress or panic in isolated environments were dosed with oxytocin, they "no longer showed signs of depression, anxiety or cardiac stress." I feel obligated to point out here that the subjects of this particular study were not humans, but prairie voles. So there's that. But perhaps the difference between receiving a series of mild shocks while separated from your furry relatives in a laboratory and, say, filling out a tax return, are not, at the end of the day, *so* different. I'm not a neurochemistry expert (I think that's a pretty specific specializa-tion for which "watching a lot of YouTube videos" is not a qualification), but I have no doubt that many of these emotionally cathartic videos do create a pleasurable, neurological sensation for the viewers that return to them regularly.

In his book *Flicker: Your Brain on Movies*, neuroscientist Jeffrey M. Zacks explains, "Our brains didn't evolve to watch movies: Movies evolved to take advantage of the brains we have. Our tendency to want to respond physically to them highlights this." He points to something called the "mirror rule" to explain why we sometimes have reactions to stimuli on-screen. "In short, our behavior often follows the mirror rule, such that when we see an action performed we have a tendency to perform the same action ourselves," he writes. "The mirror rule helps us get ready to perform appropriate actions quickly, to learn sequences of actions, and to represent the mental states of other people based on their behavior." In other words, perhaps my brain tricks me into "mirroring" the emotions and actions of the people I am witnessing in these videos, causing me to cry at my desk like an idiot and, ultimately, providing me a similar emotional release.

THERE ARE SOME videos that have achieved storied notoriety because they provide emotional satisfaction from a much deeper, darker part of our nature. These are the video-based experiences that help us

confront our insecurities and inferiorities by indulging in the humiliation of others. Most commonly they seem to star people who represent some kind of superior social status to us.

The top keyword associated with "news anchor" searches on YouTube is not "report" and it is not "broadcast." It is "fail." That is followed closely by "bloopers." There's something acutely enjoyable about watching self-serious TV personalities screw up or embarrass themselves. The high status and authority of the news anchor magnifies what is already a common human experience: Most of us, at least subconsciously, get some pleasure and satisfaction out of watching other people fail. According to the theory of downward comparison, people experiencing something negative in life can improve their sense of personal well-being when comparing themselves with someone less fortunate. This principle has been exploited in the comedy world for centuries in the form of slapstick performance. Similarly, web video allows us to remain detached from the actual negative consequences of what we watch unfold, and that makes it even easier for us to embrace the enjoyment they can bring to us.

The list of contenders for the most notorious "Fail" in web video history is long, but perhaps the moment that best encapsulates the multifaceted nature of humiliation-based catharsis originated on a television broadcast in 2007. Partway into the national Miss Teen USA beauty pageant, eighteen-year-old Caitlin Upton, the contestant from South Carolina, was asked: "Recent polls have shown a fifth of Americans can't locate the U.S. on a world map. Why do you think this is?" The beautiful blonde's response would change the course of her life. And not in a good way. "I personally believe that U.S. Americans are unable to do so because some people out there in our nation don't have maps," she began. "And I believe that our education, like such as, in South Africa and the Iraq, everywhere, like, such as, and, I believe that they should, our education over here in the U.S. should help the U.S., or, should help South Africa and should help the Iraq and the Asian countries, so we will be able to build up our future. For our children."

Upton's answer was watched and shared millions of times that first week and was still drawing tens of thousands of views per day weeks later. The reaction was brutal and, at times, overly aggressive. ("I had some very dark moments where I thought about committing suicide," Upton told *New York* magazine eight years later. "It was awful, and it was every single day for a good two years.") Even though most people were not *active* participants in the public shaming of Upton, the sight of the pretty pageant girl embarrassing herself, seemingly proving she was as unintelligent as we believed her to be, was disconcertingly satisfying.

Or, at least, it was for me; the summer after my freshman year of college, I'd worked as a production assistant/intern for the Miss Florida USA pageant. Sometimes I would wrap cables; sometimes I would carry coolers or equipment; sometimes I would hold those big reflectors to bounce sunlight at the contestants we were filming. It sounds like a dream job for a teenage boy, but it was not. The girls could be generally pretty rude and bossy (as you might imagine); and I got a rather uncomfortable sunburn *under* my chin from the reflector. On pageant day, I was assigned to the room where the girls would go sit and cry with their moms after they got cut. I genuinely felt bad for them, but I also kind of loved it in a way I wouldn't admit until years later. And so that's basically how I felt watching poor Caitlin Upton "like, such as" her way through her answer on stage. The clip allowed me (and seemingly many others) to indulge in that most base emotional release.

There's also evidence that we might enjoy these videos because we're predisposed to enjoy watching train wrecks of all sorts. In a study titled "Tragedy Viewers Count Their Blessings: Feeling Low on Fiction Leads to Feeling High on Life," a group of researchers showed participants (humans, just so we're all clear) a thirty-minute tragic film and derived from their reactions that the sadness we experience from watching the plight of another can be "worthwhile and enjoyable because this affect facilitates reflecting upon one's own life," adding that it "has an uplifting effect on personal life happiness." Basically, we are all awful.

We may never openly acknowledge—or even be aware of—our intent in watching and sharing these videos, but we continue to seek them out, and the web, in turn, offers an increasing supply through the ever-widening breadth of its content and ever-deepening specificity of its algorithms and platforms.

AN INTERESTING MICROCOSM of our dark web video pleasures can be found among the endlessly specific communities of Reddit, within a subreddit called r/JusticePorn. Founded in 2011, JusticePorn quickly became one of the top one hundred subreddits, accumulating a few hundred thousand followers. It describes itself as "a place to see bullies getting their comeuppance." Despite the name, there is no actual pornography on JusticePorn; it is a collection of videos, articles, gifs, and photos depicting criminals, bullies, or selfish, mean-spirited jerks getting "what they deserve." For example, a post titled "Road rage driver assaults motorcyclist, gets taken down" has drawn over two thousand (mostly supportive) comments. Many videos are not hosted on YouTube (or have been removed) because of YouTube's content policies. I knew about JusticePorn not because I was doing research for this book or because of my professional capacity as a video trends expert, but because I too would occasionally find myself watching JusticePorn videos late at night.

Jeff Justis, thirty-five, is the creator and lead moderator of Justice-Porn, and yeah, his last name is actually Justis. I couldn't believe it either. During the day, Justis works as an architect designing multi-family apartment buildings in South Florida.° In the evenings, he is the foremost expert in bully-revenge content. He'd gotten the idea to start up JusticePorn after coming across a video of a bully getting beaten up, and shortly after its founding, someone linked to his new

° Jeff lives, it turns out, just a few miles from the house where I spent the first eighteen years of my life, a background detail about me that is relevant only insofar as it gives me the authority to say of JusticePorn's origin: #OfCourseFlorida.

subreddit from one of the most popular sections on Reddit. "We blew up to two hundred thousand subscribers overnight," he said.

As the lead moderator, Justis sets the standards for what is and isn't allowed. For example: "One of the rules we've implemented is no death," he told me. Oh good.

Despite JusticePorn's popularity, it does not see a high volume of postings, because Justis and his fellow moderators have a pretty strict bar for what counts as actual justice porn. "We remove anything that doesn't fit the narrative," he explained. "People would post news articles about, like, a guy breaks into a store, gets caught on camera, and is arrested. That to us isn't justice porn. That's justice, you know, but it's not really that instant gratification." That quick gratification is one of the keys.

"It's instant karma. That's the best way to define it. That's what we truly go for." The other key? "You've gotta have clear justice. It can't just be someone getting beaten up. They have to have done something and it has to be apparent."

Many of the videos on JusticePorn involve some kind of physical confrontation. A woman pushes her way through a subway turnstile and gets tripped by another commuter. A drunk man tries to intimidate a street vendor only to get knocked out by a single punch. "When you come to us, you know you're going to get, for lack of a better term, good, clean violence," Justis said, with a surprising earnestness. "It's about as wholesome as violence can be. And it's not all violent." That's true. One of the most popular recurring sources was a Russian youth movement: СтопХам or StopHam (sometimes crassly translated as "Stop a Douchebag") features young people confronting drivers obnoxiously flouting basic traffic regulations in Moscow, particularly when they, say, block pedestrian walkways, double-park, or otherwise behave selfishly. Sometimes the amusing vigilantes of StopHam will put giant stickers on the drivers' windshields. "Violence just seems to be a preferred method of justice delivery," Justis explained.

The pacifist Catholic school kid in me is 100 percent against JusticePorn—I just don't believe in the use of violence to resolve

conflict—yet my basic human reaction is one of somewhat animalistic excitement watching these clips. "You feel excited and happy. Which is disturbing," Justis said. "It definitely conflicts with your emotional response to feel empathy for somebody, but you kind of enjoy it anyway."

So why do we seek these out? Why do I? Justis believes enjoyment in watching a bully "getting what they deserve" is a universal concept and, while most of us would never slap a giant sticker on the windshield of an obnoxiously parked car, there's something deeply compelling about the fantasy of it. "Everybody wants a little revenge sometimes," Justis says. Hollywood has certainly proven our appetite for revenge fantasy. Consider *Death Wish, Unforgiven, Oldboy,* and basically every Quentin Tarantino movie. But JusticePorn is, as Justis describes it, "a quick fix" of revenge and the brief, on-demand nature of its postings make it an all-too-convenient source of adrenaline.

Part of the fun of JusticePorn, I suppose, comes from our ability to vicariously experience the emotional payoffs we fantasize about in the quiet moments, hours, and days after we find ourselves slighted by someone else. But its power comes from our ability to access what we need, with incredible specificity, at will.

We have always sought out media to satisfy certain desires: to laugh, to unwind, to learn, to stimulate our intellects. But there are other human needs that entertainment can satisfy for us, needs we don't normally recognize openly because they are far too revealing or because we might not even overtly be aware of them. For many, these nontraditional motivations we may have had for engaging with certain traditional media—or the specific personal needs they fulfilled—went unacknowledged. We're more likely to discuss the Kill Bill trilogy in terms of Tarantino's artistic homage to the Spaghetti Western than its value as a vicarious revenge fantasy. I've never had anyone admit to me that they loved *The*

Notebook because of the effects of the oxytocin it delivered to them. Many people cite legendary American public-broadcasting host and painter Bob Ross as the OG of the ASMR community. But of course, Bob Ross's stated intent was to teach us how to paint, which is a perfectly acceptable and understood endeavor.

It wasn't until recently that entertainment playing directly to our conscious and unconscious desires flourished. YouTube provides a home for the type of video that can't be explained and justified in a traditional media context. Through a kind of natural selection process, new kinds of video are refined over time based on our reactions, which result in whole subgenres devoted to indulging our senses and desires with increasing precision and a distinct lack of subtlety. The crazy part is that few of us were explicitly looking for it. How could we? How could we have known what to look for given that we had no real language to describe these sensations? Maria had no way to express what she needed when she stumbled across the whisper video phenomena, yet a few years later a whole community had formed around ASMR. Oddly Satisfying. Instant Karma. These are terms we all invented to assign structure to a new class of content that directly appeals to sensations and motivations that have always existed but never really been explored.

We are all, over time, building a crowdsourced content engine that is adapting to the makeup of our individual neurochemistries and psychologies. We are, if we have not already, quickly reaching a point where the technology platforms we use inadvertently infer more about how the human mind works than several hundred years of scientific inquiry, thanks to the choices we make in what to watch and post. Our subconscious drives have come to influence our programming, meaning it's not hard to see a near future where our entertainment adheres to even less traditional logic than it does now, yet becomes more and more gratifying.

Many ASMR fans, I learned, initially feel ashamed of or embarrassed by the sensations they feel. These predilections can be a source of awkwardness for the people who indulge in them, which keeps them

generally hidden from view—aside from the occasional "Take a look at this crazy trend" Sunday think-piece, in which those who watch are often reduced to a faceless crowd of weirdos. The volume of viewership garnered by these types of videos indicates that a very real, reliable audience will gather when people create such unconventional sensory and cognitive experiences with precision. For viewers, YouTube is a space often free of judgement and social mores and allows us to explore our eccentricities and, along the way, discover that we are not as idiosyncratic as we might have thought.

Going Viral

REBECCA RENEE BLACK, thirteen, wanted to be a singer when she grew up. Her mother, like many mothers in such a position, felt her daughter didn't fully appreciate how challenging a career in music could be. Unlike many mothers, however, she agreed to pay a small music studio to help her daughter create a song and accompanying music video as a present. She didn't have the $4,000 all at once, so she paid the team at ARK Music Factory in installments, figuring it was a good opportunity for Rebecca to learn how much work and investment is involved in being a professional recording artist.

Patrice Wilson, the Nigerian-born producer at ARK, said he wrote the song for Black over the course of one evening and morning. Black recorded the song and cast her friends in the music video, which ARK posted to its YouTube channel on February 10, 2011, mostly so Black, who hadn't even seen it yet, could share the video with her friends and grandparents. They all thought it was very cute. Black hadn't been in anything other than a school play before, so having her own video was really exciting.

None of the other videos on ARK's channel had received more than a few thousand views. But the next month, Black was in the car on the way home from school when she started seeing messages pop up from friends about the video. It was suddenly being viewed millions of times per day and had become a trending topic on Twitter as the internet swiftly declared it "the worst song ever." While that's a bit harsh, "Friday," with its Auto-Tuned, unsophisticated lyrical approach, was not particularly poetic. But poetry's not exactly what Wilson was going for. "The key to [a song] becoming popular is to keep it very simple and have

repetitive words," Wilson said in a 2014 interview. "Too many words and it's too hard to remember. With fewer words, you can hear the song one time and kind of remember it the next day. I don't try and make the songs sound simple and ridiculous. It's just my style of writing . . . Even if I'm the guy who's known for writing the worst songs in the world, at least I'm still known." In any case, "Friday," as it ascended to become the web's most popular video that month, presented an interesting paradox: The most popular thing had become popular *because* people DISLIKED it. Nothing about it made sense in a traditional context.°

I first met Black when she came to visit YouTube's office seven months later (on a Friday) and participated in an onstage interview with me in front of the company. I had been hesitant to do the interview; were we about to celebrate the mass bullying of a teenage girl? Before we went onstage, there was a palpable electricity in the air and the room lit up with laughter and joy as everyone half-ironically but fully enthusiastically sang along with the snippet of "Friday" we played at the start. ("Kickin' in the front seat, sittin' in the back seat . . .") It occurred to me then that Black had somehow managed to transcend the whole "Is this good? Is this bad?" debate. She no longer embodied entitled teen-ager privilege, but instead represented the social experience "Friday" enabled us to have with our friends. Because of the way it spread, the song became tied to our reaction to it. And making fun of the song, taunting our friends with it, and singing it ironically was something we loved. *This* is what we were celebrating that day.

Partway into her first response, I realized that I was not inter-viewing a wannabe popstar. Black was the kind of fourteen-year-old girl that you could find in any high school classroom. Despite all the hate, she was astonishingly bubbly. She said the first month was really sad, until she finally just stopped reading the comments altogether.

° Hitting the Dislike button on "Friday," or a video about Black or the song, became *the* thing to do in 2011. That December, I cast Black to host an original video for YouTube Rewind, our end-of-year recap. I had a really tough time explaining to my bosses why the video had so many dislikes and how that wasn't really a function of people hating the video itself.

Even talking about the mean comments she received, Black smiled and giggled about trying to block it all out. She was not even safe at home, where her twelve-year-old brother used to tease her by playing her the latest parody versions he found. When I asked her why she thought the video was popular, she struggled a bit, saying, "I don't know . . . Everyone loves Friday?! I have *no ideeaaaaa*!" The whole room laughed. It struck everyone as adorably naïve. But she was kind of right, actually. The video for "Friday" receives more than double its daily views *on* Fridays. Below is a chart of the video's viewership, broken down by day of the week and compared to the aggregate of cat video viewership for reference (and because why not?):

PERCENTAGE OF TOTAL VIEWERSHIP BY DAY OF WEEK

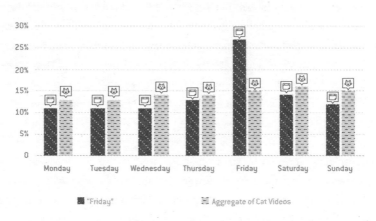

"Friday" ended up becoming the top-trending video on YouTube that year by a wide margin. It crossed the one-hundred-million view mark faster than any video by Justin Bieber. (Black was such a big fan that she woke up the whole house with her shrieking when Bieber referenced her video in a tweet. "He could have ragged on me if he wanted. It was the coolest thing in the world," Black told me with a satisfied sigh.) Black's iPod included multiple remixes people had made that she liked to listen to, including the cover they performed on the TV show *Glee*. She even made a cameo in Katy Perry's hit video for the song "Last Friday Night (T.G.I.F.)."

At Thanksgiving dinner a year later, sometime between discussing whether the turkey was too dry and the inevitable realization at the end of the meal that the crescent rolls were sitting forgotten in the oven, my mother piped up and asked, "So, Kevin, will they have you on television to talk about the YouTube videos again this year?" The year prior, I had done some live TV interviews to announce our top-trending videos of the year as a part of the now-annual Rewind launch. In particular, my appearance on *Good Morning America* had made my mother quite the popular lady at our neighborhood gym. "Yes, I think so," I replied in between mouthfuls of yams. "Well, what's going to be the #1 video this year?" she pressed. "I'm fairly sure it's going to be 'Gangnam Style' from that Korean singer, PSY," I told her. "Oh, yeah," she said with a mild familiarity. Without so much as looking up from his mashed potatoes, my father finally chimed in. "As long as I don't have to hear any more of that Rebecca Black girl."

◄◄

If you haven't noticed, I'm pretty obsessed with what, how, and why things "go viral," particularly on YouTube. So I was shocked to learn that the first video to go viral began to spread when I was just five years old, before most of us had the internet.

In 1988, Iowa-based Winnebago Industries tapped salesman and former news broadcaster Jack Rebney as on-camera talent for a new commercial about their RVs. The combination of a hot day, a challenging shoot, and Rebney's short temper led to a series of truly epic expletive-laden rants. Rebney cursed himself: "I gotta read it again because my mind is just a piece of *shit* this morning"; the crew: "I'd like to kick your fucking head in!"; and the local insect wildlife: "Son of a bitch, get out of here, you fucking flies!" As a final cathartic act, the production team compiled Rebney's outbursts into a four-minute

tirade of amazingness. "Winnebago Man" (aka "The Angriest Man in the World") became the stuff of legend, particularly in the eccentric community of rare VHS collectors. The tape of Rebney's outtakes began to spread from person to person via gradually depreciating videocassette rerecordings. There's an oft-repeated rumor that filmmaker Spike Jonze once made one hundred copies of it and gave the tapes out as Christmas presents. The clip took on a second life after the advent of web video. I'll never forget the first time I saw it back at my first job at the Huffington Post office. My then-boss Jason Reich, a former longtime *Daily Show* writer and man of impeccable comedic taste, insisted I watch it. For weeks, I could be heard quoting, "I don't want any more *bullshit* anytime during the day from anyone . . . And that includes me."

Years later, upon learning the backstory of "Winnebago Man," it occurred to me that people had been sharing and spreading media in all sorts of ways for years. Researchers at Northeastern University's Viral Texts project analyzed 2.7 million pages from five hundred newspapers in the 1800s and found hundreds of news articles that had been reprinted more than fifty times by various papers. At the time, newspaper and magazine text wasn't protected intellectual property, so news stories, short pieces of fiction, poetry, and more would spread and receive republication, with editors constantly combing out-of-town publications for content to clip out with scissors and be composited into their next edition's run. Today, we don't need a printing press or a VHS tape to make something go viral. In fact, we've become so accustomed to participating in the viral spread of something that we hardly even notice we're doing it. But the speed and reach of the dissemination of information and entertainment on the web is perhaps the biggest change in how we are exposed to media in one hundred years.

People are constantly asking me how something goes viral. There's a certain romance many of us ascribe to viral videos and memes. It's democratic and empowering. It inspires hope in the common dream to be heard and appreciated. Most of all, we love a lot of viral stuff because, well, we made it happen. After decades of mass media corporations

deciding what would entertain and inform us, viral videos demonstrate the power of our interactions to make things popular.

Before I can answer the how-things-go-viral question for *you*, I think we'd better decide what we mean by "viral" in the first place, yeah?

WHAT WE MEAN BY "VIRAL"

Between 2006 and 2007, the term "viral video" began to enter the common vernacular to describe entertainment that existed outside the mainstream but had become a part of everyday pop culture for millions. In the world of internet parlance, what we technically mean when we say something is "going viral" can vary from person to person.* To me "viral" means, quite simply, the quality of being primarily distributed through interaction. What that means is that whether something is viral is not a function of the number of views it receives, but rather of how people are coming across it.

In 2007 two friends, Adam and Will, were goofing around one afternoon. Adam's twenty-month-old daughter, Pearl, was going through a phase where she'd repeat whatever you said to her, so they brought her over, grabbed a camera, and recorded a little improvised sketch in which Will was a delinquent tenant and Pearl was a foul-mouthed landlord. In some hands, this might be a setup for certain disaster, but it helps when you're Adam McKay and Will Ferrell. "We shot that in twenty minutes," McKay recalled years later in a radio interview. "We had no idea . . . My wife was *so* mad at me."

The clip, titled "The Landlord," was the first one posted to McKay and Ferrell's new comedy video site, *Funny or Die*, and it became one of the most-viewed videos ever at the time. "It just exploded." McKay said. "We thought [*Funny or Die*] was just going to be this tiny thing. That video crashed all the servers." McKay pointed out that big name celebrities weren't creating content for the web at that time, so Ferrell's

* In the world of medicine, however, its definition is, I imagine, a subject of minimal debate.

presence in the video, at the height of his popularity, helped put *Funny or Die* on the map. Perhaps more important, "The Landlord" demonstrated to many non-internet nerds what a viral video could be. Millions of people who didn't normally share YouTube videos and were just learning the word "viral" instantly shared it.

The first time I watched something go viral, I was a freshman at Boston College, and some of the guys who lived on the dorm floor below me made a short film titled "Tuna Lowers My Inhibitions." It parodied the experience of underage college kids by basically replacing beer with cans of tuna fish. (What do you want? This is what passes for comedy for nineteen-year-olds.) Within a few weeks, it seemed like everyone in our dorm as well as the entire freshman class had seen it. This was all pre–social media and pre–web video hosting sites, so "The Tuna Movie" spread first as a Windows Media Video (.wmv) file email attachment and then as a link in people's AOL Instant Messenger profiles, which were the dominant web communication tool for American college kids at the time. It also spread beyond our school to other colleges, thanks to everyone's network of friends, and it eventually got featured on the homepage of *CollegeHumor*, which had a rudimentary Flash video player at the time.

Fifteen years later, I was still hearing about this goddamn video because two of the insufferable teenage attention-seekers who made it, Tom and Red, became two of my closest pals and also moved to New York City after graduation to work in media. For our network of friends, "The Tuna Movie" was the original viral video. While it did end up spreading to a sizable audience for that time (though, in the retelling of this story, the precise size of that audience seems to have expanded over the years like an over-embellished fisherman's tale), the scale of the popularity was irrelevant. What made it viral was *how* it spread.

Generally, though, when most people say "viral," they mean "very popular" or, more specifically, "very popular on the internet." In a bit of a twist, however, most of what is popular on YouTube is not technically viral, based on my more specific definition of the term. For example, if a creator posts a video to his or her million subscribers and they all

watch it immediately, that video is not viral.° If a "How To" tutorial picks up a million views over the course of the year as people search for, say, "how to tie a bow tie," it's not viral. Same thing goes for the trailer to an expansion pack for a widely owned video game or a new single dropped by a major singer. A viral video isn't just popular; it's something that achieves popularity by rapidly gaining velocity through a temporary and disorganized network. (Stay with me.)

"When Beyoncé releases an album, it's not viral," Kenyatta Cheese told me. "It's big because she has wide distribution from the start." Besides having the best name in the history of human names, Cheese is regarded by many, myself included, to be one of the original experts in internet culture phenomena. Cheese cofounded *Know Your Meme*, a video series and, eventually, an online database of memes, as well as the social strategy and fan community consultancy Everybody at Once. He explained that one of the hallmarks of a viral video is that it will transcend one group of us and permeate another. The process of going viral is a chain of sharing, often through different communities. You might, for example, be a part of a forum somewhere or a subcommunity on YouTube and come across something that elicits such a strong emotional reaction that you end up posting it somewhere else, like a Facebook feed or group chat. "By doing that, by grabbing it in one space and then moving it to another, you are all of a sudden increasing the distribution of the video," Cheese said. When you have enough momentum, when the rate of sharing spikes, you have the viral spread that makes something feel like it's everywhere.

IT'S NOT ONLY individual videos that go viral on YouTube. Video memes, which are concepts or ideas that get mutated and evolve over time, go viral too.† We've already explored a bunch of them, like the "Harlem Shake" and "Nyan Cat," and they spread through more active

° If a significant portion went on to share it, that would be a different story.

† Note that there is a difference between image macros (those photos you see superimposed with text) and memes, though some people use the terms interchangeably.

involvement from the audience. In the case of the "Harlem Shake," there was no central asset, really. Each of us could be familiar with the "Harlem Shake" trend without ever having seen the same video. "Nyan Cat" is a little bit different. Sure, Sarah Reihani's original video served as the patient zero and most identifiable instance of "Nyan Cat," but there were thousands upon thousands of other iterations of the meme in 2011. Parodies and fan versions of things also help turn videos and other bits of pop culture into trends that are much larger than a single video too, as we saw with the Gregory Brothers' "Bed Intruder" where Antoine Dodson's original video grew to viral fame, thanks in large part to their Auto-Tuned remix.

While there still might be disagreement about what the word "viral" means, the concept transitioned from being something novel that people observed in pop culture to something many people anticipated for themselves. Once YouTube created an advertising model that allowed people who posted popular videos to make money, it felt like everyone had, at some point, filmed a video with their phone that they *insisted* would go viral.[*] I remember friends filming their pets dancing or their nieces and nephews causing trouble and posting the videos online assuming that, at some point, these silly moments would be picked up and spread. For them, it was not a hope but an inevitability. People mistakenly think that you can make something that's somehow inherently viral, Cheese told me, but if you want to truly understand how virality works, you need to understand networks, not content.

THE NETWORKS OF VIRAL SPREAD;
OR, WA-PA-PA-PA-PA-PA-POW!

Norwegian brothers Vegard and Bård Ylvisåker were well known in their homeland, where they hosted a popular late-night comedy show, but didn't have much international reach. In 2013, Stargate, an

[*] Citing only from data collected through personal conversations.

NYC-based Norwegian music production team, reached out to them about making a video for a birthday party they were throwing. Vegard and Bård said yes, but only if the team agreed to produce a song for them in exchange, an offer they were sure would be turned down.* Stargate agreed. Vegard and Bård—jokesters as they are—decided that instead of getting Stargate to try for a chart topper, they would abuse them a bit by having them produce a silly song concept they'd had sitting around that definitely wouldn't be a hit. That plan seriously backfired.

When the Ylvis duo released the video for "The Fox (What Does the Fox Say?)" to promote the new season of their late-night talk show, they assumed it would make some noise in Norway, and that would be it. Instead, the video spread like crazy, gaining millions of views every day for months and eventually becoming the top-trending YouTube video of the year. A reporter from *Billboard* asked Bård if he had any idea how this had happened. "None," he said. "What surprised me the most is that even the very earliest comments on YouTube were 'This one is going to go viral,' 'This is the new "Gangnam Style."' Everything was about it going viral. Normally, you know we get some hits and we get some comments, but they're all about the actual contents of the songs. But this was mostly about the phenomenon, which was really strange, even when it was only at 100,000 views."

Knowing for sure whether something is "viral" can be impossible to discern just by looking at a view counter, yet we seem to have developed an instinctive sense for how and when something has viral legs. Following the path of a video's spread is a challenge too given the many different platforms we use to pass things around that are not connected in any meaningful way, but I have still been able to identify common audience patterns below the surface of many viral hits.

❀ ❀ ❀

* Stargate is not some obscure team of producer/songwriters; they're the hit-making duo behind some of the top pop songs of the early twenty-first century. Their #1 singles include Ne-Yo's "So Sick," Katy Perry's "Firework," Beyoncé's "Irreplaceable," and a slew of Rihanna's hits ("Rude Boy," "What's My Name?," "S&M").

WHEN IT COMES to longevity, some viral videos are flashes in the pan while others stick around for months if not years. Here are daily views of "The Fox" compared, for example, with an amusing video of a guy showing a magic trick to an orangutan over their first month of existence:

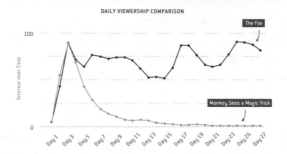

As you can see, they have near identical trajectories to start, but one has staying power while the other fades fast. (In the next section we'll cover what factors seem to contribute to these outcomes.) Using the simple metric of views, as I have above, both videos look very similar in that first part of the graph. Looking at more nuanced YouTube data, however, we can tell if the burst of views came from sharing features and embedded players, for example. If a high percentage of views come from these sources, you know for sure that conversation and interaction are driving a video's popularity.

When we scrutinize where and when different activities took place, we see how the paths to virality become more diverse. In the case of "The Fox," Ylvis fans posted the video to Reddit, where it spread quickly among that site's community. The funny orangutan video gained a lot of exposure through the popular *World Star Hip Hop* site. These venues probably account for a small amount of the overall viewership, but they each have very active user communities that love to share things to other sites, and therefore other communities, meaning that the video traverses different networks of users.*

* Cheese told me that the team at *Know Your Meme* used to joke that if you wanted to know if something was going to be big, you should see if it popped up in the body-building forums.

The "networks" are really just collections of people, communities of human beings who are connected to one another because of a shared interest or purpose. This is key to the work that Kenyatta Cheese does, which often revolves around fan communities. He advises the people he consults with that proactively creating something that will go viral is about optimizing for various groups. "You've got to figure out how to make it work for them," he told me. "What are they sharing? How are they sharing it? What's important? What are their values? What's important to them? What's not important to them? Design-wise, what fonts are they using? What's the length of videos they're already sharing? What are the attributes, the things they're latching on to: character, relationships, story? You have to understand that about the network before you create something for it."

Of course, the manner in which things go viral—in other words, the ways in which our interactivity with a video propels its success—changes over time. People stop using certain sites or adapt different behaviors as technology evolves. Social media accounts replace blogs. Apps replace web homepages. New sharing tools proliferate. This constant evolution changes the specifics of how things spread, their velocity, and so on. But our hunger for sharing the experience of videos we connect with and react to supersedes any specific piece of tech, because making things go viral is now just a part of our digital lives.

Okay, so going back to the Fox vs. Monkey viewership chart,° what's going on when the two clips deviate dramatically?

Sharing and embed traffic rarely remains consistent. Viruses are probably not the best metaphors for the spread of videos online because the analogy suggests that, upon being exposed to something, we all become "carriers" and pass it along, but in reality only a small percentage of the people who are exposed to even a very shareable video will actually share it. The engagement rates (the ratio of likes/shares/etc. versus

"For some reason, anything that was taken from a corner of the internet and passed along eventually passed through there," he said.

° I bet *that's* a phrase that has never been printed in a book before!

the number of impressions) for most social platforms is pretty low (often less than 1 percent).

Looking at the traffic itself, what holds up that longer tail of viewing? For some videos, the sharing activity will continue as more communities come across the video and begin to post it within their networks. While "The Fox," a global phenomenon, had a strong audience in Norway from the start, the video only blew up in the Philippines a month later. Poland got into it a few days before Hungary. This can happen not just with geographies, but also with different demographic or social groups. But for many videos, the source of viewership shifts to searches and YouTube's own recommendation engines. People often search for videos when they know what they're looking for, meaning the video is either something you've seen before or heard something about.

And that's when videos like "The Fox" cross over from some little fad to the kind of entertainment that has lasting value and will one day inspire nostalgia. They become the fabric of our popular culture.

THE ELEMENTS OF VIRALITY

So what characteristics do viral videos share? Pretty much every viral video I've come across in the years I've been studying the phenomenon involves three common elements. Looking at different memes and trends, you might spot other important characteristics, but these three apply to everything from shocking eyewitness videos to the renowned piece of modern video art known as "Cat In A Shark Costume Chases A Duck While Riding A Roomba."

1. PARTICIPATION

Given that web video is an active rather than passive medium, content that is optimized for the active participation of the audience is best positioned to succeed. The exact origin of the Ice Bucket Challenge is

hard to pin down. I do know that in the first half of 2014, small groups of people began to challenge one another to dump buckets of ice water on their heads in the name of charity. A number of professional golfers did it, as did Matt Lauer on the *Today* show. But it wasn't until late July that Pete Frates, the person most people credit with kick-starting the trend, posted a video to his Facebook page.

Frates and I hadn't met, but he was the year below me in college, we had the same major, and he played center field on the baseball team. Boston College is a small enough place that when doctors diagnosed Frates with ALS at just twenty-seven, word got around fast. Frates had sat down with his family the night of his diagnosis and vowed to get more exposure for the disease. "I'm going to change the face of this unacceptable situation of ALS," his mother later recalled him saying. "We're going to move the needle, and I'm going to get it in front of philanthropists like Bill Gates." Given the Jesuit school's focus on community service, many fellow alumni took up Frates's cause in the ensuing months.

Only a week after Frates posted his IBC video, which encouraged a few of his friends to participate in the challenge, it seemed like everyone I'd gone to college with had dumped water on their heads. It took me a while to figure out that my social media feed wasn't the only one that had become dominated by this trend; it wasn't just a Boston College thing, but an entire-American-internet thing.

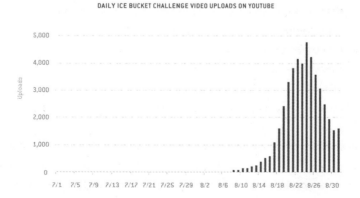

DAILY ICE BUCKET CHALLENGE VIDEO UPLOADS ON YOUTUBE

Millions of Ice Bucket Challenge videos were posted to YouTube and other platforms that August, and they were watched billions of times. It dwarfed previous trends like the "Harlem Shake." Funny enough, the most-watched Ice Bucket Challenge that year was the one posted by Bill Gates. Over an eight-week period in 2014, people donated $115 million and in 2016, a research group attributed its discovery of a new ALS gene to the funding it received through the Ice Bucket Challenge.

Again, it wasn't the celebrities that made it a big deal; it was the fact that everyone could participate. Ice Bucket Challenge videos were very easy to reproduce and part of their very structure was to cajole other people into participating. Even my father staged a rather shoddily produced one in my backyard in Florida, recorded presumably by my rarely patient mother in a scene I am disappointed I did not witness in person. The Ice Bucket Challenge succeeded because it lowered the bar for participation so close to the ground that anyone could do it and, for those who were hesitant to cross even that tiny hurdle, there was a built-in guilt factor to get you over it.

This irresistible community participation can be found in many of the big trends and viral videos. Sometimes it's a very quotable line ("Damn, Daniel! Back at it again with the white Vans."). In the case of "Gangnam Style," the accompanying horse dance provided us with one easy way to join in. Some of the most vociferous activity comes not from mimicking but from reacting, however. In 2015, YouTube comedian Nicole Arbour posted a video titled "Dear Fat People" in which she strung together six minutes of jokes making fun of the overweight. "Obesity's a disease? Yeah, so is being a shopaholic, but I don't get a fucking parking pass," she says shortly after declaring "fat shaming is not a thing." People predictably flipped out. When she later appeared on *The View* (because of course), Arbour defended her comedy, saying "That video was made to offend people, just the way I do with all my other videos." This strategy tends to bother people, but the truth is that it's effective. Despite the millions of people who hated the jokes and Arbour's point of view, the video spread because it implicitly

invited us to participate in it by adding our own perspectives. Things that inflame us invoke our participation pretty effectively. The Ice Bucket Challenge succeeded because of its inherent goodness, and videos like "Dear Fat People" succeed because of their inherent badness.

"There's a difference between media and social media," Cheese told me. "That's like the difference between egg and eggplant. They use the same word, but they're completely fucking different things. One is about content and the other is about conversation. If you're trying to figure out virality, what you have to understand is conversation, not the thing itself."

Most people have a difficult time internalizing this concept: What we think about the video is more important than the video itself. Historically, we associated the popularity of traditional entertainment with how well made or broadly enjoyable it was, but web video inverts this model, elevating the individual experiences and interactions of the audience members to the art above the art itself. Videos themselves don't go viral, the experiences we have with them do.

This is how we answer the paradoxical question indirectly posed by Ms. Black and "Friday" back in 2011: How can the most popular thing in the world be the thing people don't like?

2. UNEXPECTEDNESS

Given the millions of videos we have at our fingertips at any moment, surprise and uniqueness hold incredible value. *Michael Jackson: Thriller*, directed by John Landis in 1983, is probably the most influential music video of all time. For years, people have been re-creating the dances from *Thriller*, but one especially stands out. In 2007, Byron Garcia, head of the Cebu Provincial Detention and Rehabilitation Center in the Philippines, started using music and dance choreography to get inmates to participate in an hour of exercise each day in the yard. They danced to everything from Pink Floyd to the Village People. He began recording and sharing the videos to YouTube as the

choreography got more elaborate. Fifteen hundred inmates partici-
pated in the "Thriller" video, which floored me the first time I saw it. I
didn't know the story behind the video, and nothing about it made
sense to me, but I knew one thing for sure: I had to share it with
someone else. Several million other people felt similarly.

During an era in which we are inundated with social media and
entertainment content, uniqueness is a necessity. The volume of video
available offers us more and more opportunities to stumble across
things that are unlike anything we've ever seen before, raising the bar
for what can actually break through. When I look at the diversity of
videos that have gone viral in my years at YouTube, I see a consistent
pattern: Each contains at least one central element that differentiates
them from what we find familiar. They shock us; they show us some-
thing new or answer a question we've always had. "The Fox," for example,
is full of big surprises. For one, the lyric "What does the fox say?" itself
sets up a series of unpredictable punch lines in the form of sing–along
moments ("Hatee-hatee-hatee-ho!"). But perhaps the most unexpected
element comes from its origin with the Stargate team: It's a ridiculous
joke set to a legitimate pop soundtrack that sounds just as catchy as
what we hear on the radio.

We naturally gravitate toward the things that surprise us. Research
studies using functional MRI scans show that truly novel stimuli acti-
vate the brain's "novelty center," the substantia nigra/ventral tegmental
area (SN/VTA), and induce the release of dopamine. We're hardwired
to find pleasure in unexpected creativity.* Surprise is central to many
theories of humor, marketing, and psychology, and surprising videos
can engage us in the moment, drive curiosity, shift our perceptions, and,

* In the same study, they also determined that something sort of familiar did not have the
 same effect. Explained one of the researchers: "We thought that less familiar information
 would stand out as being significant when mixed with well-learnt, very familiar information
 and so activate the midbrain region just as strongly as absolutely new information. That was
 not the case. Only completely new things cause strong activity in the midbrain area." This in
 part explains why the Cebu inmates never truly re-created the success of their "Thriller"
 performance.

critically, lead us to share the experience with others. Surprises create extra work for us as we process the unusual thing we're experiencing, creating a cognitive burden that we instinctively seek to reduce. "We humans relieve this burden by sharing it with others," write Tania Luna and LeeAnn Renninger in their book *Surprise: Embrace the Unpredictable and Engineer the Unexpected.* "We talk about almost every emotional experience we have, keeping only 10 percent of our experiences to ourselves. The more surprising something is, the sooner and more frequently we share it with others." When it comes to viral videos, this translates to, for example, an immediate delight in seeing "Cat Wearing A Shark Costume Cleans The Kitchen On A Roomba" and then a compulsion to post that thing on your social media feed to share the experience with your friends (and hate-followers).

In summary: Why do viral videos always seem so weird? That's the very quality that helps make them viral in the first place.

3. ACCELERATORS

If you study any viral trend, you'll find, somewhere along the way, the presence of people, publications, or other mechanisms that rapidly accelerate the spread of something by broadcasting it to a larger community of viewers.

During the 2008 U.S. presidential election, I wasn't the only one making satirical political videos. A team called Barely Political produced a parody music video called "I Got a Crush on Obama," which featured a fangirl character called "Obama Girl" played by model Amber Lee Ettinger.° The clip seemed to appear everywhere someone was covering the election: cable news networks, political news websites; it even spawned a *New York Times* op-ed. Subsequent videos made "Obama

° You'll recall from the remix chapter that Noy Alooshe, who created "Zenga Zenga," scored his first viral hit with an "Obama Girl"–inspired character named "Livni Boy."

Girl" an early web video star, with *Newsweek* calling it the #2 internet meme of the decade.

"As for why it hit the zeitgeist, I think it tapped into two big stories of that election," Barely Political founder (and my YouTube colleague) Ben Relles told me. "How young people were going crazy about Barack and how YouTube was changing the way people could participate in the election." As for how it spread in the first place, after a number of tiny political blogs picked it up, the ABC News then-lead political correspondent, Jake Tapper, featured it on ABC's site. Tapper was one of the most influential reporters that election cycle, and his action spawned mainstream media coverage, which helped the Barely Political team build an audience of fans who turned out for future "Obama Girl" videos throughout the election cycle.

I've spent a lot of time trying to track down the patient zero carrier of many of my favorite viral videos, but I invariably fail. Instead, what I find are nodes: concentrated exposure points of rapid dissemination. In Relles's case, it was Jake Tapper and ABC News that served as the critical node. Imagine someone gets infected with a highly contagious virus. If they simply go to a friend's house, infect the friend, and then go home while that friend goes to another friend's house, it would take a long time for everyone to get sick. But if they go to a shopping mall, everyone in town would carry the virus by the end of the week. The same goes for videos and memes. Within the various loosely connected structures of our digital environment, many things can play the role of that shopping mall.

For Rebecca Black, it was *Tosh.o*'s blog (which itself had discovered her video from another blog, the *Daily What,* which had posted it after it was submitted by a reader) along with other comedians, like Michael J. Nelson of *MST3K* fame, who helped accelerate the spread of "Friday." With "The Fox," Ylvis broadcast it on a TV show. Even though the show was in Norway, it still reached a large enough number of viewers that it could spread quickly and internationally. From there, it invariably got swept up into other nodes. Many of the communities we've already covered are effective nodes too. The 2008 political blog scene

was insatiable in its appetite for fresh content and "Obama Girl" became perfect fodder. Nodes change too. The "blogosphere" no longer carries the same influence it once held, and in its place new nodes have emerged. Platforms themselves can be nodes now; many popular viral ads actually begin by gaining initial exposure through YouTube's advertising systems.

It's not just third parties that can act as nodes. YouTube creators themselves have grown in influence to the point where their own subscriber bases and built-in audiences can be the initial node that then goes on to share something. Previously we thought tastemakers (like Jake Tapper in the '08 election) were essential for something to reach viral scale and velocity, but in recent years the people who created things online became their own tastemakers by building these big audiences themselves.

It won't surprise you that PSY set the record for the most views in a single day of any YouTube video.° What may surprise you: He didn't do it with "Gangnam Style." No, "Gentleman," the follow-up single, achieved the feat, and it's easy to see why. "Gangnam Style" took some time to spread and pervade different communities and geographies, but by the time "Gentleman" dropped, PSY had accumulated a larger fanbase outside South Korea, which meant there was a ready and waiting diverse audience who immediately turned and shared the video with their own communities, kicking off a whirlwind of viral sharing.

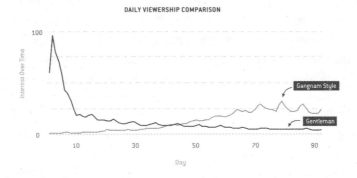

DAILY VIEWERSHIP COMPARISON

° The record stood until 2017, when Taylor Swift exploded social media with the debut of her reference-dense zombie-vengeance music video for "Look What You Made Me Do."

PARTICIPATION, UNEXPECTEDNESS, AND accelerators are the common links I've found among the most popular viral videos. But is it possible to *make* something go viral? Not exactly. Given enough money and a clever strategy to seed something within the right nodes, you can approximate the popular conception of a viral video, i.e., something that's getting a lot of attention on the internet. "If you're paying a bunch of influencers to push it, you happen to time that really well as a press push, and you're spending millions of dollars on marketing so everyone is reminded of that thing somehow in the background, then yes, you can create something that feels huge," Cheese told me. "But if [that popularity] doesn't come from actual emergent behavior, it's hard to sustain."

Ultimately, ensuring maximum exposure is one thing, but inspiring people to participate in something is a different challenge entirely. It's not about whether we will click and share, but rather what value reacting to and participating in something holds for us in the first place.

A TRANSFER OF POWER

It was a cold January day in Washington, D.C., and we'd just wrapped the "YouTube Interview with President Obama 2011" in the White House's oval Diplomatic Reception Room. I had, an hour or so earlier, somehow gotten myself temporarily locked out of the White House during an ill-conceived run back to the office to obtain a MacBook display adapter that we needed. It was a rookie move, and I was feeling pretty stupid. (I have since, literally, never gone anywhere without laptop-to-VGA/HDMI adapters in my bag.) After the interview, President Obama graciously spent a few moments chatting with us about technology and media. We asked him about YouTube videos he'd seen. "Have you seen the one about the unicorn that goes to the mountain?" he asked. "Charlie the Unicorn Goes to Candy Mountain?!" we all said, disbelievingly, in near unison. Apparently, the first daughters had showed the president the animated video, and it had stuck with him to

the point that, in one of the most surreal moments of my entire life, the president (*of the United States of America*) began recounting the plot of "Charlie the Unicorn" to us and his very puzzled staff.

"Charlie the Unicorn" is a roughly four-minute animated film created in 2005 by a twenty-year-old filmmaker named Jason Steele. In it, the titular Charlie, a depressed unicorn, is persuaded by two friends to join them on a trip to a place called Candy Mountain. Along the way, Charlie and his comrades come across a number of bizarre sights until, upon reaching Candy Mountain, Charlie is knocked unconscious. He wakes up to the frustrating realization that someone has stolen his kidney. For those of us who grew up watching saccharine children's TV, the refreshingly dark and strange satire made "Charlie the Unicorn" a huge cult favorite. The video and its three follow-ups have been watched more than 150 million times and helped launch Steele's career and his studio FilmCow. The video's irreverence spurs people with quirky senses of humor to show their friends. It's not mainstream and the very way we stumbled upon it was likely unconventional and fun too. In 2016, Steele launched a Kickstarter campaign to raise $50,000 to fund a thirty-minute finale to the "Charlie the Unicorn" story. Fans contributed more than $200,000.

I had always assumed Steele invented the video during some kind of late-night (possibly drugged-out) madman's epiphany, but the origin of "Charlie the Unicorn" turns out to be much more personal and poignant than that. "I lost most of my possessions, and my job, when Hurricane Katrina hit New Orleans," explained Steele in a 2016 Q&A. "My mom's birthday was coming up, and I was completely out of money, but I still wanted to get her something. Knowing this, she said that instead of a gift I could make a cartoon for her about unicorns. So I made 'Charlie the Unicorn.' More than ten years later she still brings up the fact that her birthday present launched my career."* Lots of

* For those wondering: According to Steele, his mother didn't seem to be very impressed at the time, but she still liked that he'd made it for her.

little interactions—in the form of emails, blog articles, forum entries, and social media posts—turned one mom's birthday wish into a piece of unforgettable internet gold.

This kind of pattern might seem like an aberrant phenomenon of limited significance, a novel side effect of the ubiquity of internet technology. But the fundamental principles underlying the spread of viral videos are a part of how we connect to one another now, spawning an entertainment landscape powered by these relationships. Each of us, no matter our age or experiences, has already adapted to playing this more active role in pop culture, whether we care to recognize it or not.

THE DIVERSITY AND unpredictability of web ephemera reflects a culture that is forming outside traditional mechanisms of control. I've found that viral videos are not specific to any one demographic or geography. Viral patterns of sharing can be found around all sorts of things among all sorts of people in many different languages.

Sharing viral content allows communities and interest groups to connect in ways that traditional media doesn't, and that's addicting. These internet-enabled points of connection are so important to us now that even the least tech-savvy people will find ways to make the clunkiest technologies work for them for this purpose. "I'm half Chinese, so there are these Chinese mom email forwards," Cheese told me. "These huge PowerPoint files! It is the *worst* way to distribute something, to distribute a meme as a 10Mb PowerPoint file over email. The reason why people do it is because of the emotion they feel about the content."

One of my favorite viral videos, from a data perspective, has a rather unlikely star. Ken Craig, an eighty-five-year-old man who grew up in Oklahoma, demonstrated to his daughter-in-law a trick to shucking an ear of corn and removing all the silk (briefly microwave, slice, and shake the ear out of the husk). She recorded it on video and posted it on YouTube so her daughter, who taught English in Korea at the time, could see. Craig, who did not even have an email account, hoped the video would draw fifty views. It racked up close to ten million. I first noticed

"Shucking Corn—Clean Ears Every Time" when it appeared at the top of our "Trends Dashboard." It became the top-trending video among users over the age of fifty-five on YouTube for a few days. A huge percentage of its views originated not on Facebook or Twitter but on Yahoo Mail. Viral videos are not a phenomenon limited to youth; they have value for all of us.

VIDEO DISTRIBUTED THROUGH interpersonal interaction can fundamentally change how people of all ages discover and relate to new information or perspectives. It allows all kinds of media the potential to attract large audiences without always requiring a preexisting network of fans or the sort of built-in viewership that comes with a prominent slot in a cable lineup or radio dial or a prime placement on a popular app. In the entertainment industry, it can enable you to "skip the line" to securing our attention. It creates overnight celebrities and can even turbocharge sales for specific products (see: the imprudent self-balancing scooter craze of 2015). The majority of viral phenomena do not really result in any kind of sustained value for their originators. Sure, there are always the winning-the-lottery moments, like when David DeVore Jr.'s father recorded him in the back seat of a car reacting to anesthesia post oral surgery and created an iconic video that earned enough money to cover David's future college tuition. But the lasting impact of viral videos on our society will not be in get-rich-quick schemes or disrupted business models, but rather in the ability of such moments to rapidly change our points of view on the world.

Cheese told me about an experience that ended up influencing how he thinks about media and technology: During the 1999 World Trade Organization protests in Seattle, he helped put together video-encoding machines that allowed groups on the ground to get video distributed rapidly. These videos altered the tone of the conversation around the protests, and the police started targeting the runners who carried the tapes, disrupting the distribution chain. Cheese was inspired to develop a backpack that supported streaming video live to the web.

The empowering nature of peer-to-peer circulated information and content felt immediately transformative. "As somebody who came from a background of activism . . . trying to bring attention to things the mainstream was trying to ignore, I am very happy, very fucking happy about this," Cheese said, though he added, "It does raise a new bunch of challenges. It requires us to rethink a lot of our values, rethink what it means to have control, rethink what it means to have the responsibility of attention."

Viral sharing opens up new avenues for us to express ourselves quickly to many. We get to choose what we create and we get to choose what we share. Our small individual actions have an almost inconceivable ability to reach the same scale that could only be unlocked by entire institutions in the past. But with such power comes, of course, responsibility. It's a little scary. But that's also how millions of people made it possible for a broke animator's birthday present to his mother to become an underground favorite so popular that even the president of the United States had checked it out.

By 2016, Rebecca Black had transitioned to a different kind of star. While one might have expected her to disappear into the one-hit-internet-wonder hall of fame, that didn't happen. First of all, "Friday" actually stood the test of time. Years later, the song still spikes every single Friday. People really *do* love Fridays. The last time I'd seen her was at the YouTube office that day in 2011 as she, with the kind of excitement only a fourteen-year-old girl can muster, ecstatically signed the placard outside the conference room we'd named after her. I saw her again from a distance, at a big internet-video convention five years later. She was meeting and taking photos with fans. Not fans of "Friday," but fans of Rebecca Black the YouTube personality. In the years following "Friday," Black amassed over a million subscribers to her channel, rebecca, and

became a more traditional "social media influencer," signing on with AwesomenessTV, releasing new less-terrible music videos, and producing weekly vlogs covering makeup, life advice, and more. As reporter Reggie Ugwu wrote in his in-depth follow-up four years after the original "Friday" phenomenon, "In Black's story, middle and high school–age kids enmeshed in the unlovely 'before' phase of life see a survivor and a role model, someone who lived through a social media nightmare of epic proportions and managed to emerge unbroken." Rebecca Black the creator had transcended Rebecca Black the inadvertent viral star.

Starting around 2012, the value of "viral videos" really began to diminish from a business perspective. Sustainable audiences, like the one Black amassed with her channel post "Friday," became the focal point. You can't really build a business trying to make individual videos go viral all the time, and that's true for creators, advertisers, and the platform itself. YouTube's strategy reoriented around channels, and while individual videos still become popular, YouTube has evolved to become a network of shows and personalities more than a library of viral clips.

But culturally, the viral video persists and I expect it will remain an important aspect of how we entertain ourselves and share knowledge for years. That's because it's a behavior that is not really tied to or created by specific technology. Instead, it's the reverse. As those old newspaper clippings show, we've been spreading things "virally" for centuries, but today's technology enables and amplifies it at such scale that we can quickly give ordinary people more cultural influence than many media industry professionals.

Yeah, the internet has matured. And original programming from Netflix/Amazon/Hulu/YouTube sometimes makes me question whether the dominant forms of creative expression on the web will soon go through the same kinds of corporate-controlled studio vetting that managed the spread of media in the past. But the concept of viral video gives me hope that some part of the web will remain strange and wonderful. It's a development that more or less guarantees the internet

maintains its delightful eccentricity because it ensures that we *all* have the opportunity to take charge of how things spread. It is a check and balance to secure that, forevermore, any of us as individuals will have an ability to influence the pop culture zeitgeist of the moment, no matter what the marketing budgets of the competition are.

This is a world where things spread not because of the money behind them (or even because of their artistic quality). This is a world where videos and talents succeed because of the unique things they do for us.

CHAPTER 11

What Videos Do for Us

A T T H E A G E of twelve, Jason Russell had a really big idea: "What
if you could tell a story to millions of people and they could expe-
rience it all at the same time?"

Russell had grown up in the theater—in the early 1980s, his
parents founded the Christian Youth Theater, which now identifies
itself as the United States' largest youth theater organization—but he
knew it would take decades to tell a story to millions of people via the
stage. So he set his sights on a career in filmmaking. After graduating
from the University of Southern California's prestigious cinema school,
Russell sold a Hollywood musical to DreamWorks and was on track to
make movies for the big screen. But he'd promised himself that he
would go to Africa first and document the war in Darfur. Inspired by
photojournalist Dan Eldon, who covered Somalia for Reuters in the
early '90s until he was killed in 1993, Russell left for Sudan.

"That's when it really shifted for me," Russell told me. "I felt like
the world didn't necessarily need another Hollywood movie or musical.
I felt like the most important thing I could do after college would be to
give a year of my life to a film that would hopefully, in a sense, free
people or save people."

While in the northern Ugandan town of Gulu, just below what's now
South Sudan, Russell was exposed to the shock of "night commuters,"
children who traveled into the city at night to avoid being kidnapped
and forced into becoming soldiers in a conflict that had been going on
for seventeen years. In the initial film shot by Russell and two other
college students, Bobby Bailey and Laren Poole, with whom he'd joined
forces, Russell said, "[We] paint ourselves as pretty naïve and stupid,

and we kind of were." But the story they told laid the groundwork for an advocacy movement focused on ending the conflict.

Over the years, Russell and the organization he founded, Invisible Children, lobbied government officials, met with influential leaders, and toured high schools across America, hosting screenings of the films and signing up young people to the cause.

Almost ten years (and eleven films) later, Invisible Children set out to produce a new film to be distributed primarily online in what Russell described as "kind of the last-ditch effort for people to pay attention." They narrowed the target audience profile to "a fourteen-year-old white girl in suburbia in her bedroom" and edited it down to twenty-nine minutes and fifty-nine seconds. They knew that was long. "We were making it and constantly saying, 'Nobody watches a thirty-minute YouTube video,'" Russell recalled. Regardless, they still set a pretty aggressive goal—five hundred thousand views by the end of the year—and published it to YouTube on Monday, March 5, 2012.

"To level with you, this movie expires on December 31, 2012, and its only purpose is to stop the Rebel Group the L. R. A. and their leader Joseph Kony," Russell narrates partway through the video. "And I'm about to tell you exactly how we're going to do it."

You've likely seen "Kony 2012" by now, or at least heard of it.[*]

The documentary was the second-biggest video of that year, behind only PSY's epic "Gangnam Style" in our annual end-of-year trending video list. It was a global phenomenon. The video blew past the team's target in the first few hours. Two days later, it set a record for most views of a video in a single day. It was watched more than thirty-one million times that Wednesday alone.[†] "Kony" was the most searched phrase on all of YouTube for a few days and Google declared it one of the top ten trending searches of the year in the United States. "Kony 2012" became

[*] As a quick refresher, it depicted Russell explaining the conflict to his five-year-old son and communicating the story of the L. R. A. through the lens of the people he'd met in Africa, including his friend Jacob, an L. R. A. escapee he'd bonded with ten years prior.

[†] A feat that was surpassed only by PSY a year later with "Gentleman."

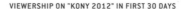

VIEWERSHIP ON "KONY 2012" IN FIRST 30 DAYS

and remained for years the most-viewed nonprofit/activism video on the web. And people weren't just clicking and bailing. The average viewing duration was over nine minutes (more than four times what most other videos drew at that point). More than 10 percent of the views came from people who watched the full thirty minutes at once.

This sort of velocity was unheard of at that time. "What were you expecting to happen?" I asked Russell. "Not that," he replied. "I mean, no one saw it coming because it's never really happened."

Just a few years prior, when I was producing viral videos myself for the Huffington Post, we had three rules: 1) Make it funny, 2) Make sure it's explainable in a sentence, and 3) Keep it short. (I used to go so far as to trim videos down so the video length would be one minute and fifty-nine seconds, as if they were going on a viral-video discount rack.) "Kony 2012" defied all those rules, yet it was a massive phenomenon. How did Russell and his team do it?

To start, the Invisible Children team studied the history of propaganda and woke up each day trying to apply its tenets with a singular goal: Make Joseph Kony famous. Russell described this focus as "the game changer to hyper success," and it carried over into the video itself. "Specificity and simplicity are the most powerful ways to tell a story," Russell explained. Editing-wise, they judged its "online-worthiness" on whether the video successfully hooked you every six

seconds. But the production style was ultimately only a small part of the reason the video spread so fast.

"It was all about the grassroots fourteen-year-old girl in her bedroom doing something," Russell said. The video called out "three things you can do right now," which included signing a pledge, getting a bracelet and an "action kit," and signing up for small monthly donations. "ABOVE ALL SHARE THIS MOVIE ONLINE," the on-screen graphics read. "IT'S FREE." Invisible Children explicitly called out that sharing the video meant you were participating in the cause. Despite being a key to the success of "Kony 2012," this is, perhaps, one of the more controversial and widely criticized elements of the campaign. "People say clicktivism and slacktivism don't do anything," Russell told me. "You know, they get a message across pretty powerfully." He pointed to marriage equality and transgender rights as issues where a focus on awareness has played a significant role in changing hearts and minds. "These types of concepts would have taken decades to understand or empathize with, and now they're taking months or years," he said. "To me it's a really exciting time in terms of understanding the 'other' and putting yourself in someone else's shoes."

Not to speak ill of teenage idealism, for which I maintain great fondness and, in some cases, intense jealousy, but there's something more at play here. The cynic in me believes "Kony 2012" was so widely shared because of, more than anything else, what it did *for the viewer*. It was an opportunity to express yourself as the kind of person who cares about global affairs. It provided a central issue around which we could engage with the other people in our social groups. It empowered us to be a participant in the phenomenon, not a passive bystander, as a means of saying something about who we are. Russell explicitly invited us to embrace the idea that we can have an active influence on the world. "I definitely think people were supporting it because it made them feel good about themselves that they were helping and it made them believe that they were part of something bigger than they are, which I think all human beings desire," Russell said. "Kony 2012" was just as much about the audience as it was about the topic.

Over the prior decade, Invisible Children had reached huge numbers of students via in-person screenings and events, giving the video a running start. Russell estimates there were some five million young people ready and willing to participate before the video even came out. Meanwhile, Invisible Children was able to accelerate the spread of the video by giving an arbitrary deadline and asking that viewers reach out to twenty "culture makers" and get them to become a part of the movement. They turned the tables on the common strategy of having celebrities help drive awareness, which, Russell said, often falls flat. In this case, *you* were asking Ben Affleck, Rihanna, and Tim Tebow to participate and join *your* cause. Celebrities weren't the focus of the campaign, but they played a critical role as "accelerators" of the video; five of the top fifteen most followed accounts on Twitter shared the video within hours of one another. Oprah, who'd long been a supporter of their cause, tweeted about the video within the first day, boosting awareness immediately.

All that sharing led to a critical mass of conversation. You really couldn't escape the video that week; it was a huge grassroots movement seemingly led by a legion of fourteen-year-old girls. By the end of the week, White House Press Secretary Jay Carney was getting questions about it, and every major publication was covering it in some way. Bono declared that "Kony 2012" deserved an Oscar. This was to be just the start.

"We had a bunch of cool things that we were ready to roll out which we didn't get to at all because the whole thing kind of lasted ten days," Russell said.

I had forgotten how fast the narrative of "Kony 2012" shifted from unifying humanitarian outrage to skepticism and ridicule. But, like many people, I had not forgotten how that ultimately happened.

Two days after "Kony 2012" hit the web, a nineteen-year-old university student posted a detailed criticism on a Tumblr called "Visible Children," writing, "I do not doubt for a second that those involved in KONY 2012 have great intentions, nor do I doubt for a second that Joseph Kony is a very evil man. But despite this, I'm strongly opposed

to the KONY 2012 campaign." The post called into question the move-
ment's tactics, finances, and mission. It drew millions of clicks, as did a
vlog posted the same day by a teenage girl—whose parents were born in
Uganda—purporting Kony was already dead. Then came criticisms from
other activists, experts, and more, both on small blogs and prominently
in the mainstream press. These ranged from accusations of oversim-
plification to misrepresentation to emotional manipulation to endorse-
ment of the "White Savior Industrial Complex." (A few years after this,
I was giving a talk to a room of activists and used "Kony 2012" as a case
study in successful online distribution, only to have the mere mention
of it derail the session into aggressive debate on the campaign's merits.)

The video had made Russell the face of the movement, and this
criticism intensified a global spotlight on him for which he wasn't
prepared. On March 15, just ten days after he posted the video, Russell
suffered a psychotic breakdown that left him ranting and raving,
naked, in the streets of San Diego, an incident that someone recorded
and gave to *TMZ*, which posted it online. Unfortunately for Russell,
that video went viral too. "I think it totally ruined it, tainted it, and
got people super confused," Russell said. "I mean, for any leader who
has a naked meltdown and it's posted on *TMZ*, it's just, 'Sorry. You
can't be trusted again.'"

Russell is surprisingly open about what happened. "The break-
down was horridly embarrassing and very traumatizing for me person-
ally and my family, but in the long run I can't tell you how many people
have come to me and said, 'Thank you. You took the heavy end of that,
but [a similar breakdown] happened to my sister, that happened to my
friend,'" he told me. "I view it as something that will always be a part
of my story, but I don't believe it will be the thing that defines my story.
And I'm talking about the long game."

These days, Russell operates a small creative agency called Broom-
stick Engine, working on campaigns for cause-based organizations.
When we spoke, he told me he was completing a film for Charity: Water.
He also had a long-term plan to create the world's largest humanitarian

effort via an augmented-reality gaming experience, which he considered his "big idea" for the next few years.

Was "Kony 2012" a success? That's a tough question to answer, even for Russell. More than four years after the video's debut, Joseph Kony had still not been captured and the L. R. A was still operating, though in a severely diminished capacity. "I believe all of us saw the beauty in humanity because of its desire to bring justice to a region of the world which honestly doesn't have a lot of justice," Russell said. He acknowledges that the dream of Invisible Children was cut short, that criticism of the film created a lot of confusion, that the ensuing events may have even ruined his life (at least temporarily). "But overall if I was to give it a Yelp review, I'd say four out of five stars," he said with a smile. "It was worth it. It was amazing."

There's no denying that "Kony 2012" achieved one of its goals: It made Joseph Kony famous. And it did so by connecting its abstract humanitarian message to the value we derive from videos on an immediate, personal level. It also changed the way many of us look at what the right video at the right time can do for an idea. And for us.

◄◄

Thanks in part to many, many years of conditioning through traditional media, when we talk about why a piece of video becomes popular, we often focus on the viewing experience. Is the video funny? Is it informative? Does it demonstrate some interesting artistic quality? This is a completely reasonable way to assess entertainment but often has nothing to do with what is actually popular. Because, when you look at the most-watched, -shared, and -discussed videos each day, much of that is irrelevant.

Within six months at YouTube, I learned that the qualities that made certain popular videos resonate with people were a bit different

from what I'd originally thought. More than anything, what propelled the popularity of a video was what happened AFTER someone watched it. It took that thirteen-year-old girl Rebecca Black to clarify things for me. As we entered the throes of the "Friday" craze, I realized that the way we reacted to a video was more important than the content of the video itself. And the ease with which a creator or video could facilitate interaction among us could supersede any other creative decision or element. "Friday" was more about us than it was about Ms. Black at the end of the day (week?). And the same was true for "Kony 2012."

Essentially, the criteria by which we individually and as a society assess the value of our media has shifted quite a bit. Today, the way we use technology places less emphasis on artistic merit alone and more on the possible roles a video or trend can play in our lives. The ultimate gratification we derive from them isn't necessarily surprising, but the kinds of content that offer the best opportunities to extract that satisfaction often are. The value lies not in the videos themselves but rather in the connections they generate and facilitate.

THE MOST POWERFUL DRIVER OF ALL SOCIAL MEDIA

In 2015, comedian Matt Little had just wrapped up a late Sunday night at the UCB Theatre in New York's East Village and was catching the L train back home to Brooklyn when he saw it. He could barely believe his eyes. Little turned to his friend Pat and said, "Okay, well, this is happening." "OH YEAH," Pat replied. Little whipped out his phone and began recording because he knew that describing what he was seeing to his friends wouldn't be as effective as actually showing them the transcendent scene playing out that night in the First Avenue subway station at three in the morning.

It was a rat. Dragging an entire slice of pizza down the subway stairs.

Little's fourteen-second video was EVERYWHERE that week. It drew more than four million views in two days, though given the number of animated images and reproductions out there, it's impossible to truly measure how many times people saw it. #PizzaRat trended on Twitter. Blogs, late-night shows—everyone was talking about it. "Pizza Rat" was the #2 spiking Halloween costume search on Google in the United States that October (behind only "el chapo").

Considering the brief clip was, well, basically void of any creativity, useful information, or dramatic merit, why was it so popular?

I'd lived in New York for almost ten years at that point, yet "Pizza Rat" was probably the most New York thing I had ever seen. The city's most iconic animal meets the city's most iconic food. For so many, "Pizza Rat" became a perfect metaphor. Little went so far as to suggest in an interview that it might be the new Statue of Liberty. "The more I thought about it, the more I identified with this little rat trying to hustle some pizza down a staircase," Queens resident William Scholl told the *Daily News* a few weeks later . . . after getting a depiction of the "Pizza Rat" tattooed on his right calf. As someone who'd originally moved to New York without a job, I too identified with the plight of a small creature trying to literally bite off more than he could chew in the big city. Sharing "Pizza Rat" gave me, more than anything else, a chance to express that about myself.

" 'PIZZA RAT,' IT is the heart of New York," BuzzFeed's vice president of international, Scott Lamb, said to me, laughing. "The beating, dirty heart of New York." Lamb joined BuzzFeed way back in 2007 when he became the site's first and longtime managing editor after spending a few years as a traditional journalist.[*] In his early years at the company, Lamb was part of a very small community of people

[*] One of Lamb's claims to fame is that he pioneered the infamous BuzzFeed "listicle," a format that became nearly inescapable for a period. Also, full disclosure: Lamb briefly left BuzzFeed in 2013 to help me create and launch *YouTube Nation*.

professionally tasked with trying to figure out what was big on the internet each day. "You could get them all in the same room, almost," he said. "And that's now totally impossible."

Though internet self-expression would only later grow to be such a significant driver of pop culture, those assigned to track it learned a few key lessons pretty early on. Lamb's biggest aha moment was when he realized that people were using the images, articles, and videos on BuzzFeed to connect with other people and express themselves, an insight that influenced his work and sat at the heart of many of the company's initiatives, including, as you'll recall, Ze Frank's ever-experimenting video unit. "Until that point, I thought mostly about consumption. You make something and if a lot of people read it or watch it, that's the best thing that can happen," he said. "When we started thinking more about why people pass stuff on . . . it's usually actually not about consumption. You're not just wanting [the person you share with] to consume this, you're wanting them to have an experience that connects them with you."

It all came down to a single concept: identity. "I think identity is the most powerful driver of all social media," Lamb explained. "One of the amazing things about video is the immediacy with which it allows people to either express their identities or ask questions about other people's identities."

In 2015, my colleague and friend Bonnie sent me a BuzzFeed video titled "Italian Grandmas Try Olive Garden For The First Time," knowing full well that I'd find it irresistible. Olive Garden was the source of much debate in my Italian American family that included many opinionated older Italian women with amazing taste in food. (For the record, I was in the "it's the worst" camp.) Before I had even finished watching the video, I was already composing an email to my immediate family. Subject line: "Please Watch This." Of course Olive Garden holds a . . . er . . . *special* place in many Italian American families, and so I was certainly not alone in my reaction. There are, after all, more than seventeen million Italian Americans out there. BuzzFeed produced more than one hundred videos using the "__ Tries __ for the

First Time" format, and these videos, which range from "Americans Try Extremely British Snacks" to "Koreans Try Southern BBQ" to "People In China Try Fortune Cookies For The First Time," have been watched more than a billion and a half times.

BuzzFeed was among the first to effectively employ an identity-focused editorial strategy at scale, but the principles on which they based their approach are apparent in many popular trends and videos.

In 2011, writers Graydon Sheppard and Kyle Humphrey launched a joint Twitter account that originated when one said to the other, "Could you pass me that blanket?" in a soft, feminine voice. They were just messing around, but ideas kept coming. As the "@ShitGirlsSay" account grew, they even picked up some celebrity followers, including Juliette Lewis, to whom they reached out on a whim and convinced to make a cameo in a video based on their jokes that December. After a lot of thought, Sheppard decided he'd put on the wig and heels to bring their collection of phrases to life.

"Oh, I had such a good sleep!"

"Listen to this email!"

"Twinsies!"

"First of all, ew."

The video version of "Shit Girls Say" was a huge hit, resulting in three sequels from Sheppard and Humphrey and spawning the first big trend of 2012; people started posting "Shit __ Say" videos for every possible occupation, ethnicity, or social group. More than five hundred were posted in just the first month, and that number continued to climb. Some popular iterations included "Sh%t Southern Women Say" ("Hey, y'all." "How can I be outta hairspray?"), "Shit Asian Dads Say" ("Respect your elder!" "Why you not doctor?"), "Sh°t Girls Say to Gay Guys" ("I love that you're, like, practically a girl." "Help me pick out something to wear!"), "Shit White Guys Say to Brown Guys" ("Teach me how to say 'What's up?' in Indian." "Yo, how come you don't wear a turban?"), "Shit White Girls Say to Black Girls" ("You guys can do so much with your hair." "Not to sound racist, but . . ."), "Shit White Girls Say to Arab Girls" ("Do you belly dance?" "Has anyone told you you look like

Jasmine?"), "Sh°t Nobody Says" ("I miss faxing." "I'm hoping he asks me to help him move."), and, of course, "Shit People Say About Shit People Say Videos" ("That's so true." "Ahhh, I say that." "This one should be shorter.") Some were dull parades of stereotypes while others were clever social commentaries.

While there were certainly "Shit People Say" videos that everyone could relate to, the success of the trend was largely driven by the myriad super-narrow iterations that people connected with and shared as commentaries on their own personal identities (whether the rest of us found them amusing or not).

Lamb, who when we spoke was in the process of trying to launch and build BuzzFeed's editorial operations in Japan, Brazil, Germany, and elsewhere, said that his experiences studying internet culture abroad only further convinced him of the power of identity to drive sharing. "It's a universal thing that people find meaning in media in this way," Lamb told me. "And certain examples cross cultural lines in ways that you wouldn't totally expect." I've seen this play out on YouTube in India, where Indian comedy channels like All India Bakchod and Being-Indian have drawn lots of attention with videos examining (and making fun of) the wide array of cultures, traditions, and languages that populate the country. Similar channels can be found all over the world.

Identity-driven media is not entirely new—I did not wear that black Pantera T-shirt in the Florida sun when I was fifteen because it was particularly functional or very aesthetically pleasing—but in an age where social media platforms entreat us to express aspects of our personality or point of view in order to connect with other people, entertainment that enables us to communicate these things about ourselves becomes increasingly useful and necessary.

OUR APPETITE FOR content that expresses identity now runs so deep that we frequently hijack videos created for other purposes and use them to fulfill this need. In fact, sometimes the videos that best allow us to express ourselves are the ones that were meant to serve an

entirely opposing purpose. These are the cases where disliking something publicly says even more about who we are than liking something.

In August 2006, Jim DeBois and Ethan Chandler, both executives at Bank of America in Manhattan, were asked to write and perform a song at a meeting of credit card execs at the headquarters of MBNA, a company Bank of America had recently acquired. The pair appeared on the stage in Wilmington, Delaware, wearing white dress shirts and bright-colored neckties—standard bank employee attire. DeBois sat with an acoustic guitar, and a few feet away, Chandler stood at a microphone as they launched into a retooled version of the U2 song "One" called "One Bank." An excerpt: "Is it even better . . . now that we're the same? Two great companies come together . . . Now, MBNA is B of A. And it's *one bank*! One card! One name that's known all over the world. One spirit. We get to share it. Leading us all to higher standards, ooo-ooo-OOO." Video of the cringe-inducing performance leaked online that November and made the rounds on what we used to call "the cubicle circuit." That Chandler does a very good Bono made it all the more painful to watch. That month, guitarist Johnny Marr of Modest Mouse (and the Smiths, of course) performed the song at one of the band's concerts with comedian David Cross handling the vocals. The crowd roared. Some sang along. Universal Music Group sent a cease-and-desist to Bank of America. In a mere five minutes, DeBois and Chandler's performance captured what, to many, made the banking industry and corporate culture in general feel so obviously out of touch with reality.

I was just five months out of college when the video was being shared (this was pre-Twitter and pre–Facebook newsfeed, so the song was mostly being posted on blogs, on forums, and in emails). What was just a bit of fun for some bank execs represented for me everything I didn't want my professional life to become. And that's why I wanted to share it.

I loved sharing random videos back then. In a way, being the kind of person who knows about the latest meme or trend is itself a form of identity, particularly in the earlier days of internet video, before trends

were so quick to go mainstream. "Because digital media then was still pretty niche, people who found things that really meant a lot to them could feel a certain amount of ownership over those things," Lamb told me.

Well before YouTube, around the turn of this century, a meme that began as a small in-joke on some web forums was extracted from a poorly translated SEGA video game called *Zero Wing*. During one of the introductory scenes, there is an explosion. "What happen?" asks one character. (The text appears as on-screen subtitles and is spoken in robotic voiceover.) "Somebody set up us the bomb," responds another. "How are you gentlemen !!" asks the game's primary antagonist in an incorrectly punctuated greeting. "All your base are belong to us. You are on the way to destruction."

As *Wired* reported back in 2001: "These are the words that have launched a thousand e-mails and inspired a Web artist to create the flash movie spreading like a grass fire across the cyber-plain." That year, the "All Your Base" meme (aka "AYBAB2U") inspired countless parodies, including a music video that was very widely spread, mostly via email and message boards. Technology reporters fell over themselves to cover it. Shirts and mugs were made. For a long while, it became, basically, the secret handshake for people obsessed with web culture, and then it became one of the first big internet jokes to cross over into a broader consciousness. As the phrase became co-opted by the mainstream media, it fell out of style, though it has since enjoyed a resurgence among gamers and "old internet" aficionados. Over the years, trends like this have continued to sprout up, but it only works if they are too obscure or complicated to be subsumed easily into the mainstream. ("Leeroy Jenkins" and "Trololo" are all a part of this proud tradition.)

Today, thanks to the internet's vast networks of niches and communities and its near constant call to participate, a trend's value may be increased simply because it's not immediately accessible to everyone. As with many things, this helps us balance our need to express ourselves as individuals with our need to connect with others in both the digital and physical lives we lead. When we launched YouTube Trends in

What Videos Do for Us

263

2010, I made T-shirts for the occasion with three different slogans. The shirts that read "ALL YOUR VIDEO ARE BELONG TO US" were by far the least popular, and I wouldn't have had it any other way.

I DON'T EVEN HAVE ANY WORDS FOR IT

In May 2007, Howard Davies-Carr, an IT consultant in Buckingham-shire, United Kingdom, recorded an adorable video of his sons and posted it on YouTube so he could share it with the boys' godfather in the United States. It was watched a total of three hundred times in the ensuing months, but gradually, other people began stumbling across the video, and in September, the video was drawing a few hundred views each day. A few hundred turned into a few thousand. By Christmas the video hit one million views and Davies-Carr was stunned. But that turned out to be just the beginning. Because a lot more than a million people have seen it by now. In fact, you've definitely seen it at some point too . . .

"Ouch, Charlie! OUCH! Char-lee! That really hurt! Charlie bit me."

"Charlie Bit My Finger," which starred Harry Davies-Carr and his little brother, Charlie, turned the pair into unwitting international icons. In addition to YouTube revenue, Howard began selling T-shirts and other merchandise. (He thought it was ridiculous that anybody would want a shirt with a photo of his kids on it, but then he saw lots of unauthorized sellers offering them up online.) Unlike many web sensations, "Charlie Bit My Finger" didn't get a huge spike in views; its weekly viewership just increased gradually. It was watched seventy million times in 2007 and maintained a consistent level of viewership for quite a while. It remained the most-viewed nonmusic video on YouTube for years. The video is very cute, of course, but, as many, *many* have asked, what makes it so hugely popular?

There are a number of possible explanations. Part of it is time and place; it hit during a less fragmented, less noisy time in internet video

history, cementing a legacy before it could be crowded out. And it undeniably holds universal appeal. A quick look at the data shows that, in recent years, "Charlie Bit My Finger" has been nearly as popular in Saudi Arabia and Mexico as it is in the United Kingdom. To me, the video initially succeeded because it captured a tiny but highly relatable snapshot of human experience. Anyone with a sibling (and any parent, really) can relate in some way to Harry and Charlie.° "Charlie Bit My Finger" represents an amusingly familiar childhood truth that speaks to millions of us.

The fact that we can access it whenever we want is important too. Reliable availability—a relatively new idea in media history—means we can watch or share it whenever the mood strikes. The data bears this out; the video was still garnering more than one million views each month almost ten years after it felt like everyone who would ever see it had already watched it. Sometimes Charlie and Harry can provide us with that quick laugh that we need at the right moment. They also help us share that feeling with someone else. Lamb describes this type of action, which plays out every day across the web, as "an emotional gift that you give someone, with some social information or humor."

VIDEOS CAN OFTEN help us communicate complex emotional concepts that we'd otherwise struggle to express. You can see this clearly when you examine the actual phrases people use when they share things with their friends, families, or followers. "We look a lot at the sharing statements around identity and people say, 'Oh, this video explains a part of me better than I can explain it myself,'" Lamb told me. "That is in a nutshell exactly what is going on when they pass something on."

In 2006, eleven-year-old Edgar and his cousin Fernando were going for a walk just outside Monterrey, Mexico, when they needed to cross a stream across which two logs had been placed. Fernando

° As a toddler, my now-adult little sister made a habit of assaulting me in the backseat of the car on the way home from Publix. I got revenge twenty-eight years later by recounting it in a footnote of a book.

went across first, and as the pudgier Edgar carefully made his way, Fernando began to move one of the logs, halfheartedly trying to throw him off balance. "¡Ya wey!" exclaimed Edgar ("Stop, dude!"), accompanying it with some colorful Spanish expletives. When Fernando dropped the log, Edgar slipped and fell into the shallow water below. Soaked, he continued shouting angrily at his cousin, all while his uncle Raul filmed. "La Caída de Edgar" ("Edgar's Fall") became Mexico's biggest viral hit in the early days of YouTube, and while it is not incredibly well known in the English-speaking world, "Edgar's Fall" is basically the "Charlie Bit My Finger" of Latin America (or perhaps, considering it came out two years later, "Charlie Bit My Finger" is the "Edgar's Fall" of the United Kingdom). The video has been seen upwards of fifty million times. It was endlessly parodied. Someone made a web page purporting that Edgar was running for president of Mexico.

The reason for the popularity of "Edgar's Fall," I think, goes beyond obvious physical comedy. Like many of the best "Fail" video stars, Edgar is all of us. We've all had a day like Edgar's when we've just wanted to shout "¡Ya wey!" at our parents or our coworkers or the guy who decides seven A.M. on a Saturday is the best time to work on his motorcycle engine. In just forty-two seconds, Edgar succinctly represents one of life's truths, our inevitable powerlessness in the face of the infuriating thoughtlessness of another. We can return to "Edgar's Fall" whenever we need to communicate that feeling of defeat.

We crave and devour these life-as-art metaphorical moments. Lamb told me that simplicity or specificity is essential to their spread; short video clips or animated gifs that convey a single message are most effective. "It's a little bit more of a blank canvas for people," Lamb said. "Whereas a Hollywood movie's definitely not a blank canvas in any way." The nonprofessional, almost accidental quality of these videos, as well as their role as blank canvases, grants us the ability to project our own experiences onto them through the context we add when we share them.

✧ ✧ ✧

"I THINK WE should ditch school and go to Disneyland, what do you think?" Katie Clem asks her eight-year-old daughter, Lily, who is sitting in the backseat of the car. "YOU'RE SERIOUS?!" responds a wide-eyed, incredulous Lily. Once assured that, indeed, her parents *are* serious and she will be going to Disneyland that day, Lily immediately bursts into tears of overwhelming joy. It's an infectious happiness that would make almost any viewer smile. Two years prior, when Lily was six, her mother had filmed a similar scene, 2011's "Lily's Disneyland Surprise!," and her reaction drew millions of viewers. Would the Clem family once again strike viral gold?

In "Lily's Disneyland Surprise. . . . AGAIN!" the camera pans from Lily's hysterical sobbing to the face of her two-year-old sister, Chloe, who stares at Lily from the side of her eyes with complete and unamused confusion. Though still a toddler, Chloe's searing look captured the "WTF?" we've all felt when witnessing irrational outbursts from our own friends and family. "[Lily]'s very emotional, wears her heart on her sleeve," her mother told ABC News. "But Chloe is my little danger kid. She's just like, 'Yeah, whatever.' I don't even have any words for it."

"Side-Eyeing Chloe" became one of my favorite memes of 2013. People extracted the frames that contained Chloe's reaction and began sharing that moment as an animated image, sometimes with their own text overlaid, sending it to friends and family with captions like "That face you make when that one weird guy in class talks to you" or "#DoneWithYourShit" or "COULD YOU NOT?" It worked in an absurd number of contexts. Two-year-old Chloe's face was Photoshopped onto the heads of Taylor Swift, Lana Del Rey, and other stars in images and GIFs. She was declared the "Patron Saint of Tumblr" in one headline that year. *Seventeen* included Chloe in its list of the Top 10 Most Epic Celebrity Side-Eyes.

Chloe's reaction to Lily was the perfect "blank canvas" for us to communicate our own reactions to the current events, pop culture, or even everyday scenarios in our lives. For me, it encapsulated exactly

why we love sharing videos. There is no denying that, some days, we are all Chloe:

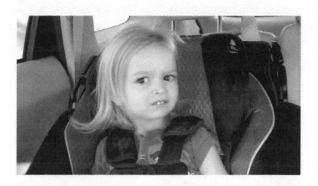

IT WAS REAL, AND IT WAS REALLY AWESOME

In the 1980s, British producers and songwriters Pete Waterman, Mike Stock, and Matt Aitken were on a hot streak with hits for bands like Dead or Alive and Bananarama. One night, Waterman spotted a young singer from Lancashire with a powerful baritone voice performing in a soul band. Waterman hired him to work as an assistant around the studio, and he allowed him to record some demos of his own. He had such a boyish, meek appearance that A&R execs didn't believe it was his actual voice singing on the tapes and made him perform in front of them to prove it. In 1986, he and Waterman were having a conversation about Waterman's girlfriend when the young man asked, "You're never gonna give her up, are you?" The comment served as inspiration for the song that would make twenty-one-year-old Rick Astley an international star. "Never Gonna Give You Up" was a chart-topping song all over the world and became the United Kingdom's bestselling single that year. Following a few other hits, Astley retired from music in 1993, but his career was far from over.

In the mid-00s, image-posting forum 4chan rose to prominence as, among other things, an influential community that invented and

disseminated memes. The generally anonymous user base had a storied history of originating some of the web's most recognizable art forms; they were responsible for popularizing "Lolcats," for example. At the time, a popular bait-and-switch prank was circulating: a link in the form of a hopelessly enticing headline would lead only to an image of a duck on wheels. It was known as a "Duckroll." In 2007, as the story goes, a 4chan user claimed to have the trailer for the widely anticipated video game *Grand Theft Auto 4*, but the link instead pointed to the music video for Rick Astley's "Never Gonna Give You Up." That little gag forever changed internet history and kicked off one of the most famous memes of all time, the "RickRoll."

The "RickRoll" prank spread to forums all over the web in the ensuing months. According to referral traffic, the earliest YouTube "RickRoll" on Reddit was in December 2007. The following March people were RickRoll'd twenty-two thousand times after someone posted: "Rick Astley (of RickRolld Fame) Requests YouTube Remove Videos." How meta. That year there were more than one hundred Reddit posts (and almost one thousand comment links) pointing people to the video on YouTube. On April Fool's Day, YouTube itself redirected every video on its homepage to the video, amusing and infuriating millions. Thanks to the trend, Astley became a popular ballot-stuffing target in fan contests. The song was voted to be the New York Mets eighth-inning sing–along song for the 2008 season, and Astley was named MTV Europe's Best Act Ever that fall after receiving 100 million votes. Beginning in 2010, a bipartisan group of state legislators in Oregon led by Representative Jefferson Smith spent more than a year slipping pieces of the lyrics into their speeches on the house floor. The rules: They could not change the subject or take extra time, and it had to be germane to the speech. The final edited video was so entertaining that many people assumed it was fake, but Smith assured Yahoo News, "It was real, and it was really awesome . . . Democracy is a glorious thing."

"I think it's just one of those odd things where something gets picked up and people run with it," Astley told the *Los Angeles Times* when first interviewed about the meme in 2008. "But that's what's

brilliant about the Internet." Astley performed a live "RickRoll" that year in the Macy's annual Thanksgiving parade. While he didn't really understand the whole thing at first—in 2007, some of his friends sent him "RickRoll" emails, but he couldn't figure out why they were just sending him links to his own song—Astley came to embrace it (without milking it). He toured widely and released a new album at age fifty that went to #1 in the United Kingdom, thirty years after his first single.

One of the crazy things about the "RickRoll" phenomenon was that, unlike the short-lived nature of most popular internet ephemera, it continued to be popular for *years* after it first surfaced. The number of "RickRolls" on Reddit* continued to increase—there were almost two thousand posts in 2015 and nearly twenty thousand links in comment threads—and the song still sees an annual resurgence every April Fool's Day:

RELATIVE DAILY VIEWERSHIP AVERAGE ON VIDEOS CONTAINING "NEVER GONNA GIVE YOU UP," 2015–2016

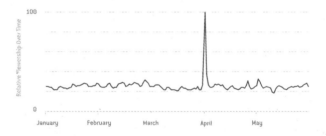

The "RickRoll" might be the most important meme in YouTube's history, not just because of its longevity, but also because of what it demonstrates about our changing relationship with entertainment media. It's a perfect example of the power of interactivity that defines internet

* The most popular "RickRoll" headlines in Reddit history: "YouTube has officially changed the URL of Rick Atley's 'Never Gonna Give You Up' to include 'gIveyouUP'" (175,000 "RickRolls," 2015). "A sad day indeed—the original Rick Roll video has finally been taken down from YouTube from a copyright claim" (200,000 "RickRolls," 2014). "Don mattrick apologizes for the xbox one being a failure and not meeting to their customers standards" (200,000 "RickRolls," 2013).

video. "Never Gonna Give You Up" was written to be a mid-'80s pop
hit, a song about a man professing his dedication to his lover. Now it
represents internet nerd tomfoolery. We, the viewers, gave it a whole
new meaning decades later, one that was totally unintended. The song,
and Astley's career, hold a completely different place in our culture
thanks to the "RickRoll" trend to which thousands (millions?) of people
have contributed individually.

You might even say that the choice of "Never Gonna Give You Up"
wasn't that relevant. Astley himself admits this. "It's been a bit weird,
but my daughter said to me, 'Look, just remember it's got nothing to do
with you,' and she's right. It's a totally different work and it's just doing
its own thing," he told *Billboard* in 2016. "What I've always tried to take
from it is it just happened and it could've been anybody's song." Right
now we could be talking about Wham!'s "Wake Me Up Before You
Go-Go," DeBarge's "Rhythm of the Night," Starship's "We Built This
City," or Phil Collins's "Sussudio" (i.e., "You just got Sussudio-ed").

The new role "Never Gonna Give You Up" played for us is more
important than which song is featured in the meme. The song's purpose
in your life is to enable interaction between you and someone else, to
allow you to mess with someone. That's why we love it. The same is
true, to varying degrees, for why we love so many of these unusual
trends and memes. They exist to facilitate interaction between us.

▸▸

I'm not sure when it was that I stopped asking myself why I shared
something or what something I shared meant to me. Must have been
sometime between that link to "Yatta!" in my Instant Messenger profile
in 2002 and a tweet of the rap song "Combination Pizza Hut and Taco
Bell" in 2009. That is to say, the same time as most everyone else.
Interaction through sharing video, among other media, became second
nature to us and we rarely stop to consider how some piece of ephemera

helps us express identity, encapsulate a complex emotion, create an opportunity for connection, or enter into a new social experience. Many of the clips and trends that spread efficiently online deliver value to us in these ways, even when we're not acknowledging it. And this wasn't something that evolved over time; it's a behavior that we took to almost immediately, even before platforms like YouTube made it so easy. I sometimes think leveraging the accessibility and portability of video to extract these specific values might have even been instinctual given how quickly and naturally we took it up.

The secret truth of the boy who fell into a stream, the rat that dragged its pizza, and the two-year-old who side-eyed her sister is that none of them achieved widespread fame because of creative ingenuity. They instead opened a new path for us to communicate and interact with each other. Our personal interactions and expressions of individual identity shape the meaning of these videos and memes and are what propel them to popularity. In our hands, seemingly trivial content gains significance from the interactions they inspire.

Scott Lamb suggested to me that, as a result of the way we interact with content, we now have a complex relationship with—or feel a sense of ownership over—internet video that isn't possible with other forms of media, like movies or TV shows, even the ones we love. It's true. These videos play a more personal role for us because we are able to use them to stand in for our own perspectives or emotions. This type of interactivity is a major part of what makes YouTube distinct as a medium.

And as with any new medium, a set of stars emerged that were unique to YouTube. They were the ones who understood the qualities that make this world unique and mastered the ability to facilitate the interactions that mattered to us. They took the elements that made these videos successful and built something much bigger upon them. And just as with the videos we watch, we feel a far deeper connection with them than we ever would with movie stars or TV personalities.

CHAPTER 12

The New Talent

A T MY VERY first VidCon, the annual internet video fan and industry convention in California, which in 2011 was only the second VidCon ever, about twenty-five hundred people showed up to a Hyatt Regency in L.A. I was to emcee YouTube's keynote presentation, introducing our executives as well as guests like Joe Penna (whom you may recall as MysteryGuitarMan), star vlogger Shay Carl Butler, and video personalities Charles Trippy and Alli Speed of daily vlog series *CTFxC*.

The night before, we all met up to run through the presentation. It was a peculiar scene. It felt kind of like an ill-organized rehearsal of a high school play, except replace a misfit crew of drama kids with a bunch of goofball YouTube vloggers, me, YouTube's then-CEO Salar Kamangar, two of our product managers, and one of our senior business executives who appeared to be so uncomfortable speaking to a big crowd (or any group of people really) that I felt jittery just watching the poor guy. I'd been at YouTube for less than a year at that point and I, along with the rest of the company, didn't quite know what to make of the site's creator community yet. We all understood that personalities like Shay Carl drew an increasingly critical subset of viewers, but these stars had a kind of celebrity so unlike anything we'd seen before. It was, deep down, hard for most of us to *really* take them seriously. The general public had just wrapped their heads around the idea that viral videos were a thing, and most everyone outside their fan communities and observant industry folks struggled to see these burgeoning creators as anything but an abstruse fad.

That night at the Hyatt, I finally began to understand that my narrow notions of celebrity and fandom had become obsolete. When we finished the awkward rehearsal and the doors opened for us to leave,

we were greeted by a crowd of excited teens who'd gotten word that a bunch of their favorite stars were all in a conference room and hoped to meet them and get autographs. In that moment, the goofballs started looking like legitimate entertainment pros, and we YouTube employees were a bunch of irrelevant, awkward lackeys. It's a disquieting experience to be twenty-seven and feel like an old fart.

That weekend, people of all ages (though mostly teenagers) met, took pictures of, and shot their own videos with this new class of talent. While the creators didn't feel like *People* magazine celebs—they didn't have bodyguards or public relations reps—they elicited the kind of emotional outpouring from fans I'd previously only seen with professional athletes and singers. As a viral video aficionado, I had a freak-out of my own upon meeting Bear Vasquez (the "Double Rainbow" guy) and Tay Zonday of "Chocolate Rain" fame.

As the years progressed, the YouTube creator phenomenon exploded, and VidCon grew like crazy. The event had to relocate from the Hyatt to the Anaheim Convention Center to accommodate the crowds. In 2015, I exited an industry party sandwiched between Benny and Rafi Fine. We walked with a collection of other YouTube stars down a narrow hotel hallway lined with frantic high schoolers desperate for a piece of their favorite creators. It was terrifying!

By 2016, when I was assigned to moderate a panel of creators who'd been on YouTube for a decade, I was a veteran VidCon-goer. More than twenty-five thousand people attended the conference that year and there was no chance of getting them all in the same room. The crowds lining up laughably dwarfed the one that waited outside our hotel conference room in 2011.

By now the bigger stars, including some of the same people I'd met that night at the Hyatt five years earlier, did have bodyguards. And the top tiers of talent were actually barred from walking around the convention floor and interacting with fans to avoid stampedes and other potentially dangerous scenarios. As much as I'd become very, *very* acquainted with this new generation of celebrity and its cultural influence and power, seeing it live at VidCon never stopped exploding my brain.

And I'd watched this evolution happen gradually and from the inside. It must have been stupefying for adults who didn't have a professional obligation to study this stuff. I wondered how bizarre and unfamiliar it might feel to the uninitiated. I needed to meet outsiders experiencing this disorientation in full.

I needed to meet some dads.

If there were military-style decorations awarded for dad acts, taking your daughter to a VidCon would certainly earn you a distinguished service medal. Three days of squealing, shrieking, and queuing up in a sea of selfie sticks and rainbow-colored hair. Finding dads who were up for a chat turned out to be incredibly easy; most of them were itching to have a real conversation with another adult.

"When you're here, you can see the audience," one fifty-year-old father, Tahir, explained to me. "It's not just a number. I get it."*

"I didn't know it was so popular," Eric, forty-three, told me. "My daughter will start crying, and I'll think, what's going on?!" Both he and another father, Juan Carlos, who'd come up from Mexico City for the event, had young daughters whose primary goal for the week was to meet twenty-one-year-old actress and personality Meg DeAngelis, a rising star who posted everything from sketch comedy to fashion and beauty life hacks. The dads didn't complain, but they did seem a bit baffled by the overall hysteria that surrounded them.

"We need references. When I was a kid, it would be a guy from TV," Juan Carlos said. "This is the next generation—not millennial, but the one after that. It's a challenge for me . . . but I don't like to judge. My daughter's happy here."†

* A friend of mine on the engineering team liked to say that VidCon is like seeing the actual video view counts walking around in front of you, which is funny, both because it's true and because it's an absurdly stereotypical way for an engineer to interpret a convention center filled with screaming teenagers.

† Our conversation was interrupted by a shrieking mob that enveloped some lesser-known video star I didn't recognize. "I don't even know who that is!" happily exclaimed one fourteen-year-old girl with a tie-dye backpack to her friends.

For many fathers, VidCon had just become the latest annual family vacation destination. "My daughters told me, 'This is one of the best vacations ever,'" Will, forty-seven, said. "I think that's great. It's not even close to the price of Hawaii, and they were bored when we were there. And we're inside." #DadGoals.

But for others, it had become an opportunity to understand the alien things their kids were into. Perhaps the biggest sign that these new kinds of stars were cemented in the mainstream was that they'd begun to feel mainstream to the parents too.

"It's been an eye-opener," Jeff, a fifty-four-year-old from Phoenix, said. It was Jeff's first VidCon, and he'd gotten there that day at seven A.M. to line up with his daughter to meet the conference's founders, Hank and John Green. "In the 1970s it was rock concerts. The fans were crazy. It was a frenzy. They would run up and be grabbing their shirts, their hair. They just wanted a chunk of 'em. Now there's more openness. It's more about being socially accepted." Many of the fathers I met noted that the tech their kids used every day wasn't like anything they'd had growing up and it enabled a different type of relationship between their children and the celebrities they were there to meet. Instant communication over mobile devices meant that fewer things were kept private, something they worried about, but that access made it easier to feel a connection to the talent and a sense of community with the other fans.

"My son and I used to go to baseball parks. With my daughter, it's this: Shane Dawson, Dan and Phil," Dan, fifty-two, told me. "It's what parents should do. It gets exhausting, but you do stuff with your kids, and I'm making the best of it." I met Dan outside the signing hall as he awaited his fifteen-year-old's return from a meet-and-greet with Jack and Dean, a popular British comedy duo in their early twenties. He'd decided to sit this one out but had joined her for some of the autograph signings earlier in the day. He rattled off their names with little hesitation: Cimorelli, Sawyer Hartman, Grace Helbig. Dan knew what was up, despite growing up with only three television channels. He found

the desperate attention-seeking and foul language of some creators off-putting, but there were some that he'd come to really enjoy, like Helbig, a popular comedian and host. When he and his daughter met her, though, he played it cool. "I thought it would be weird if I were to tell Grace I was a fan as a fifty-two-year-old man," he said. I'm sure his daughter appreciated the restraint.

The perspective that these creators were somehow not "real" celebrities had long felt out of touch. To the kids at VidCon the suggestion would have been absurd. And now even *the dads* had come see this as the new normal.

◄◄

The creators at VidCon really constitute only one small slice of the new kinds of talent that have emerged through platforms like YouTube. Remix producers, hydraulic press operators, and ASMRtists, for example, don't generally do autograph signings, and pop stars or influential pundits don't often attend fan "cons." But the dynamics that propel the community-driven fame achieved by über-popular YouTube stars like Grace Helbig or Dan and Phil affect celebrity musicians, comedians, actors, journalists, and athletes on and off YouTube.

Stars of the past achieved fame via a limited number of broadcast media channels we all shared. It was harder to acquire the spotlight, but once there, given the comparatively constrained amount of noise, the path to major fame was manageable. In a land of three TV channels, if you were famous, you were probably known to pretty much everyone. Given that social entertainment and communication platforms personalize our feeds instead of subjecting everyone to the same content, it's highly unlikely that today's parents would *ever* be exposed to the same faces and voices that their kids come across, unless they specifically take an interest in it.

YouTube creators are a pretty modern phenomenon, but they definitely have some parallels in pre-internet history. Today's talents, interestingly, have more in common with America's original celebrity, Ben Franklin, than many of the celebrities from my youth. Franklin is remembered in history for his role as a Founding Father and inventor, but he got his start as a newspaperman. As a boy, he worked as a printer's apprentice and achieved minor fame as a teenager (posing as a middle-aged widow columnist named Silence Dogood) via the first independent newspaper in the colonies. At twenty-two, he became the publisher of his own paper, the *Pennsylvania Gazette*, where his essays and opinion pieces helped him achieve an elevated public profile. A hard-to-describe celebrity, famous for sharing his thoughts about life and current events, Franklin decided himself what topics he'd cover and managed his own channels of distribution to audiences. Sound familiar?

Obviously I'm not claiming that popular web video creators will achieve the same historical significance as one of our Founding Fathers, but the concept of the hard-to-define figure who achieves cultural credibility and influence through frequent, unfiltered self-expression is not new. See also: professional boxer turned media sensation Muhammad Ali and talk show host turned mogul/icon Oprah Winfrey.

What *is* new? For one, the talents of today don't need to own newspapers or front television shows or become professional athletes to reach us. They take new and unusual paths to prominence and, often, employ skills that are very different from our traditional notions of "talent" to get there. As a consequence, our relationship with them is pretty different too; our role as fans is far more active than ever before. It's all made possible by the new ways we interact with one another and with the things we watch.

An entire generation of talent has emerged that bears little resemblance to the one that came before.

YOU CAN SEE ALL THE STARS AS YOU WALK
DOWN PROVO BOULEVARD

One of my favorite early YouTube success stories started in Uruguay's capital, Montevideo.° Not exactly a hotbed of motion picture talent, Montevideo served as the setting of an alien robot attack in the short film *Ataque de Pánico!* by thirty-one-year-old filmmaker Fede Alvarez. It had a production budget of $300 and Alvarez handled the visual effects on his own computer. Alvarez had expected to remain in Uruguay for the remainder of his career, but within a few days of the video's release in 2009, his inbox was stuffed with inquiries from big studios and talent agencies in the United States. The video spread throughout Hollywood, thanks in large part to Kanye West, of all people, who featured the short on his then-influential blog. After a trip to Los Angeles, Alvarez had signed on with talent agents at Creative Artists Agency and locked a deal with director Sam Raimi's production company. His first feature-length film, released four years later, was an *Evil Dead* reboot, which he wrote and directed. It had a budget of $17 million.

By the late 2000s, the established entertainment industry was starved for fresh talent, and the web became a new source of creative voices who didn't have access to Hollywood or New York boardrooms. These new talents represented less of a gamble too because they had already proven their skills in highly competitive environments. YouTube became a mainstream-media farm league, altering the tried-and-true paths most singers, writers, actors, comedians, etc., had gone down to catch their "big break." On the web, a solid talent could break him- or herself.

° Which fittingly translates to "Video Mountain."[1]

 1 The etymology behind the name "Montevideo" is actually the source of much debate, though almost no scholar will tell you it means "Video Mountain." This is merely a rumor I am trying to perpetuate for my own amusement.

The field most immediately affected was the music industry, as you may recall. One of the world's biggest pop stars, Justin Bieber, was discovered via a YouTube video of a talent show performance, after all. Greyson Chance, 5 Seconds of Summer, Shawn Mendes, Alessia Cara . . . A pretty decent and growing roster of young performers got their break through social media platforms instead of radio play. Even the new faces who first gained exposure through traditional channels could grow a surprisingly large fanbase thanks to the interactive nature of the web. When a memorable moment within a larger television broadcast can be broken out and made available online to be replayed, reshared, and rediscovered by millions who were not regular viewers, a star can be made in a matter of days (see: the *Britain's Got Talent* Susan Boyle craze of 2009). The audience suddenly played a much more influential role in deciding who succeeded.

Oftentimes, the talented people our online actions elevated made the rigid categorizations and instincts of mainstream scouts look off base. For example, Jeff Dunham had been a moderately successful performer for years, but the fact that he was a ventriloquist prevented Comedy Central from investing much in him. When his "Achmed the Dead Terrorist" character became an online sensation, Dunham catapulted to the highest ranks of comedy and became one of North America's top-grossing stand-up acts (at which point ventriloquism stopped seeming so quaint). Lindsey Stirling appeared as the quarterfinalist "hip-hop violinist" on *America's Got Talent*, where she was told by judges she couldn't carry a show on her own. Her unusual mix of dancing, electronic beats, and violin was labeled unmarketable. A few top-charting albums and 1.5 billion views later, Stirling became our poster child for the renegade indie artist's ability to find a passionate fanbase in an unmediated fashion. "I had previously tried so many different ways to get my music out there, but there were too many gatekeepers in the business and no one thought I was worth investing in," Stirling said in an interview. "After putting up one video on a popular YouTuber's page, my music started to sell, people were requesting more,

and I realized that finally I had found a world where I didn't have to wait for someone to believe in me. I could believe in myself and the fans would decide rather than the professionals."

YOUTUBE OFFERED A path forward for people who had skills that didn't clearly fit into the predefined notions of mainstream entertainment or for those who didn't want to deal with the biz itself. It meant that talented people could flourish and they could do it outside places like New York, L.A., London, Tokyo, and Hong Kong, where professional production had been concentrated.

One of the more unlikely hubs for YouTube talent: the state of Utah. The "UTuber" community, as it is known, gave rise to a host of well-known channels, including a few I've already mentioned like Blendtec and Lindsey Stirling. I first came across the whole UTuber thing when some former film students from Bringham Young University caught my attention. If you had told me that the film program at BYU could be as influential in the web video space as the one at USC, I would have asked what type of mushrooms you ingested on your mission trip to Samoa, but Provo, the university's home, also harbors people like Devin Graham, who's known for his epic, stylized adventure videos featuring zip lines, water jet packs, and oversized rope swings and Slip 'N Slides. (His "Festival of Colors" video, filmed during a colored-powder-throwing Holi celebration, was a staple of every YouTube marketing sizzle reel for a few years.) Today, there's even a professional brand of camera stabilizer named after him (the Glidecam Devin Graham Signature Series). "Everyone thinks you need to be in L.A. to succeed, but that's not the case," he told *Adweek*. Dozens more very successful channels have sprouted up from a part of the country some people call "Silicon Slopes."

It helps that these videos appeal to a broad audience. Graham strives to ensure his videos have no language barrier and are family friendly. In an era of raw, unfiltered entertainment, many Utahan channels offer a wholesome alternative that plays well across America,

is easy to share, and is very brand friendly. Ubisoft, Disney, Mercedes-Benz, Mountain Dew, and other big-name advertisers have all funded videos from Devin Graham. While companies are often reticent to work with pranksters, Utah-based prank channels like Stuart Edge have gotten sponsorships from Honda and Turkish Airlines. One might think you need to push the envelope to draw views online, but the UTubers have proved the opposite. I suppose a large part of that wholesomeness comes from the fact that many of them grew up in the Mormon faith. I once asked a popular LDS vlogger why so many Utahans are successful YouTube creators, and he suggested that Mormons, an industrious bunch, often have the entrepreneurial proclivity required to run a successful YouTube enterprise.

YouTube made possible a scenario where industriousness matters a whole lot more than luck, timing, and even good looks when it comes to grabbing attention and starting a career as an entertainer. For some, YouTube became the path to professional opportunities that once would have seemed out of reach, but for others YouTube itself is the opportunity, an environment where you can connect with an audience big enough to support your creative endeavors.

While anyone has the opportunity to reach an audience, however, not everyone can build one. For many of these new stars, audience building requires a whole different way of looking at their relationship with viewers and a whole different set of skills to engage us too.

WHAT DOES IT TAKE?

"So we are currently in Tallahassee, and I'm not really sure how to do these vlog things," Charles Trippy said into the camera from the passenger seat of a car. "I'm sure I'll get better as I progress. Basically, I'm going to be doing one of these things every single day . . . for at least a year." He marked it "Day 1" in a series he called *Internet Killed TV*. This was May 1, 2009.

On August 12, 2013, Trippy posted Day 1,565 and entered the Guinness World Records for most consecutive daily video blogs.° Trippy, who also plays bass in the rock band We the Kings, shares a massive amount of his life in these roughly ten-minute episodes. On Day 934, Trippy and his girlfriend, Alli Speed, got married. (Their wedding trended on Twitter). On Day 1,029, Trippy vlogged from an ER in Boise, Idaho, after fainting. On Day 1,030, he revealed he'd been diagnosed with a brain tumor. On Day 1,041, Trippy's wife followed him as he went in for his first surgery. On Day 1,601, after it recurred, the surgeons allowed him to vlog the resection of the oligodendroglioma of his right frontal lobe. On Day 1,803, Trippy announced he'd be separating from Speed, a moment that shocked and divided his audience. Most days, however, were filled with far less drama: housework, errands, dog walking. *Internet Killed TV* is sort of like a real-life *Truman Show*, and Trippy has described his daily video diary as a kind of reality show of his life. Trippy is an extreme example of a variety of twenty-first-century video maker that might be, for many rabid viewers, a more compelling alternative to traditional entertainment. "These vloggers fill a void between the sanitized entertainment of the Disney Channel and the over-sexed world of The CW: a glimpse at the fun, funny, often mundane world of adulthood," commented pop culture writer Caroline Siede. "If reality TV makes stars of the insane, YouTube makes stars of the relatively normal."

Trippy's show plays directly to our modern expectations for conversational, authentic entertainment. While the form is new, the desire for this type of interaction has, perhaps, always existed. "I think intrinsically we need each other; we need to communicate, we need to connect, we need to feel understood, and ultimately that's what vlogging is," longtime YouTube star Shay Carl Butler told me during a panel discussion at VidCon. "It's the least contrived form of entertainment there is."

<p style="text-align:center">◦ ◦ ◦</p>

° I can't imagine there are many people who are even close.

IN HOLLYWOOD'S GOLDEN age, gossip columnists like Hedda Hopper and Louella Parsons were some of the entertainment industry's most powerful players. With a combined readership of seventy-five million, they could make or break careers, not just by peddling salacious tidbits, but also by controlling one of the only windows through which fans could connect on a personal level with their favorite big-screen stars. Even then, personal backstory and genuine insight into the lives of the talents we cared about created critical bonds that kept us buying tickets and tuning in.

The age of social media has taken that to another level. Now you don't need a gossip columnist. In fact, a large percentage of YouTube creators operate a second channel to fulfill this kind of connection. For those whose primary channels are not dedicated to daily reality shows like Trippy's, the second channel is often a home for personal vlogs and behind-the-scenes videos, a tactic that most creators feel is essential to creating the 360-degree experience their fans require. Lindsey Stirling, for example, has a channel, LindseyTime, where she shares messages and skits from backstage on her tours and shoots. Even Maria from Gentle Whispering has a second channel called Sassy Masha Vlogs. (On this channel, she mostly speaks at full volume.)

Those who do not get their daily entertainment on YouTube might think to themselves, what exactly is interesting about this? Couldn't anybody do this? Yes, in fact, literally any of us could grab a camera and document our lives. On the average day, more than forty thousand vlogs are uploaded to YouTube.* If you were to somehow watch them all—which would be impossible, since you would need about six months just to watch a single day's worth—I imagine it would be like mainlining the human experience, an incredible concentration of its highs, lows, and everything in between. It would also be a more figuratively and literally diverse experience than anything traditional mediums

* This is a very, very conservative estimate based on 2017 data; many things you might recognize as "vlogs" are challenging to aggregate as such at this scale.

offer. "For people of color, it's a portal to provide authentic stories online you're not seeing anywhere else," comedian/actress/writer Franchesca Ramsey said in an interview. "On YouTube if you don't see your story told, you record it." That's not something you could ever say about a twentieth-century-broadcast technology.

But I think many of us underappreciate the skill required in creating these authentically engaging experiences. What does it take? For starters, a commitment to consistent communication that many of us would find extreme. Teen fans in particular expect regular acknowledgment from YouTube creators, weekly if not daily posting, responses to comments, and, often, quite a fair bit of personal sharing to maintain that feeling of authenticity. Not everyone can sustain that. Internet communication researchers find that even digitally native celebrities struggle with the tricky task of sharing enough about themselves to be authentic without jeopardizing their personal lives or careers.

I've seen many creators grapple with the psychology of this new kind of exposure. One of YouTube's most popular couples, Jesse Wellens and Jeana Smith of *PrankVsPrank*, announced in 2016 that, after ten years of dating and six years of constant vlogging on their BFvsGF channel, they'd be splitting up and ending their daily vlogs. One of the biggest culprits in their breakup: the experience of sharing their lives in such an unrelenting and unfiltered way. "It's not a healthy lifestyle to film your life every single day, edit it that night, post it in the morning," Wellens said in a video he didn't want to make but felt obligated to record for the viewers he felt he was letting down. "In the beginning, it's really fun. It's awesome. I love it. I *still* love it. But when it gets to a point where it starts to feel like a job and you're not doing things because you love the person, you're doing them for a vlog, that puts a huge burden on a relationship."

This kind of display of vulnerability is not often found among traditional celebrities, though there are, of course, exceptions (see: Taylor Swift, Adele, or even Eminem, whose art reflects their lives). But

viewers have made this kind of transparency nearly a requirement for YouTube stars.

"MONEY IS A topic that I have purposefully tried to avoid for the five years that I've been making videos," mega-popular YouTube gaming star Felix Kjellberg, aka "PewDiePie," told his fans in a 2015 video titled "Let's Talk About Money." A few days prior, a newspaper in his native Sweden reported that Kjellberg had earned $7.4 million the previous year, a headline that was picked up by numerous sites and became a trending story on social media. "I'm not going to pretend it doesn't matter to me; it matters to everyone," he said.

Kjellberg began making videos as a college kid living off student loans, barely able to afford a computer capable of recording his game-play. He famously quit school and took a part-time job at a hot dog stand to fund his hobby making funny, profane Let's Play videos, which at the time had no clear path to financial success. None of the handful of YouTube creators who had made careers out of their video work then were gamers. Five years later, Kjellberg was answering questions from his "Bro Army" of fans about the millions he was earning from his signature brand of gameplay commentary. "What people, I guess, don't really think about until it's in their face is that I have nine billion views, and that translates to something," he flatly explained. "There're ads on my videos. I make money out of those. So whenever it comes out how much I made a certain year, people just get so shocked. A lot of people also were very, very angry. They thought it was unfair, they thought I just sit on my ass all day and I just yell at the screen over here. *Which is true,*" he said, laughing maniacally.

If you have heard of any YouTube creator, there's a good chance you've heard of PewDiePie.* At fifty million subscribers, Kjellberg's

* Either through his giant audience or one of the many controversies he's stirred up with the general lack of filtering he applies to his comedy and commentary, most notably a 2017 *Wall Street Journal* inquiry into Kjellberg's use of anti-Semitic humor.

is the biggest channel on YouTube. In 2016, a greater number of users around the globe were subscribed to his channel than those of YouTube's two most-subscribed pop stars, Justin Bieber and Rihanna, *combined*. There are only twenty-six countries in the world with more people *in them* than PewDiePie has subscribers.

I never remember caring how much money my favorite band or actor or television personality earned. (In fact, I think most of us tend to presume, often falsely, that every performer we hear on the radio or person we see on our TV screens pulls in solid bank.) Today, the relationships between people like Kjellberg and their fans are different—not so removed as one we might have with a Hollywood movie star, but not as immediate as a personal friendship—and Kjellberg's surprisingly frank conversation about the economics of his life is a product of that. It was not a conversation he wanted to have, it was one he *had* to have. And it's why his fans love him.

While Kjellberg's was the most prominent case, the release of financial figures for other YouTube stars has inspired reactions ranging from support to disbelief to frustration to betrayal. Most people are simply shocked. The anybody-can-do-it aesthetic of YouTube is a semi-illusion of course, and the average viewer has little appreciation for the skills that go into successful YouTube channels. We can't help but shake our heads when the world so lucratively rewards someone for doing something so seemingly simple or inane.

The emotions of superfans can venture into far more complex territory. A discussion about money breaks what we might here call the "fifth wall": our belief that the personalities we connect with are "just like us" and that our relationships with them are as intimate as the ones we have with our real-life friends, most of whom aren't making millions. While many fans are happy to see their favorite stars find financial prosperity, others are conflicted because they feel responsible for someone's success but reap none of the rewards.

Navigating all of this is a challenge, and one that most of us are not cut out for. Even the most skilled creators and community managers can

find themselves in the midst of an audience revolt or, worse, exodus. Truly understanding fame in the context of a space like YouTube requires an even more multidimensional understanding of modern fandom.

THE ORGANIZING POWERS OF TEENAGERS

In 2008, the race was on to see which video would be the first to cross one hundred million views, a previously unthinkable number. In one corner, you had the classic viral "Evolution of Dance." In the other? The music video for the song "Girlfriend" by Canadian singer-songwriter Avril Lavigne. While "Evolution of Dance" now holds a place in the internet hall of fame, despite not necessarily withstanding the test of time, the vast majority of people struggle to recall any of the scenes from "Girlfriend." Most of us assumed the "Evolution of Dance" would come out victorious. I mean, *everyone* had seen it. But "Girlfriend" won, and the internet learned one of its first lessons about respecting the organizing powers of teenagers. Lavigne's rabid fanbase had launched a campaign to claim this trophy milestone for their idol. In fact, someone even cooked up an automatically refreshing site to help pump the view count. Wrote one Lavigne superfan on a message board, "Keep this page open while you browse the internet, study for exams, or even sleep. For extra viewing power, open up two or more browser windows at this page!" As Kenyatta Cheese remarked in a totally unrelated discussion about how the "Beliebers" (Justin Bieber fans) figured out how to game Twitter's trends algorithm, "When you're going against an army of fourteen- to sixteen-year-old girls, that is the most amazing parallel processing computer system in the fucking world."

Facilitating and harnessing the power of fan communities has become a prerequisite skill for the new class of talent. And it's made us feel, in stark contrast to traditional celebrities, a party to their fame. Being a star no longer requires pop culture ubiquity, but what's lost in overall awareness is gained in depth of interaction. In other words,

there are now more celebrities that we do not know, but we tend to feel much more familiar with the ones we like and have more opportunities to connect with them too.

In 2006, Chris Anderson, then editor in chief at *Wired*, described this as a "flattening" of celebrity. "There's more celebrities, so the nature of celebrity is devalued," he said. "We're moving into an era of microhits and ministars, where your celebrity may not be my celebrity, and you may not have heard of mine." Around the same time, writer Rex Sorgatz used the term "microfamous" in *New York* magazine to describe what was unfolding: "Microfame is its own distinct species of celebrity, one in which both the subject and the 'fans' participate directly in the celebrity's creation. Microfame extends beyond a creator's body of work to include a community that leaves comments, publishes reaction videos, sends e-mails, and builds Internet reputations with links."

Back in 2006, these interactions seemed to be a supplementary experience to how people were using YouTube to connect with the personalities they were interested in. But in the ensuing years, as social media platforms spread and their use became commonplace, our behavior online supercharged this phenomenon. And one of the first things I realized when I joined YouTube was that the commenting and the sharing and everything else that made you feel like part of a larger community in fact represented the *primary* experience. The content was often secondary to that. Which meant that building meaningful connection points for fans to engage with one another and with you became the most critical skill one could have as a modern entertainer.

You can see it right in the data. Here's a comparison of views versus comments (the simplest form of interactive engagement) between a big YouTube star, gamer Mark Fischbach (aka "Markiplier"), and two of YouTube's most popular mainstream celebrity-focused channels:

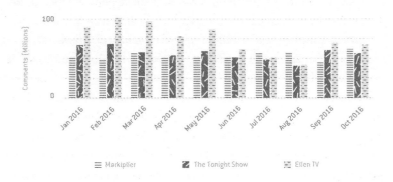

MONTHLY VIEWERSHIP COMPARISON

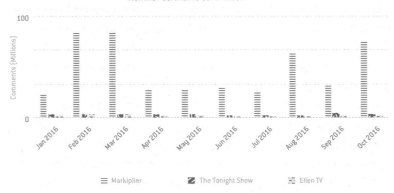

MONTHLY COMMENTS COMPARISON

This reality—that the interactive experience the audience has with the creator or with each other through the content outweighs the experience of viewing that content—has completely changed the way creators communicate with fans today and introduced less-understood dynamics between the audience and the onscreen talent they follow.

BACK WHEN ZE FRANK first began creating web video, he learned that having direct, emotional conversations with viewers could quickly grow an audience and keep them coming back. "Leaning into emotion,

generally, was very powerful, just talking openly about things like sadness. I found that virtual emotional experiences are incredibly powerful for a lot of different reasons," he said. The best works of art have always communicated with us on emotional terms; there's nothing new about that. But in the world of web video, the concentration of that emotional exchange through a single individual—someone who personifies what we believe in, care about, love, etc.—makes all the difference. "The intensity of these kinds of personal connections is greater when there is a physical manifestation of a person," Frank told me.

Not all creators are equipped to handle that intensity, and we are still learning about the dynamics it can create between them and their audiences. Dissonance between reality and perceived reality can push things in a concerning direction. In July 2016, the hashtag #SaveMarinaJoyce became a worldwide trending topic, the result of a frenzy among fans of the nineteen-year-old British creator. Over the previous few days, they'd become convinced that something was very wrong with their favorite beauty tutorialist. In her recent videos, she seemed detached, unblinking, and thinner than usual. Those who dissected her videos spotted bruises on her arms, a gun in the background of one clip, and mysterious containers on her nightstand. Some claimed she could be heard whispering, "Help me," on the audio track of her date-outfit-ideas video. Many thought she'd been kidnapped. As the *Guardian* put it, "Thousands of teenagers revealed that they couldn't sleep and were shaking from their belief that Marina had been kidnapped or was being held hostage. More than 60 people tweeted that it had caused them to have an anxiety or panic attack. The mood was one of hysteria." Police officers visited Joyce's home at three A.M. after calls from fans, but said she was safe and fine. (If anything, Joyce, in subsequent messages and videos, appeared mostly just ill-prepared for the all the attention.)

It's disturbingly easy for things to go awry when a creator loses control of their community, and that's probably because now the relationship between fans and talent can feel just as unpredictable and emotionally charged as the relationships we have in real life. Joyce's

story is a particularly drastic example of the perils of modern celebrity, but it's not the only one in a world where fans' self-identities become intertwined with the public figures to whom they can feel so connected.

The parasocial relationships—personal but ultimately artificial—that exist between celebrities and their fans are no doubt magnified, expanded, and mutated in the egalitarian environment of web video, where distance between the adored and the adoring feels practically nonexistent. This is especially true in formats like vlogs, in which video creators share intimate (albeit curated) details of their lives directly to the camera, further enhancing the feeling of an authentic, real-life relationship with us. The illusion of intimacy becomes less of an illusion when fans' comments are read and responded to, viewers are acknowledged on screen, and social media posts from these personalities intermingle with those of our friends and family.

In some cases, this leaves impressionable fans in a vulnerable position with a new type of celebrity not necessarily fit to responsibly manage that vulnerability in all the spaces we can connect with them. This was acutely laid bare in 2014 when some well-known figures in the U.S./U.K. creator community were accused of sexually abusive and emotionally manipulative interactions with fans turned "friends" outside of YouTube that ranged from inappropriate conversations to solicitation of nude photographs to assault. In some cases, these fans were underage at the time of the reported events. The majority of alleged perpetrators were ostracized and had business relationships severed (though few faced criminal investigation) and the benevolence of the modern celebrity–fan connection was called into question. "In light of recent developments, we cannot stress this enough to you," wrote the organizers of Summer in the City, the United Kingdom's largest web video meetup, in a message to attendees. "In planning for this year: The people you look up to are just people, and in some cases, unfortunately, their intentions are not the purest."

The scandal and the honest dialogue that followed reminded us that the virtual communities of YouTube can be just as strong as the physically proximate communities that form around our homes and

families. Some relationships are dangerous, but more are positive, in real life and online.

If asked (and often unprompted) pretty much every YouTube creator will expound on the differences between their relationships with fans and with those they feel exist with traditional media stars. "Creators are more like friends, brothers, or sisters to the audience— rather than celebrities who are seen as idols," beauty guru Michelle Phan has said.

In 2013, popular YouTube personality Philip DeFranco mentioned on his daily news-and-pop-culture talk show that his father was likely to need a kidney transplant. One of his fans, a retired army veteran in Idaho, donated his. "I started making videos because I wanted to talk to people, to connect to people, to have a community," DeFranco told me onstage at VidCon in 2016. "I mean, my dad has a kidney because someone that has watched me for years gave a kidney, right? And he was nowhere near the only person that offered. And that's amazing. It's this digital connection that then converted somehow into this amazing net reality."

DeFranco's "Nation"—the millions of people who watch his show—represent one of many, many fan communities that exist on YouTube. (Other prominent fandoms include PewDiePie's "Bro Army" and Bethany Mota's "Motavators.") While large-scale fan communities have always existed in entertainment—"Deadheads," "Trekkies," and so forth—the organizing power of the web has turned YouTube fan communities into some of the most powerful forces in popular culture. Hank and John Green's "Nerdfighters" have helped raise millions for charity through the duo's Foundation to Decrease World Suck. (Yeah, that's a real thing and it's pretty great.) So many of these creators have had bestselling books that a London bookstore I once visited had an entire section dedicated to YouTube stars. When Zoe Sugg (aka "Beauty & Lifestyle" YouTube superstar "Zoella") released a novel in 2014, it became the fastest-selling debut of all time.

When it comes to the web video star, fandoms look more like social movements than groups of enthusiasts. It's ironic that in the social media

age we call these digital crowds "followers," because in a world where our interactivity drives the popularity of our favorite talents, we often feel like anything but.

▶▶

One reason those of us who grew up before YouTube struggle to categorize the new types of stars who emerge from the land of web video is that the stars themselves struggle with it. We don't always have the vocabulary for their craft or stature. Jordan Maron ("CaptainSparklez") has had a tricky time explaining himself to customs and border patrol agents. He's resigned himself to oversimplification. Anything more just tends to confuse everyone. "I did once say 'I'm an online entertainer' to a customs border patrol agent. I assume by their face they thought I did porn. So then I dropped that one and just went with 'I make YouTube videos.' So far I have not been detained."

The manner in which we discover and interact with the people who create the things we love has completely altered the classic notion of both celebrity and talent. The word "celebrity" used to mean the kind of renowned figure pretty much anybody across different ages and locales could recognize. But throughout my years at YouTube, I encountered more and more people who were famous to *someone* rather than *everyone*. I suspect we'll always have the Kim Kardashians and the Prince Harrys to gossip about collectively, but there's now an opportunity for any of us to build our own audiences with whom our passions might resonate.

While studio executives and A&R reps still play important talent-spotting roles in modern entertainment, our actions and interactions online can propel individuals to the spotlight more quickly through less formalized paths. Many of these new talents excel because of a very twenty-first-century skill: enabling authentic interactions with frequency and intensity. Some of them feel less like pop culture royalty and more

like friends. They communicate with us through many of the same tools as our friends, and we often feel like collaborators in their fame rather than bystanders since we can trace how we contributed to it.

Record labels, movie studios, TV networks, and book publishers, with their reach and financial clout, will continue to assess, hone, promote, and sustain many of the talented individuals whose work we enjoy. But they are no longer the only paths to reaching stardom. Having the right look or being in the right place at the right time or knowing someone who knows someone matters a lot less than it used to when exposure is driven by how many people you connect with online and how effectively you do it.

And that's changed things for us too. We are no longer just fans. We are members of communities. We are no longer even solely an audience. We are all, to varying degrees, participants.

End Card

In January 2007, Ken Snyder was riding his bicycle along Venice Beach when he spotted something he *had* to record on his new digital camera and immediately share with everyone.

It was a bulldog . . . casually riding a skateboard.

As it weaved between gathered teenage skate crews, a brown-and-white blur with a long pink tongue flopping in the air and small paws thwacking along the pavement grabbed the attention of Venice Beach that day and soon grabbed lots of attention online too, where Snyder's video, "Skateboarding Dog," drew millions of views and fans. It was even featured prominently in an original Apple iPhone commercial that year. For many, the clip basically summed up the fun, zany world of viral video.

In addition to winning the Guinness World Record for "fastest skateboarding dog"—yeah, it turns out there's more than one—Tillman also skimboarded, surfed, and snowboarded with his owner and best pal, Ron Davis. Over time, Tillman became a legend among viral-pet-video aficionados. But Tillman had also become a different kind of legend at YouTube's HQ, where he'd inadvertently attained distinction as the most infamous animal in the entire media industry.

Between 2011 and 2013, images of Tillman appeared in more slide presentations than I could count, used as the ultimate metaphor for the stereotypical view of web video content held by many casual viewers, industry partners, and advertisers. The phrase "dogs on

skateboards" (which over time merged with another online media pejorative to form the stranger and much less rational "cats on skateboards") turned into a popular shorthand to cast derision toward entertainment on the web. In press interviews, sales pitches, and fancy conference keynotes, YouTube's executives regularly relied on the phrase to demonstrate that the platform had evolved away from its amateur roots. "YouTube," it was declared over and over again, "was not just dogs on skateboards." It felt as though one of our marketing team's objectives in those days was to convince the public of this explicit fact.

All of this perturbed me, to be honest. While I appreciated that "Skateboarding Dog" might not be Shakespeare and that too many people, including many media professionals, *were* too quick to dismiss the unique kind of professional creativity unfolding each day on YouTube, it bugged me that this particular dog had become some sort of symbolic albatross of the industry. It bugged me because "dogs on skateboards" summed up everything I *loved* about YouTube. It was weird and random and eye-popping and very much *not* television or radio or film. It was the kind of thing that each of us *made* popular through what are, frankly, some rather sophisticated forms of engagement made possible by YouTube. We watched it. We shared it. We rediscovered it. We participated in its joy and surprise every time we had a bad day or wanted to offer an "emotional gift" to a friend. In the world of YouTube, it represented a celebration of the small moments of magic that populate our daily lives. For me, Tillman stood—on a *skateboard*—for exactly what I found inspiring about the democratic nature of this new medium.

Over the years, of course, YouTube and web entertainment ultimately transcended the "dogs on skateboards" stigma, and everyone began to recognize that a professional level of creativity and talent was thriving online. That image of Tillman gleefully gliding on his skateboard stopped appearing in slide decks. It was rarer and rarer to see any pet video go viral amid the noise of each day's trending clips.

Toward the end of 2015, I came across a small news item. Tillman had passed away of natural causes. "We spent 10 years making so many incredible memories skating, surfing and hanging out together," Ron

Davis wrote of his beloved bulldog. "No words can truly describe how much he'll be missed. Thanks for all the good times, Tilly."

I felt very sad reading that. And not just because it's a bummer when someone loses a pet. Just as Tillman's antics had represented for me the exhilarating wonder of unfiltered individual expression, his death suddenly symbolized what felt like the end of a special, bygone era for which I was already quietly nostalgic. As the business of web entertainment grew and a professional video industry flourished, it could sometimes feel like those raw moments of serendipity were less likely to reach us. Had the things that I loved about this new world of video, that made places like YouTube distinct from traditional entertainment, died too? Had they been snuffed out by the influx of money and advertising and traditional media conglomerates? I began to wonder if web video still represented a democratic creative revolution.

But the truth is that all the businesspeople in the world can't change what makes YouTube unique. Even as I write this, millions of things that make absolutely no sense to most media or advertising professionals are being posted, watched, and shared. We each still hold the power to make things popular—to make things matter. Tomorrow, someone will have an idea—the most random and nonsensical creative idea—that will turn into something that will touch the lives of millions of people. We all make that possible.

As a result, this is the least predictable and most confounding era in the history of human expression. We're in the early days of a dramatic restructuring of the role that media created by both amateurs and professionals can play in our lives. And we should consider for a moment what that means.

THIS BOOK HAS focused almost exclusively on web video and YouTube since that's the realm that I know best. But YouTube is just one of the largest and most diverse examples of a bigger trend in which our actions online affect our lives and the world around us. The incongruous offerings on YouTube and many other platforms can seem

chaotic, but the collective cultural impact is bigger than any one video, meme, or creator.

In hearing the stories behind many of these YouTube phenomena (especially the earlier ones), you might have noticed a recurring theme. So often, success seemed to come almost entirely by accident. A video intended to be shared with a small circle of friends or relatives—or in the case of OK Go, exclusively with Michel Gondry—broke loose and took on a life of its own. That some small video could have such dramatic effects on the lives of so many people *unintentionally* spoke volumes to me about how different the web video era could be from the time when access to large audiences was tightly controlled and managed. In less than a decade, we went from bands begging to get on *TRL* to accidentally creating a hit in their backyard. Over the years, as more people begin to understand how the medium works and how people behave online, internet culture has moved from the accidental to the purposeful. Few of the most popular videos or creators succeed inadvertently anymore. But that spontaneous, unprocessed spirit can still be found at the heart of many of the biggest successes, from the diverse, experimental production techniques they employ to the unpredictable and irreverent topics they cover.

Even as platforms like YouTube sometimes feel as though they're becoming more commercialized and calculated, the unique quality that makes web video stand out as a transformational medium remains *our* ability to shape it. And that is what makes YouTube so fascinating. It's populated with creative artifacts and avenues for interaction that speak to nearly every aspect of the human experience. So many of the best videos and channels succeed because they capture that experience with intensity and authenticity. Despite having overseen promotional tools on some of the most prominent real estate on the entire internet,*

* For a period, I was in charge of the "Spotlight" module on YouTube's homepage as well as the equally defunct "Ticker," a highly visible link that ran across the top of every desktop page on YouTube. It was a responsibility that made me both very popular around the office and frequently miserable.

I rarely felt as though I held the power to make something popular. Certainly not in the way that even someone with a few thousand subscribers could. While my marketing colleagues have worked hard to help inform how people perceive YouTube's brand, ultimately what YouTube *is*—and what any technology driven by our self-expression represents—comes from the way millions of people use it.

YOUTUBE IS MOLDED in our own image, for better or worse. It's the broadest and most unmediated reflection of who we are and what we care about, and it says a lot about us.

For one, we force technology to work for us, given the opportunity, rather than the reverse. We go to great lengths to bend our tools to fit our actual needs and desires, often taking them in directions far afield from what their designers had in mind. Chad, Steve, and Jawed, YouTube's founders, thought people would use their new video hosting site for dating profiles. No one could have foreseen Autonomous Sensory Meridian Response or Auto-Tuned presidential debates. The world of web video shows us just how potent our passions can be, transforming niche hobbies, geographically distributed fandoms, and personal obsessions into popular channels, prolific communities, and thriving new genres.

Our needs can vary dramatically, of course. Sometimes we seek refuge among a community of people who understand our unique passions (like elevators). Sometimes we simply must know whether it's possible to outrun flatulence. (Thanks, Greg and Mitch!) But some needs are more universal than others, and we demand more from what we watch and read and listen to now than we ever have before. The standards we have for the media we consume have risen, and we're not going to let them drop anytime soon. Our tolerance for the vacuous is waning, and we expect entertainment to play a meaningful role in our lives. I get how strange that sounds when so many of the popular videos and channels can feel like the absolute peak of inanity. (Watching

"Nyan Cat," one is not exactly reassured that they are on an intellec-
tual journey to modern enlightenment.) But remember, the value of
web video lies not necessarily in its content, but rather in the connec-
tions it facilitates for us. And while that seems like something that
should have always been the case, it's only now that the value we
derive through active participation in media has become such a promi-
nent force driving popular culture.

We elevate the people and creativity that allow us to connect to
something and to one another, on a deeper, more personal level, and
that provide us with ways to express who we are and what we care
about. In a rather dramatic inversion, the size of something's reach and
the manner in which it spreads are now determined by its interper-
sonal value rather than its business value.

AS WE MOVE beyond the rigid structures of traditional mass media,
we lose some of the safeguards that kept entertainment and informa-
tion consistent, predictable, and largely inoffensive. Remember, in the
twentieth century, most of the messages that reached a mass audience
were broadcast through expensive systems that relied on sales and
advertising revenue to justify their use. Controversial forms of expres-
sion that threatened existing economic models generally didn't stand
a chance. Corporate influence over creativity and expression is oft
derided for good reason, but brand-safety concerns from the people
who pay the bills tend to enforce a sense of duty in the people who
produce and disseminate the things we watch and listen to. It was hard
for truly irresponsible messages to reach us en masse.

Over the course of writing this book, some long-simmering issues
that spoke to the potential long-term implications of the culture we're
creating came to a head. Major debates sparked by "fake news" and
mob harassment were a few of the big challenges presented by the new
ways we're using technology to express ourselves and connect with one
another and with world events. What I wanted to believe was demo-
cratic often felt anarchic.

By the mid-2010s, there was an ever growing and changing collection of people with cultural clout who rarely, if ever, thought about palatability to anyone but their own narrow audiences. When, at the start of 2017, Felix Kjellberg was called out by the *Wall Street Journal* for repeated use of anti-Semitic humor, leading major business partners (including YouTube's Originals initiative and Disney-owned Maker Studios) to cut certain ties with him, Kjellberg came off surprised at the uproar, upset with the *WSJ*'s approach, and apologetic, admitting that his jokes went too far. In a more mature, established media organization, that type of humor would be unlikely to find its way to an audience of his scale. What Kjellberg might have seen as edginess in the spur of the moment was to others offensive and dangerous and never would have passed through the filters built into traditional media. "I love to push boundaries, but I would consider myself a rookie comedian, and I've definitely made mistakes like this before," Kjellberg said in a video response that was watched tens of millions of times. "But it's always been a growing and learning experience for me." It's strange to think of Kjellberg, twenty-seven at the time, and one of the most recognizable faces to teenagers around the world, as a rookie entertainer. And while this amounted to more than a simple rookie mistake, Kjellberg had catapulted from college gamer to household name in just a few years through a medium that rewarded his unfiltered style, and even with an audience of millions he still had no real production staff behind his daily output. Creators are individually accountable for their poor decisions and that accountability increases when audiences grow. It's become disquietingly easy for the results of reckless choices to reach larger and larger groups of people.

In some ways, we're all rookies; all first-timers trying to figure out how this web video machine is supposed to work, both as performers and as part of the viewing community.

The new power our online behavior has to influence the world around us went largely underestimated. Outside the safety of the sanitizing mass media structures most of us grew up with, our lesser selves could sometimes run amok. The same place that had become a home

for documenting injustice and organizing communities could also be a venue for thoughtless attack and calculated harassment. Platforms that helped us express ourselves in more intimate and personal ways also enabled the expression of negativity. While concerns about organized bullying had been brewing for a few years, things seemed to boil over in 2015 and 2016, when organized behavior on social media platforms began to show just how ugly we could be. Celebrities, activists, and everyday people were targeted with sometimes relentless misogyny and threats. Nearly every major community-driven media platform, including Facebook and Twitter, had to grapple with that problem.

And then came the 2016 election. While 2008 was the first true election of the social media era, the 2016 election was the first to take place after the political influence of online behavior had surpassed that of traditional mass media venues.* Simultaneously we saw a major influx of new and questionable voices with incredible persuasive capabilities and unmediated communication that lacked critical context and corroboration. To a greater extent than ever before, the loudest mouths could drown out any complexity, and the kinds of messages we'd been accustomed to trusting as fact were often not very trustworthy at all.

The hardest part about all this is that we don't have a road map for how to proceed. Our voices have been given unprecedented reach, and it seems clear that we are not fully prepared to manage the implications.

Kenyatta Cheese told me that we must "rethink what it means to have the responsibility of attention." In a space where we can spread messages and organize communities so easily, all of us have new ethical obligations to consider. For me, the mob behavior and "fake news" debate represented the consequences of ignoring those obligations. "Many of us who have been good at attracting attention and keeping it . . . are inadvertently raising troll armies," Cheese said. "There's a

* We saw this play out in the numbers too. On YouTube, viewership on election-related content about the candidates was eight times in 2016 what it was in 2008.

physics to attention, to the power that we can have. I think some of us are more aware of it than others."

It's true. Many of us dramatically underestimate our own ability to influence public debate and the perspectives of others, and when we do discuss the power of individual expression, we mostly focus on the positive. We think about how the videos we watch or create connect us to a larger community or how our interactions can be a source of individual amusement. "It's possible to create an amazing community focused around doing things that are good," Cheese added. "But in the same way you create things around love, you can also create things around hate."

WHEN THINKING ABOUT the future, it's easy to focus on technological innovations and what those will mean for us. Advances in entertainment tech around virtual reality and in the arena of automation and machine learning will no doubt have a significant impact on culture. But the story of the last decade, above all else, has been one of access and distribution—boring words that belie the immense influence they'll have in the decades to come.

While thousands of employees have contributed to YouTube's underlying code and business strategy over the years, those of us who use it each day are the ones who turned it into a cultural hatchery: a medium that's changing our relationship with global events, how we acquire knowledge, and the definition of both music and celebrity. Each of us, through even our smallest actions online, help increase the impact everyday expression can have on the world. And each of us will help shape the influence that expression will have in our lives in the years to come. The story of where online video takes us in the next century will not be decided by bits of code, but by how we choose to use it.

I'm not naïve about the pitfalls that come with entrusting so many with this responsibility, but I'm basically optimistic because I believe it's ultimately better to have a culture shaped and reflected by individual

acts of expression than one heavily driven by corporate interest and the pursuit of a return on investment. Messy as it can be, the strange and unpredictable environment that has emerged over the past decade—the unexpected communities and talents and forms of creative expression— better reflects the reality of who we are than any medium that came before. Through even the most trivial things we create and watch and share—the lip-syncs and reaction videos and, yes, even the dogs riding skateboards—we gain greater insight into one another and greater opportunity for true, honest connection with people and ideas that matter to us.

So thanks for all the good times, Tilly. And for the challenging and enlightening ones too. There are lots more to come.

Acknowledgments

Whatever I may have learned over the years about the topics covered in this book was acquired through the help of many, many smart people and by taking in the exhilarating creativity of fascinating, weird, and passionate individuals who make things on the internet. I'd never be able to thank all of them, but I owe them an incredible debt.

In terms of making this specific book possible, thank you to Lea Beresford, my seriously awesome and tireless editor, and the team at Bloomsbury for believing in me and sharing the vision right from the start, particularly Cindy Loh, Nancy Miller, Christina Gilbert, and George Gibson, as well as Laura Keefe, Nicole Jarvis, Shae McDaniel, Marie Coolman, and Sarah New for getting the word out. Also to Dan Rembert for his wonderful design work and Jenna Dutton and Laura Phillips for ensuring my writing looked so good. I feel incredibly lucky to be able to work with you.

To Stephanie Higgs for helping turn the daunting process of writing a book into something manageable and fun (even if you *were* the last person ever to see "Gangnam Style") and to my fantastic researchers Kiran Samuel and Teiko Uyekawa for, among other things, digging up facts and studies on some of the most random topics ever. To Jeff Kleinman at Folio Literary Management for his dependable encouragement, enthusiasm, and unfailingly honest advice, and for having the foresight that a book about videos could actually be a thing.

Thank you to old friends and colleagues Steve, Olivia, Cristos, Billy, Hammy, Ben R., Benny and Rafi, Evan, Michael, Andrew G., David C.,

Kenyatta, Kuti, Casey, and Scott, who agreed to be interviewed. To the talented Jordan (CaptainSparklez), Mitch and Greg (AsapSCIENCE), Ze (BuzzFeed), Andrew R. (ElevaTOURS), Maria (Gentle Whispering), Noy, Jeff J., Gianni and Sarah (Walk off the Earth), Damian (OK Go), Craig, Sam P., Sam G., Nick (Pogo), Ben B. (MyNiceTie), Matt N. (carsandwater), Jason R., and the dads of VidCon—as well as Bear, Chris T., Rebecca, and Sarah R. from years past—who shared their stories and expertise with me.

Massive thanks to Gina, Matt T., Abbi, and Chris D., as well as Marly, Ross, Earnest, Carly, Bonnie, Jeff, Kevin M., Matt D., Marc, Bangs, Taylor, Ramya, Maany, Steph S., Elizabeth L., Lance, Emily, Margaret G., Meg C., Grant L., and many others back at the office who were so unbelievably generous with their wisdom, advice, and assistance. To Danielle, Anna, and Lucinda for the years of positivity, trust, and support for which I will truly remain forever grateful. To Susan, Salar, and Lorraine for being the sort of leaders who enable amazing people to make amazing things possible around me each day. To Steve for always being Steve.

Thanks to Ken Snyder for his image of Tillman and Katie Clem for her hilarious image of Chloe. To Kevin A. #2, Ania, Red, Tom, and many other patient friends who put up with all my absences and impromptu ramblings. To Vanessa for her feedback and thoughtfulness down the final stretch. To Communitea in Long Island City for basically providing my second office.

There are not enough words to thank my father for being the kind of father who made my unusual path in life possible, my mother for being the kind of mother who thinks everything I do is the best even when it isn't, my sister for being the kind of sister who sets that straight,* my cousin Terri for being my home away from home, and my grandfather Joe Allocca, to whom this book is dedicated, who witnessed the birth of commercial radio, the invention of television, the explosion of the internet, and the rise of virtual reality and never flinched. You'll

* jk love you, Kristine! You're the best first video collaborator I could have asked for.

always inspire me to be, like you, a man not defined by time or circumstance, but by the life and relationships he builds around him.

Finally, to the millions of people whose individual expression has made YouTube what it is, who've opened themselves up to vulnerability, who've been real when it was hard to be real, who've in some cases even risked their lives or well-being to share a part of themselves when it was scary, discouraging, or dangerous: It matters. And it's changing everything.

Notes

PRE-ROLL

xi **cost approximately $50,000 in 1959**: "Price List: Broadcast Camera Equipment for Television," Radio Corporation of America, Jan. 1959.

xi **"Popular culture"**: Bernard Rosenberg and David Manning White, *Mass Culture: The Popular Arts in America* (Glencoe, IL: Free Press, 1957), 519.

1: AT THE ZOO

2 **integration into web pages**: Scott Kirsner, "Why Did YouTube Win? An Interview with Co-founder Chad Hurley from 2005," *Boston Globe*, Feb. 16, 2015. http://www.betaboston.com/news/2015/02/16/why-did-youtube-win-an-interview-with-co-founder-chad-hurley-from-2005.

5 **YouTube went from zero**: acmuiuc, "r | p 2006: YouTube: From Concept to Hypergrowth—Jawed Karim," YouTube video posted Apr. 22, 2013. https://youtu.be/XAJEXUNmP5M.

5 **"indistinguishable from magic"**: Arthur C. Clarke, *Profiles of the Future* (London: Orion, 2013).

16 **tweeted T-Pain**: T-Pain, Twitter post, Jul. 29, 2012, 2:43 P.M. https://twitter.com/TPAIN/status/229693595437912064.

16 **tweeted Katy Perry**: Katy Perry, Twitter post, Aug. 21, 2012, 2:19 A.M. https://twitter.com/katyperry/status/237841455782182912.

17 **long dominated**: Sukjong Hong, "Beyond the Horse Dance: Viral vid 'Gangnam Style' Critiques Korea's Extreme Inequality," *Open City*, Aug. 24, 2012. http://opencitymag.com/beyond-the-horse-dance-viral-vid-gangnam-style-critiques-koreas-extreme-inequality/.

17 **"exciting song with a good hook"**: Jaeyeon Woo, "Psy Reveals All About 'Gangnam Style,'" *Wall Street Journal*, Aug. 9, 2012. http://blogs.wsj.com/koreareal time/2012/08/09/psy-reveals-all-about-%E2%80%98gangnam-style%E2%80%99/.

18 **"see the future"**: Alphabet Investor Relations, "Google Q3 2012 Earnings Call," YouTube video posted Oct. 18, 2012. https://www.youtube.com/watch?v=gEifqZU7ntY.

2: CREATING ENTERTAINMENT IN THE AUTO-TUNE ERA
30 **thrift stores and Target**: jm42892, "Lonelygirl15 Creators Nightline Interview," YouTube video posted Nov. 17, 2006. https://www.youtube.com/watch?v=rnjZzDeepE8.

30 **to try it himself**: Fine Brothers Entertainment, "YOUTUBERS REACT TO LONELYGIRL15," YouTube video posted Dec. 27, 2015. https://www.youtube.com /watch?v=qhjLjaCt1DM.

31 **"we just put it out there"**: Elena Cresci, "Lonelygirl15: How One Mysterious Vlogger Changed the Internet," *Guardian*, Jun. 16, 2016. https://www.theguardian .com/technology/2016/jun/16/lonelygirl15-bree-video-blog-youtube.

40 **utilized the Let's Play format**: Harrison Jacobs, "Here's Why PewDiePie and Other 'Let's Play' YouTube Stars Are So Popular," *Business Insider*, May 31, 2015. http://www.businessinsider.com/why-lets-play-videos-are-so-popular-2015-5.

44 **"figuring that out"**: Ze Frank, "My Web Playroom," TED video posted Oct. 15, 2010. https://www.ted.com/talks/ze_frank_s_web_playroom/transcript?language=en.

45 **sound turned on**: Sahil Patel, "85 percent of Facebook video is watched without sound," *Digiday*, May 17, 2016. http://digiday.com/platforms/silent-world-facebook-video/.

45n **Carson's final week in '92**: Rick Kissell, "Jimmy Fallon's 'Tonight Show' Audience Biggest Since Johnny Carson Exit," *Variety*, Feb. 27, 2014. http://variety .com/2014/tv/ratings/upon-further-review-jimmy-fallons-first-week-drew-the-largest -tonight-show-audience-since-johnny-carsons-exit-1201122644/.

48 **"which bits flew"**: Edinburgh International Television Festival, "The Late Late Show: Conquering America with Corden and Carpool Karaoke," YouTube video posted Aug. 26, 2016. https://www.youtube.com/watch?v=66VEMLRCsyg.

3: THE LANGUAGE OF REMIXING AND THE PURE JOY
OF A CAT FLYING THROUGH SPACE
51 **"a split-second decision"**: Elizabeth Fish, "Profiles in Geekdom: Chris Torres, Creator of Nyan Cat," *PC World*, Feb. 4, 2012. http://www.pcworld.com/article/249299 /profiles_in_geekdom_chris_torres_creator_of_nyan_cat.html.

54 **"speaking impossible"**: Lawrence Lessig, *Remix* (New York: Penguin Press, 2008), 83.

54 **"became a mass movement"**: Matt Mason, *The Pirate's Dilemma: How Youth Culture Is Reinventing Capitalism* (New York: Free Press, 2009), 71.

57 **"Tel Aviv, but now it's all good"**: Scott Thill, "Kutiman's *ThruYou* Mashup Turns YouTube into Funk Machine," *Wired*, Mar. 25, 2009. https://www.wired.com/2009/03/kutimans-pionee/.

58 **"sovereignty, or territorial integrity"**: U.S. Department of the Treasury, *Treasury Targets Additional Ukrainian Separatists and Russian Individuals and Entities*, Dec. 19, 2014. https://www.treasury.gov/press-center/press-releases/Pages/jl9729.aspx.

59 **"registered on social networking sites"**: Agence France-Presse, "Russia Tries to Curb Crimean Prosecutor's Internet Fame," Inquirer.net, Apr. 2, 2014. https://technology.inquirer.net/35177/russia-tries-to-curb-crimean-prosecutors-internet-fame.

59 **at the University of Tennessee**: Tom Ballard, "Part 1: Baracksdubs' Fadi Saleh Started at UT in Pre-Med," Teknovation.biz, Apr. 12, 2016. http://www.teknovation.biz/2016/04/12/part-1-baracksdubs-fadi-saleh-started-ut-pre-med/.

60 **"up to three weeks"**: Michelle Jaworski, "Barack's Dubs: How a Biochemistry Student Makes President Obama Sing," *Daily Dot*, Jul. 16, 2012. http://www.dailydot.com/upstream/baracks-dubs-fadi-saleh-interview/.

60 **between ten and one hundred hours**: Andres Tardio, "Meet the Man Behind the 'Sesame Street' Rap Mash-Ups," *MTV News*, Jun. 8, 2015. http://www.mtv.com/news/2180975/sesame-street-mash-ups-animal-robot/.

61 **public health becomes corporatized**: Liv Siddall, "The Art Student Behind Shia's DO IT!!!," *Dazed*, Jun. 9, 2015. http://www.dazeddigital.com/artsandculture/article/24996/1/the-art-student-behind-shia-s-do-it.

63 **"we are all artists really"**: Hannah Ellis-Petersen, "Shia LaBeouf Collaborates with London Art Students on Graduation Project," *Guardian*, May 27, 2015. https://www.theguardian.com/film/2015/may/27/shia-labeouf-collaborates-london-art-students.

65 **"they were potentially containing"**: Timothy D. Taylor, *Strange Sounds: Music, Technology and Culture* (New York: Routledge, 2001), 45.

65 **manipulate and create music**: Jonathan Patrick, "A Guide to Pierre Schaeffer, the Godfather of Sampling," *FACT*, Feb. 23, 2016. http://www.factmag.com/2016/02/23/pierre-schaeffer-guide/.

69 **"single massive video montage"**: Andy Baio, "Fanboy Supercuts, Obsessive Video Montages," *Waxy*, Apr. 11, 2008. http://waxy.org/2008/04/fanboy_supercuts _obsessive_video_montages/.

69 **two years to compile**: Patrick Kevin Day, "'Sorkinisms' Reveals Aaron Sorkin's Penchant for Recycled Dialogue," *Los Angeles Times*, Jun. 26, 2012. http:// articles.latimes.com/2012/jun/26/entertainment/la-et-st-sorkinisms-aaron-sorkin -20120626.

70 **"collapse of the Third Reich"**: Roger Moore, "'Downfall' Presents Human but Still-Grim Look at Hitler," *Orlando Sentinel*, Apr. 5, 2005. http://articles.orlando sentinel.com/2005-04-05/news/0504040307_1_hitler-downfall-eva-braun.

71 **"better compliment as a director"**: Emma Rosenblum, "The Director of *Downfall* Speaks Out on All Those Angry YouTube Hitlers," *Vulture*, Jan. 15, 2010. http://www.vulture.com/2010/01/the_director_of_downfall_on_al.html.

75 **country's widespread internet blackouts**: "Libya Starts to Reconnect to Internet," BBC News, Aug. 22, 2011. http://www.bbc.com/news/technology-14622279.

76 **"king of kings of Africa"**: "Muammar Gaddafi: Bizarre Quotes from the 'Mad Dog of the Middle East,'" *Sydney Morning Herald*, Oct. 21, 2011. http://www.smh .com.au/world/muammar-gaddafi-bizarre-quotes-from-the-mad-dog-of-the-middle -east-20111021-1mbcb.html.

77 **"until the law effectively blocks it"**: Lawrence Lessig, *Remix* (New York: Penguin Press, 2008), 83.

4: SOME MUSIC THAT I USED TO KNOW

83 **"inheritance of man alone"**: John Philip Sousa, "The Menace of Mechanical Music," *Appleton's Magazine* 8 (1906).

91 **former president of Turkmenistan**: "Turkmenistan Bans Recorded Music," *BBC News*, Aug. 23, 2005. http://news.bbc.co.uk/2/hi/asia-pacific/4177622.stm.

92 **debut in the network's history**: Tim Kenneally, "'Lip Sync Battle' Premiere Delivers Ratings Records for Spike," *Wrap*, Apr. 3, 2015. http://www.thewrap.com/lip -sync-battle-premiere-delivers-ratings-record-for-spike/.

93 **Krasinski asked Merchant**: Leigh Blickley, "John Krasinski on the Wild Car Ride That Inspired 'Lip Sync Battle,'" Huffington Post, Aug. 22, 2016. http://www .huffingtonpost.com/entry/john-krasinski-on-the-wild-car-ride-that-inspired-lip -sync-battle_us_57b4cbf9e4b095b2f5424282.

93 "'**This is going to be huge**'": Emily Steel, "On Spike TV, Celebrities Clash Where Everyone Can Watch Their Lips Move," *New York Times*, Mar. 31, 2015. http://www.nytimes.com/2015/04/01/business/media/lip-sync-battle-to-make-its-debut-on-spike-tv.html?_r=0.

93 "**happening in pop culture anyway**": Gillian Telling, "Lip Sync Battle: Inside TV's Newest Viral Sensation," *Entertainment Weekly*, Apr. 16, 2015. http://www.ew.com/article/2015/04/16/lip-sync-battle-producer-what-makes-show-so-popular.

94 **collaborated with DanceOn**: Nathan McAlone, "Madonna Cofounded a Startup That Manufactures Viral Dance Trends—and 'Whip/Nae Nae' Was Its First Monster Hit," *Business Insider*, Jan. 28, 2016. http://www.businessinsider.com/madonna-cofounded-a-company-that-creates-viral-dance-videos-and-whipnae-nae-was-its-first-monster-hit-2016-1.

97 "**I don't want that shit**": Corban Goble, "Baauer," *Pitchfork*, Aug. 16, 2013. http://pitchfork.com/features/update/9187-baauer/.

98 "**I called all my coolest art friends**": Swiper Bootz, "The Haus Sans Dada, Sans Laurieann, Heavy on the Nicola . . . #OhNico Ian, Michael, Asiel #Werethedancers," *Art Nouveau Magazine*, Jan. 17, 2012. http://www.an-mag.com/the-haus/.

99 "**the fans are the story**": Sirius XM, "Lady Gaga: 'The Haus of Gaga Is a Real Thing'// SiriusXM // Oprah Radio," YouTube video posted Jun. 13, 2011. https://www.youtube.com/watch?v=YQvT4QnFpWo.

101 "**keep ur party trill**": Katy Perry, Twitter post, Jul. 24, 2014, 10:07 A.M., https://twitter.com/katyperry/statuses/492310013894221824.

102 "**none of us could imitate that**": Jocelyn Vena, "Beyonce 'Nailed It' in 'Girls' Video, Choreographer Says," *MTV News*, May 19, 2011. http://www.mtv.com/news/1664223/beyonce-run-the-world-girls/.

104 "**catchiest song**" he'd ever heard: Jocelyn Vena, "Justin Bieber Relives First Time He Heard 'Call Me Maybe,'" *MTV News*, Sept. 14, 2012. http://www.mtv.com/news/1693836/justin-bieber-carly-rae-jepsen-call-me-maybe/.

105 **#2 song of 2012**: "Hot 100 Songs: Year End Chart," *Billboard*, 2012. http://www.billboard.com/charts/year-end/2012/hot-100-songs.

105 **Tom Hanks**: Shannon Carlin, "Carly Rae Jepsen on How You Get Tom Hanks to Star in Your Music Video," Radio.com, Mar. 6, 2015. http://radio.com/2015/03/06/carly-rae-jepsen-i-really-like-you-video-tom-hanks-interview/.

106 **(More than 90 percent of Americans)**: "Everyone Listens to Music, But How We Listen Is Changing," *Nielsen*, Jan. 22, 2015. http://www.nielsen.com/us/en/insights /news/2015/everyone-listens-to-music-but-how-we-listen-is-changing.html.

5: THE AD YOUR AD COULD SMELL LIKE

109 **deodorant after the ad debuted**: Noreen O'Leary and Todd Wasserman, "Old Spice Campaign Smells like a Sales Success, Too," *Adweek*, Jul. 25, 2010. http:// www.adweek.com/news/advertising-branding/old-spice-campaign-smells-sales -success-too-107588.

112 **register some 150 of those**: Media Dynamics Inc., *Adults Spend Almost 10 Hours per Day with the Media, But Note Only 150 Ads*, Sept. 22, 2014. http://www .mediadynamicsinc.com/uploads/files/PR092214-Note-only-150-Ads-2mk.pdf.

114 **watch the Super Bowl just for the ads**: "Google Consumer Surveys, Canada," *Think with Google*, Jan. 2016. https://www.thinkwithgoogle.com/data-gallery/detail /canada-super-bowl-viewership-for-ads/.

115 **most-shared Super Bowl ad ever**: Will Heilpern, "The 10 Most Shared Super Bowl Ads of All Time," *Business Insider*, Jan. 12, 2016. http://www.businessinsider .com/10-most-shared-super-bowl-ads-ever-2016-1.

115 **"which one is a TV commercial"**: Josh Sanburn, "The Ad That Changed Super Bowl Commercials Forever," *Time*, May 25, 2016. http://time.com/3685708/super -bowl-ads-vw-the-force/.

115 **average 2.5 times the number of views**: "The Big Game Becomes a Month-Long, Multi-Screen Event on YouTube," *Think with Google*, Jan. 2015. https://www .thinkwithgoogle.com/articles/youtube-insights-stats-data-trends-vol9.html.

117 **wrote *Ad Age***: Ann-Christine Diaz, "Geico's 'Unskippable' from the Martin Agency Is Ad Age's 2016 Campaign of the Year," *Ad Age*, Jan. 25, 2016. http://adage .com/article/special-report-agency-alist-2016/geico-s-unskippable-ad-age-s-2016 -campaign-year/302300/.

118 **"one human being to another"**: London International Awards, "John Mescall McCann Melbourne Talks About 'Dumb Ways to Die' the 2013 Grand LIA," YouTube video posted Nov. 8, 2013. https://www.youtube.com/watch?v=RrGWwS JLoyI.

118 **(average length was three minutes)**: "YouTube Data," *Think with Google*, 2014. https://www.thinkwithgoogle.com/data-gallery/detail/top-10-youtube-ads-length -2014/.

122 **"all of the activities"**: Alicia Jessop, "The Secret Behind Red Bull's Rise as an Action Sports Leader," *Forbes*, Dec. 7, 2012. http://www.forbes.com/sites/aliciaj essop/2012/12/07/the-secret-behind-red-bulls-action-sports-success/#20b46b3 d4ede.

6: THE WORLD IS WATCHING

127 **"used toward immigrants"**: Fredrick Kunkle, "Fairfax Native Says Allen's Words Stung," *Washington Post*, Aug. 25, 2006. http://www.washingtonpost.com/wp -dyn/content/article/2006/08/24/AR2006082401639.html.

128 **overtaken him for the first time**: "Battleground States Poll," Dow Jones & Company, Inc., *Wall Street Journal*, Oct. 31, 2006. http://online.wsj.com/public /resources/documents/info-flash05a.html?project=elections06-ft&h=495&w=778&h asAd=1.

128 **Governor Mitt Romney**: "2008 Republican Insiders Poll," *National Journal*, May 13, 2006. http://syndication.nationaljournal.com/images/513insiderspoll.pdf.

128 **barrage of questions**: Jim Rutenberg and Jeff Zeleny, "Democrats Outrun by a 2-Year G.O.P. Comeback Plan," *New York Times*, Nov. 3, 2010. http://www.nytimes .com/2010/11/04/us/politics/04campaign.html.

128 **Person of the Year in 2006**: Michael Scherer, "Salon Person of the Year: S.R. Sidarth," *Salon*, Dec. 16, 2006. http://www.salon.com/2006/12/16/sidarth/.

129 **"heard about from their children"**: Frank Rich, "2006: The Year of the 'Macaca,'" *New York Times*, Nov. 12, 2006. http://www.nytimes.com/2006/11/12/opinion /12rich.html?_r=0.

130 **"remarkably, has never diminished"**: Ben Cosgrove, "Kennedy's Assassina- tion: How LIFE Brought the Zapruder Film to Light," *Time*, Nov. 6, 2014. http://time .com/3491195/jfks-assassination-how-life-brought-the-zapruder-film-to-light/.

131 **"impression with you; it's terrible"**: Assassination Archives and Research Center, *Warren Commission Hearings*, vol 7, 576. http://www.aarclibrary.org/publib /jfk/wc/wcvols/wh7/html/WC_Vol7_0292b.htm.

133 **Mousavi had announced**: Dominic Evans and Fredrik Dahl, "Andy Mousavi Says Iran Vote Result a Fix," Reuters, Jun. 13, 2009. http://www.reuters.com/article /us-iran-election-mousavi-sb-idUSTRE55C1K020090613.

134 **the camera still recording**: *Frontline*, "A Death in Tehran," PBS, 2009. http://www.pbs.org/wgbh/pages/frontline/tehranbureau/deathintehran/etc/script .html.

134 **fellow Iranian seeking asylum**: Robert Tait and Matthew Weaver, "How Neda Agha-Soltan Became the Face of Iran's Struggle," *Guardian*, Jun. 22, 2009. https://www.theguardian.com/world/2009/jun/22/neda-soltani-death-iran.

135 **store in his 1991 Mercedes**: Associated Press, "Records Reveal Details About Past of Man Shot by Cop," CBS News, Apr. 11, 2015. http://www.cbsnews.com/news /south-carolina-details-walter-scott-michael-slager/.

136 **"shot him, police alleged"**: Christina Elmore and David MacDougall, "N. Charleston Officer Fatally Shoots Man," *Post and Courier*, Apr. 3, 2015. http://www .postandcourier.com/archives/n-charleston-officer-fatally-shoots-man/article_483 b2c62-f65e-5c33-b92b-314062866c9a.html.

136 **"away from the Taser"**: Melanie Eversley, "Man Who Shot S. C. Cell Phone Video Speaks Out," *USA Today*, Apr. 9, 2015. http://www.usatoday.com/story/news /2015/04/08/walter-scott-feidin-santana-cell-phone-video/25497593/.

136 **concerned for his safety**: Valerie Bauerlein, "How Feidin Santana Caught South Carolina Shooting on Video," *Wall Street Journal*, Apr. 9, 2015. http://www.wsj .com/articles/south-carolina-shooting-fled-after-taking-cellphone-video-1428595282.

136 **"I got mad"**: James Queally and David Zucchino, "Man Who Recorded Walter Scott Shooting Says His Life Has Changed Forever," *Los Angeles Times*, Apr. 9, 2015. http://www.latimes.com/nation/nationnow/la-na-nn-videographer-south-carolina -20150408-story.html.

137 **renamed for Scott the month following**: Jeremy Borden, "House Approves Body Cam Bill," *Post and Courier*, May 12, 2015. http://www.postandcourier.com/poli tics/house-approves-body-cam-bill/article_79c725ab-8045-5722-bf34-dc8fa00968af .html.

137 **Garner's daughter**: Democracy Now!, "Two Years After Eric Garner's Death, Ramsey Orta, Who Filmed Police, Is Only One Heading to Jail," YouTube video posted Jul. 13, 2016. https://www.youtube.com/watch?v=QbMouO8zy2E.

137 **"glaring light of television"**: Stephen Bijan, "Social Media Helps Black Lives Matter Fight the Power," *WIRED*, Nov. 2015. https://www.wired.com/2015/10/how -black-lives-matter-uses-social-media-to-fight-the-power/.

138n **in over one hundred years**: Geoff Brumfiel, "Russian Meteor Largest in a Century," *Nature International Weekly Journal of Science*, Feb. 15, 2013. http://www .nature.com/news/russian-meteor-largest-in-a-century-1.12438.

140 **forced him into significant debt**: Kareem Fahim, "Slap to a Man's Pride Set Off Tumult in Tunisia," *New York Times*, Jan. 21, 2011. http://www.nytimes.com /2011/01/22/world/africa/22sidi.html?_r=1&pagewanted=2&src=twrhp.

140 **and posted online**: Thessa Lageman, "Mohamed Bouazizi: Was the Arab Spring Worth Dying For?" Aljazeera, Jan 3, 2016. http://www.aljazeera.com/news /2015/12/mohamed-bouazizi-arab-spring-worth-dying-151228093743375.html.

144 **increased generosity**: J. A. Barraza and P. J. Zak, "Empathy Toward Strangers Triggers Oxytocin Release and Subsequent Generosity," *Annals of the New York Academy of Sciences,* 1167 (2009): 182–189.

144 **2009 interview with the BBC**: "Iran Doctor Tells of Neda's Death," BBC News, Jun. 25, 2009. http://news.bbc.co.uk/2/hi/middle_east/8119713.stm.

145 **explained in a 2006 TED talk**: Peter Gabriel, "Fight Injustice with Raw Video," TED video. https://www.ted.com/talks/peter_gabriel_fights_injustice_with _video/transcript?language=en.

146 **"minding my business"**: Josh Sanburn, "The Witness: One Year After Filming Eric Garner's Fatal Confrontation with Police, Ramsey Orta's Life Has Been Upended," *Time,* Jul. 17, 2015. http://time.com/ramsey-orta-eric-garner-video/.

147 **never would have posted it**: Raphael Satter, "AP Exclusive: Witness to Paris Officer's Death Regrets Video," Associated Press, Jan. 11, 2015. https://apnews.com/5 e1ee93021b941629186882f03f1bb79.

147 **created a crowdsourced site**: Dan Verderosa, "Digital Media and Iran's Green Movement: A Look Back with Cameran Ashraf," *Hub,* Dec. 15, 2009. http://hub .witness.org/en/blog/digital-media-and-irans-green-movement-look-back-cameran -ashraf.

7: I LEARNED IT ON YOUTUBE
153 **less than 10 percent**: Joseph Carroll, "'Business Casual' Most Common Work Attire," *Gallup,* Oct. 4, 2007. http://www.gallup.com/poll/101707/business-casual-most -common-work-attire.aspx.

154 **"vast wasteland"**: Newton N. Minow, "Television and the Public Interest," (speech, Washington, D.C., May 9, 1961), *American Rhetoric.* http://www.american rhetoric.com/speeches/newtonminow.htm.

158 **sneaking into Syria**: Clarissa Ward, "Sneaking into Syria," CBS News, Dec. 5, 2011. http://www.cbsnews.com/news/sneaking-into-syria/.

165 **he later told CNN**: Matt Bonesteel, "YouTube-Taught Javelin Thrower Julius Yego Wins Gold at World Championship," *Washington Post,* Aug. 26, 2015. https://www .washingtonpost.com/news/early-lead/wp/2015/08/26/youtube-taught-javelin-thrower -julius-yego-wins-gold-at-world-championships/?utm_term=.eccfecdc373a.

166 **national rugby team**: Nick Purewal, "'I learned the Irish National Anthem from Youtube clips'—CJ Stander excited to be part of Six Nations squad," Independent .ie, Jan. 1, 2016. http://www.independent.ie/sport/rugby/international-rugby/i-learned -the-irish-national-anthem-from-youtube-clips-cj-stander-excited-to-be-part-of-six -nations-squad-34407742.html.

167 **one year old**: Bruce I. Reiner, "Strategies for Radiology Reporting and Communication," *Journal of Digital Imaging* 26, no. 5 (Sep. 2013): PMC.

167 **"processes visual images"**: Riad S. Aisami, "Learning Styles and Visual Literacy for Learning and Performance," *Procedia—Social and Behavioral Sciences* 176 (2015): 542, *ScienceDirect*.

167 **students to engage more fully**: Joel D. Galbraith, "Active Viewing: An Oxymoron in Video-Based Instruction?," Sep. 14, 2004.

8: NICHE: THE NEW MAINSTREAM

170 **digital word of mouth**: Dina Bass, "Microsoft to Buy Minecraft Maker Mojang for $2.5 Billion," *Bloomberg Technology*, Sep. 15, 2014. https://www.bloom berg.com/news/articles/2014-09-15/microsoft-to-buy-minecraft-maker-mojang -for-2-5-billion.

171 **"most detailed map ever in Minecraft"**: Steven Messner, "Over Four Years Went into Building This Gorgeous Minecraft Kingdom," *PC Gamer*, Oct. 6, 2016. http://www.pcgamer.com/minecraft-kingdom/.

173 **"from 27 in 1980"**: "Changing Channels: Americans View Just 17 Channels Despite Record Number to Choose From," *Nielsen*, May 6, 2014. http://www.nielsen .com/us/en/insights/news/2014/changing-channels-americans-view-just-17-channels -despite-record-number-to-choose-from.html.

173 **wasn't nearly enough**: Tim Molloy, "Discovery to Spend Another $50M on OWN," *Wrap*, Feb. 11, 2011. http://www.thewrap.com/discovery-spend-another-50m -own-24656/.

175 **"gratification through others"**: Elise Hu, "Koreans Have an Insatiable Appetite for Watching Strangers Binge Eat," Salt, *NPR*, Mar. 24, 2015. http://www.npr.org /sections/thesalt/2015/03/24/392430233/koreans-have-an-insatiable-appetite-for -watching-strangers-binge-eat.

176 **"community that isn't geographic"**: Carol Kino, "It's Not Candid Camera, It's Random Culture," *New York Times*, Feb. 4, 2011. http://www.nytimes.com/2011 /02/06/arts/design/06random.html?_r=0.

181 **"enjoyment or value out of it"**: Phil Kollar, "The Past, Present and Future of League of Legends Studio Riot Games," *Polygon*, Sep. 13, 2016. http://www.polygon.com/2016/9/13/12891656/the-past-present-and-future-of-league-of-legends-studio-riot-games.

181 **two thirds of the U.S. population**: Mike Snider, "Nielsen: People Spending More Time Playing Video Games," *USA Today*, May 27, 2014. http://www.usatoday.com/story/tech/gaming/2014/05/27/nielsen-tablet-mobile-video-games/9618025/.

184 **"give 'em hope"**: Dan Savage, "How It Happened: The Genesis of a YouTube Movement," *Stranger*, Apr. 13, 2011. http://www.thestranger.com/seattle/how-it-happened/Content?oid=7654378.

185 **"a part of everyday life"**: Jonathan Wells, "Tyler Oakley: How the Internet Revolutionized LGBT Life," *Telegraph*, Nov. 12, 2015. http://www.telegraph.co.uk/men/thinking-man/tyler-oakley-how-the-internet-revolutionised-lgbt-life/.

9: SCRATCHING THE ITCH
192 **"'tingling' in the head and spine"**: Nitin Ahuja, "'It Feels Good to Be Measured': Clinical Role-Play, Walker Percy, and the Tingles," *Perspectives in Biology and Medicine* 56, no. 3 (Summer 2013): 442–51.

194 **sample of individuals**: Emma L. Barratt and Nick J. Davis, "Autonomous Sensory Meridian Response (ASMR): A Flow-Like Mental State," *PeerJ*, Mar. 26, 2015. https://peerj.com/articles/851/.

196 **"along with the commercials"**: George Gent, "WPIX's Night Before Christmas: Nothing Stirring But a Yule Log," *New York Times*, Dec. 9, 1966.

196 **Trollfjorden in Vesterålen**: Haakon Wærstad, "How Do We Measure Viewing Figures," *NRK*, Jun. 21, 2011. https://www.nrk.no/telemark/slik-maler-vi-seertallene-1.7682457.

196 **"more right it is"**: Mark Lewis, "Norway's 'Slow TV' Movement: So Wrong, It's Right," *Time*, Jul. 8, 2013. http://world.time.com/2013/07/08/norways-slow-tv-movement-so-wrong-its-right/.

199 **funny and bewildering 2014 essay**: Mireille Silcoff, "A Mother's Journey Through the Unnerving Universe of 'Unboxing' Videos," *New York Times Magazine*, Aug. 15, 2014. https://www.nytimes.com/2014/08/17/magazine/a-mothers-journey-through-the-unnerving-universe-of-unboxing-videos.html?_r=0.

199 **panicky news story**: Nicole Chettle, "'Unboxing' Internet Craze a Threat to Kids: Psychologists," *New Daily*, Jul. 26, 2015. http://thenewdaily.com.au/life/tech/2015/07/26/unboxing-internet-craze-threat-kids-say-psychologists/.

200 **told the *Telegraph***: Rosa Prince, "Toddlers Mesmerised by Surreal World of Unboxing Videos," *Telegraph*, Sept. 22, 2014. http://www.telegraph.co.uk/news/world news/northamerica/usa/11112511/Toddlers-mesmerised-by-surreal-world-of-unboxing -videos.html.

200 **wrote Jackie Marsh**: Jackie Marsh, "'Unboxing' Videos: Co-Construction of the Child as Cyberflâneur," Academia.edu (2015): 10. http://www.academia.edu/ 20711532/Unboxing_videos_co-construction_of_the_child_as_cyberfl%C3% A2neur.

202 **"remain that way"**: Alfred Maskeroni, "Meet the Mysterious YouTube Food Surgeon Who Hypnotically Concocts Freaky Candy Hybrids," *Adweek*, Mar. 9, 2016. http://www.adweek.com/adfreak/meet-mysterious-youtube-food-surgeon-who-hyp notically-concocts-freaky-candy-hybrids-170045.

202 **Gillian Roper told the *Atlantic***: Julie Beck, "The Existential Satisfaction of Things Fitting Perfectly into Other Things," *Atlantic*, Aug. 14, 2015. http://www.the atlantic.com/health/archive/2015/08/the-existential-satisfaction-of-things-fitting -perfectly-into-other-things/401213.

202 **"it was so close"**: Peatoire, "This Is Me Hydrating a Compressed Sponge," *Reddit*, 2014. https://www.reddit.com/r/oddlysatisfying/comments/2k2waq/this_is _me_hydrating_a_compressed_sponge/.

204 **"clear his ears must feel now"**: Lecia Bushak, "Removing Earwax from an Ear Has Never Looked So Gross, Yet Satisfying," *Medical Daily*, Jun. 19, 2015. http:// www.medicaldaily.com/pulse/removing-earwax-ear-has-never-looked-so-gross -yet-satisfying-339114.

204 **"when the extraction is complete"**: Diana Bruk, "Watch Someone Pull Out a Monstrous Chunk of Ear Wax and Try Not to Hurl," *Cosmopolitan*, Jun. 17, 2015. http://www.cosmopolitan.com/sex-love/news/a42162/watch-someone-pull-out-a -monstrous-chunk-of-ear-wax/.

205 **(some form of it)**: Siri Carpenter, "Everyday Fantasia: The World of Synes-thesia," *American Psychological Association* 32, no. 3 (Mar. 2001). http://www.apa .org/monitor/mar01/synesthesia.aspx.

207 **"the Leidenfrost effect"**: Wikipedia, https://en.wikipedia.org/wiki/Leiden frost_effect.

209 **Daniel Markham told the local news**: Martha Ostergar, "'What's Inside?': Kaysville Family Hits 100K Subscribers on YouTube," KSL.com, Aug. 18, 2015. http:// www.ksl.com/?sid=36023553&nid=148.

209 **including, of course, the RHNB**: Adam Freelander, "Watching This Popular YouTuber Crush Household Objects with 100 Tons of Pressure Is Pure Catharsis," *Quartz*, Apr. 8, 2016. http://qz.com/657279/watching-a-finnish-man-crush-household -objects-with-100-tons-of-pressure-is-pure-catharsis/.

214 **"anxiety or cardiac stress"**: Tori DeAngelis, "The Two Faces of Oxytocin," *American Psychological Association* 39, no. 2 (Feb. 2008). http://www.apa.org/monitor /feb08/oxytocin.aspx.

214 **"to them highlights this"**: Jeffrey M. Zacks, *Flicker: Your Brain on Movies* (Oxford: Oxford University Press, 2015).

215 **theory of downward comparison**: Thomas A. Willis, "Downward Comparison Principles in Social Psychology," *Psychological Bulletin* 90, no. 2 (Sept. 1981): 245–71. http://psycnet.apa.org/index.cfm?fa=buy.optionToBuy&id=1981-30307-001.

216 **"for a good two years"**: Clint Rainey, "10 Former Viral Sensations on Life After Internet Fame," Select All, *New York* magazine, Dec. 2, 2015. http://nymag.com /selectall/2015/12/10-viral-sensations-on-life-after-internet-fame.html?mid=twitter _nymag#.

216 **"effect on personal life happiness"**: Silvia Knobloch-Westerwick et al., "Tragedy Viewers Count Their Blessings: Feeling Low on Fiction Leads to Feeling High on Life," *Sage Journals* 40, no. 6 (2012): 761. http://journals.sagepub.com/doi/pdf /10.1177/0093650212437758.

10: GOING VIRAL
222 **$4,000 all at once**: Lisa Belkin, "An Internet Star's Mom Responds," Motherlode, *New York Times*, Mar. 25, 2011. http://parenting.blogs.nytimes.com/2011/03/25 /an-internet-stars-mom-responds.

222 **one evening and morning**: Jessica Hundley, "Patrice Wilson of Ark Music: 'Friday' Is on His mind," Pop & Hiss, *L.A. Times Music Blog*, Mar. 29, 2011. http:// latimesblogs.latimes.com/music_blog/2011/03/patrice-wilson-of-ark-music-friday-is -on-his-mind.html.

223 **"I'm still known"**: John Semley, "Patrice Wilson—Songwriter, Producer," *Believer* 12, no. 2 (Feb. 2014). http://www.believermag.com/issues/201402/?read =interview_wilson.

226 **fifty times by various papers**: Britt Peterson, "There Were Listicles That Went Viral Long Before There Was an Internet," *Smithsonian Magazine*, Jul. 2015. http://www.smithsonianmag.com/innovation/listicles-went-viral-long-before-internet -180955742/.

231 **"only at 100,000 views"**: Evie Nagy, "Ylvis Q&A: What 'The Fox' (Viral Stars) Say About Their Surprise Hit," *Billboard*, Sep. 7, 2013. http://www.billboard.com /articles/news/5687218/who-is-ylvis-the-fox-creators-on-going-viral-and-whats-next.

235 **"philanthropists like Bill Gates"**: Nancy Frates, "Meet the Mom Who Started the Ice Bucket Challenge," TED video. https://www.ted.com/talks/nancy_frates_why _my_family_started_the_als_ice_bucket_challenge_the_rest_is_history/transcript? language=en.

236 **received through the Ice Bucket Challenge**: ALS Association, *ALS Ice Bucket Challenge Donations Led to Significant Gene Discovery*, Jul. 25, 2016. http:// www.alsa.org/news/media/press-releases/significant-gene-discovery-072516.html.

238 **release of dopamine**: Nico Bunzeck and Emrah Duzel, "Absolute Coding of Stimulus Novelty in the Human Substantia Nigra/VTA," *Neuron* 51, no. 3 (Aug. 2006): 369–79.

238 **pleasure in unexpected creativity**: University College London, "Novelty Aids Learning," UCL News, Aug. 2, 2006. http://www.ucl.ac.uk/news/news-articles/news -releases-archive/newlearning.

239 **"share it with others"**: Tania Luna and LeeAnn Renniger, *Surprise: Embrace the Unpredictable and Engineer the Unexpected* (New York: TarcherPerigee, 2015).

243 **"launched my career"**: Fathomas, "I Am Jason Steele, Creator of Charlie the Unicorn, Llama with Hats, and Other Internet Videos. Ask Me Anything!," *Reddit*, Mar. 2016, https://www.reddit.com/r/IAmA/comments/49prlm/i_am_jason_steele _creator_of_charlie_the_unicorn/dotrvpm/.

244 **Korea at the time could see**: Jonah Berger, *Contagious: Why Things Catch On* (New York: Simon & Schuster, 2013), 156.

244 **draw fifty views**: "Bouquets and Brickbats: Ken Shucks Corn, and We All Care," *Tribune*, Oct. 20, 2011. http://www.sanluisobispo.com/opinion/editorials/article3918 6507.html.

247 **"managed to emerge unbroken"**: Reggie Ugwu, "The Unbreakable Rebecca Black," BuzzFeed, Aug. 7, 2015. https://www.buzzfeed.com/reggieugwu/the-unbreak able-rebecca-black.

11: WHAT VIDEOS DO FOR US

253 **deserved an Oscar**: Malaka Gharib, "Bono Comments on Invisible Children's Kony 2012 Campaign," *One*, Mar. 12, 2012. https://www.one.org/us/2012/03/12/bono -comments-on-invisible-childrens-kony-2012-campaign/.

256 **"OH YEAH," Pat replied**: Jukin Media, "Behind The Video—Matt Little and 'Pizza Rat,'" YouTube video posted Jun. 9, 2016. https://www.youtube.com/watch?v=NpLzuTkgHQ8.

262 **"across the cyber-plain"**: Jeffrey Benner, "When Gamer Humor Attacks," *Wired*, Feb. 23, 2001. https://www.wired.com/2001/02/when-gamer-humor-attacks/.

263 **Davies-Carr was stunned**: Matthew Moore, "Finger-Biting Brothers Become YouTube Hit," *Telegraph*, Dec. 5, 2008. http://www.telegraph.co.uk/news/uknews/3564392/Finger-biting-brothers-become-YouTube-hit.html.

266 **"have any words for it"**: Eliza Murphy, "Little Sister's Unamused Reaction to Disneyland Surprise Steals the Spotlight," ABC News, Sep. 25, 2013. http://abcnews.go.com/blogs/lifestyle/2013/09/little-sisters-unamused-reaction-to-disneyland-surprise-steals-the-spotlight/.

267 **an assistant around the studio**: Richard Buskin, "Rick Astley 'Never Gonna Give You Up,'" *Sound on Sound*, Feb. 2009. http://www.soundonsound.com/people/rick-astley-never-gonna-give-you.

267 **in front of them to prove it**: Fred Bronson, *The Billboard Book of Number One Hits* (New York: Billboard Books, 2003), 693.

267 **"give her up, are you?"**: Tom Bromley, *Wired for Sound: Now That's What I Call an Eighties Music Childhood* (London: Simon & Schuster, 2012).

268 **receiving 100 million votes**: Matthew Moore, "Rickrolling: Rick Astley named Best Act Ever at the MTV Europe Music Awards," *Telegraph*, Nov. 7, 2008. http://www.telegraph.co.uk/news/celebritynews/3395589/Rickrolling-Rick-Astley-named-Best-Act-Ever-at-the-MTV-Europe-Music-Awards.html.

270 **"could've been anybody's song"**: Gary Graff, "Rick Astley on Returning to the Spotlight with His No. 1 Album '50' and the 'Weird' Phenomenon of Rickrolling," *Billboard*, Aug. 1, 2016. http://www.billboard.com/articles/news/7454407/rick-astley-talks-new-album-50-rickrolling-being-back-in-spotlight-touring-america.

12: THE NEW TALENT

280 **"rather than the professionals"**: Tom Butler, "Interview with Lindsey Stirling," *London Calling*, Oct. 23, 2014. http://londoncalling.com/features/interview-with-lindsey-stirling.

280 **he told *Adweek***: T. L. Stanley, "Why Utah Is Poised to Be America's Next Tech and Creative Hub: College Grads, Beehive Work Ethic Put Silicon Slopes on the Map," *Adweek*, Jul. 10, 2016. http://www.adweek.com/news/advertising-branding/why-utah-poised-be-americas-next-tech-and-creative-hub-172444.

282 **"the relatively normal"**: Caroline Siede, "YouTube Stars Create Communities, Not Fans," *A.V. Club*, Jun. 26, 2014. http://www.avclub.com/article/youtube-stars-create-communities-not-fans-205939.

283 **readership of seventy-five million**: Katie Calautti, "Hedda, Louella, and Now Tilda: The Hollywood Rivalry That Inspired *Hail Caesar!*," *Vanity Fair*, Feb. 2, 2016. http://www.vanityfair.com/hollywood/2016/02/tilda-swinton-hail-caesar-hedda-hopper-louella-parsons.

284 **"you record it"**: Lindsay Deutsch, "Unfiltered YouTube 'Changing Diversity' for Minorities," *USA Today*, Dec. 20, 2014. http://www.usatoday.com/story/tech/2014/12/19/youtube-diversity-millennials/18961677/.

284 **their personal lives or careers**: John Hartley, Jean Burgess, and Axel Bruns, *A Companion to New Media Dynamics* (Boston: Wiley-Blackwell, 2013), 361.

284 **"burden on a relationship"**: BFvsGF, "A New Chapter," *YouTube*, May 18, 2016. https://www.youtube.com/watch?v=loKazRqIJ9U.

285 **$7.4 million the previous year**: Peter Thunborg, "Youtube-jättens stora vinst: 63 miljoner," *Expressen*, Jul. 3, 2015. http://www.expressen.se/nyheter/youtube-jattens-stora-vinst-63-miljoner/.

287 **"browser windows at this page!"**: Lindsay Robertson, "We Must Stop Avril Lavigne from Owning YouTube," *Stereogum*, Jun. 23, 2008. http://www.stereogum.com/1779993/we_must_stop_avril_lavigne_fro/vg-loc/videogum/.

288 **"may not have heard of mine"**: John Leland, "Where All the Beautiful People Are Ho-Hum," *New York Times*, Sept. 24, 2006. http://www.nytimes.com/2006/09/24/weekinreview/24leland.html?_r=0.

288 **"reputations with links"**: Rex Sorgatz, "The Microfame Game," *New York* magazine, Jun. 17, 2008. http://nymag.com/news/media/47958/.

292 **fastest-selling debut of all time**: Anita Singh, "Zoella Breaks Record for First-Week Book Sales," *Telegraph*, Dec. 2, 2014. http://www.telegraph.co.uk/news/celebritynews/11268540/Zoella-breaks-record-for-first-week-book-sales.html.

END CARD
301 **"to push boundaries"**: PewDiePie, "My Response," YouTube, Feb. 16, 2017. https://www.youtube.com/watch?v=lwk1DogcPmU.

Index

KEVIN ALLOCCA is head of culture and trends at YouTube, where he has spent more than seven years tracking and explaining trending phenomena. He is one of the world's leading experts on viral video. Allocca has given conference keynotes around the world on web video culture, including a TED Talk that has been viewed more than two million times. He's also obsessed over more videos than every teenager and serial workplace procrastinator you've ever met. He lives in New York City.